Genius,
THE LIFE

Isolated
AND ART OF ALEX TOTH

DEAN MULLANEY AND BRUCE CANWELL

THE
LIBRARY OF
AMERICAN
COMICS

IDW PUBLISHING
SAN DIEGO, CALIFORNIA

THE LIBRARY OF AMERICAN COMICS

EDITED AND DESIGNED BY Dean Mullaney

ASSOCIATE EDITOR & BIOGRAPHICAL TEXT BY Bruce Canwell

ASSOCIATE ART DIRECTOR & JON FURY RESTORATION BY Lorraine Turner

CONTRIBUTING EDITORS David Armstrong & Scott Dunbier • INTRODUCTION Mark Chiarello

MARKETING DIRECTOR Beau Smith • BIBLIOGRAPHY Francisco San Millan & Axel Kahlstorff

ISBN: 978-1-60010-828-0 Second Printing, September 2011

LibraryofAmericanComics.com

IDW Publishing
a Division of Idea and
Design Works, LLC
5080 Santa Fe Street
San Diego, CA 92109
www.idwpublishing.com

OPERATIONS: Ted Adams, Chief Executive
Officer/Publisher • Greg Goldstein, Chief
Operating Officer • Matthew Ruzicka, CPA,
Chief Financial Officer • Alan Payne, VP of Sales
Lorelei Bunjes, Dir. of Digital Services • Jeff Webber,
Dir. ePublishing • AnnaMaria White, Dir. Marketing
& PR Manager • Dirk Wood, Dir. Retail Marketing
Marci Hubbard, Executive Assistant • Alonzo Simon,
Shipping Manager • Angela Loggins, Staff Accountant
Cherrie Go, Assistant Web Designer

EDITORIAL: Chris Ryall, Chief Creative Officer/Editor-in-Chief
Scott Dunbier, Senior Editor, Special Projects • Andy Schmidt,
Senior Editor • Justin Eisinger, Senior Editor, Books • Kris Oprisko,
Editor/Foreign Lic. • Denton J. Tipton, Editor • Tom Waltz, Editor
Mariah Huehner, Editor • Carlos Guzman, Editorial Assistant • Bobby
Curnow, Assistant Editor

DESIGN: Robbie Robbins, EVP/Sr. Graphic Artist • Neil Uyetake, Senior
Art Director • Chris Mowry, Senior Graphic Artist • Amauri Osorio, Graphic
Artist • Gilberto Lazcano, Production Assistant • Shawn Lee, Graphic Artist

*This book has been produced with the
generous coöperation and support of
Alex Toth's children—Carrie,
Damon, Dana, and Eric—and
their mother, Christina Hyde.*

*Special thanks for help above
and beyond the call of duty to:*
Ruben Espinosa
John Hitchcock
Axel Kahlstorff
Bill Peckmann
Rubén Procopio
James Robinson
Francisco San Millan
Jim Steranko

Additional copyrights, permissions,
thanks, and acknowledgments
continue on pages 324 and 325.

Gandhi said, "In simplicity, directness, and strength."
Von Schmidt admired "the beauty of the simple thing."
Katharine Hepburn: "Elimination makes a great artist. Simplify, simplify, simplify!"

Seems in all arenas of "art" this is the eternal quest and an elusive goal…
to survey what it is we do best and try to strip out all surface technique
and superficiality, layer by layer, to reach for "truth" through simplicity—
and let it stand naked, bright, and alone.

Honesty, simplicity, and beauty are the
"holy trinity" of great art.

—Alex Toth, in a letter to Milton Caniff, March 1976

After all the other pioneers had pooped out,
he picked up the flag and started going up the hill again.

—John Romita Sr., on Alex Toth's influence and legacy

PREFACE

Alex Toth's significance to comics and animation art cannot be overstated. In comic books, he was the foremost proponent of modern design and composition. Starting in 1950, his work influenced almost every one of his contemporaries and has continued to work its magic on the generations that followed. In animation, his 1960s model sheets for Hanna-Barbera are still passed around as swipe sources from animator to young animator in the 21st Century.

A difficult task confronts us when we attempt to survey the entirety of an artist's life and career. The difficulty is amplified when that artist is not primarily known for one or two specific creations, but instead for a multifarious output that is actually defined by his restless genius. The challenge of the undertaking is compounded when the artist is one whom many people knew and many thought they knew, an artist who created for himself a larger-than-life personality—a partial fiction, perhaps—in the many opinion columns he published and in the prolific correspondences with which he engaged dozens upon dozens of peers, fans, and old friends.

Fundamentally, he became very much like his great hero, Noel Sickles—the guy all the others wanted to draw like—but he wasn't comfortable in that role. I remember his reaction to such a compliment one day when he stopped at my office for a visit in the mid-1980s. Instead of acknowledging the compliment, he immediately turned the conversation back to Sickles and Caniff, throwing in Robbins and Andriola for good measure, while noting that the real talent in the family was his son, Eric, who designed cars.

Yet Alex Toth was more than a singular talent. He was also a keenly insightful thinker and philosopher about the nature of comics and art, and it's in this role that he had an additional influence in the last two decades of his life: by encouraging young cartoonists to stay true to their own visions. Some may have seen him as "old school," because he had very definite thoughts about comics and animation, about how they are created as opposed to how he felt they should be created. The great editor and artist Dick Giordano observed that it must have been difficult being Alex Toth. "He saw things on a different plane than the rest of us," Dick told me at a comic book convention in 2009.

It was Toth's sense of design—what he could imagine, but an editor could not see—that often made his professional life problematic. His other frustration was the difficulty he had with writing comics. Without the facility to originate his own stories, he would accept drawing assignments, ignore the supplied scripts, and unilaterally rewrite at his own discretion. Perhaps if he had been more comfortable writing, or if he'd had a scripting partner he could trust, his career would have taken a different turn.

· · · · ·

We went into this project searching for the truth, whatever that might be. The truth to one is not necessarily the truth to another. Among Alex's long-term friends and even his family, the truth would prove to be malleable.

David Armstrong's Toth is not Jim Amash's, nor is either of theirs the husband remembered by Christina or the father whom Dana, Carrie, Eric, and Damon recall. Mark Chiarello's Alex Toth was not John Hitchcock's, and neither of theirs was the Toth of Jerry DeFuccio, Rubén Procopio, or Manuel Auad.

There are as many perspectives on the man as there are people who knew him. What has emerged from two-and-a-half years of research and interviews is that there is no single Alex Toth, but a mosaic, an overall picture made up of everyone's individual little pictures: the artist, the man, the husband, the father, the peer, the mentor, the friend.

The search for truth can sometimes take us down unexpected paths. I have long been a great fan and admirer of Alex's work. I thought I was well-versed in his career, yet in the production of this book (and the subsequent two that complete the *Alex Toth: Genius* trilogy)—in view of the full breadth of his work—a new, more intimate insight is obtained into the whole of his creative being, and how one period or story is surprisingly related to another.

Our research also exposed new aspects of Alex's personal life, which has been a cathartic experience for his children, in particular, who have told us they now have a deeper and better understanding of their dad.

· · · · ·

Some might question the relevance of Toth's private life and his personal demons in an overview of his work. The answer lies in his restlessness, his self-imposed isolation. He would sometimes provide a laundry list of his failures, both personal and professional, and while those "failures" were not as great as he himself believed, that he believed them is what's important. If he could not live up to his expectations, how could anyone else? He could end a twenty-year relationship in a second. A young cartoonist who gladly supplied Alex with books—at Alex's request—once made the mistake of allowing his young children to play with the box before it was packed. The kids dropped a few pennies in the

box. The last the cartoonist ever heard from Alex was, "I don't accept charity."

He was hard on other people, but was hardest on himself. While he would turn his back on editors and writers who didn't see things his way, it was his elusive search for solitary contentment that just as often caused him to close the iron door behind him. Despite the obstacles from without and within, his personality was too large, his talent too immense, for the door ever to fully close. During his sixty years as a professional cartoonist, Alex Toth created an astonishing, unique body of work that will continue to be read and studied for years to come.

· · · · ·

Many of the works in this book are reproduced from the original art. We have spent several years tracking down artwork across the globe and are proud to present the largest collection of Toth originals ever assembled. On key stories for which no originals could be found, we scanned the printed comics. Whether as original art or printed example, Alex Toth's genius may have flourished in isolation, but we are all the richer for its current exposure.

· · · · ·

The first comic book I remember reading was an issue of *Four Color* featuring Zorro. It was 1958, and I was four years old. It was an adaptation of my favorite television series produced by Walt Disney, and those ten-cent comics gave me endless reading pleasure.

Flash-forward thirty years to 1988, and I had the great pleasure of working with Alex when I edited the definitive *Zorro* collections.

Flash-forward another twenty-three years to this present endeavor. I'm no longer four or even thirty-four years old, but—lucky me—Alex Toth is still providing me with endless pleasure and enjoyment.

Dean Mullaney, Editor
January 2011

INTRODUCTION

Discussions of Alex Toth are invariably divided equally into two distinct subjects: his brilliant artistic ability and, unfortunately, his sometimes difficult personality. I guess since I've been asked to write an introduction to a book about the man and his work, I should probably address both.

Alex and I corresponded for over sixteen years, sending letters back and forth about every possible subject. Very often Alex would shove five or ten of his sketchbook pages into the envelope along with his letters. Over the course of those sixteen-plus years, I accumulated about three hundred sketch pages from Alex. Beautiful drawings of people, airplanes, cars…but mostly people. Of course, I still have them all, and often take the stack out to marvel over them. Looking at them recently, something totally bizarre occurred to me: every face on every page is of a different person. We're talking about thousands of drawings of people. If you're an artist, you can probably make up ten or twenty completely different people out of your imagination. If you're a great artist, you might be able to create fifty or seventy-five totally different faces before you start to repeat yourself, but *thousands*??? It's just not possible! For Alex, it was not only possible, it was simple.

Once, while I was visiting Alex at his home in the Hollywood Hills, I screwed up all of my courage and asked Alex to do a drawing for me. It wasn't that I wanted a free drawing, but rather, I wanted to see the Master do the drawing. He bitched and crabbed, but eventually walked over to the kitchen table that he did all of his drawings at and, sitting down in a huff, looked up at me and said, "OK, pest, what do you want me to draw?" I blurted out, "Um…draw me a gangster!" He got a chuckle out of my request and said something about my Italian heritage and how predictable I was.

Then the amazing happened…he drew the inside of an ear. I mean, *Who* starts a drawing with the inside of an ear? I watched his pen as it etched out a series of unrelated lines and shapes that eventually formed the drawing of a gangster. I've seen Clapton play the guitar, I've seen Willie Mays make a running basket-catch in center field, I had seen Alex Toth create a human being with a pen and a piece of paper. In each of those cases, I saw something I couldn't fully fathom; in each of those three instances I suddenly wondered what planet I was on. I had witnessed magic, or more accurately, I was privy to a demonstration of genius.

In Alex's case, I just couldn't figure out how he was doing what he was doing. I'm an artist, when I watch a fellow artist do a drawing it's fairly easy for me to figure out his thought process and how he's constructing the drawing. While watching Alex draw that gangster I looked around myself, wishing that someone was standing next to me, wishing someone else was seeing what I was seeing. I wanted *so* desperately to ask someone if they could explain this parlor trick to me. When he was done, Alex looked up at me with raised eyebrows and a funny smile on his face, as if to say, "See, kiddo, it's simple."

"Simple" was everything to Alex Toth. Either you were a real artist or you weren't. If you were, it was simple. If you weren't, you were a charlatan. Life was equally simple, either you were a good guy who always stood for real values, or you were less of a person. Simple.

But life isn't really like that. We're all flawed, we all occasionally slide away from what we know is "right," and then feel like crap as we try to return to being who we know we truly are. That's what was so hard for Alex—he knew he could tell a comic story better than anyone, but sometimes (especially later in life) something stood in his way. He wasn't sure what that something was, and it hurt and confused him. It was on those occasions that he acted like a wounded animal, and, frankly, wasn't very nice to be around. He took many things that his friends and family did and said as personal insults, and once that happened he closed the door on those relationships forever. After a long friendship it happened to me, and for a long time I was devastated that my hero had turned on me for no good reason.

I'm happy to say, however, that through his four kids and a mutual friend of ours named Rubén Procopio, Alex finally took a good look at himself and realized how hard he had been on everyone, including himself, and mended a lot of bridges. I'm also happy to say that he wrote me a wonderful letter a few days before he died, in which he apologized for his behavior. Well, OK, it wasn't so much an apology (remember, we're talking about *Toth* here), but it was a really nice, sweet letter.

Alex's work speaks for itself. You don't need me to tell you its place in the history of the comics medium, or what makes it so incredible, or how many artists it profoundly influenced. Just look through this book and you'll know. It is *simply* the work of a genius.

Mark Chiarello
Art & Design Director
DC Comics

ABOVE: Hand-painted animation cel for *Space Angel*, circa 1962.

PRO/LOGUE

SWASHBUCKLER

The boy leaped from the stoop, hitting the 23rd Street sidewalk in a crouch, then up and off at top speed. His right hand flicked an imaginary Pariser to ward off Prince John's men. *Hah*—a skillful *Attaque au Fer* put paid to the cowardly Sherriff! *Ho*—a lunge, stop-cut, and lightning riposte left Sir Guy unarmed and unmanned, begging for mercy!

"Whoa!"

The boy stutter-stepped, dodging left, narrowly avoiding the old widow woman who lived on the corner. Arms full of packages, her eyes blazed at him over a box of Lux soap flakes as she spit harsh words, the likes of which noble Robin never heard in Sherwood.

He slowed, turned, doffing his hat and laughing. "A thousand pardons, madam!" he shouted before spinning and picking up the pace. He had to make time if he was going to get the package on 14th Street, bring it back to Frank, and get home before supper.

The boy wondered what pictures would be in the package Irving Klaw had waiting for him. Frank was one of "The Pin-Up King's" steady customers, buying movie stills to use for reference in his comics. Frank might be buying photos from *The Good Earth*, or maybe some combat scenes from a picture like *Wake Island*. Sometimes Frank bought a few "cheesecake" photos, too, featuring the types of women his mother and father argued about all too often; the boy didn't care for those.

A rumble in his stomach turned his mind to the meal that would be awaiting him when he returned home. He put on an extra burst of speed at the thought of his mother's chicken paprikash and *gulyás*, with *dobos torta* for dessert. All too tasty to miss!

He hoped tonight momma and pop wouldn't pester him about his job. "These cartoons," his mother loved to say, "these funny pictures! Where's the future? What kind of living can a man make drawing such things?" His father only further fueled his mother's fretting, too engrossed in his own pursuits to focus on his son's efforts. All of pop's singing engagements, all the time and effort he put into his plays—they brought more heartache and squabbles than money into the household. When his parents questioned the boy's desire to make a living through his artwork, he knew it was an expression of their hope that he would enjoy a better life than theirs.

But couldn't they see? His talent would help him find that better life. *Famous Funnies* was just a start, proof his stuff was good enough to be printed alongside the works of real artists like Dave Tendlar and Hank Kiefer.

Good enough, but he was striving to make it even better. He was meeting real artists, learning from them. Mort Meskin—tops! Al Andriola—who learned from Caniff and the unbeatable Sickles! And of course, Frank Robbins—Frank, so generous with his time, carefully explaining his bold brush techniques on *Scorchy Smith*, letting him observe the process of creating a new feature as he developed this new aviation hero he was hot to sell, this *Johnny Hazard*. These little errands seemed poor payment for everything he was learning from Frank.

Plenty of work lay ahead; the boy welcomed it. He would learn and then apply his lessons, making every job better than the last, improving until at last his characters came fully to life, until the stories he illustrated were as lively and exciting as a great film.

He'd show them how good he could be—his parents, his mentors, his editors, his readers.

He'd show them all.

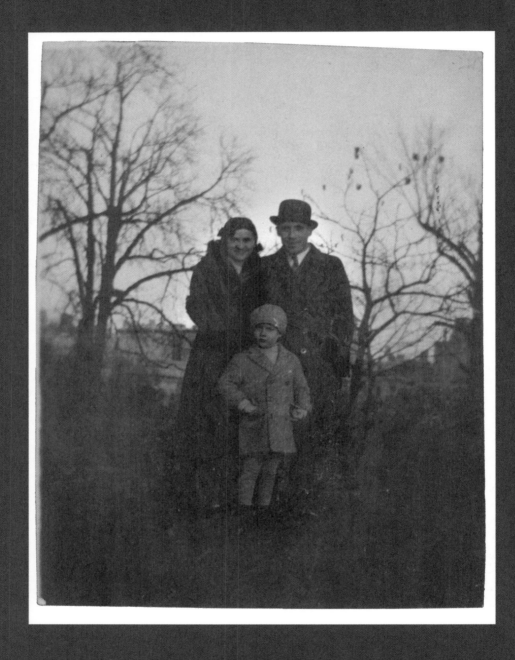

ABOVE: Sandor and Mary Elizabeth Toth with their son Alex in New York's Central Park, early 1930s.

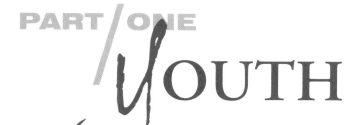

PART/ONE
YOUTH

If geniuses were trees, they would grow tall and wide, dwarfing their more modest fellows. Their roots would run deep, pulling needed early nourishment from family and friends—from neighborhood libraries, newsstands, and cinemas—from parks, playgrounds, and the corner drugstore. Their trunks would grow wide and sturdy; their leaves would rise upward, ever upward, straining to reach the rarified air many can sense but few can taste.

In the forest of genius, Alex Toth was an enormous teakwood—tough, durable, inflexible. His reach extended from the comics publishing houses of the East Coast to the animation studios of the West. His branches could offer fellow artists shelter or rake them as if whipped by a raging storm.

Toth may have flourished in California, but he sprouted in the section of Manhattan known as Yorkville.

• • • • •

When Alex was born, on June 25, 1928, Yorkville had been home to immigrant Middle Europeans for more than a generation. The Bohemians (Poles, Slovaks, and Czechs) and the Germans had their neighborhoods, while the Hungarian region extended from the mid-70s to East 83rd Street. Alex's parents—Sandor Toth and his wife, the former Mary Elizabeth Hufnagle—came to North America seeking opportunity and prosperity, but in spirit they never abandoned their homeland.

The route to Yorkville was not a direct one. Originally, the young lovers left Hungary for Canada, where agricultural opportunities existed in the prairie provinces of Manitoba and Saskatchewan while Ontario offered industrial and mercantile jobs in cities such as Port Colborne, Welland, and St. Catharines. Sandor was the first to make the transatlantic crossing. He either accompanied or quickly followed in the path of a family friend named József Aladár Vogl, who had relocated from Monor, Hungary to Middle Lake, Saskatchewan. There József spent a brief period farming before relocating to Hamilton, Ontario, in order to establish himself as a merchant; the city boasted one of Canada's most populous Hungarian communities, offering immigrants jobs amidst a growing industrial base.

Born in Budapest, Mary Elizabeth was living with her father in Monor until she emigrated in early October 1924; she traveled with József Vogl's wife, Eva, and sons Louis, Joseph Jr., William, and Stephen. Young Miss Huffnagle's stated goal for coming to Canada was to keep house for an uncle, Jacob Mueller, residing in Saskatchewan.

Uncle Jacob had to look elsewhere for domestic help, because his niece never reached his little house on the prairie. On October 27, 1924, twenty-one-year-old Sandor Toth took still-teenaged Mary Elizabeth as his bride. József Vogl was the legal witness for the ceremony. Following the practice of many early 20th-Century immigrants, Sandor Anglicized his given name to "Alexander"; he would alternate between "Alex Sandor Toth" and "Sandor Alex Toth" throughout his lifetime.

At the time of his wedding, Sandor's listed occupation was coal miner, but that life was not for him. During 1925 József founded his own painting and decorating business, "J.A. Vogl & Sons Ltd.," and it seems likely Sandor learned this trade—more in line with his creative sensibilities—while working for József. The Vogls made occasional trips into the U.S., visiting Buffalo and New York, and this likely set in motion events that ultimately resulted in Sandor and his wife relocating to America's greatest city. There they discovered Yorkville and its many pleasing echoes of home. Mary regularly cooked her native dishes and patronized Hungarian merchants such as Myrtle's, the meat store on the corner

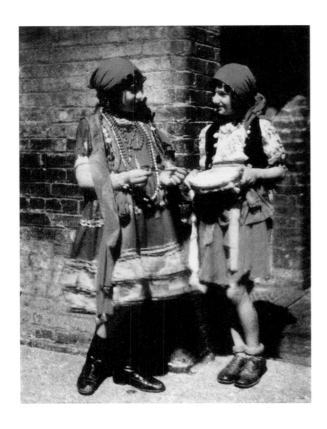

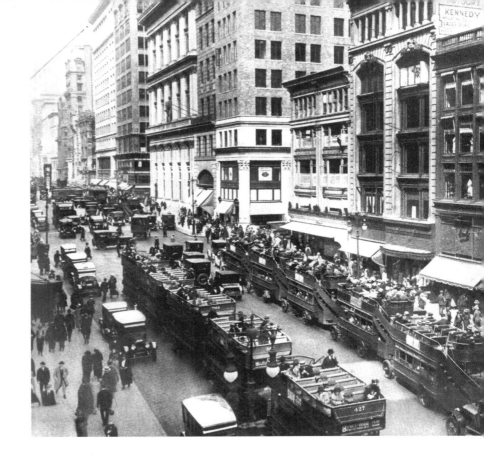

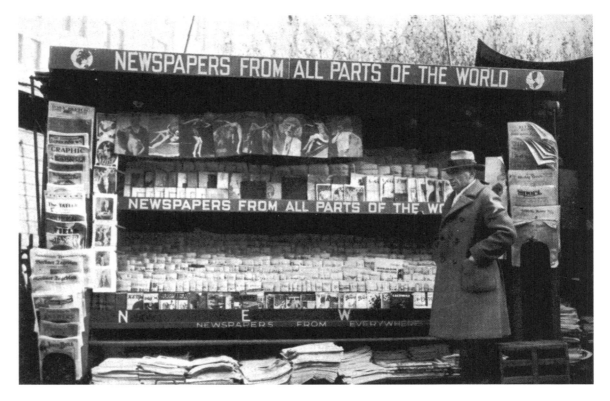

of 79th Street and 2nd Avenue. Sandor earned his living as a commercial painter of businesses and residences, but he was fulfilled by his after-work hobbies; they, like his wife's cooking, were connected to Hungary. He bought theater magazines from his homeland at the local import stores, then adapted the plays he found in their pages for staging. It was not unusual for Sandor to produce, direct, and sometimes star in these shows. As time passed and the popularity of radio soared, this restless young man explored the world of broadcasting through a small on-air program of his own.

Sandor was a versatile and enthusiastic musician,

playing the dulcimer (in his household it was known by its Hungarian name, the cimbalom) as well as guitar and violin. Alex Toth's third wife and the mother of his four children, Christina Hyde, offered a first-hand recollection of Sandor when she spoke extensively for the first time about her ex-husband and his family in support of this project. Christina said, "Alex's dad loved to sing—I thought he had a great voice." Theirs was a musical home, as Alex himself once recalled: "[My father] and my mother would sing together at home. He'd start playing and singing something and she'd join right in. And she sang well."

The high point of Sandor's performing career was

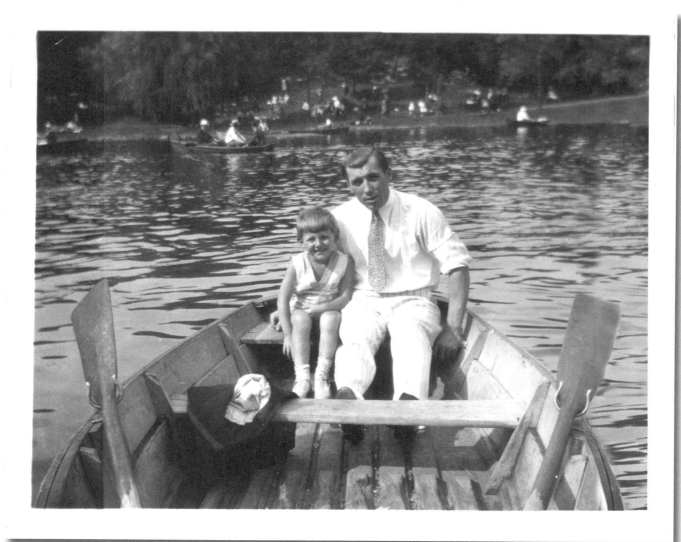

ABOVE:
Sandor and young Alex enjoying a
boat ride on the lake north of
Bethesda Fountain in New York's
Central Park, early 1930s. Fathers
and sons can still rent rowboats to
survey the 18-acre lake designed in
1857 by Frederick Law Olmsted and
Calvert Vaux.

OPPOSITE:
Top left: New York school girls
dressed in traditional Hungarian
costumes. **Top right:** Open-topped
double-decker buses were Alex's
preferred method of seeing his city.
Bottom: The polyglot that was New
York kept abreast of news from the
"old country" via newsstands such
as this. All photos circa 1930.

when he was selected to represent New York's Hungarian population at one of President Franklin Delano Roosevelt's birthday balls. "They would have ethnic groups—singers, comedians, actors giving readings. He was part of that whole thing…. He sang in his Hungarian costume and was very proud of that," said Alex.

Though music filled his home, young Alex was never especially interested in carrying a tune. Motion pictures were one of his great loves, and it took Walt Disney's 1940 *Fantasia* to spur Alex into making his first musical commitment, as he described in a 1991 letter:

Tho' already exposed to music via my father's cimbalom/violin/singing/operettas, etc., and radio's classical music stations, and grade school music appreciation classes of classic (light) music—it was *Fantasia* which, after viewing it in our local movie house, made me save pennies to plunk down on my first "buy," of a three record album (78 RPM) set of "The Nutcracker Suite." For $1.98, which was a fortune for this eleven- or twelve-year-old Yorkville kid. I guess I drove my mom nuts with it on the old Philco radio/player. She loved light classics, but later called the 'three Bs' [Beethoven, Bach, and Brahms] "funeral music"—Aarrrgghhh—!!

Sandor and Mary Elizabeth found more chances to prosper in America than in either Hungary or Canada, yet existence was a constant struggle. Both of them worked before Alex was born, and for a time after his arrival in June of 1928, each of his parents continued to hold down jobs, striving to keep a steady income as the Depression struck. Meanwhile, Sandor's leisure pursuits put him squarely into the path of the temptations that are part and parcel of an entertainer's lifestyle.

Each of Alex Toth's children contributed their time and memories to this biography, and Alex's eldest daughter, Dana Toth Palmer, offered her perspective on the strains within the family created by Sandor's choices: "My dad's dad was a flirtatious, sort-of-talented, had-a-drinking-problem kind of guy. He was out there, and there were a lot of reasons for conflict between a husband and wife when some of those things were going on." Dana's mother, Christina Hyde, echoed her daughter's thoughts, saying, "[Sandor's devotion to singing] meant going to bars, and [Mary Elizabeth] didn't drink, and then he'd come home and he'd be drinking or had been drinking, and that's not a good combination. And then Alex couldn't figure out why [his mother] couldn't keep quiet instead of picking at Sandor. As a child, I think that's the way Alex looked at it."

One of Alex's long-time friends, artist Jim Amash, inquired about Alex's upbringing over the course of their many long telephone conversations. Interviewed for this book, Amash discussed what he had been told about the senior Toth and his relationship with his son.

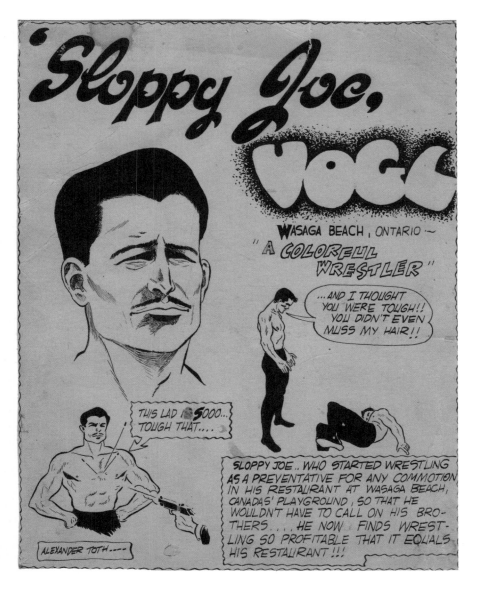

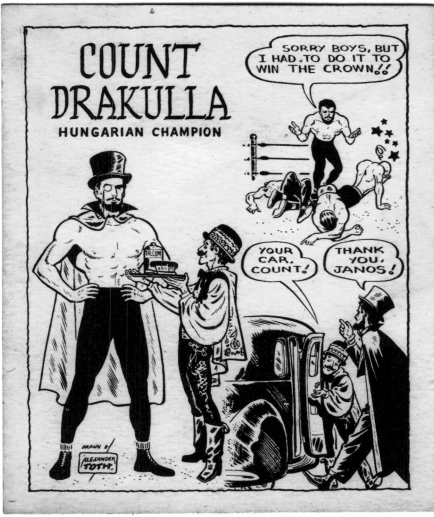

"There was a lot of drama. [Sandor] was a ladies man, he was an alcoholic. I think it scarred Alex, because he told me a lot of times he would hide when his parents would fight, when his dad came home and had drunk too much. I asked him, 'Did he ever hit you?' He said, 'No, he never beat me up,' though Sandor spanked Alex when he was a little boy."

With a father earning a living by day in order to enjoy nighttime performances and revelries, with a mother working in order to maintain a stable income for the family, with both parents alternating between periods of affection and antagonism, young Alex followed the pattern of so many children in similar circumstances: he looked outward, roaming his neighborhood, even as his personality turned inward.

Alex's neighborhood was Manhattan of the 1930s, a real-world fantasia where a youngster could haunt the grand movie palaces and begin a life-long infatuation with swashbucklers Errol Flynn and Douglas Fairbanks. On summer days the boy and his dog Muki would cool off at the city's 77th Street swimming pool. He drank in the enticing blend of sounds and smells in front of the grand department store Bloomingdale's, located at the corner of 59th and Lexington Avenue. He discovered artistic wonders at "the Met," New York's Metropolitan Museum of Art, which at 5th Avenue and 82nd Street was an easy walk from his home. He rode the 3rd Avenue trolleys and the elevated trains all over the city and later admitted, "I was addicted to 5th Avenue double-decker buses (some open air top deck)—ten-cent fares then, when all others (buses, trolleys, subways, bus, ferries) were a nickel! The open-air types were worth it!"

Still, the road always led back to the family's apartment, often an empty place, as Christina Hyde explained. "Alex would tell me he'd come home from school, nobody was there, and he'd have the key around his neck," she said. "That's kind of how he got started with his drawing."

Toth echoed that view in an autobiographical essay: "[I was] an only child, with a working Mom and Dad, alone a lot, and it set my life's pattern/mindset as 'loner.'… My solo times at home, nursery school, anywhere, had me with pencil or crayon to paper, doodling anything/everything…. At age 3, [art], plus 'reading' comics in our daily paper and listening to radio after school…filled my mind/imagination with pictures/characters I tried to draw on paper." In many autobiographical reminiscences about his youth, Toth discussed how his mother would help encourage him by drawing with him, always doodling the same image: a woman's face in profile, with "bee-stung lips, long eye lashes, and marcelled hair."

Alex first felt the sharp sting of criticism at age four. He had drawn a side view of an ocean liner, out of scale and

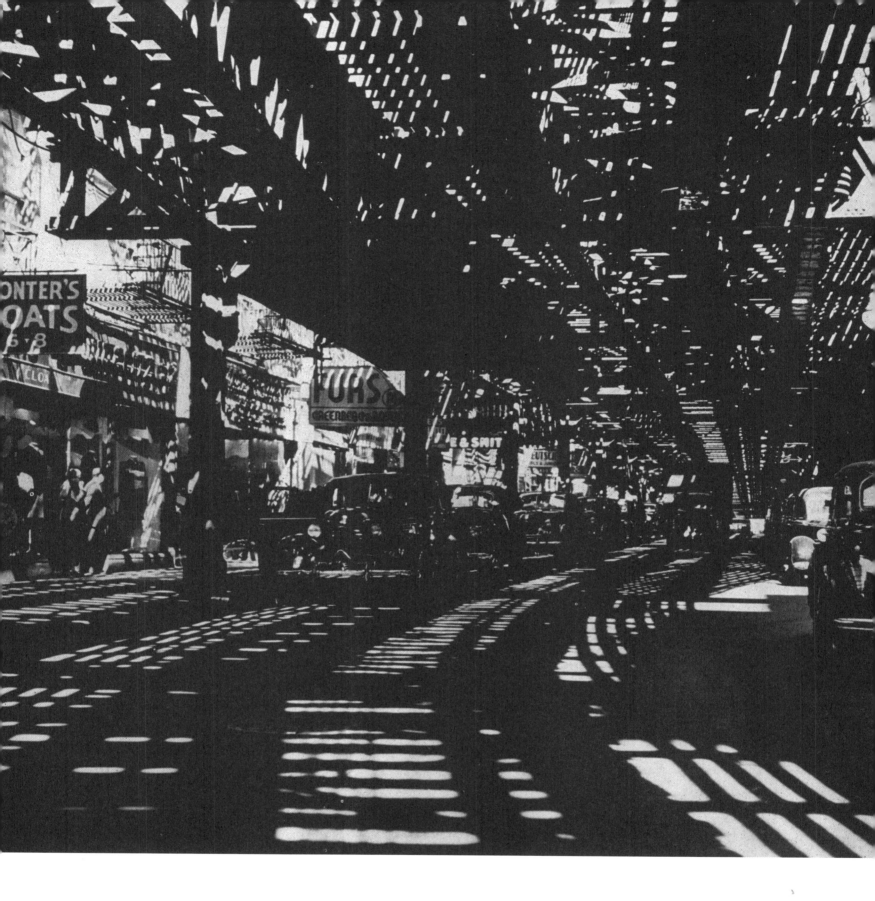

crammed with circular portholes; a child's picture. The drawing was shown to a friend of Sandor's named Martin Tittle, who was visiting the Toth apartment that day, and years later, Alex recalled the critique his efforts received:

> "Too many portholes/windows, and too close together. Ships don't look like that, Sonny," [Martin] said, making his point—the hard way!
>
> It was a heads up, very early on…. He didn't say it or mean it to be nasty. Truth hurts, though…. It had everything

to do with the rest of my curious life—so Martin could mebbe look again, smile, say "Good"?

Many of Toth's peers in comics and animation have expressed wonder and admiration at Alex's amazing recall and photographic memory. How many of them stopped to consider the cruel downside of those gifts? How many would realize the relentless pursuit of excellence that fueled an unparalleled career was at least partly driven by a preschool boy's desire to please a family friend?

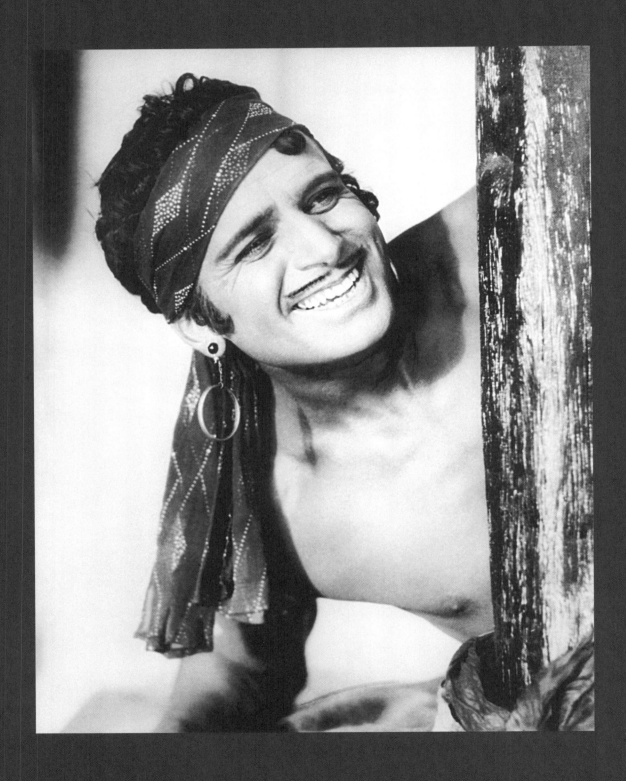

ABOVE: Douglas Fairbanks Sr., in *The Thief of Bagdad*, 1924.

TREASURES UNTOLD

ABOVE right: A 1938 *Radio Orphan Annie* decoder badge premium from Ovaltine for members of the Radio Orphan Annie Secret Society. Like millions of other American children, Alex Toth listened attentively to the radio adventures of Harold Gray's famous comic strip. His friend Jim Amash recalled, "[Alex once] said, 'I have to show you something I've had since I was a kid.' He turned around in his chair, reached into a drawer, searched for a moment before pulling out his *Little Orphan Annie* decoder ring. With childlike enthusiasm, he told me about all the Ovaltine he had to drink to get that ring. The experience was still fresh in his mind as he described the anticipation of waiting for the ring to arrive in the mail and the pure joy he felt when it came. The expression on his face was the kind of look that must have been there the day he got the ring. I was sitting next to a sixty-three-year-old man, going on ten. In so many ways, the boy never left the man."

A simplified but useful view of the comics artform's early evolution places its first wave of creators in the late 19th and early 20th Centuries, with Richard Outcault, John Tinney McCutcheon, Jimmy Swinnerton, and the immortal "TAD" (Thomas Aloysius Dorgan) among the cartoonists whose panels enlivened newspapers from Maine to California. Their efforts inspired the second wave, those who launched their careers during the period from the late 1910s to the early 1930s. Many of the artists from this period refined the concepts and language of graphic storytelling for the newspaper page; their number included Harold Gray (*Little Orphan Annie*), Elzie Crisler Segar (*Thimble Theatre/Popeye*), Chester Gould (*Dick Tracy*), Hal Foster (*Tarzan*), and Milton Caniff (*Dickie Dare*). These men inspired yet a third wave of talent, many of whom seized the opportunity to hone their craft in a new type of graphic story vehicle: the comic book. Alex Toth was a member of that third wave.

His interests were sparked by more than comics, of course. Alex also belonged to the first generation that grew up amidst a broad-based popular culture and he immersed himself in all its different media, absorbing artistic and narrative lessons along with a tremendous dose of entertainment. The wonders imparted by his many boyhood favorites remained with him throughout his lifetime; a portion of his later disillusionment may have stemmed from an inability to find a similar *frisson* in late-20th-Century works, ignoring or perhaps never realizing that it is a rare day indeed when an adult with decades of stockpiled pop culture memories can experience the same "Gosh-wow-gee!" reactions so uniquely connected to youth.

Toth's love affair with film began in his pre-teen years. He was fixated on swashbucklers: Errol Flynn's Peter Blood and Robin Hood; Robert Donat's Edmond Dantes, protagonist of *The Count of Monte Cristo*; and both Douglas Fairbanks Sr. (*The Thief of Bagdad*, *The Black Pirate*, *The Private Life of Don Juan*) and his son, Fairbanks Jr. (Doug Scott of *The Dawn Patrol* and Rupert, *The Prisoner of Zenda*). Toth once told his 1980s editor and friend, cat yronwode, that he combined the face of Flynn and the body of Fairbanks while depicting Zorro for Western Publishing/Dell Comics in the late 1950s and very early '60s.

Yet Alex did not limit his cinematic forays to tales of derring-do. He watched and adored the comedies of Harold Lloyd and the Marx Brothers; William Powell and Myrna Loy's *Thin Man* series; *Lost Horizon*; many John Ford Westerns (especially *Stagecoach*, featuring a young John Wayne in his breakout performance); and literally scores of others from his boyhood, hundreds across the span of his lifetime.

Before Alex saw his first movie, however, radio serials firmly gripped his imagination. His childhood coincided with the medium's so-called golden age, when the airwaves were filled not only with music, news, and commentary, but also daily comedy and drama programming. While he listened to such nighttime staples as *Renfrew of the Mounted*, *Silver Eagle*, and *The Lone Ranger*, he was devoted to the afternoon bill of fare based on popular pulp magazine, comic strip, and (later) comic book heroes. Over the years Alex listened to the ongoing audio adventures of *Buck Rogers*, *Batman and Robin*, *Superman*, *Terry and the Pirates*, and *Flash Gordon*.

The character with whom the Toth family came into closest contact was the radio incarnation of pulp fiction's most popular hero, The Shadow. Perhaps using "inside pull" gained from his own work in broadcasting, Sandor Toth on two occasions reportedly took young Alex to see *Shadow* radio broadcasts as they were being performed. A teenaged Alex was equally thrilled when his father was hired in his day-job

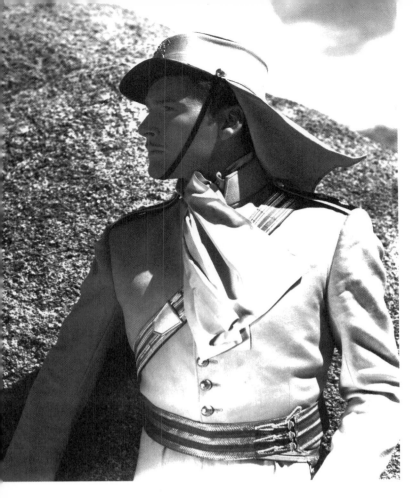

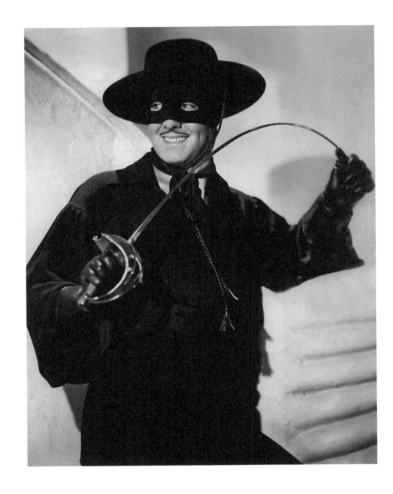

ABOVE: Erroll Flynn (left) in *The Charge of the Light Brigade*, 1936. Tyrone Power (right) in *The Mark of Zorro*, 1940. Alex kept a framed photo of Power on a wall in his home. The heroic characters portrayed by both actors had a lasting influence on the type of "straight, honest adventure story" Toth said he preferred to draw. The influence can be seen from 1950s' "Battle Flag of the Foreign Legion" to Toth's 1980s retro-masterwork, *Bravo for Adventure*.

BELOW LEFT: Alex and his father on the steps of the pavilion at Orchard Beach in the Bronx, circa 1939.

BELOW RIGHT: His recollection of the artwork his mother drew in their Yorkville apartment when he was a child.

capacity by Bill Johnstone, the voice actor who portrayed the Dark Avenger over the airwaves from 1938 to 1943. According to Jim Amash, "Alex was proud of that, even years later. He'd say, 'You know, my dad painted Bill Johnstone's apartment!'"

Beginning at age three, Alex sought to translate radio adventures into pictures. As he listened to an installment of *Little Orphan Annie* or *Hop Harrigan* he would draw, attempting to bring to life on paper the characters and situations he heard spilling from the speaker on the family's radio. It was a foreshadowing of things to come: that boy at the family table, laboring to turn radio entertainment into pictures, had no way of knowing he would grow up to adapt movies and television series—everything from *No Time for Sergeants* to *Oh! Susanna*—into comics form.

Despite the exotic glamour of the movies and the immediacy of radio, comics were young Toth's first and strongest love. They came into the household in the pages of the New York *Daily News*, Sandor's newspaper of choice, and Alex fixated on their artwork long before he could read their text. Alex described the Sunday *News* as it existed in the later 1930s:

> They had *Dick Tracy* on the front page of the Sunday comics section and *Little Orphan Annie* on the back and inside was *Terry and the Pirates, Gasoline Alley*. Of course, *Terry* grabbed me. It was pretty exotic stuff. And *Little Joe*, which was in the same style as *Annie*. And *Smitty*, I loved. *Smilin' Jack* was one of my favorites when I was a little kid, because of the airplanes and the cute little gals and the funny characters.

Smilin' Jack was Zack Mosley's long-running aviation adventure strip, following in the contrails of

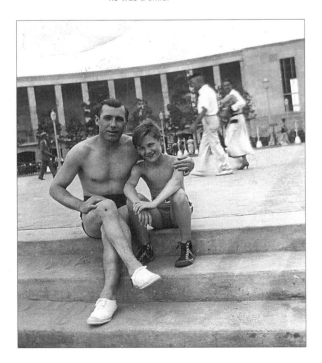

MY MOM WOULD 'DOODLE' PRETTY GIRL PROFILES (LIKE THIS MEMORY SKETCH) --and NOTHING ELSE BUT! AND, WATCHING HER MUST HAVE LED ME TO COPYING THEM, and LATER, TO DRAWING ON MY OWN — THO THE SUNDAY FUNNIES, COMIC BOOKS, and AFTERNOONS SPENT LISTENING TO DAILY RADIO ADVENTURE SERIALS HELPED a LOT, I'M SURE, TO FIRE MY IMAGINATION, AS I'D SIT SKETCHING CHARACTERS TO MATCH THE VOICES HEARD, AS WELL AS SCENES: CONTINUITY, IN THOSE PRE-WAR (and PRE-TV) YEARS OF SWASHBUCKLING MOVIES, FLYING ACTION FILMS, WEEKLY MOVIE SERIALS, TOO!

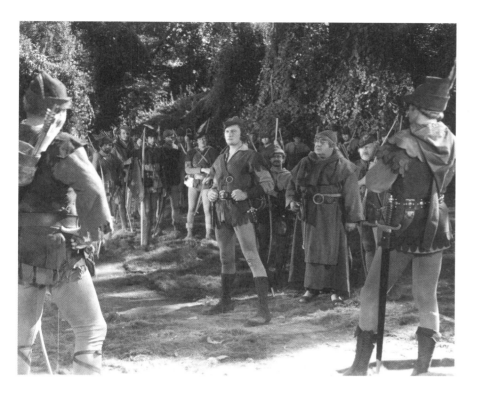

other flyboy features (such as the Associated Press's *Scorchy Smith*), all of them held aloft by the public's continued fascination with pilots, though Charles Lindbergh's non-stop transatlantic crossing in *The Spirit of St. Louis* was more than five years in the past. More than once, Alex admitted his earliest career aspiration was to become an aviator. He gave up dreams of earning his wings at an early age, yet his fascination with planes and the men who flew them remained strong throughout his entire life.

And naturally, Toth loved Walter Berndt's *Smitty*, a comic about a smiling, upbeat thirteen-year-old who brimmed with energy, held down a fast-paced job as an office boy, then returned home to warm, caring parents and a precocious younger brother. *Smitty* was an escapist's ideal, reflecting a life far removed from the hardscrabble existence and continual squabbling that was bound to the Toth family's life in Yorkville.

LEFT: Flynn in his most famous role, the title character in Michael Curtiz's *The Adventures of Robin Hood*, 1938.

BELOW: Toth's 1995 homage to one of the heroes of his youth, The Shadow, whose two novels each month were primarily written by Walter Gibson.

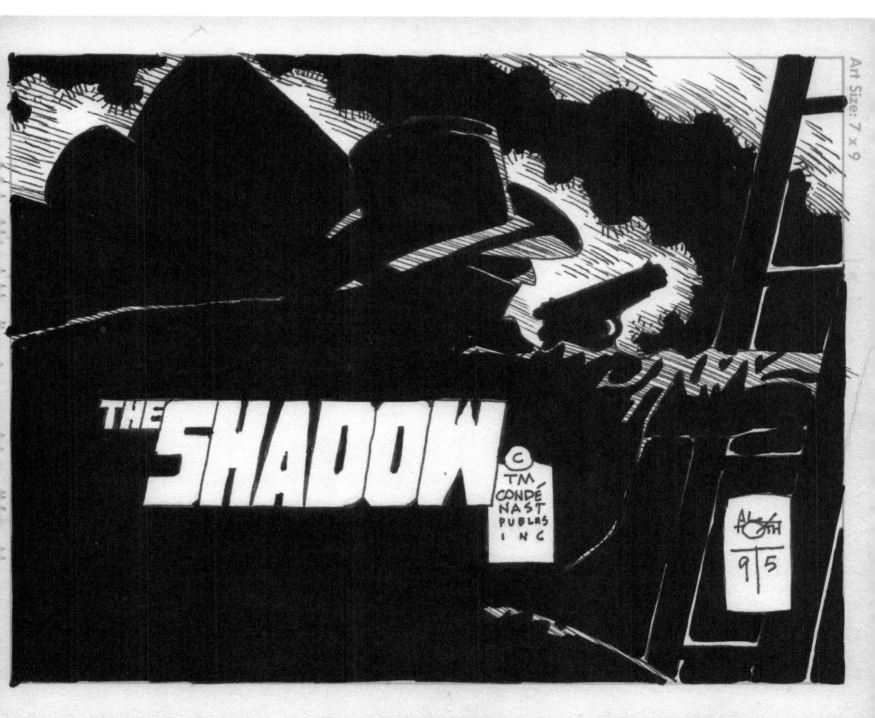

ABOVE and **LEFT:** Alex's official school graduation portraits, 1946.

PART/THREE

*T*UTELAGE

OPPOSITE: On the yearbook page is John Stepniewski, one of Alex's cohorts with whom he visited Alfred Andriola's home.

As an only child and first-generation latchkey kid, Alex Toth was destined to have difficulty adjusting to the social aspects and regimented routines of the Depression-era New York public school system. He was a loner who had to find ways to fit in with groups of children his own age. Inquisitive by nature and packed with energy, he exasperated more than one of his grade school teachers by disrupting the classroom atmosphere.

Not that Alex was the only rambunctious student in his class! To encourage both good scholarship and good behavior, one of his teachers, Mrs. O'Connor, investing out of her own salary, bought two comic books at the end of each week to award to her best boy and girl student. The comic book was still very much a novelty at that time, having debuted on newsstands in 1934. Mrs. O'Connor favored purchasing *Famous Funnies* and one-shot books that collected short runs of newspaper comic strips such as *Smitty* and Billy DeBeck's *Barney Google*.

The fact his teacher was using her money to offer an incentive to her pupils was not lost on Alex. "I have no idea what grade school teachers in New York City were getting in those days," he said, recalling Mrs. O'Connor decades after he last sat in her classroom. "Ten cents was a lot of money in those days, and she was spending twenty cents." Alex also admitted the considerable challenge he faced in order to claim one of the weekly rewards: "I only won a couple of those, because I was always in hot water for some reason or another…. Nostalgically, sentimentally, I think that's one of the reasons why I have that kind of warm feeling for the comic book. The way I first got my hands on them was in that classroom as a prize, and it meant a lot."

Another grade school teacher had a different way to keep Alex engaged. She brought in European travel posters collected from a neighborhood travel agency, provided heavy oak tag paper that was assembled into a long strip, excused Toth from some of his daily classes, and set him the task of creating a panoramic landscape mural based on those posters. Though only eighteen inches high, it ran ten feet in length. Alex produced it entirely in crayon, under far-from-ideal conditions. The oak tag had been affixed above tall cabinets running down the wall of the school's corridor and Alex produced his images crouching atop the cabinets, more than eight feet above the floor. "Now that I think back, that was pretty dangerous," the artist wryly said.

Alex may have been precocious, but his intelligence, drive to learn, and sharp memory helped him earn top marks, which under New York's "rapid advance" scholastic policies allowed him to move into an all-boys junior high by skipping two years of grade school. This created another period of adjustment for Alex, who felt out of place among many of his older classmates. Many, but not all—in a 1997 note, Alex discussed going to school with a boy named Marty Bresenoff, son of the owner of one of the delis the Toths frequented. Alex talked of buying pot cheese and lekvar ("thick, black, tar-like Hungarian…prune jam") at the Bresenoffs' deli, all of it wrapped in "strong, thick, white matte, crisp paper stock. Yes, I drew on it, too."

Outside distractions helped blunt the boy's social unease. A model airplane shop was located next door to the school and Alex spent many hours inside, debating the merits of every purchase as he kindled his love of building hobby kits. It was a pastime he carried into his adult years, as Christina Hyde recalled: "[Something] we used to do before the kids came [was construct] the little plastic models. We used to paint them…. He really did like making those models."

Also during Alex's junior high days, the New York World's Fair was in full swing. He attended in both 1939 and 1940; a half-century later he was still

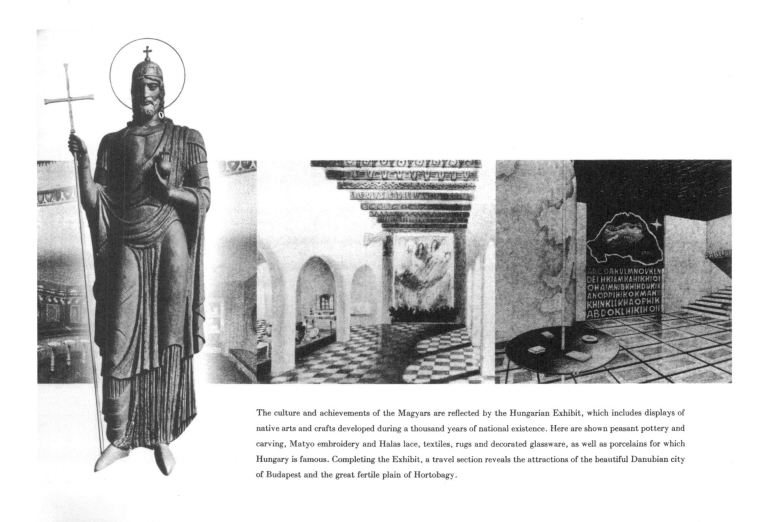

The culture and achievements of the Magyars are reflected by the Hungarian Exhibit, which includes displays of native arts and crafts developed during a thousand years of national existence. Here are shown peasant pottery and carving, Matyo embroidery and Halas lace, textiles, rugs and decorated glassware, as well as porcelains for which Hungary is famous. Completing the Exhibit, a travel section reveals the attractions of the beautiful Danubian city of Budapest and the great fertile plain of Hortobagy.

ABOVE: The Hungarian Pavilion at the World's Fair was popular with the Toths and their fellow Magyars.

BELOW: A *Wash Tubbs* daily by Roy Crane, March 10,1938.

OPPOSITE: Milton Caniff's *Terry and the Pirates* Sunday page from February 23, 1941.

doodling that skyline from memory, prominently displaying the two landmark structures in the Fair's Theme Center, the needle-like Trylon and the domed Perisphere.

Alex's junior high offered classes in art history and poster making; Alex's teachers in those two subjects were Mrs. Tyndall and Mr. London. Each of them recognized their young student's abilities and encouraged him to take on specialized courses of study to help hone his skills. They recommended two schools for Alex to consider: the High School of Music and Art and the High School of Industrial Arts. Mr. London encouraged Alex to opt for the latter because it placed an emphasis on commercial art. Alex was enthusiastic about the school's schedule, structured with half a day of academics and half a day devoted to vocational, artistic studies. Sandor and Mary Elizabeth were pleased by its 79th Street location, close to their home. The decision was unanimous: Alex enrolled at S.I.A. and

would attend throughout the World War II years.

The school was housed in a red brick building built in 1860, reportedly used as a hospital for soldiers during the Civil War. Seats were jammed close together to fill each small classroom to capacity. Spartan accommodations did not prevent S.I.A. from earning a reputation as a cherished institution of learning, with students maturing to become significant names in many branches of entertainment. Ventriloquist Paul Winchell, singer Tony Bennett, and fashion designer Calvin Klein are numbered among the school's alumni, which includes a long list of those who enjoyed careers in the comics industry, artists such as Chic Stone, Joe Giella, Joe Orlando, Sy Barry (who would eventually ink many of Toth's stories at National/DC Comics), John Romita Sr., Dick Giordano, Neal Adams, Art Spiegelman, Joe Jusko, and Denys Cowan.

S.I.A. students declared majors that dictated their course of vocational study. Industrial design, fashion

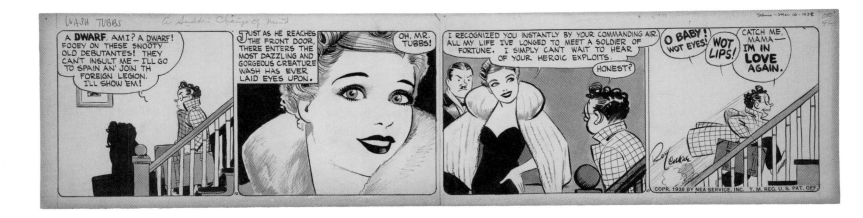

illustration, advertising art, and photography were among the tracks available. Alex declared for book illustration, then switched to magazine illustration but was disappointed in the class. He quickly returned to book illustration, studying under Howard Simon, an artist and illustrator of some renown. Alex would remember him as "a quiet, sad-looking man—good and gentle man, in every sense of the word."

Simon was born in 1902 and studied art at the New York Academy before moving to France for three more years of education. He resided in San Francisco upon his return stateside, but eventually returned to New York to live, work, and teach. He specialized in woodcuts and watercolors, and his abilities were put to use illustrating texts such as *Candide, Mlle de Maupin,* and *Golden Years*. He was also the author of 1942's *500 Years of Art in Illustration*.

It was at S.I.A. where, as Alex put it, "the cartoonist bug bit deep." Knowledge gained from Simon and his fellow instructors was a plus, but the single factor that most energized Alex was the companionship of like-minded friends. For the first time he enjoyed the company of boys his own age, teenagers whose artistic leanings echoed his own and who were even more enthusiastic about comics. It was these boys whom Alex credited with convincing him to sharpen his focus with a goal of finding employment in the comics industry.

Pete Morisi and Jack Katz were two of Alex's S.I.A. chums; both went on to do comics work. Morisi began

as an assistant on the Associated Press's long-running *Dickie Dare*. After a stint in the Army he moved into comic books, freelancing for publishers like Fiction House, Harvey, Quality, and Al Capp's Toby Press. By the mid-1950s Pete accomplished a boyhood dream by joining the New York City police force, though he continued to freelance in comics during his off-hours. His best-known project, Charlton's *Peter Cannon…Thunderbolt*, came out of this period.

Katz, meanwhile, earned credits at Standard Comics before taking a job with King Features Syndicate. Beginning in 1974, Jack became one of the pioneers of independently published comics, beginning a twenty-four-issue run of his fantasy series, *The First Kingdom*.

During the War years of the early 1940s, however, Morisi, Katz, and Toth were students bonded by a shared love of comics. Together they enjoyed goofy games and physical tests—both Alex and Jack Katz were able to broad jump over three trash cans laid side-by-side on the sidewalk—and surely their group buzzed with excitement the day J. Edgar Hoover's G-Men swooped into Yorkville and broke up a German spy ring operating only two blocks from the Toths' apartment. Yet more than current events or shared horseplay, comics was the glue that bound them. "Pete, Alex, and I were the triumvirate—hanging out all the time," said Katz. "Alex and I went really crazy over breaking into comics."

The circle of comics lovers at S.I.A. was broader

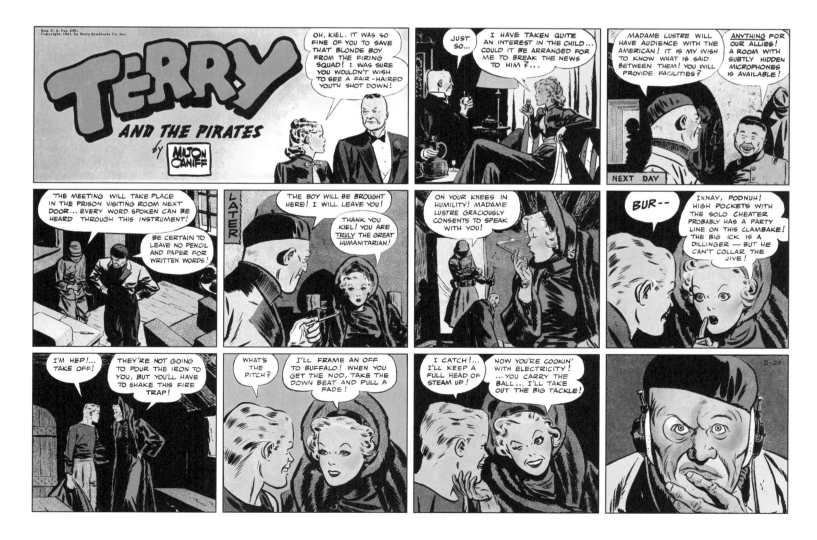

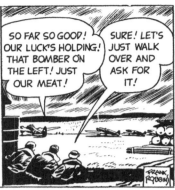
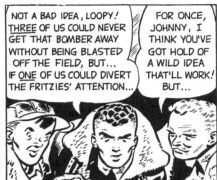

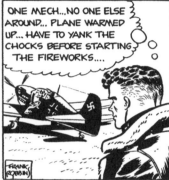
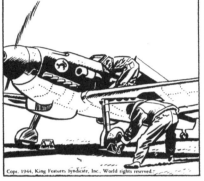
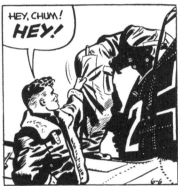

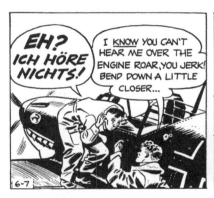

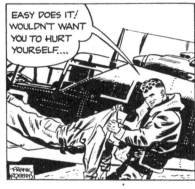
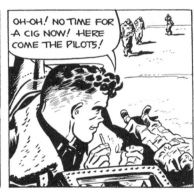

ABOVE: The first three *Johnny Hazard* strips by Alex's mentor, Frank Robbins, June 5-7, 1944.

OPPOSITE: Noel Sickles's *Scorchy Smith* was the biggest influence on Alex Toth's art. Three examples from 1936: July 10, August 8, and August 20.

than a simple threesome; it also reflected a racial color blindness that was far from the norm in 1940s America. Alex and his pals were friends with a handful of black students—Alex would long recall the names of Leo Sharper, Ronal Ray, and Sam Huger, though he lost touch with them after graduation. Two other African-American friends whose careers Alex closely followed were Ezra Jackson, who became an editor after a period of freelance creativity, and perhaps the most influential person from Toth's high school days, Alfonso Greene.

In the 1950s Greene drew Westerns for Atlas (the forerunner of today's Marvel Comics), having previously produced art for National/DC. But it was the teenaged Greene's approach to finding assignments that was so important: Alfonso used telephone directories to compile a list of home addresses for artists living in New York City in addition to finding the

locations of many Manhattan comic book publishers. He then aggressively worked both lists. It was Alfonso Greene who proved to his fellows that established cartoonists would be willing to critique a tyro's portfolio. Moreover, as Jack Katz remembers, it was Greene who first realized that World War II was driving many artists into America's military ranks, meaning a high school boy attending S.I.A. and capable of rendering to a sufficient level of quality could earn professional assignments:

> [Alfonso] was the first of us kids to get into the comics industry. He was picked up by Will Eisner at Quality. Eisner's studio was on the top floor of a building across the street from the Chrysler Building—the Rooftop Paradise, we called it.

Alex was developing a very, very strong-headed attitude about life, even at that time, though he wasn't quite as agitated then. Alfonso gave us the address for Frank Robbins, who lived on 23rd Street. We were galvanized by the comics, so Alex and I went down to see Frank Robbins. And we went several times with Alfonso. Toth took a look at Frank Robbins's work and started copying it drawing for drawing, until he mastered that particular technique. I call it the "post-Sickles look."

"Post-Sickles" because Robbins drew the Associated Press aviation strip *Scorchy Smith*, following in the trailblazing footsteps of artist Noel Sickles before launching his own creation, *Johnny Hazard*, with King Features, in 1944. After *Hazard* folded in the late 1970s, Robbins spent several years creating stories for the major comic book companies, writing and drawing *Batman* and *The Shadow* for DC Comics and *Captain America*, *Luke Cage*, and *The Invaders* for Marvel. Alex was consistently lavish in his praise for Robbins, both as artist and mentor. Yet Robbins was far from the only

professional cartoonist with whom the teenaged Toth crossed paths.

In 1943, together with Leo Sharper and fellow classmate Johnny Stepniewski, Toth twice visited the home of Alfred Andriola, whose career took off in 1938 as he was selected to draw *Charlie Chan* for the McNaught Syndicate. When the S.I.A. studentry caught up to him, Andriola was briefly involved with comic books, producing *Captain Triumph* for Quality's *Crack Comics*, while in the process of moving back to strips with King Features, where he teamed with writer Allan Saunders first on *Dan Dunn* and then on their own original crime-busting character, *Kerry Drake*. Alex was especially enthusiastic about this contact because Andriola's career began in Tudor City, where he assisted two of Toth's favorite artists, Sickles and Milton (*Terry and the Pirates*) Caniff, who became known as "The Rembrandt of the Comic Strip." Picking up tips from someone who had learned from two of the Masters was surely heady stuff.

A handful of weeks later, Alex was invited into the studio apartment of artist Mort Meskin, who at the time was drawing the Western series *Vigilante* and superheroes such as *Johnny Quick* and *Starman*. In 1981, Toth wrote an appreciation of Meskin for a fan

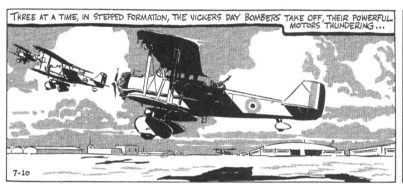

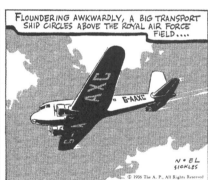
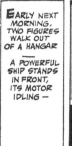
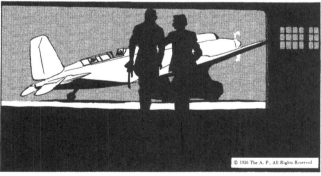
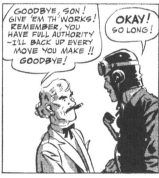
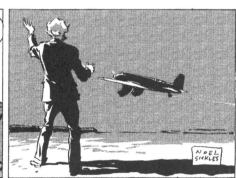
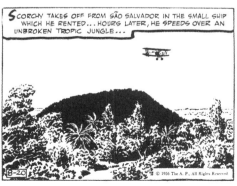

ABOVE: The syndicate roll-out for *Charlie Chan* by Alfred Andriola in *Editor and Publisher*, September 10, 1938. Andriola, like Frank Robbins, offered helpful advice to the young Alex Toth and his fellow aspiring cartoonists.

publication and had this to say about their first meeting:

> Mort was busy penciling a *Vigilante* story, despite my intruding and questioning presence…. He took a DC blank page and rubbed soft 2B lead across its face, smudged it into a smooth, overall gray tone. Script at hand, he took a kneaded eraser and proceeded to "pick out"/erase panel borders, across top row to bottom, from circles to squares to rectangles, in varying sizes, of course. I was fascinated, delighted, and puzzled.
>
> Then his eraser picked out solid white shapes of each panel's interiors—a caption panel, a balloon, another—a figure, another. Working in reverse, he erased shapes, forms, interlocking compositional elements, to create complete (but negative —white on gray) pictures. It was simple, efficient, and effective—no messy haylined penciling for Mort Meskin!
>
> His way was astoundingly basic, elementary—devoid of any concern other than to sculpt out from a gray mass his solid forms—damn, it was brilliant! My eyes and memory bank absorbed his every move! Pure joy, it was—panel by panel,

enthralled with his overall page composition. If a shape or space didn't work, he merely smudged in more gray tone and tried again until he got it right.

> All the while, he cautioned me not to try the same thing, because I was too young, green, and ungrounded in experience to fully comprehend or utilize the procedure…. Well, now, he knew that that was exactly what I intended to do, once home again. He was absolutely right, though—absolutely 100% correct! I did try it, again and again and again—never did get it quite right. Gave it up, went back to my own stumbling way of creating pictures with a pencil…years later, I finally learnt enough to use Mort Meskin's reverse-method, and learnt even more for having done so—fully appreciating, if not partially-achieving, such concentration on shapes, forms, in those first moments of composition. It led me on to deeper study of all other types of graphic art. I owe [Meskin] a great debt.

Through his S.I.A. contacts, Alex landed a job as an usher for the Society of Illustrators at their East 63rd Street location. There the eager young student met and quizzed several of his heroes from the field of magazine illustration, foremost among them Robert Fawcett, whose art was featured in *Collier's*, *The Saturday Evening Post*, and *Holiday*, among other high-end "slick" magazines.

Toth's enthusiasm occasionally allowed him to meet select artists by crashing a publisher's offices. That was how he met Jack Cole, the inspired creator of *Plastic Man*.

One crisp morning, fifteen-year-old Alex cut his morning classes in favor of a subway ride to Lexington Avenue and the offices of Quality Comics. He pushed through the open doors around 8:30AM, found the reception area empty, but heard the sound of whistling coming from one of the interior offices where a radio also played. Following the sound to its source, Alex discovered Cole already at work inking a *Plastic Man* cover. The professional was not too busy to make time for a talented amateur; he was gentle with his

"What dost thou make of this?"

observations when he reviewed the boy's portfolio.

Alex said, "[Cole] made his points—draw, draw, draw, learn, study, practice—my penciling was promising, inking wasn't. I was grateful, knew my stuff was 'rough.'"

This visit with Cole lasted approximately a half-hour. Alex drew attention as other Quality staffers began trickling in to begin the business day. Unfortunately, included in their number was art director George Brenner, who quickly swooped in when he saw one of his star artist's valuable time being co-opted by a nervy kid. Brenner intervened between fan and pro, smoothly ushering Alex toward the exit. "Mustn't slow the wheels of progress," Brenner said in a condescending tone as he scooted Alex through the front doors.

Enthusiasm stoked by Cole's words, Alex spent the next several weeks creating a new batch of samples. Armed with this fresh material, he braved the front desk at Quality on an after-school visit, managing to talk his way in to see Cole, show off his latest material, and earn introductions to other artists, such as Klaus Nordling and Lou Fine, who were also employed by Quality at

this time. Of course, George Brenner once again showed up to spoil the fun.

At least Brenner was polite; the same could not be said for all of Alex's interviewers. P.C. Hamerlinck, editor of the fanzine *Fawcett Collectors of America*, once began an article with this quote from Alex: "Jack Binder was an S.O.B. to me!"

Binder was art director at Fawcett Comics, the original home of Captain Marvel, whose popularity rivaled Superman's during the 1940s. Alex was among "the big red cheese's" many fans, and the best part of his trip to the company's offices was being introduced to the Captain's creators, C.C. Beck and Pete Costanza. The portfolio review with Binder was far less enjoyable.

The art director criticized Alex's samples, pointing out deficiencies in the figure drawing and anatomy in the bluntest possible terms. Alex left Fawcett Comics seething, angry perhaps at Binder and his tactless words, but even angrier at himself for producing material that could be so harshly judged.

"[That visit made] me tear up my portfolio when I left the office," Alex admitted. "I just tore everything up, page by page, and threw it in the garbage can on the corner. [Binder] made me hate everything I'd done."

Out of that anger came determination. Alex attacked the page with renewed vigor, producing better drawings in a new set of samples, which would land him his first professional assignment at age fifteen.

"So, in perverse logic, Binder helped start my career," Alex concluded.

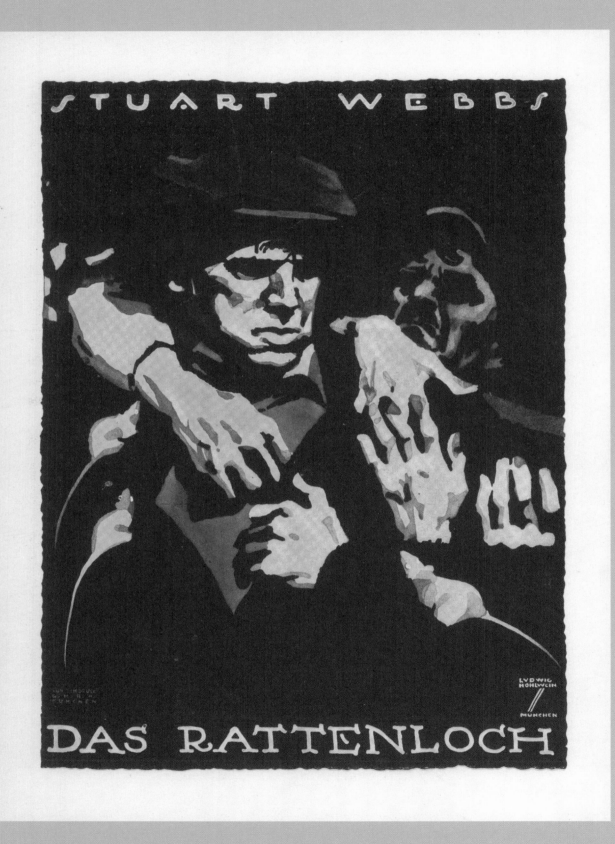

ABOVE: *Das Rattenloch* movie poster by Ludwig Hohlwein, 1926.

PART/FOUR
*I*NFLUENCES

The youthful Alex Toth immersed himself in more than the comic strips, movies, and radio shows of the late 1930s and early '40s—he absorbed the artwork and illustrations that papered pre-World War II New York. On billboards and movie marquees—at schools and libraries—in books, newspapers, and magazines—Alex took in every piece of art with an increasingly knowledgeable eye. His understanding of which techniques worked and *how* they worked steadily expanded. He knew what he liked and what he didn't; he was increasingly able to articulate *why* a given piece succeeded or failed.

Toth's primary influences from the ranks of newspaper cartoonists are well documented, often by the artist himself. Of Milton Caniff he wrote, "His work dazzled me as a kid of seven or so. I loved the cryptic *Little Orphan Annie* art of Harold Gray (and still do), the cartoon fun of *Smitty* by Walter Berndt, the pure, sweet beauty of *Gasoline Alley* by Frank King…. But Milton Caniff was snappy, new, modern, and dramatic."

He was equally lavish in his praise of *Wash Tubbs* and *Buz Sawyer*'s Roy Crane: "He was a master of first single-tone, then double-tone, crafting grays to enhance his spare black and white line art. He came to literally 'paint' lovely vistas of day and deep, dark, mysterious scenes of night, creating great depth, solidity of forms, weight, and mass with simplicity."

Frank Robbins, though ten years Toth's senior, remained a key figure, often investing full days in his protégé's tutelage. Together, they spent hours examining the latest strips in the daily newspapers before Robbins turned on his record player, unleashing booming classical music, setting the mood as the pair practiced fencing ("[Robbins] parrying only…as my foil or saber just swished and swashed about amateurishly," Toth recalled).

It would require a separate and lengthy volume to chronicle all the illustrators embraced by teenaged Alex, but it remains possible to highlight some of his lesser-known favorites, such as the Scotsman Keith Henderson. Born in 1883, Henderson was educated at Marlborough College before moving to Paris, where he studied at The Slade School of Fine Art and, at age nineteen, shared a studio with sculptor Gaston Lachaise and two fellow expatriates from the British Isles, painters Maxwell Ashby Armfield and Norman Wilkinson.

Henderson first attracted international attention as a book illustrator. His art appeared in a 1908 edition of Geoffrey Chaucer's translation of *The Romaunt of the Rose*; he later illustrated *The Worm Ouroboros*, by E.R. Eddison, as well as W.H. Hudson's *Green Mansions* (1926) and *The Purple Land* (1929).

Henderson was involved in both World Wars. He captured his experiences during World War I in 1917's *Letters to Helen: Impressions of an Artist on the Western Front*, chronicling his days attached to the British Army cavalry service. He also provided illustrations for the book historians consider the premier air chronicle of the First World War: *Sagittarius Rising*, by combat pilot Cecil Lewis. During World War II Henderson was appointed Air Ministry Artist for the Royal Air Force (RAF), responsible for producing paintings of the aircraft and surroundings at Scottish aerodromes. Dissatisfaction with his speed and output caused the RAF to terminate his commission, and after World War II Henderson was employed in advertising, designing posters for the Empire Marketing Board and London transport.

Henderson eventually became a master of scraperboard, a drawing board coated in white clay, then covered in black ink, upon which images were brought forth by scraping away the ink to reveal the underlying whiteness, an approach that echoes Toth's description of Mort Meskin's process of creating comic book panel art. Henderson's scraperboard work built upon earlier successes, which combined an excellent grasp of chiaroscuro with woodcut techniques and featured strong lighting effects with an often-arresting depth of field.

Another contemporary of Henderson's favored by Alex was Frederick T. Chapman, whose bold mastery of two-color design would have attracted young Toth's eye as much as his preferred choice of subject matter: chivalrous knights in armor, frontiersmen, axe-wielding reavers, cowboys, seamen, and pirates. Chapman's pieces appeared in *Collier's* and *Woman's Home Companion*, but he was best known as an illustrator of children's books, including such titles as *White Falcon, Custer's Last Stand, Wreck of the Wild Wave, Door to the North*, and *Joan, Maid of France*. Today, Chapman's papers reside in the University of Minnesota's Children's Literature Research Collections.

One of the illustrators Alex most enthusiastically

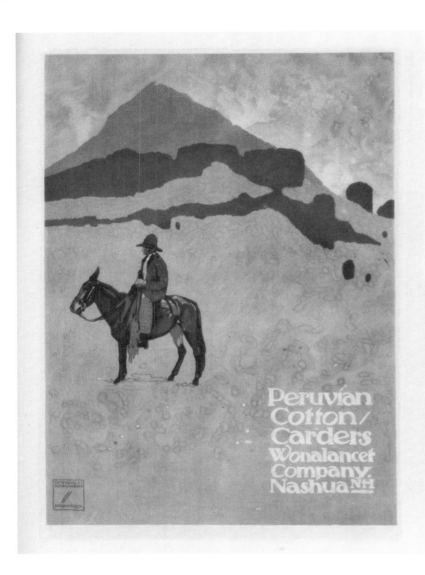

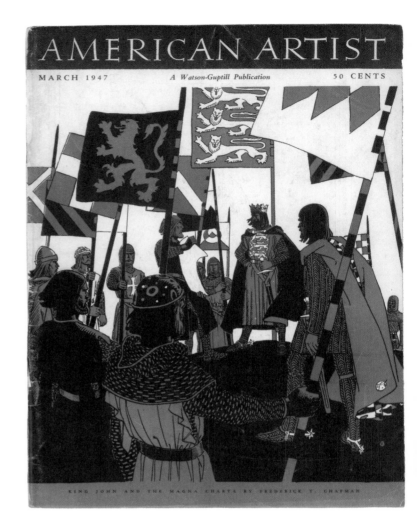

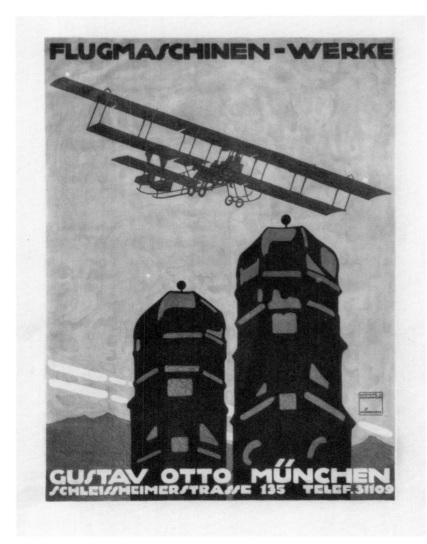

endorsed was German poster artist Ludwig Hohlwein (sometimes spelled "Höhlvein"). "Flamin' genius, he!" Alex enthused in the letter-writing of his mature years. "He's one of my heroes! Great designer of strong shapes and maddening economy! The key to all of his marvelous works is…the silhouette, negative as well as positive!"

Hohlwein was born in Wiesbaden in 1874, his approach to poster-making influenced by Britons James Pryde and Pryde's brother-in-law, William Nicholson. All three men favor the use of flat color, though Hohlwein's posters tend to feature fewer figures and less elaborate backgrounds than his English contemporaries.

Settling in Munich while in his mid-twenties, where he would remain for the rest of his life, Hohlwein's eye-catching advertisements sold everything from teas and chocolate to electronics, haberdashery, and the city zoo. As early as 1909, he was acknowledged as one of Germany's foremost artists: as commissions came from across Europe, his reputation grew

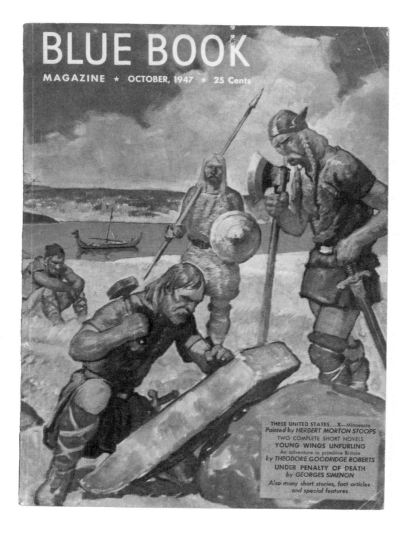

BLUE BOOK

MAGAZINE ★ OCTOBER, 1947 ★ 25 Cents

THESE UNITED STATES...X— Minnesota
Painted by HERBERT MORTON STOOPS
TWO COMPLETE SHORT NOVELS
YOUNG WINGS UNFURLING
An adventure in primitive Britain
by THEODORE GOODRIDGE ROBERTS
UNDER PENALTY OF DEATH
by GEORGES SIMENON
Also many short stories, fact articles
and special features

worldwide. Artists living in and around Munich followed his lead until he became known as the patriarch of southern Germany's *gemütlich* ("cozy") school of poster-making.

Hohlwein art began to disappear from Britain and the United States after Adolph Hitler became Germany's Chancellor, though the artist continued to produce throughout World War II, creating artwork for the Nazi Party. He died in 1949, but spirited endorsements from Alex Toth and others have helped Ludwig Hohlwein's reputation live on into the 21st Century.

One of the pulp magazines young Alex strived never to miss was *Blue Book*, a thick fiction monthly that explored many genres and published authors as diverse as Booth Tarkington, Robert A. Heinlein, Edgar Rice Burroughs, Agatha Christie, Sax Rohmer, and Philip Wylie. *Blue Book*'s authors and their tales drew Alex's attention, but the magazine's splendid art fascinated him, especially the Impressionistic covers of Herbert Morton Stoops (who also drew interiors for the magazine under the name "Jeremy Cannon"). Toth's eye was attracted to Stoops's grasp of composition and ability to indicate drapery with a handful of slashing pencil sweeps.

Born in 1888, Stoops spent a portion of his boyhood in a town less than a hundred miles from Yellowstone Park. When his father, a Presbyterian minister, relocated the family to Idaho, Stoops spent his teenage years among the remnants of the Wild West—cowboys, Indians, cattle ranchers, and dwindling herds of roaming buffalo and wild horses. He was also a gifted student, graduating Utah State College at age eighteen.

After a brief stint with a local newspaper, Stoops

moved to San Francisco, where he spent four years as a newspaper staff artist, first for the *Chronicle* and then for the *Examiner*. In 1914 he moved to Chicago, employed at the *Tribune* while taking courses at the Art Institute. World War I interrupted his career. He served in the Sixth Field Artillery as a first lieutenant; the sketchbooks he filled while stationed in France would be published in 1924 as *Inked Memories of 1918*.

Stoops returned Stateside after the Great War, marrying and settling in Manhattan. He began selling interior art to magazines such as *Liberty*, *Collier's*, and *McCalls*. His painted covers for *The American Legion Magazine* led to his first assignment for editor Donald Kendicott at *Blue Book*. By 1935, Kendicott had installed Stoops as his regular cover artist.

During this time Stoops painted covers featuring Confederate horsemen, Clipper ships with sails a'billow, Spanish conquistadores, and jungle scenes (including *Tarzan*, when *Blue Book* was lucky enough to publish a new Burroughs adventure featuring the jungle lord). In early 1947 Stoops began an ambitious project known as "These United States," for which he intended to paint a cover featuring an historical scene for each of the then-forty-eight states. Fate interfered with that plan: Stoops died in his Greenwich Village studio on May 19, 1948, the series unfinished.

The artists Toth admired ranged from those who enjoyed a period of success but afterward fell into relative obscurity, such as cartoonist Robert Bugg and poster creator Leslie Ragan ("[His] watercolor technique was first class, very simple, clean, tight, and reminiscent of Hohlwein," Alex observed in a 1981 letter) to those two founding members of the Famous Artists School whose names remain well known in even the most casual art circles, Robert Fawcett and Albert Dorne. Fawcett was one of the artists Alex met and intensely quizzed during his youth in the early 1940s; more than a half-century later, Toth was still one of Fawcett's students. In a 1995 note he enthused, "In his book, *On the Art of Drawing*, [Fawcett stated] that every drawing should be a struggle! If it comes too easily, be suspicious of it, do it again! While this is self-flagellation of a sort, it is nevertheless mostly sound theory and practice!"

One of the things Alex prized most about Dorne was his speed and his ability to draw from memory, without reference (though Dorne kept a voluminous scrap library).

"Al Dorne's halftone underpainting in transparent grays, using the excellent German Pelikan inks (the very best ground-pigment gray inks available!) was brilliantly done," wrote Toth. "If using posed models' photos, Dorne cartooned and exaggerated faces and figures and objects to suit his fancy! This gave a Roy Crane-like vitality and fun to his art, well suited to many of the ad series to which he regularly contributed: most of his work was given this humorous twist."

The humor of Dorne—the silhouettes of Hohlwein—the chiaroscuro of Henderson…young Toth blended them all into a potent concoction and drank deeply. This was the draught that helped transform a teenaged tyro into a polished professional.

ABOVE: Alex and his mother, New York City, circa late 1940s, around the time he broke into the comics business.

PART/FIVE
FIRST STEPS

Attending high school, palling with his friends, absorbing lessons from multiple sources, creating samples, visiting cartoonists and comics companies…1944 and early 1945 were a dizzying whirl for young Alex Toth. His hours of effort, study, and face-to-face meetings paid off as he landed his humble but oh-so-important first paying assignments. A visit to Lloyd Jacquet's company, Funnies, Inc., netted a gag-page tryout that would pay on acceptance. Alex earned twelve dollars for the piece, but received no further offers from Jacquet.

Alex's inquiries at Eastern Color Printing yielded longer-lasting results. Eastern was the home of *Famous Funnies*, the same comic book series Mrs. O'Connor often handed out as prizes to her grade-school pupils. There Alex met with a woman editor who was in the late stages of her pregnancy; she tested her teenaged visitor by having him produce a spot illo for a text story. She bought the resulting piece for five dollars and it fronted "Yankee King" in *Heroic Comics* #32. Toth had his first publication credit. Equally important, the pregnant editrix handed Alex a second assignment to depict another text feature, this time with two illustrations.

Alex remembered his editorial angel as being named "Mrs. Blum." The possibility exists that she was Audrey Blum, nicknamed "Toni." Blum was employed at the Eisner/Iger Studio in the early 1940s and was praised as a talented writer and editor by *Spirit* creator Will Eisner. Among her credits, Blum wrote "Captain Terry Thunder," with art by Bill Bossert; the two married and had three children. Was Toni Blum working for Eastern, using her maiden name professionally, while expectant with her first child? Was she the editor who cracked open the door to Alex Toth's comics career? None of us were there, none of us can really know—yet it makes for intriguing speculation, especially since if true, it was a connection between

Toth and Will Eisner of which neither artistic titan was aware.

What can be said with confidence is that Toth's first editor saw enough promise in the lad to ensure he was introduced to Steve Douglas, who would return to the Eastern helm when Mrs. Blum departed for the joys of motherhood. At this time Douglas was a warrant officer in the Army; he edited on the side, in addition to his military duties, until he was mustered out of the service as World War II concluded, leaving him free to return to comics full-time.

Douglas continued to send *Heroic Comics* assignments Alex's way: he stockpiled the pages, and Toth's art would continue to appear in *Heroic Comics* through #47, the March 1948 issue.

Alex was walking on air, regularly seeing his art printed in *Heroic* and picking up a pair of additional small jobs for The Frank Publishing Company. These early successes, however, did not build support at home. Toth recalled how his parents became increasingly cool toward his progress:

> When I got serious about making a living at it (running around visiting publishers with a portfolio), both [my parents] were weird about it. I really didn't get a lot of encouragement then. First of all, they didn't know what it was all about, how all that works. It was foreign to them—the whole idea of visiting publishers, editors, and what that kind of work would entail, or what kind of money, because it was peanuts when I finally did break in.

Perhaps the parental lack of support partially stemmed from the change they saw in their son.

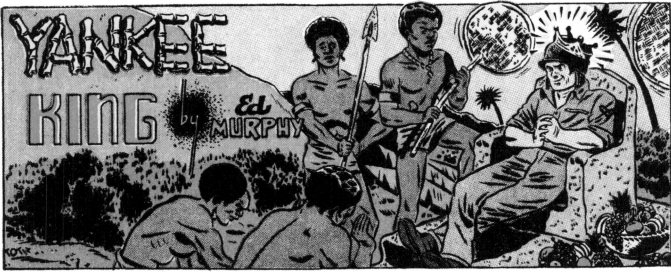

THE battle was over and Cape Gloucester was That night he slumbered in the royal bed while

Having grown up an active child—one who roamed the city and was involved in diverse pursuits—Alex was now home immediately after school and lashed to his lapboard, only reluctantly laying down his pencil around ten or eleven at night. Even then, sleep came hard as his mental wheels kept turning. Recalling those days, Toth once wrote: "It kept me awake in the dark, as I thought up answers for tomorrow afternoon and evening's board time. Tried to, that is, 'sleep on it.' If I awoke early enough, I'd sit at the board next to my bed to squeeze in work time—then off to school again." He was on a mission. "[My] after-school afternoons/evenings were seriously dedicated to learning my new craft—trying to make each job better, for me, for Steve, for the book, for readers!"

The relationship between Sandor and Mary Elizabeth Toth seems to have been especially strained at this time, and emotional turmoil may have further distracted both parents. It was a time when Sandor was absent from the household and Alex turned over his comics earnings to his mother. This gave Mary Elizabeth financial as well as parental leverage over Alex, limiting his options in those rare instances when social opportunities presented themselves.

"He supported his mom when he was about fifteen," Christina Hyde said. "She would dole out the money to him. He wanted to go on a date and she'd say, 'You can do it on ten,' or maybe fifteen. You can't do that to a young man who's working."

Christina's daughter Dana heard this story and more when her father discussed his teenaged years with her. She said, "This, to me, is so pivotal—two things. First, when Daddy was supporting my grandma, he turned all his money over to her and she would turn around and give him an allowance, and it belittled him. And when he started dating, he said, 'You know, this isn't enough money.' And she'd say, 'That's all you get.' And he felt so belittled, because he had to go back to her to get the money to go on a date and then to try to barter to see if he could get more.

"Then he told me this other story once…he must have been a very young boy. They went to this dance, and I don't know if his dad was playing at this thing or what, but both his mom and father were there. And my dad said this lady asked him to dance, and she was very beautiful. He said he came up to a little above her waist when they were slow dancing. His mom comes up, grabs him away, and takes him to the corner—evidently, this is a woman that his father had an affair with, or flirted with.

"You know, girls get stuff from their dad, guys get stuff from their mom. And I just think Dad had a challenge there with my grandma. She just wasn't a warm and fuzzy [person]. She just wasn't."

Another problem struck around the time of Alex's graduation from S.I.A.: in 1946, the work dried up. The freelancer's burden is securing a steady stream of work, and Alex first lifted that burden when a strike in the Canadian pulp and paper industry caused Eastern to cancel two-thirds of their comics line. The build-up of personal and professional pressures—"troubles at home; at work, what work?"—led Toth to try enlisting for a minimum four-year tour of duty in the Navy. Even that avenue was denied him: he failed his vision test, judged incapable of distinguishing between certain pale shades. This in turn created more conflict at home, as Sandor—a painting contractor by trade—raised the roof at the thought of a color-blind son.

The easy out of military service denied him, Alex did what he knew how to do—keep drawing, keep meeting with other peers and professionals in comics, keep looking for an assignment—*any* assignment. In a six-month span his only credits were a pair of short jobs for *Catholic Pictorial*: Alex said he did a third piece for this outlet, but it was never paid for or published, as a lawsuit filed by the distributor scuttled the comic's long-term viability. The calendar pages turned, 1946 became 1947, with no breakthroughs in sight.

It seemed to be just another depressing day when Alex paid a visit to Irwin Hasen, one of the artists he had previously met, befriended, and idolized. Alex could not know that knocking on the door of the 79th Street hotel room Irwin used as an apartment would initiate a sequence of events that would shape his future.

Alex Toth was about to be transformed into ***ALEX TOTH***.

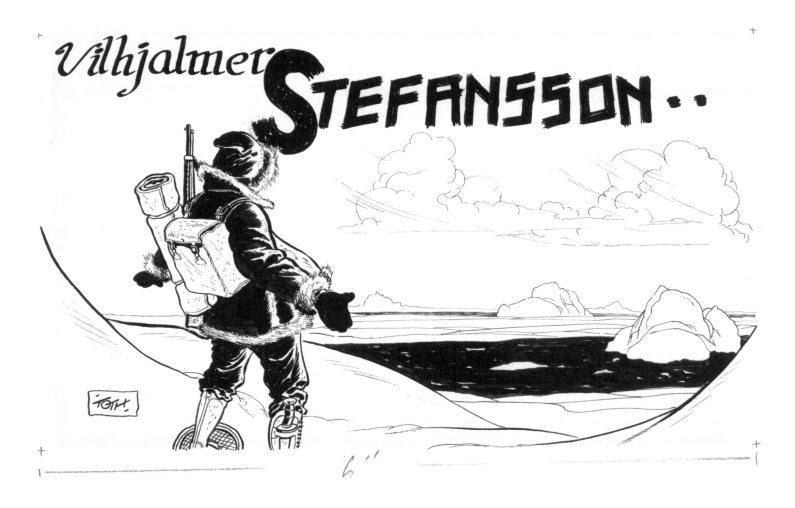

Vilhjalmer STEFANSSON..

I'M GOING TO MAKE A **RUN FOR IT!** YOU TRY TO BEAT IT WITH THE CAR!

IN A DESPERATE MOVE THE CROOK PULLS THE CAR SHARPLY OVER TO THE SIDE OF THE ROAD AND PREPARES TO **JUMP**...

IF YOU DON'T STOP, I'LL SHOOT AGAIN!

YOU ASKED FOR IT!

...AND THEN WHEN I WENT AFTER THE GUNMAN, SHERIFF CODY HERE PULLED UP IN FRONT OF THAT GIRL'S CAR SO FAST, SHE NEVER HAD A CHANCE TO GET AWAY!

BUT WE NEVER WOULD HAVE GOTTEN THEM IF IT WASN'T FOR YOU, MISS BAHR! YOU'RE A **HERO!**

...AND THE NEXT MORNING, ALL WAS QUIET IN THE COMMUNITY TELEPHONE COMPANY OF FAIRCHILD, WISCONSIN...

DAILY CALL
SWITCHBOARD OPERATOR HERO
ALERTNESS LEADS TO CAPTURE OF GUNMAN and DOLL

..when they were.. Young

ALEXANDER TOTH

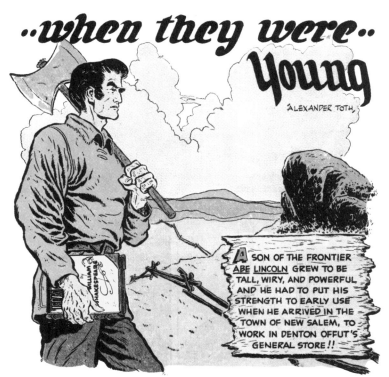

A SON OF THE FRONTIER **ABE LINCOLN** GREW TO BE TALL, WIRY, AND POWERFUL AND HE HAD TO PUT HIS STRENGTH TO EARLY USE WHEN HE ARRIVED IN THE TOWN OF NEW SALEM, TO WORK IN DENTON OFFUT'S GENERAL STORE!!

HERE YOU ARE, SON! THIS IS NEW SALEM!

THANK YOU, SIR!

HELLO THERE! ABE LINCOLN? I'M DENTON OFFUT! BEEN LOOKING FOR YOU!

YOU'VE COME JUST IN TIME, ABE! I NEED SOME HELP TO CARRY THIS BARREL OF MOLASSES TO THE STORE!

WHY, SURE! JUST HOLD MY BUNDLE!

CONTINUED NEXT PAGE

ONE OF OUR HEROES IS... "MISSING!"

A. TOTH.

BRIGADIER GENERAL FREDERICK W. CASTLE OF THE 8TH AIR FORCE WAS NOT REQUIRED TO FLY COMBAT AGAINST THE NAZIS — BUT WHEN THE TOUGHEST COMBAT MISSIONS HAD TO BE FLOWN, REGULATIONS OR NOT, GEN. CASTLE WAS ALWAYS IN HIS PLANE TO FLY THEM AND TO LEAD HIS MEN INTO THE THICKEST ACTION... IT WAS ON HIS 30TH MISSION WHICH CAUSED A SORROWFUL REPORT TO AMERICA THAT... **"ONE OF OUR HEROES IS MISSING"**...

THE MOST FATEFUL DAY IN GEN. CASTLE'S LIFE, STARTED OUT IN ROUTINE FASHION....

WELL, SO LONG, BILL! THE REASON YOU DON'T WANT ME TO GO IS THAT YOU'RE JEALOUS YOU AREN'T IN MY BOOTS!

GUESS YOU'RE RIGHT, FRED! I'D GIVE A LOT TO HAND THE RATZIS THE BOUQUET YOU'RE GOING TO GIVE THEM!

O.K., CASTLE GO AHEAD!

IT'S GONNA BE A NICE BUS RIDE!

SURE GOOD HAVING YOU FLY THIS SHIP, GENERAL!

CONTINUED NEXT PAGE

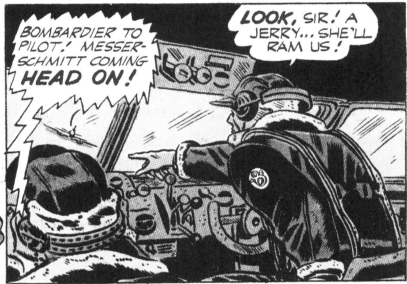

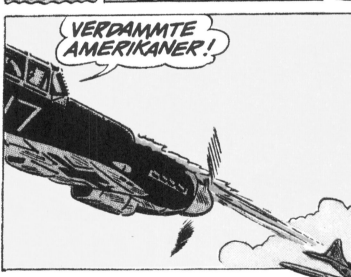

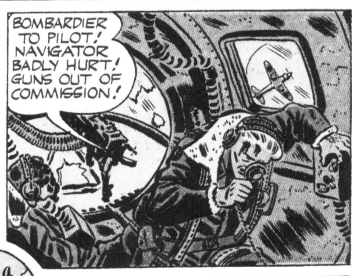

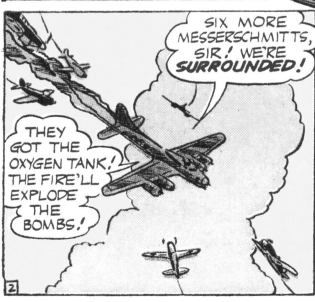

CONTINUED NEXT PAGE

Mercy FLIGHT

STARTING A RACE WITH *DEATH*...*EARL JOHNSON*, OF WASHBURN WISCONSIN, BAKER AND AMATEUR PILOT, LIFTED HIS TINY PLANE FROM AN IMPROVISED RUNWAY INTO DARKNESS...FLYING A POLIO VICTIM STRAPPED TO THE SEAT BESIDE HIM TO MINNEAPOLIS...200 MILES AWAY...

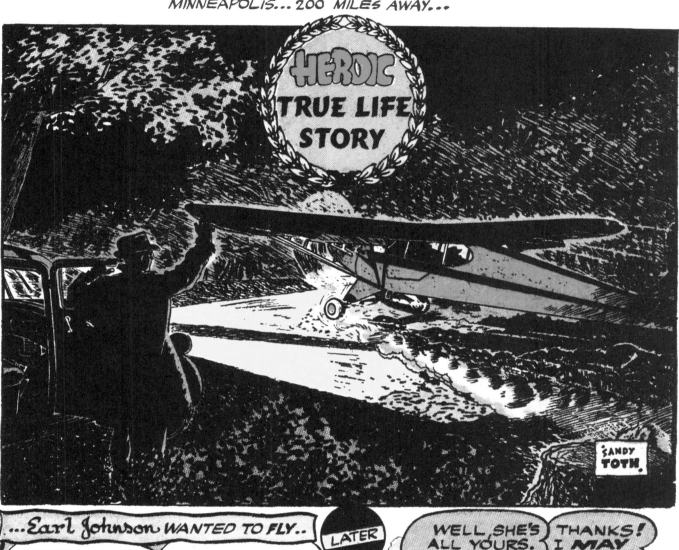

HEROIC TRUE LIFE STORY

SANDY TOTH.

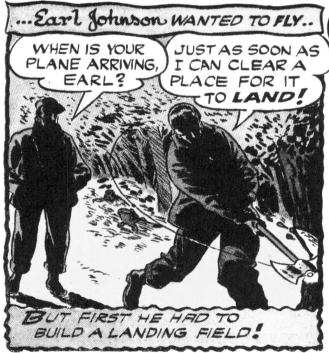

...*Earl Johnson* WANTED TO FLY..

WHEN IS YOUR PLANE ARRIVING, EARL?

JUST AS SOON AS I CAN CLEAR A PLACE FOR IT TO *LAND!*

BUT FIRST HE HAD TO BUILD A LANDING FIELD!

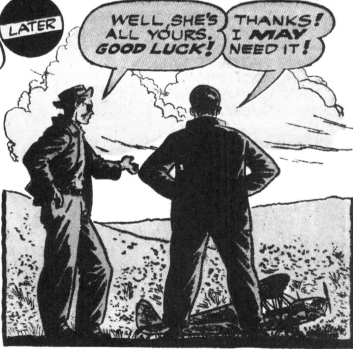

LATER

WELL, SHE'S ALL YOURS, *GOOD LUCK!*

THANKS! I *MAY* NEED IT!

Jimmy Wakely

THE TOWNFOLK OF POWDER BASIN GAVE JIMMY WAKELY, HOLLYWOOD'S COWBOY CAVALIER, A WARM WELCOME! BUT IT WASN'T THE KIND EXPECTED BY THE WESTERN ACE WHO HAD ALWAYS BEEN A TRUE REPRESENTATIVE OF LAW AND ORDER TO THE CITIZENS OF THE WEST. BUT THAT WAS BEFORE HE DISCOVERED HE HAD THE FIGHT OF HIS LIFE SUDDENLY THRUST UPON HIM IN ...

Jimmy Wakely VS JIMMY WAKELY!

PART/SIX
GOING NATIONAL

"I was introduced to Alex Toth by Sheldon Mayer, who was the editor [at All-American Publications] at that time. Alex took a liking to my work…. He used to visit me at my little hotel room, and he would bring me some of his mother's Hungarian goulash. Now, this kid in his knickers came to me, and I could never understand what the hell he saw in my work, 'cause I was a young kid myself, early twenties, maybe. But whatever it was, he must have taken a liking to it. And we became dear friends."

Interviewed for this project, Irwin Hasen remembered his old friend with great fondness, a fondness Toth reciprocated as he recalled his fledgling days. "[Irwin and I] lived just across the Park from each other, he on the West Side, me on the East. We'd work together. I'd bring my stuff over, set up my lapboard against his drawing table, and we'd listen to the radio, talk, work, go out and grab a bite to eat, and then come back and work some more. And then I'd go home. Sometimes, my mother would send a potful of Hungarian cooking with me, then we'd have a feast at his place. That was fun, because he loved Hungarian food…my mother's anyway."

Hasen was born in 1918, receiving his art training in New York's Art Students League and National Academy of Design. He gravitated to comics at the start of the 1940s, producing his first pages for the Harry "A" Chesler shop, packager of comic books for various publishing houses, before moving to *All-American Comics*, where he produced features such as *Wildcat* (which he co-created with writer Bill Finger) and the original *Green Lantern*. During Toth's high school days, when he first met Irwin, *All-American* was being published by M.C. "Charlie" Gaines, with Sheldon Mayer its editor.

Like Alex, the undersized, nearsighted Mayer began his comics career while a teenager, selling strips to flamboyant Major Malcolm Wheeler-Nicholson

before placing *Scribbly*, a comic strip about a teenaged cartoonist, with Charlie Gaines at Dell. When Gaines left to publish his own line of comics under the All-American Publications banner, he tapped Mayer to be his editor. Shelly played a role in the seminal event in comic book history—Superman's launch in the March 1938 issue of *Action Comics*—and by 1940 his All-American line was riding the superhero wave with anthology titles like *Flash Comics* (which debuted the original versions of The Flash, Hawkman, and Johnny Thunder) and *All-American* (home to the Golden Age Green Lantern, as well as the Atom and Dr. Mid-Nite).

Throughout his years at S.I.A., when Alex was making the after-school rounds of comics artists and companies, he went through the doors of the All-American offices at 225 Lafayette Street multiple times. Toth was introduced to Hasen during a later visit, but Irwin was very much the centerpiece of the initial meeting with Sheldon Mayer:

I remember my first visit. I was a big fan of Irwin Hasen's *Wildcat*. [Mayer] liked Hasen's work. He thought well of me because I saw in Hasen's work what he saw.

He brought in a set of Irwin's originals on *Wildcat* and I thought they were gorgeous. When he took them back out and gave them to somebody in "production" (and unbeknownst to me), he asked them to make full-size stats of those pages and to mount them on page blanks that DC printed for their artists. Plus lots of extra pages so I could practice my lettering on their blue-lined guides, for size and consistency. So when I left that day, he surprised me not only with all that, but also with a reducing glass, because he

OPPOSITE: Original art for splash page to "Jimmy Wakely vs. Jimmy Wakely," inked by Frank Giacoia, *Jimmy Wakely* #12 (July 1951).

said, "Every time you draw a page or panel, I want you to look at it through this glass and see how it's going to come down in print. And see how clear it's going to be. If it isn't clear, simple enough, change whatever needs changing and simplify it. This is the best tool you can have by your drawing board."

He told me to come back. To practice my lettering, to learn how to letter well. "Every cartoonist ought to be able to letter himself and not have anyone else do it." The one thing I don't remember getting encouragement to do was writing. And I wish that had been thumped into my head from the very beginning, so I would have paid more attention to that and not just trying to improve the art.

Writing was the furthest thing from the mind of the glum young man who appeared at Irwin Hasen's door on that 1947 day, determined to figure out how to jump-start his artistic career. Irwin listened to the discouraged teenager complain about how every avenue seemed to lead to a dead end. He then turned to the two friends who were in the room when Alex came knocking: Lee Elias and Joe Kubert were on hand to hear Toth's tales of woe. Elias had been drawing for a number of comic book publishers since 1943, while Kubert was a bona-fide *wunderkind*, at the time completing his first decade in comics at age twenty-one. Joe's first comics assignments came in 1938, when he was twelve years old; young Alex had a deep respect for Kubert, in part because Joe labored for a time as inker over Mort Meskin's pencils on *Johnny Quick*.

ABOVE and RIGHT: Alex Toth's first three solo covers for DC Comics. *All-Star Comics* #38 and *All-American Comics* #92 were both cover-dated December 1947; *Green Lantern* #30 (February 1948). The *All-American* cover is actually a flopped version of Toth's splash page for the interior story "The Icicle Goes South." (His first cover, a collaboration with Shelly Mayer, is on page 52.)

OPPPOSITE: Original artwork from "The Unexpected Guest," *Green Lantern* #37 (March 1949).

ABOVE: A rare collaboration with Alex's early mentor, Shelly Mayer (October 1947).

OPPOSITE: Splash page for the lead story in *All-American Comics* #96 (March 1948).

The three young professionals discussed the wannabe's situation and all three delivered the same advice: Alex was overdue for another visit to Shelly Mayer.

Things had changed at the All-American stable since Alex's last visit. Jack Liebowitz bought out Gaines, merging All-American with his own National Comics to create National Periodical Publications, the forerunner of today's DC Comics. The synergy between National's stable of superheroes and All-American's crime-fighting lineup made possible one of comics' core concepts: the superhero team, which first took shape as The Justice Society of America, in the pages of *All Star Comics*. Hasen, Kubert, and Elias agreed: the possibility of assignments existed at National. Perhaps for Alex, the time was right…?

Indeed it was.

Alex took his friends' advice, met with Sheldon Mayer, and emerged with "Dr. Mid-Nite" work slated to appear in the summer edition of *All-American Comics*. Before 1947 ended, the young artist had produced a twelve-page "Green Lantern" story as well as Justice Society pages slated to appear in *All-Star Comics* #37 and 38, including a cover for the latter issue. Alex Toth's career was officially underway.

The first character with whom Alex would be associated was Alan Scott, the Green Lantern of comics' Golden Age. He proved increasingly adept at depicting the original G.L.'s solo adventures, as well as stories featuring unlikely stars such as the comedic Doiby

Dickles or Streak, the Wonder Dog. Toth's tales of the Emerald Gladiator appeared in *All-American Comics*, plus *Comic Cavalcade* #26 through 28 and eight issues of the bi-monthly *Green Lantern* title. Since each issue featured multiple stories, there were issues (such as *Green Lantern* #31) in which one of Toth's stories appeared with one of Hasen's. The pages, likely created simultaneously in Irwin's hotel room, remained together through editorial, publication, and coast-to-coast distribution.

Though now a steadily-working professional, Alex remained very much an apprentice. Sheldon Mayer invested time and energy coaching his new young artist, employing "tough love" techniques learned through the angry tongue-lashings Shelly had received from his own volatile father while growing up. Once, for example, Toth claimed he expressed a need to experiment in order to refine his technique, only to be told, "If you want to experiment, do it on your own time!" Alex surely took no pleasure from Shelly's well-intended verbal bashings, yet his external response always amounted to, "Thank you, sir, may I have another?" More than twenty years after beginning at National, Toth unhesitatingly sang Mayer's praises:

> Shelly was the first and only really creative and knowledgeable comics editor I've worked for in all these years in the field. He was rough. He'd tear up my pages if I got too cute, too arty in telling the story. He'd tear them up on the spot and tell me to go home and do 'em over again. I tried to put in all the elements that I thought were important. But they weren't important, and Shelly was the one who pointed that out to me. He didn't care how pretty the pictures were if they didn't develop the story. "Stop trying to be another Michelangelo," he'd say, "and just tell the story! Just tell the story."
>
> Every time I walked out of his office, I'd learned something—whether I wanted to or not.

Alex was the perfect student for such a demanding taskmaster. Did a harangue in Shelly's office really differ from a berating from Sandor about color blindness or a showdown with Mary Elizabeth over money? Was it different from Martin Tittle's rebuke of a four-year-old's drawing?

Yes—because Toth was able to move past the barbs in Shelly's delivery and extract information from the message, valuable information he would process, internalize, and translate into his next batch of drawings. Alex willingly absorbed the verbal batterings as the price of becoming a better artist.

And he *was* becoming better. He seemed largely unaware of the way his facility impressed others, yet decades later no less a talent than Joe Kubert—who has continued to produce top-flight material throughout the 20th Century and into the 21st while educating

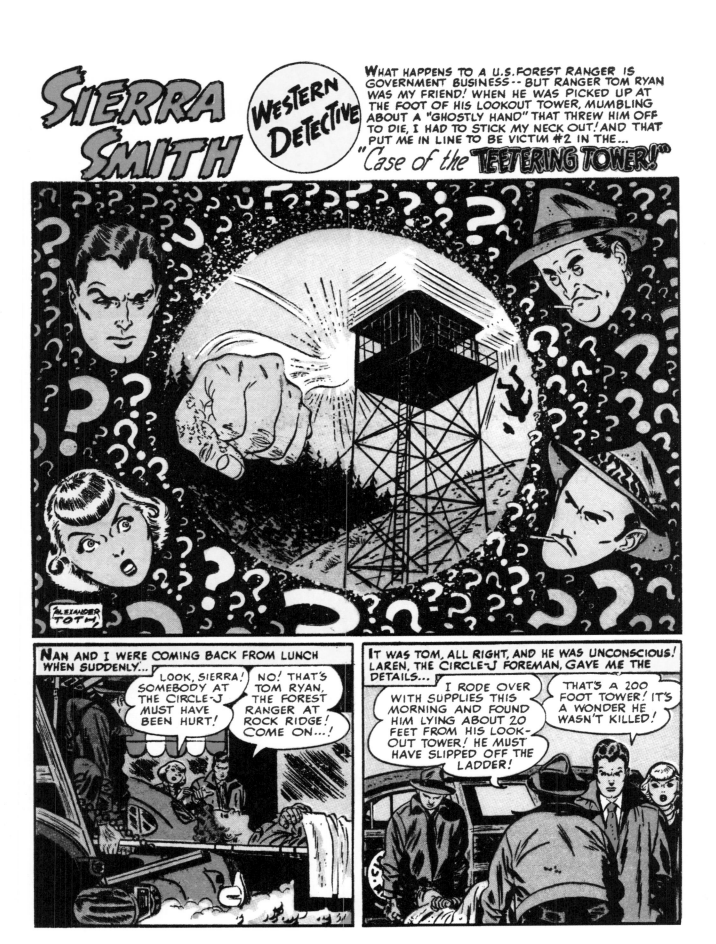

ABOVE: Splash page from the "Sierra Smith" feature in *Dale Evans Comics #7* (September 1949). All of the "Sierra Smith" stories drawn by Toth were written by Joe Millard. In a 1958 letter, Toth said that Millard at DC and Kim Aamodt at Standard were "my picks for top comic writers." Millard was born in 1908 and started his career writing for pulps, then moved to comics during the 1940s and 1950s, writing for Fawcett, Quality, DC, and others. He often collaborated with *Plastic Man*'s creator Jack Cole. In a later phase of his career, he wrote film novelizations, including *For A Few Dollars More*, based on the 1965 Sergio Leone/Clint Eastwood film.

scores of artists at his New Jersey-based School of Cartoon and Graphic Art—remembers his jaw dropping as Alex displayed a magical rendering touch in the Manhattan studio Kubert maintained together with some of his fellow artists.

Kubert reminisced about those early days during a 2010 interview for this project. "The studio—well, the address sounds very officious and fancy. It was on Park Avenue, about a block off 34th Street, but it was one of these little skinny leftover buildings that was jammed in amongst all the prettiest buildings on Park Avenue. The elevator—I'll never forget it!—the elevator was large enough to accommodate two very slim people. If you were a little bit overweight, two guys could never get into it!

"We had the top floor. What it was, actually, it was an apartment, and guys like Carmine—Carmine Infantino, of course—and a number of other guys were up there. We were all still very young. You know, I can't even recall clearly what kind of rental arrangement we made. I dunno who the hell paid rent! I don't remember doing that myself.

"One day, Alex was up there working on a Western. Now, here's this skinny kid sitting at the table, and I was there and a couple of other guys working at the place. But there he is, sitting and just throwing in the details on this huge Western story, working with the brush, putting in all the details of the terrain, this long shot of a horse riding up the side of the hill with a bunch of guys. We were absolutely amazed at his facility with the brush, and it was apparent he had a clear vision in his mind of what the drawing should look like. What he was doing was concentrating and merely copying what was in his head. You could see it, you

could see the connection. We were all just watching in amazement."

The move toward Westerns and away from superheroes like Green Lantern occurred in the wake of a post-War decline in popularity for "long underwear" characters. Costumed hero sales had steadily slipped each year since 1945; in a country catching its breath after protracted struggles in Europe and the Pacific, there was a desire for entertainment that offered something different than uniformed characters fighting never-ending battles. For Alex Toth, this shift away from superheroics played to his personal interests and artistic strengths, creating an ideal hotbed that allowed his skills to flourish.

The Western genre—already popular in print and on the movie screen—began to dominate the comics racks. National licensed to do comic book exploits of range-riding actors and from 1948 to early 1952, Alex drew back-up stories for several issues of *Dale Evans* while dominating the pages of the first fifteen issues of a comic starring cowboy crooner and Monogram motion picture star Jimmy Wakely. Alex's contributions to these titles are little known today, the fame of both Evans and Wakely having long since faded, but his efforts on a fictional Western character continue to be fondly remembered.

Johnny Thunder elbowed Green Lantern off the cover of *All-American Comics* #100, which sports a dynamic Toth image. Johnny's origin story in that issue was written by longtime National/DC mainstay Robert Kanigher, with full art and lettering by Toth. When confronted with evil, school teacher and Arizona native John Taine lives up to the promise made to his mother not to take up the ways of the gun by blackening his

WHEN I STOP TO PONDER ON THE ACCIDENTS OF LIFE, THE SILLY LITTLE THINGS THAT LEAD TO HAPPINESS OR STRIFE, I WANT TO HOLD YOU CLOSER, FOR IT HELPS ME TO FORGET HOW VERY CLOSE WE CAME, MY LOVE, TO NEVER HAVING MET!

A ROAD THAT'S CROSSED TOO QUICKLY, OR A TURNING THAT YOU MISS, AND TWO WHO MIGHT BE SWEETHEARTS WILL NOT EVER EVEN KISS, I HUMBLY THANK MY LUCKY STAR WITH EVERY PASSING DAY, THAT I WAS STANDING WHERE I STOOD, FOR YOU TO COME MY WAY!

INSTEAD OF TURNING DOWN THE LANE, I MIGHT HAVE CLIMBED THE HILL, AND IF I HAD, I'D BE ALONE AND WAITING FOR YOU STILL. IF YOU HAD STOPPED YOUR MORNING WALK A LITTLE FURTHER ON, YOU NEVER WOULD HAVE SEEN ME IN THE CLEAR AND DEWY DAWN...

WE NEVER WOULD HAVE STOPPED TO TALK, OUR HANDS WOULD NOT HAVE MET, YOU NEVER WOULD HAVE SMILED THAT SMILE I NEVER WILL FORGET— BUT, OH, IT HAPPENED AS IT DID, AND, OH IT ALL CAME TRUE, PERHAPS IT **HAD** TO BE THAT WAY... WHO KNOWS? WHO KNOWS? DO YOU?

ABOVE and OPPOSITE: Toth's DC output included all genres. These two filler pages from DC romance titles were originally printed in black-and-white. "It All Came True" from *Secret Hearts* #2 (November 1949); "The World is Ours" from *Girls' Love Stories* #3 (December 1949).

hair, donning buckskin-and-denim, and riding forth in a new identity—"Johnny Thunder"—to mete out justice (sixteen years later, Stan Lee would bring a similar setup into the resurgent superhero world to launch Matt Murdock's crime-busting career as Marvel's costumed Daredevil).

All-American Comics was rechristened *All-American Western* with its 103rd issue; Alex produced an uninterrupted run of "Johnny Thunder" stories through issue #125. He also created the majority of covers for those issues, several of them exceptionally striking. At times they were almost *avant garde*, as with the cover of *All-American* #103, which featured Johnny looking up

at the reader as he stands atop an open comic book, as if he had just stepped out of its pages; at other times they mixed high drama and natural beauty in a manner echoing John Ford's classic Western films. Foremost among them was the "Cheyenne Justice" cover of issue #107, with Johnny standing tall amidst a beleaguered group who face a hail of Indian arrows as their covered wagon burns behind them.

The changes at National extended to personnel as well as genres: Sheldon Mayer resigned in 1948. "Shelly Mayer?" Irwin Hasen said. "He wanted to be a cartoonist in the worst way, and he ended up a frustrated editor." Those frustrations ended when Mayer devoted himself

full-time to creating comics, *Sugar and Spike* being his most famous contribution to the form.

Though Shelly was gone, Alex still had a mentor in the National offices in the form of production manager Sol Harrison. It was Harrison who drilled the idea of *simplicity* into the young artist's brain. In a 2002 reminiscence, Toth recalled his reaction to Harrison's favorite saying: "'You still don't know what to leave out.' He sang the above refrain many times, driving me up the wall—what should I, could I 'leave out?'"

Alex would ponder these high mysteries all his life. He came to understand them better than most and he boiled down his approach to a single pithy statement:

his goal, he said, was to "strip away everything you don't need, then draw the hell out of the rest." He would bring to his work a degree of simplicity that remains the envy of three generations of comics artists, yet he was never fully satisfied. He was still the knight errant, chasing a grail only Shelly Mayer and Sol Harrison could see.

Alex had opportunities in this timeframe to critique tyros who sought to follow him into a comics career. When these chances presented themselves he offered positive feedback that was the antithesis of the often-barbed criticisms he received from his National mentors. Comics and children's book artist Tony

Tallarico described the kindness and generosity Alex displayed when the pair first met:

In 1947, I was attending the High School of Industrial Arts in New York City. The [S.I.A.] Annex was on 51st Street, off Lexington Avenue, blocks from [National Periodical Publications]. One day I gathered up my nerve and decided to visit…. I went to the reception room and was introduced to an elderly man wearing a blue artist's smock—I don't remember his name, but he brought me inside to the bullpen, where several freelancers were…one of them was Alex Toth.

Alex greeted me like a long-lost brother—looked at my work and gave me words of encouragement (this fifteen-year-old was on Cloud Nine). He asked me if I'd like an original page of his. My answer, of course, was *yes*!

Almost sixty years later—I still have the page.

While Alex kept a certain number of Western

stories on his drawing board throughout the early '50s, with "Johnny Thunder" in *All-American* and "The Roving Ranger" in the pages of *All-Star Western*, National expanded the breadth of material it requested of him. In the third issue of the short-lived anthology series *Danger Trail*, Alex produced the bravura "Battle Flag of the Foreign Legion," still revered by fans as one of their hero's absolute high-water marks.

In an interview for this biography, comics retailer and long-time friend of the artist John Hitchcock commented on "Battle Flag," saying:

"[Famed editor and eventual Toth collaborator] Archie Goodwin told me that ['Battle Flag'] was the story that changed everything. That was the one where everyone began to notice that this guy was a genius, that this guy was from another planet…. I'm convinced that's the story Alex did that [influential EC Comics artist] Bernie Krigstein saw and said, 'That's the way I'm going.' Because it's very linear, it's very beautiful, but it's very simple and the lines are very, very advanced. From then on, I think Alex was one of the top two or three guys in the field."

By 1951, science fiction and fantasy were being added to the mix and Toth produced stories for *Mystery in Space*, *Strange Adventures*, and *Sensation* (his tale "Queen of the Snows," from *Sensation* #107, was selected for inclusion in DC Comics's 1990 anthology *The Greatest 1950s Stories Ever Told*). Alex even had stories appear in the first three issues of *The Adventures of Rex, the Wonder Dog*.

Perhaps most important, National began jumping on the romance comics bandwagon that began rolling in 1947, when the team of Joe Simon and Jack Kirby launched *Young Romance* for the Crestwood publishing house. By 1949 National was releasing *Girls' Love Stories* and *Romance Trail* (a hybrid combining heartstrings with horses); the next year, *Secret Hearts* and *Girls' Romances* followed. Alex's art graced multiple issues of each title, helping to pave the way for the next step in his career.

Alex Toth produced over forty covers and at least thirteen hundred pages of comics art for National Periodical Publications during his initial stint with the company. In 1947 he began as a young novice, as green as he was eager. By the time he left in 1952, he cemented a reputation as one of the most exciting draughtsmen and storytellers in the industry.

Looking back to their National days together, Irwin Hasen recalled two young men sitting together, talking, laughing. And drawing, always drawing. Irwin is as modest about his own talents as he is accurate in his assessment of his friend:

"Alex slowly became one of the best. He was the greatest of them all, this young kid who came into my apartment. I lived in a hotel room. He wore knickers, and I can't believe he liked my work that much.

"But it makes me feel wonderful."

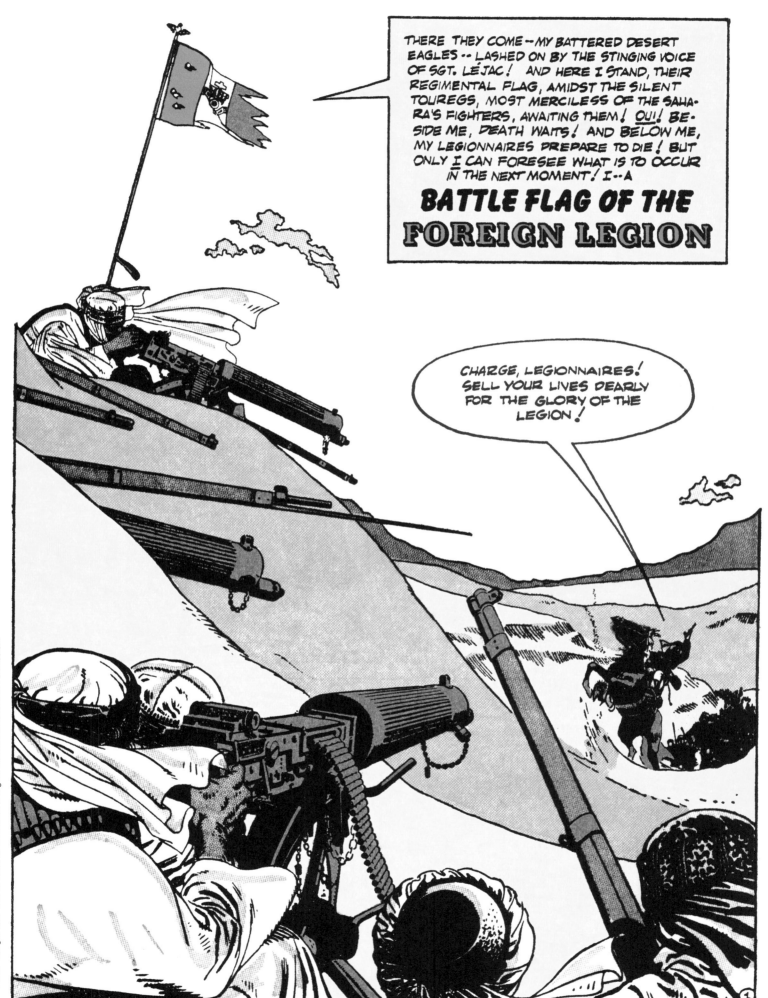

I WATCHED SGT. LÉJAC AS HE LED THE MEN OF MY REGIMENT UP THE BURNING SANDS OF THE IGIDI!

SGT. LÉJAC! WHY DO THEY NOT FIRE?

I PREFER BULLETS TO THIS TERRIBLE SILENCE!

SAVE YOUR BREATH FOR FIGHTING! ON, MY DESERT VULTURES! THE TOUREGS WILL NOT BREAK US BY THIS TACTIC! FORWARD!

I DO NOT KNOW WHICH SGT. LÉJAC WAS MOST SURPRISED AT— THE TOUREGS— OR ME!

HALT—WHILE THIS MIRAGE VANISHES OR --- OR—

BUT THE STRANGE SIGHT WHICH GREETED SGT. LÉJAC ATOP THE DUNE DID NOT DISAPPEAR...

LEGIONNAIRES —. BEHOLD! IT IS LA BELLE — OUR OWN REGIMENTAL FLAG!

SGT. LÉJAC! THESE TOUREGS ARE MORTS— DEAD!

OUI! THAT IS WHY WE WERE NOT CUT TO RIBBONS!

SERGEANT! WHAT KILLED THEM?

AND HOW DID OUR REGIMENTAL FLAG LAND HERE, IN THE MIDDLE OF THE DESERT?

ONLY LA BELLE CAN TELL YOU THAT, MES SOLDATS! AND WHAT AN EPIC IT MUST BE! BUT ONE WHICH, ALAS, MUST REMAIN UNSUNG — ANOTHER GREAT MYSTERY OF THE SAHARA SANDS!

2

To a fighting flag, honor means more than life!

That is why I, LA BELLE, must speak —because the honor of a legionnaire is at stake!

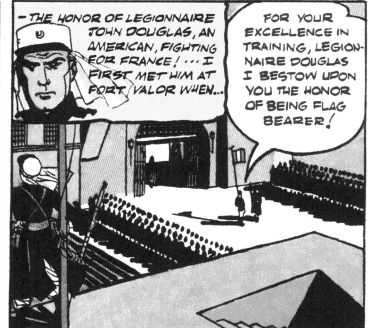

—THE HONOR OF LEGIONNAIRE JOHN DOUGLAS, AN AMERICAN, FIGHTING FOR FRANCE! ... I FIRST MET HIM AT FORT VALOR WHEN...

FOR YOUR EXCELLENCE IN TRAINING, LEGIONNAIRE DOUGLAS I BESTOW UPON YOU THE HONOR OF BEING FLAG BEARER!

I HAVE FAITH IN YOU, LEGIONNAIRE DOUGLAS! GUARD LA BELLE WITH YOUR VERY LIFE!

I WILL, SGT. LÉJAC!

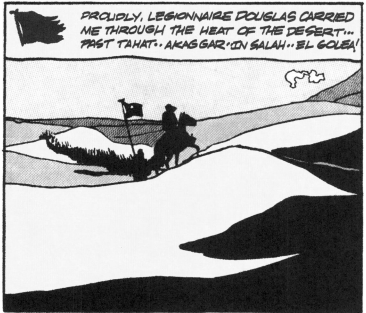

PROUDLY, LEGIONNAIRE DOUGLAS CARRIED ME THROUGH THE HEAT OF THE DESERT... PAST TAHAT...AKAGGAR...IN SALAH...EL GOLEA!

IT IS 122 DEGREES, LEGIONNAIRE DOUGLAS! I WILL EXCUSE YOU IF YOU WISH SOMEONE ELSE TO CARRY THE FLAG FOR A WHILE!

MERCI, MON SERGEANT! BUT.. I AM NOT TIRED!

UP 8,000 FEET, LEGIONNAIRE DOUGLAS CARRIED ME, TO THE EXTINCT VOLCANO ON MT. TUSIDDE ...

SNOW IN THE SAHARA, SGT. LÉJAC! WHO WOULD HAVE THOUGHT IT?

THE DESERT HAS MANY SURPRISES, LEGIONNAIRE! ONE MUST ALWAYS BE PREPARED FOR THEM!

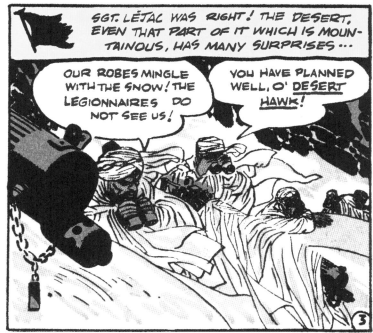

SGT. LÉJAC WAS RIGHT! THE DESERT, EVEN THAT PART OF IT WHICH IS MOUNTAINOUS, HAS MANY SURPRISES ...

OUR ROBES MINGLE WITH THE SNOW! THE LEGIONNAIRES DO NOT SEE US!

YOU HAVE PLANNED WELL, O' DESERT HAWK!

No one can tell how one will act under fire, until bullets whistle around one's head and comrades are falling!

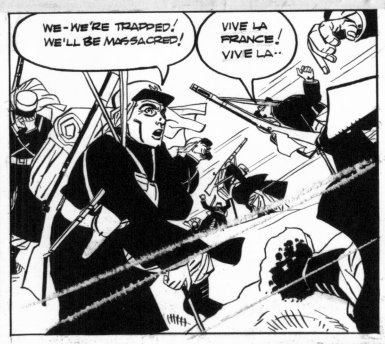

WE—WE'RE TRAPPED! WE'LL BE MASSACRED!

VIVE LA FRANCE! VIVE LA..

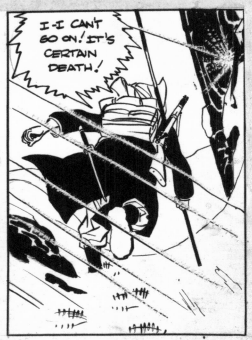

I-I CAN'T GO ON! IT'S CERTAIN DEATH!

Carrying a battleflag is a grave responsibility as well as an honor, and when a flagbearer fails in his duty, his disgrace is all the greater!

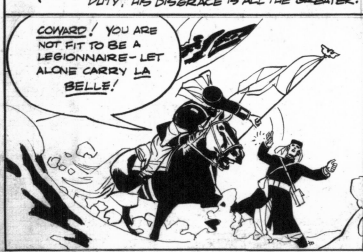

COWARD! YOU ARE NOT FIT TO BE A LEGIONNAIRE—LET ALONE CARRY LA BELLE!

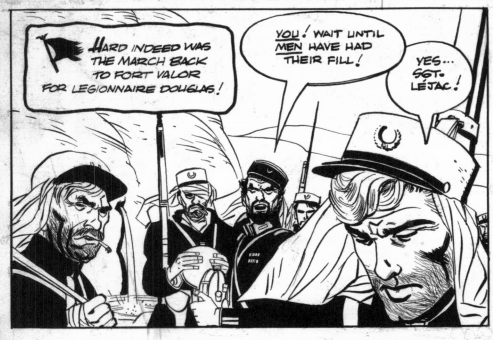

Hard indeed was the march back to Fort Valor for Legionnaire Douglas!

YOU! WAIT UNTIL MEN HAVE HAD THEIR FILL!

YES... SGT. LÉJAC!

IT IS GOOD SGT. LÉJAC STOPPED THAT COWARD!

OUI! HE WOULD HAVE CONTAMINATED THE WATER!

COLOR / NOTE: PANELS 1-3 — SNOW SCENES —

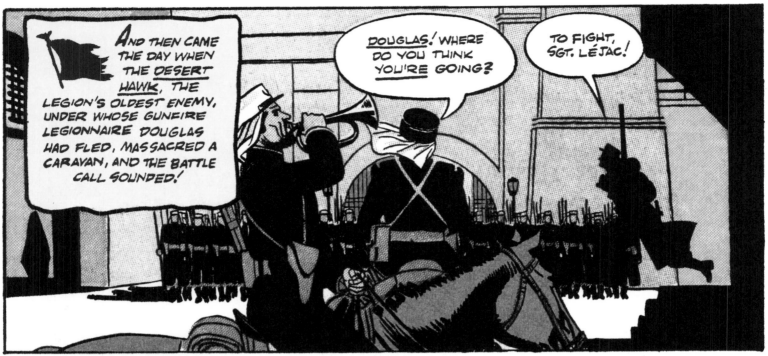

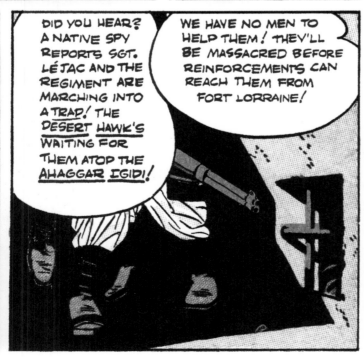

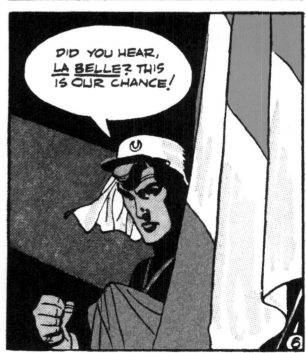

WITH THE FORT UNDERMANNED, IT WAS A SIMPLE MATTER FOR LEGIONNAIRE JOHN DOUGLAS TO STEAL OFF INTO THE DARK NIGHT!

HOUR AFTER HOUR, MY FLAG BEARER RODE ACROSS THE SILENT DESERT, PASSING THE MEN OF HIS REGIMENT, HIDDEN BY THE IGIDI!

PAUSING ONLY TO REST HIS MOUNT, HE CONTINUED ON, UNTIL DAWN, WHEN THE DESERT SUN ROSE ONCE AGAIN IN THE SKY—BEATING FIERCELY ON THE LONE LEGIONNAIRE AND HIS MOUNT!...

WHO CAN TELL WHAT HE THOUGHT AS HE REACHED THE FOOT OF AHAGGAR IGIDI, AND AGAIN LOOKED UP INTO THE GUNS OF THE DESERT HAWK!

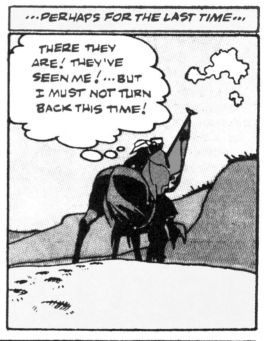

···PERHAPS FOR THE LAST TIME···

THERE THEY ARE! THEY'VE SEEN ME!...BUT I MUST NOT TURN BACK THIS TIME!

THE SPECTACLE OF A SINGLE LEGIONNAIRE, SEEMINGLY UNARMED, EXCEPT FOR A FLAG,! AMUSED THE DESERT HAWK AND HIS BAND!

LOOK! IT IS THE SAME FLAG BEARER WHO RAN FROM US ONCE BEFORE! HO, HO! AND LOOK AT HIS WRETCHED FLAG—IT CANNOT EVEN SUPPORT ITS OWN WEIGHT!

IF THIS IS THE BEST THE LEGION CAN SEND AGAINST US—ALL OF THE SAHARA SHALL SOON BE OURS! LET US SEND HIM RUNNING BACK WITH HIS TAIL BETWEEN HIS LEGS! —HO HO HO!

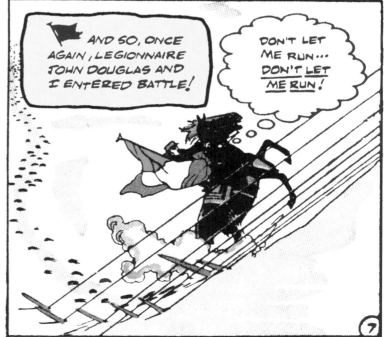

AND SO, ONCE AGAIN, LEGIONNAIRE JOHN DOUGLAS AND I ENTERED BATTLE!

DON'T LET ME RUN··· DON'T LET ME RUN!

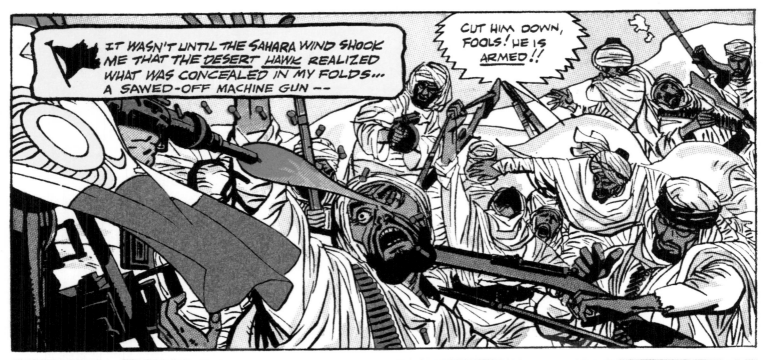

IT WASN'T UNTIL THE SAHARA WIND SHOOK ME THAT THE DESERT HAWK REALIZED WHAT WAS CONCEALED IN MY FOLDS... A SAWED-OFF MACHINE GUN —

CUT HIM DOWN, FOOLS! HE IS ARMED!!

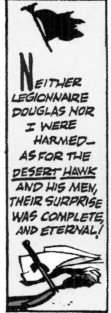

NEITHER LEGIONNAIRE DOUGLAS NOR I WERE HARMED... AS FOR THE DESERT HAWK AND HIS MEN, THEIR SURPRISE WAS COMPLETE, AND ETERNAL!

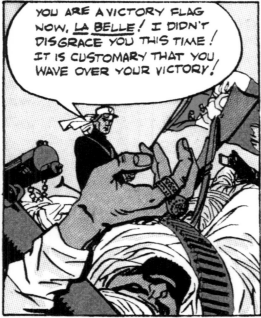

YOU ARE A VICTORY FLAG NOW, LA BELLE! I DIDN'T DISGRACE YOU THIS TIME! IT IS CUSTOMARY THAT YOU WAVE OVER YOUR VICTORY!

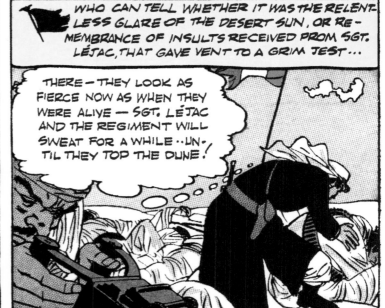

WHO CAN TELL WHETHER IT WAS THE RELENTLESS GLARE OF THE DESERT SUN, OR REMEMBRANCE OF INSULTS RECEIVED FROM SGT. LÉJAC, THAT GAVE VENT TO A GRIM JEST...

THERE — THEY LOOK AS FIERCE NOW AS WHEN THEY WERE ALIVE — SGT. LÉJAC AND THE REGIMENT WILL SWEAT FOR A WHILE... UNTIL THEY TOP THE DUNE!

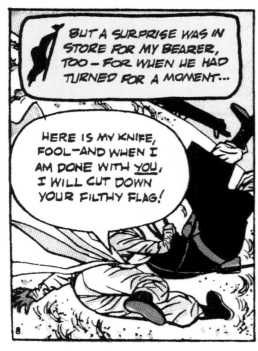

BUT A SURPRISE WAS IN STORE FOR MY BEARER, TOO — FOR WHEN HE HAD TURNED FOR A MOMENT...

HERE IS MY KNIFE, FOOL — AND WHEN I AM DONE WITH YOU, I WILL CUT DOWN YOUR FILTHY FLAG!

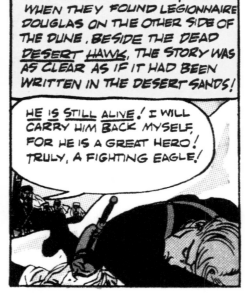

ALL THIS, COULD I'VE TOLD SGT. LÉJAC! BUT IT WAS NOT NECESSARY, FOR WHEN THEY FOUND LEGIONNAIRE DOUGLAS ON THE OTHER SIDE OF THE DUNE, BESIDE THE DEAD DESERT HAWK, THE STORY WAS AS CLEAR AS IF IT HAD BEEN WRITTEN IN THE DESERT SANDS!

HE IS STILL ALIVE! I WILL CARRY HIM BACK MYSELF, FOR HE IS A GREAT HERO! TRULY, A FIGHTING EAGLE!

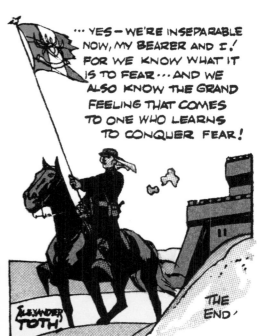

... YES — WE'RE INSEPARABLE NOW, MY BEARER AND I! FOR WE KNOW WHAT IT IS TO FEAR... AND WE ALSO KNOW THE GRAND FEELING THAT COMES TO ONE WHO LEARNS TO CONQUER FEAR!

ALEXANDER TOTH

THE END.

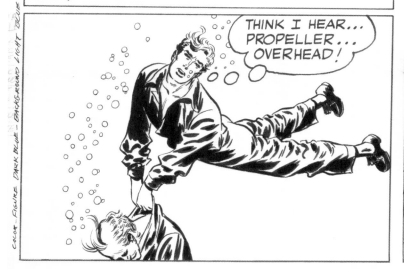

WITH MY BRAIN WARNING ME IT WOULD SEEK A NEW TENANT IF I CONTINUED TO IMITATE A FISH, I TORE MY WAY THROUGH THE PROFESSOR'S SACK, AND STARTED UP WITH HIM...

THINK I HEAR... PROPELLER... OVERHEAD!

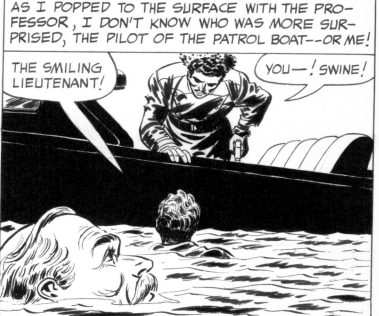

AS I POPPED TO THE SURFACE WITH THE PROFESSOR, I DON'T KNOW WHO WAS MORE SURPRISED, THE PILOT OF THE PATROL BOAT--OR ME!

THE SMILING LIEUTENANT!

YOU—! SWINE!

ABOVE: The "house style" at DC morphed as more and more of Toth's contemporaries were awed by his example. In this page from "Hangman's House" in *Danger Trail* #2 (September 1950), Carmine Infantino does his best Toth impersonation, inked by Joe Giella.

RIGHT: Later, at Standard Comics, Toth also set the pace, as seen in this very Toth-like page from "My Other Love," a 1954 effort by Vince Colletta from *Thrilling Romance* #24 (January 1954). The similarity to Toth's splash for "Blinded By Love" from a year earlier (see page 165) is striking.

BELOW: Toth's influence was so pervasive at Standard that the story "Gift of Murder," signed "Scott" (there was no "Scott" at Standard), is still uncredited. When shown the art in the 1980s, even Toth couldn't tell if was his work or that of a penciler working in his style "under all the Peppe-ink finishes as per those he set upon my works at that time." It may be by Toth, or by Mike Sekowsky, or…

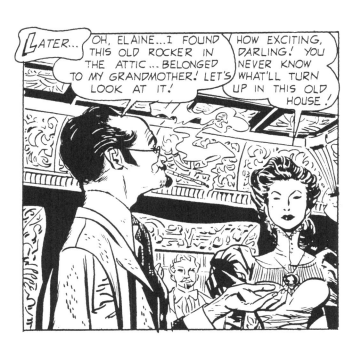

LATER... OH, ELAINE...I FOUND THIS OLD ROCKER IN THE ATTIC...BELONGED TO MY GRANDMOTHER! LET'S LOOK AT IT!

HOW EXCITING, DARLING! YOU NEVER KNOW WHAT'LL TURN UP IN THIS OLD HOUSE!

MY OTHER Love

My problem was simple... but I took the wrong way out. The web of lies I had woven to get around my parents' objections to my marriage became an unbreakable net. I thought I could break it by running away!

YOU CAN'T KEEP RUNNING AWAY, LENORE...IT ONLY MAKES THINGS WORSE!

I LOVE YOU, LENORE! WE CAN WORK THIS OUT TOGETHER!

I CAN'T! I CAN'T! THERE'S NO WAY TO SOLVE MY PROBLEMS! SOB! I MUST GO AWAY!

"LEE WHITE AND I HAD BEEN IN LOVE SINCE OUR HIGH SCHOOL DAYS. IN SPITE OF OUR PARENTS' DISAPPROVAL WE DATED SECRETLY, AND AFTER HE WAS DRAFTED, WE CARRIED ON A CORRESPONDENCE THROUGH A POST-OFFICE BOX...AND NOW HE WAS COMING HOME ON LEAVE BEFORE GOING TO KOREA!

OH, LEE! LEE! I'VE MISSED YOU SO!

MMMM...

LET'S GO TELL YOUR PARENTS WE'RE GETTING MARRIED RIGHT AWAY!

OH, LEE. I--LET ME THINK IT OVER UNTIL TOMORROW? PLEASE?

ABOVE: The dashing young artist posing on a New York stoop.

PART / SEVEN
MYSTERY DATE

Those early 1950s years were a period of personal as well as artistic growth. Alex Toth, life-long New Yorker, severed his roots to chase a seemingly golden opportunity that turned leaden. He also changed his income tax filing status for the first time (though not the last), all while regularly turning in assignments at National for editors Julius Schwartz and Whitney Ellsworth.

While Alex was learning his craft in comic books, he was yearning—as were so many of his peers—for a chance in newspaper comic strips. The general public labeled comic books as disposable and trashy, but strips retained a cachet of respectability from their early 20th Century heyday, and cartoonists such as Al (*Li'l Abner*) Capp enjoyed a degree of notoriety and wealth impossible to attain for those toiling in the comic book field.

The doors to the comic strip arena opened for Toth in 1950: cartoonist Warren Tufts was in the market for an assistant on his Western series, *Casey Ruggles*. He had seen examples of Alex's Westerns at National and offered the young artist an opportunity to serve as the *Ruggles* "ghost," producing artwork for the strip that would emulate Tufts's style and bear his signature. At age twenty-two, Alex accepted the job even though it meant leaving his home, parents, and friends in New York and relocating to Tufts's hometown of San Jose, California.

Alex got his first taste of California living and found it to his liking. The sunny skies and perpetual warmth made for great driving; the West Coast architecture and more relaxed lifestyle were welcome changes from New York's cacophony and chaos. At first there was little time for Alex to enjoy his new surroundings, as he made clear in a letter to his Manhattan-based friend Jerry DeFuccio, reprinted here by permission of writer and comics historian Ron Goulart:

> As you can well imagine, I'm up to my ears in confusion, doing my work and Warren's, trying to steal time to shop for furniture and get some rest! To tell you the truth, all the dailies were dumped in my lap yesterday at noon, I've worked on 'em since, right now it is exactly twenty-five hours that I've been awake! Great!
>
> Don't repeat this to Mom or I'll brain you!
>
> If I had about three days off, I could straighten all personal tasks and then conform to routine, but as yet, time is not mine to spend as I wish! Pity!
>
> I'm not kicking about work, or Warren, because the setup is very nice…studio, apartment, money, future!
>
> I'm enclosing a copy of the San Jose *Mercury Herald*'s leading local column! Back-fence gossip type of thing, but this columnist was told of my arrival and five days after I blew in, this column appeared—ha, I'm a celeb-*brat*-ee! Hoping all the gals in town would look me up. Proved fruitless! Oh, well! Bought ten copies of the damned thing anyhoo! Vain, wot?

The ladies may not have battered down Toth's door, but as a healthy young man with an eye for pulchritude, he enjoyed dating California girls as his schedule became less frenetic. One particular lady so struck his fancy, he married her.

The story of Alex Toth's early marriages remains a partly unsolved mystery. Alex almost never spoke of his first two wives and the persons with whom he discussed those early unions retain only foggy memories of the discussions, as if Toth deeming Wife-One and Wife-Two insignificant caused everyone in his social circle to reach the same conclusion and dismiss them from their thoughts.

Toth's friend Jim Amash could recall, "His first wife was an Italian. I believe her name was Francesca." This matches a passing reference to "Fran" contained in a letter to DeFuccio that Alex wrote in 1956. Toth's daughter Dana added, "I saw a photo of her [Francesca] that Dad had. I have no idea where that might be today, but I saw a picture of her and she was quite beautiful. It seemed like she had some sort of a black, Latin-looking dress on."

The demands of comics deadlines left precious little time for a honeymoon, but the new Mr. and Mrs. Toth did a fair bit of traveling not long after their nuptials. Having produced the *Ruggles* sequence "Aquila"—about a foundling reared in the wild who grows up to become a bird-man with limited powers of flight—and contributing to the next storyline, "The Spanish Mine," Alex and Warren Tufts went their separate ways.

There seemed little acrimony to the separation—both men kept in intermittent contact after their business dealings ended, and their paths would cross again more than once during the early 1960s. Discussing some of the specifics that ended his time with *Ruggles*, Toth said:

> Warren [Tufts] wanted to withdraw entirely from the art and just write the continuity, so there came a time when he turned the whole thing over to me and said that we should start submitting the strip in my own style instead of his. I didn't think United [Features Syndicate] would buy our making such a radical departure in the strip from one style to another, but we plowed on through a two-week sequence, and sure enough, it bounced back. The editor didn't like it, and demanded that every bit of it be redrawn. Due to this and other problems, both personal and professional, I decided to leave *Casey Ruggles* and concentrate on my own New York-based freelance accounts.

United's reaction to a Toth-style *Casey Ruggles* points to larger problems Alex had with the business side of the comic strip game. There was a great deal of resistance to experimentation at the syndicates, with stringent stylistic demands imposed on many artists. Toth once spoke of approaching the august King Features Syndicate during the 1940s. King—whose artistic superstar at that time was Alex Raymond of *Flash Gordon*—was in the market for someone to take on their *Perry Mason* strip. Editor Sylvan Byck favorably reviewed Toth's portfolio and offered Alex three days' worth of continuity to draw as samples, provided he copied the Raymond style. Angered and offended at being asked to mimic an approach that differed so radically from his own, Toth said he refused the assignment, telling Byck, "The name is Toth, not Raymond."

Since the War years, newspapers had been shrinking the size of newspaper strips, and Alex also chafed against this constraint, lamenting, "By the time I was 'ready,' [comic strips] were already dying, being throttled, squeezed, and distorted. The strip medium had changed. The Big Squeeze was on to force it out, not give it the area and respect it once had."

The dalliance with *Casey Ruggles* over, Alex and Francesca Toth returned to the East Coast, though not to New York. They set up housekeeping in suburban Connecticut, where Alex produced the final two years of his National output. He was also represented by an art agency that landed occasional extra assignments for him, including 1951's *Unconquered*. This fourteen-page booklet produced for a political group called the National Committee for a Free Europe offered a stark, dramatic view of one woman's struggle against both Nazi and Soviet oppression in her native Czechoslovakia.

These days also marked Alex's brief flirtation with freelance assignments at EC Comics. Founded by

BEGINNING
AQUILA!

Traveling northward, Casey Ruggles pulls into a Tehachapi Pass way station...

IT'S JEST A LONE RIDER...AN' COMIN' FROM TH' SOUTH!

I CAN'T UNNERSTAN' IT!!

HI—WARM DAY YOU'VE GOT HERE!

YOU COME FROM LOS ANGELES WAY—ANY TALK O' BANDITS ON TH' PROWL?

NO, WHY?

AW, TH' BLESSET VALLEY STAGE IS THREE HOURS OVERDUE! SOMETHIN'S GONE HAYWIRE!!

'YOU STRONG, WHITE MAN! YOU SLEEP MANY DAY, BUT YOU LIVE!

GOD AQUILA NOT FIGHT YOU! THAT SIGN HE WANT YOU LIVE! WE SAVE YOU!

HE WAS JUST AFRAID! HE'S STILL A KILLER AND HE'S STILL GOT TO BE STOPPED!

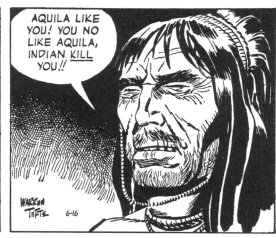

AQUILA LIKE YOU! YOU NO LIKE AQUILA, INDIAN KILL YOU!!

EDGE OF THE CLIFF! BELOW IS THE LIGHTHOUSE WHERE AQUILA WAS KIDNAPED 12 YEARS AGO...

...BUT WHERE IS AQUILA??

IN THE LIGHTHOUSE FAR BELOW, A MOTHER WHO HAS WAITED 12 YEARS FOR HER SON'S RETURN, SCREAMS!

HIGH ON THE ROCKS ABOVE CASEY, AQUILA FLEXES HIS WINGS FOR THE PLUNGE!

IF I CAN JUST MAKE YOU UNDERSTAND, AQUILA, NEITHER OF US HAS TO DIE...

YOU'RE NOT AN EAGLE, AQUILA—YOU'RE A BOY! MANY YEARS AGO...YOU WERE KIDNAPED...BY EAGLE...FROM LIGHTHOUSE BELOW...

YOUR MOTHER HAS WAITED 12 YEARS FOR YOU, AQUILA! SHE IS WATCHING! GO BACK WITH ME— SHE WILL CARE FOR YOU...

ABOVE: Alex and his father enjoying the water and coconut palms in Florida, undated.

BELOW: Two illustrations from *Unconquered*, a pamphlet published by the National Committee for a Free Europe, Inc., in 1951.

Charlie Gaines and run by son Bill following Charlie's death, EC had a reputation for attracting stellar artists such as Jack Davis, Frank Frazetta, Wally Wood, and Bernie Krigstein, all of whom produced stories for the publisher that remain greatly beloved within the comics community. Alex produced three stories for EC's war books, *Frontline Combat* and *Two-Fisted Tales*, presided over by a genius in his own right, Harvey Kurtzman. Though Alex's *Frontline Combat* stories—"Thunderjet!" and "F-86 Sabre Jet!"—are fondly remembered by many, the collaboration between Toth and Kurtzman ended there, since differences in personality and approach made them as compatible as oil and vinegar.

Ron Goulart spoke about this stormy and short-lived relationship. "Toth never got along with Kurtzman," he remarked, "although Kurtzman inked one of [Toth's] stories. Alex didn't like anybody telling him how to lay something out, and Kurtzman laid out everything, gave people roughs, and said, 'This is the way it's gonna look.' And Alex resisted that. That story where all you see are the airplanes all through the whole story, that supposedly pissed Kurtzman off."

With his side excursions withering on the vine, Alex's main account through the early 1950s remained comic book stories for National. He teamed with a variety of inkers, artists who would work over his penciled pages, rendering the images in permanent ink so they could be faithfully reproduced during printing. Perhaps the most successful partnership from this period was between Alex and Sy Barry. Though Toth was displacing Sy's brother, Dan Barry, as National's "house stylist," the inker was generous with his praise for Alex's ability:

I marveled at the clarity and the marvelous placement of blacks that Alex had a skill for. He had

ABOVE AND RIGHT: Toth drew six striking covers for consecutive issues #8-13 of *Big Town*. Above is #12 (December 1951) and at right, #9 (September 1951) and #11 (November 1951). *Big Town* was a long-running radio drama that premiered in 1937 with Edward G. Robinson playing the lead; its move to television for the 1950-1951 season prompted the DC Comics version.

°ALEXANDER TOTH.
22 CROCKETT ST.
ROWAYTON, CONN. / STRANGE
ADVENTURES / "ARTIST OF OTHER WORLDS!"

10 PAGER

1

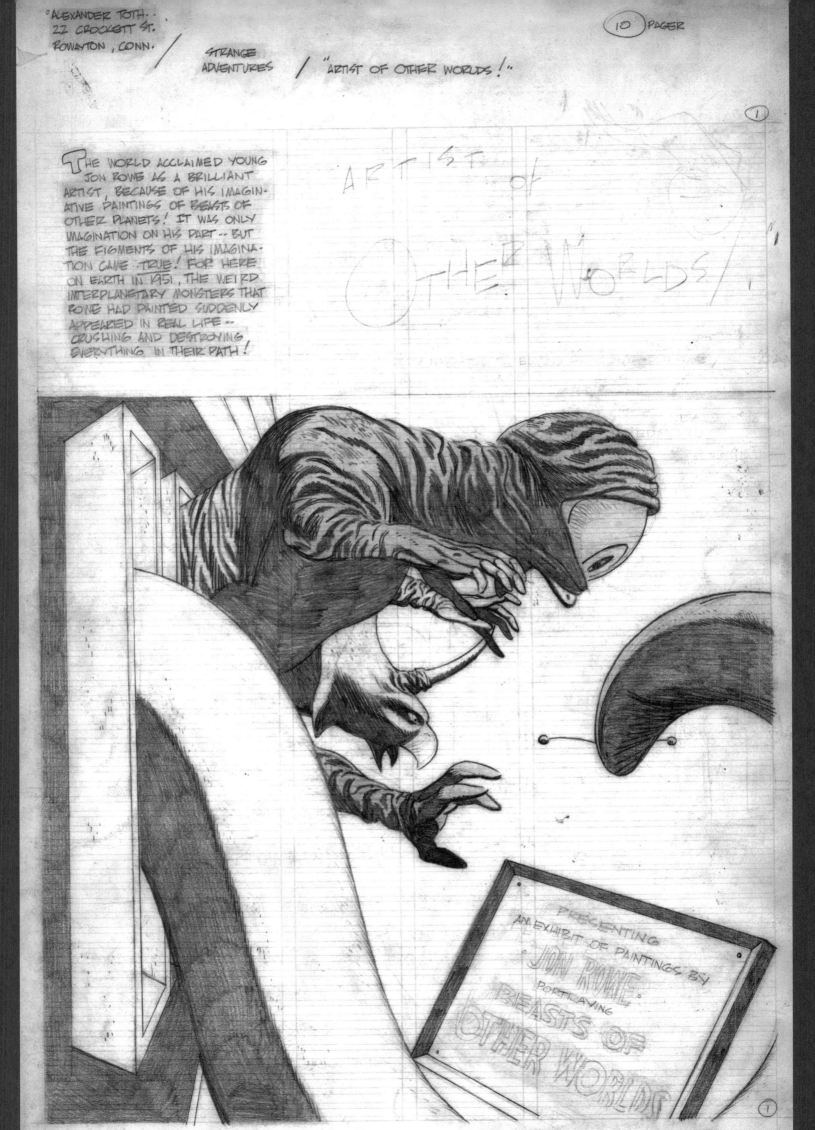

THE WORLD ACCLAIMED YOUNG JON ROWE AS A BRILLIANT ARTIST, BECAUSE OF HIS IMAGINATIVE PAINTINGS OF BEASTS OF OTHER PLANETS! IT WAS ONLY IMAGINATION ON HIS PART -- BUT THE FIGMENTS OF HIS IMAGINATION CAME TRUE! FOR HERE ON EARTH IN 1951, THE WEIRD INTERPLANETARY MONSTERS THAT ROWE HAD PAINTED SUDDENLY APPEARED IN REAL LIFE -- CRUSHING AND DESTROYING EVERYTHING IN THEIR PATH!

ARTIST OF OTHER WORLDS!

PRESENTING AN EXHIBIT OF PAINTINGS BY °JON ROWE· PORTRAYING BEASTS OF OTHER WORLDS!

°GASPAR: PLEASE USE LEGIT TYPE LETTERING ON THE EXHIBIT PLAQUE ABOVE --

THE WORLD ACCLAIMED YOUNG JOHN ROWE AS A BRILLIANT ARTIST BECAUSE OF HIS IMAGINATIVE PAINTINGS OF BEASTS OF OTHER PLANETS!
IT WAS ONLY IMAGINATION ON HIS PART-- BUT THE FIGMENTS OF HIS IMAGINATION CAME *TRUE*! FOR HERE ON EARTH IN 1951, THE WEIRD INTERPLANETARY MONSTERS THAT ROWE HAD PAINTED SUDDENLY APPEARED IN REAL LIFE -- CRUSHING AND DESTROYING EVERYTHING IN THEIR PATH!

STORY BY EDMOND HAMILTON

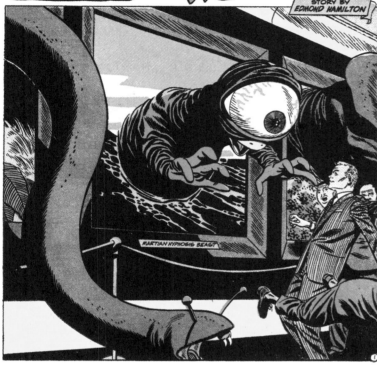

MARTIAN HYPNOSIS BEAST

OPPOSITE AND ABOVE: Toth's original splash page for "Artist of Other Worlds," slated for *Strange Adventures* #13 (October 1951), was rejected and is printed here for the first time. The accepted rendition is above.

PAGES 78-79: Original art for "Girl in the Golden Flower," inked by Sy Barry, from *Strange Adventures* #18 (March 1952).

BELOW: Margin note detail from the original art on page 78.

an acute eye for design and composition, and I just was thrown for a loop every time I looked at his pencils. They were glorious pencils to ink. His pencil work was very clean and tight.

I never saw him pencil, but I could just visualize the way he sat down at a page, ruled out the panels, and then saw these compositions in his mind's eye, and just put them down so cleanly and with such sureness. It was incredible to see the finished product.

I loved his line, yet I felt it was a little different than mine. I tried to give it a little more softness and a little more delicacy here and there, rather than a harsh, hard line. I think the delicacy against the strong, sharp blacks, that contrast, is what really set one thing against another. In fact, I don't even think Toth recognized precisely what made my inking a little different than most other inkers on his work.

He said, "There's something in there in your inking that defines you and separates you from most of the inking that's being done on my work."

When Toth came in, he was a whole new fresh concept, and I loved it. It was far

different than my thinking and the way I developed. And it was so interesting to me. It really struck me, and I just felt that it probably just needed a couple little lighter touches to it to really make it a presentable style, according to my taste.

Barry also told *Alter Ego* a bit about the fiery temper for which Alex was building a reputation, even early in his career:

> Alex was a very bright guy, very well-informed and well-educated. On one occasion, Alex, [inker] Joe Giella, and I had lunch together. Alex was having another one of his little fits in the office, and we kind of got him out of there and took him to lunch. So Alex and I were having a little conversation and were hoping that Joe would join in. Finally, after about ten minutes of conversation, Joe said, "You're both full of crap." You know, there's a way of breaking up the seriousness of the conversation. Joe just wanted to get a little sense of humor in there. Alex and I just cracked up laughing. Alex really liked Joe.

Not all flare-ups ended in laughter. Jack Katz recalled one incident in which the student confronted his teacher. "Once Alex started working at [National], he and Frank Robbins had an argument in front of the elevator outside the [National] offices…. Alex got red in his face. Frank was good with his dukes, a tough Jew from the Lower East Side. If another artist hadn't stepped in [to break them up], I don't know what would have happened."

Another contemporary of Toth's was Jack Mendelsohn, whose variegated credits include contributions to The Beatles's motion picture *Yellow Submarine*, TV series such as *Rowan & Martin's Laugh-In* and *George of the Jungle*, and the comic strip *Jacky's Diary*. Also speaking to *Alter Ego*, Mendelsohn said, "Alex was a grumpy old man, even when he was nineteen years old; I think he kind of reveled in being one. I think he played to it. I'm not a psychiatrist, but I think he enjoyed being disgruntled and complaining, and being very, very negative about everything, the work in general and how the work was treating him."

Between mercurial Hungarian blood and his upbringing in a household where sparks would regularly fly, Alex developed a low boiling point, especially when he felt questions of honor and respect were involved.

And one day in 1952, a confrontation occurred in which Alex did not simply boil—he boiled over.

GIRL IN THE Golden Flower!

OUT OF THE VASTNESS OF INTERSTELLAR SPACE IT CAME ... THIS TINY SPORE THAT WAS DESTINED TO PLAY SUCH A VITAL PART IN THE LIFE OF YOUNG ASTRONOMER BRAD MULFORD.

FOR THAT SPORE WAS THE SEED OF AN ALIEN FLOWER—LIFE, THAT WAS TO BLOSSOM INTO THE...

STORY BY **ROBERT STARR**

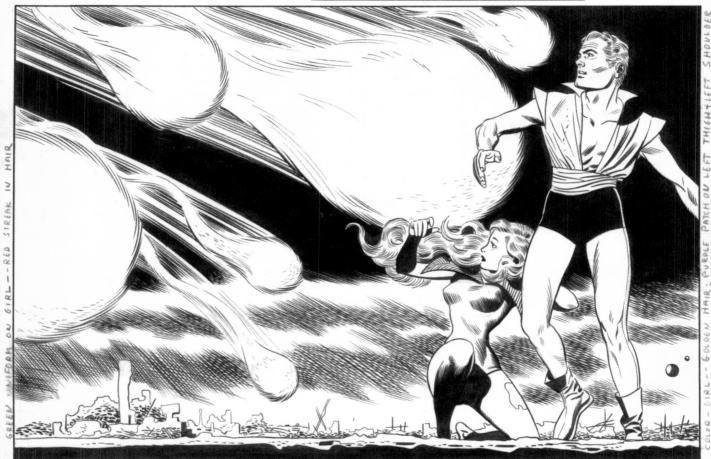

THE SPORE DRIFTED DOWN ON THE CURRENT OF A SOFT MAY BREEZE, INTO THE FLOWER-BOX OF BRAD MULFORD'S LITTLE COTTAGE...

SOME DAYS LATER, AS THE WEATHER TURNED HOT ...

I DIDN'T PLANT ANY FLOWER LIKE *THAT*! HOW DID IT GET HERE?

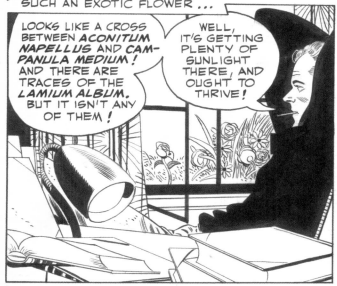

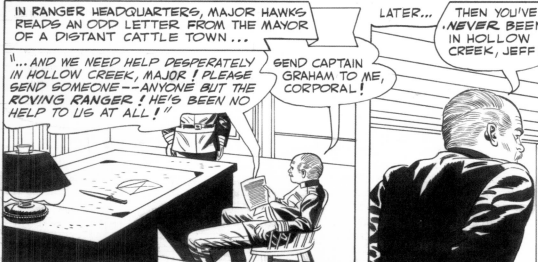
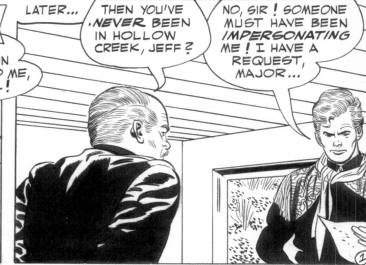

ABOVE AND OPPOSITE: Two original art boards from "The Riddle of the Rival Ranger!", inked by Sy Barry, *All-Star Western* #64 (April 1952).

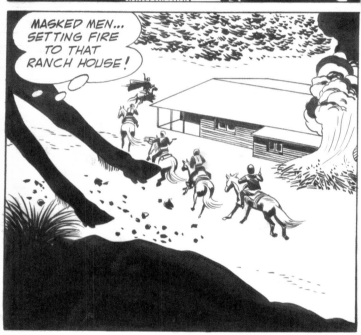

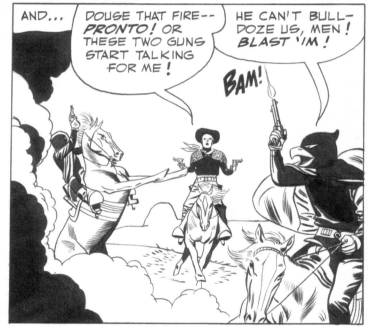

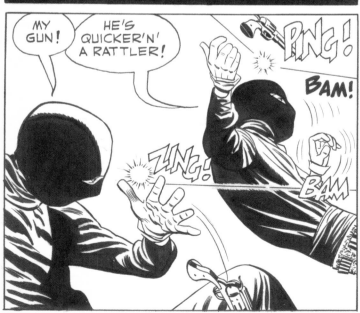

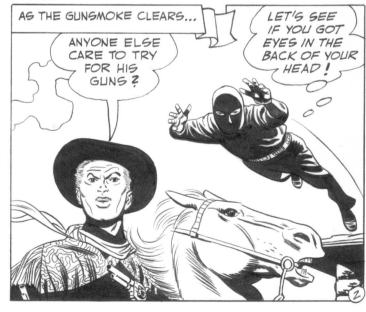

12 Jul Aug 43

FEW HOURS LATER...

WE CORNERED THE OWL-HOOT WHO'S BEEN ROBBIN' POWDER BASIN! HE'S RUNNIN' INTO THE LIVERY STABLE!

WHO IS HE?!

DON'T KNOW BUT HE'S MIGHTY HANDY WITH A GUN! CAREFUL! I JUST CAUGHT HIM TRYING TO BLAST MY BANK'S SAFE!

Color: Night

CAREFUL, SHERIFF! ANY MAN WHO CAN HAMSTRING A WHOLE TOWN FOR MONTHS WILL BE MIGHTY DANGEROUS WHEN HE'S GOT HIS BACK TO THE WALL!

I'LL TAKE HIM! STAND BACK, FOLKS! NOW, WHO-EVER YOU ARE--COME OUT OF THAT BARN HANDS HIGH! YOU HAVEN'T A CHANCE! WE'VE GOT YOU SURROUNDED!

A MOMENT LATER... AS THE DOOR OPENS...

LET'S HAVE A LOOK AT YOU...

WHA-?! IT'S JIMMY WAKELY!

NO WONDER WE COULDN'T CATCH UP WITH HIM!

PRETTY SLICK!

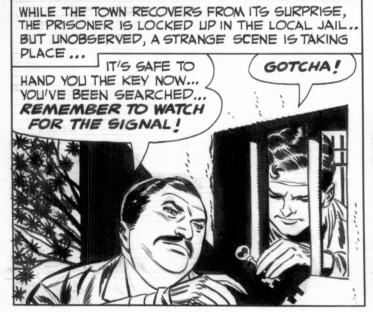

WHILE THE TOWN RECOVERS FROM ITS SURPRISE, THE PRISONER IS LOCKED UP IN THE LOCAL JAIL... BUT UNOBSERVED, A STRANGE SCENE IS TAKING PLACE...

IT'S SAFE TO HAND YOU THE KEY NOW... YOU'VE BEEN SEARCHED... REMEMBER TO WATCH FOR THE SIGNAL!

GOTCHA!

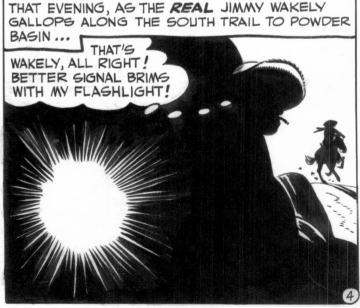

THAT EVENING, AS THE REAL JIMMY WAKELY GALLOPS ALONG THE SOUTH TRAIL TO POWDER BASIN...

THAT'S WAKELY, ALL RIGHT! BETTER SIGNAL BRIMS WITH MY FLASHLIGHT!

ABOVE: Original art from "Jimmy Wakely vs. Jimmy Wakely," inked by Frank Giacoia, *Jimmy Wakely* #12 (July 1951).

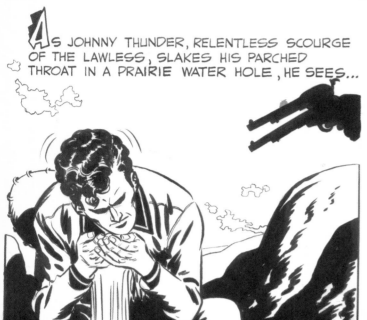

As JOHNNY THUNDER, RELENTLESS SCOURGE OF THE LAWLESS, SLAKES HIS PARCHED THROAT IN A PRAIRIE WATER HOLE, HE SEES...

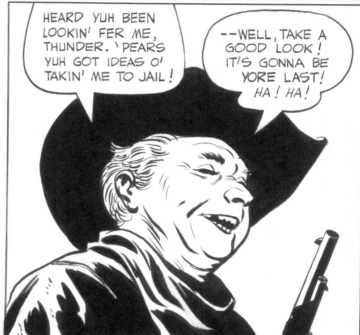

HEARD YUH BEEN LOOKIN' FER ME, THUNDER. 'PEARS YUH GOT IDEAS O' TAKIN' ME TO JAIL!

--WELL, TAKE A GOOD LOOK! IT'S GONNA BE YORE LAST! HA! HA!

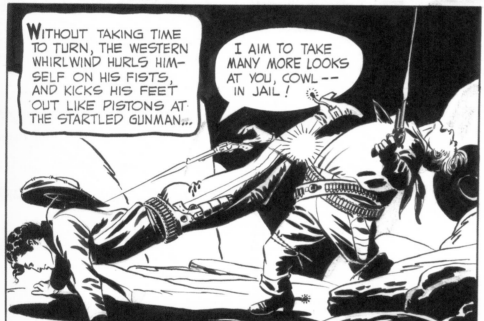

WITHOUT TAKING TIME TO TURN, THE WESTERN WHIRLWIND HURLS HIMSELF ON HIS FISTS, AND KICKS HIS FEET OUT LIKE PISTONS AT THE STARTLED GUNMAN...

I AIM TO TAKE MANY MORE LOOKS AT YOU, COWL -- IN JAIL!

AS THE FIGHTING PLAINSMAN RISES TO HIS FEET...

I ALWAYS SAID COWL LICKE WASN'T SMART ENOUGH TO FINISH YUH OFF, THUNDER! HE MADE THE MISTAKE OF GETTING ON EQUAL FOOTING WITH YUH! *BUT I'M NOT!*

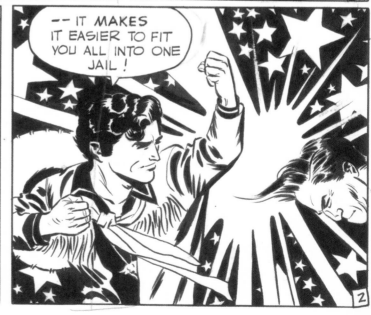

BUT THE QUICK-THINKING JOHNNY SEIZES THE MANE OF THE SECOND DESPERADO'S HORSE, WAVES HIS FREE HAND, AND YELLS LOUDLY...

YAHIEE I'M SURE GLAD TO SEE YOU OWL-HOOTS STICK TOGETHER, DRILL HARPER!

-- IT MAKES IT EASIER TO FIT YOU ALL INTO ONE JAIL!

ABOVE: Original art from "Challenge of the Aztecs!", inked by Joe Giella, *All-American Western* #118 (February 1951).

ABOVE: Original art from "Ambush at Painted Mountain," inked by Sy Barry, *All-American Western* #120 (June 1951).

ABOVE: Original art from "Secret of Crazy River!", *All-American Western* #109 (August 1949).
PAGE 86-93: The complete story, "Thunderjet!", Toth's collaboration with Harvey Kurtzman, reproduced from the original artwork.
Frontline Combat #8 (September 1952). Jerry DeFuccio wrote, "Harvey Kurtzman…approached the Air Force's Colonel Keim, who made it possible for he and Toth to inspect the actual plane on the assembly line at Republic Aircraft."

FOR _____ (PUBLICATION) MONTH & ISSUE NO. PAGE NO.

THIS STORY IS BASED ON FACT... THE STORY OF A MISSION, AS NEAR TO THE TRUTH AS WE CAN MAKE IT! WE ARE GOING TO TAKE YOU FOR A RIDE OVER KOREA! WE ARE GOING TO TAKE YOU FOR A RIDE OVER 'MIG ALLEY'! WE ARE GOING TO TAKE YOU WITH US IN A...

THUNDERJET!

ALEXANDER TOTH /52

IT IS OCTOBER 1951! YOU ARE TROTTING IN THE SHOES OF CAPT. **WOOD PALADINO** ACROSS A KOREAN AIR BASE!

YOU HAVE BEEN BRIEFED BY THE WEATHER OFFICER, THE GROUND OFFICER, AND YOU HAVE BRIEFED YOUR FLIGHT!

AN ENEMY TRAIN IS CUT OFF ON A BOMBED OUT TRACK! YOUR JOB WILL BE TO **DESTROY THAT TRAIN!**

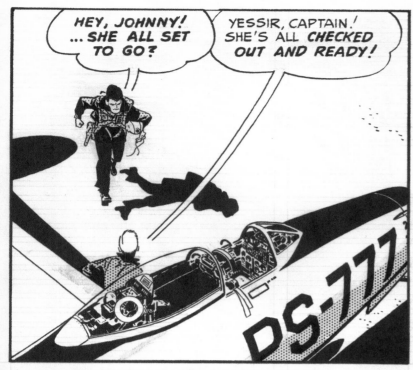

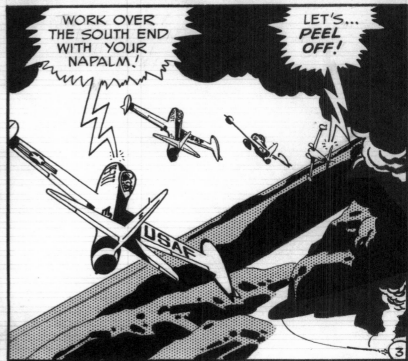

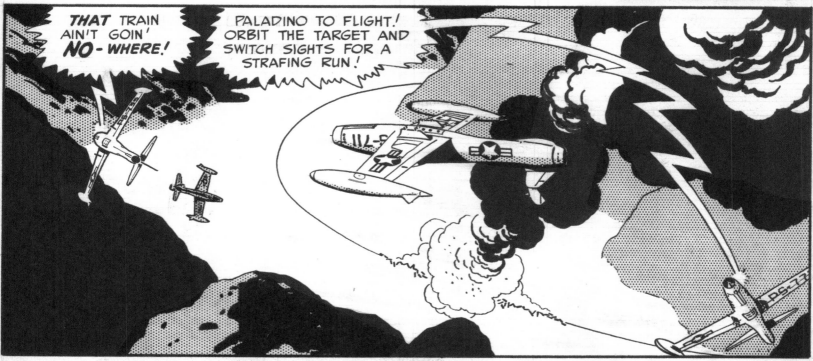

THAT TRAIN AIN'T GOIN' *NO-WHERE!*

PALADINO TO FLIGHT! ORBIT THE TARGET AND SWITCH SIGHTS FOR A STRAFING RUN!

...SET MACHINE GUN SIGHTS! GOL-DARNED AIR SURE GETS ROUGH ON THE DECK!

...IDEAL DAY! SKY CLEAR! HEY! THEY STOPPED THROWING FLAK! THAT CAN MEAN ONLY ONE THING...

...MIGS! UH OH! UP THERE! BOGIES OR BANDITS? ...YEP!

BANDITS AT II O'CLOCK HIGH!

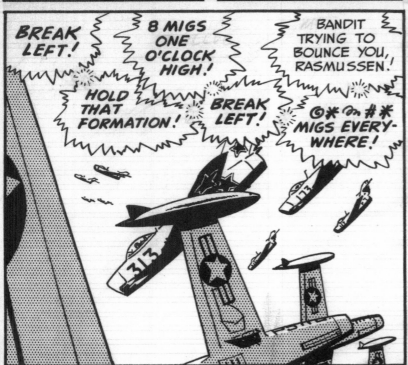

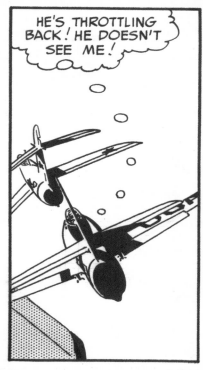

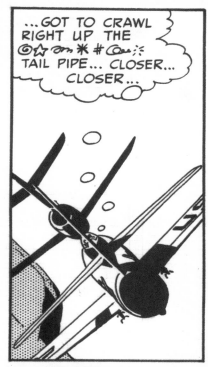

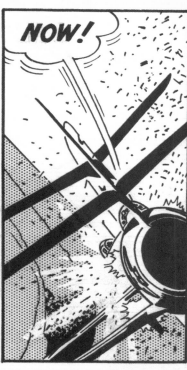

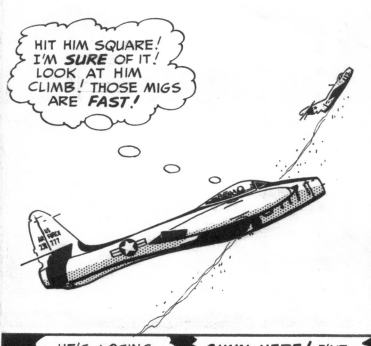

I'VE GOT HIM IN SIGHT ALL RIGHT! I'LL **NEVER** CLOSE IN TIME! IF ONLY WE HAD 20 MM CANNON LIKE THE MIGS DO!

HE SPOTTED ME! IF I HAD A CANNON I COULD'VE KNOCKED HIM DOWN!...THIS FIGHTER BOMBER CARRIES A HEAVY LOAD AS IT **IS** WITHOUT A **CANNON!**

UH-OH! FUEL DOWN TO 2300 LBS! TIME TO GO HOME!

LEADER TO FLIGHT! **SWEET ADELINE!**

THE MIGS ARE BREAKING FOR HOME TOO... LIKE A SKY FULL OF BUCKSHOT! THOSE JETS ARE BEING FLOWN BY **KIDS**...NO FORMATION, NO NOTHING! THEY COME UP, EVERY DAY, LIKE A **CLASS ROOM!**

THAT'S WHAT THIS IS! A **BIG CLASS ROOM**..THOSE MIGS AREN'T TRAINING FOR **NOTHING!** AND THEY'RE LEARNING **FAST!**

THE FLIGHT'S WAITING FOR ME TO CATCH UP!

ABLE LEADER TO CONDUCT CONTROL! THIS IS MISSION 2120!

ROGER ABLE LEADER!

TARGET ATTACKED AND DESTROYED!

ROGER! PROCEED! YOU ARE CLEARED TO BASE! OVER!

ABLE LEADER CALLING RAZZLE TOWER! ABLE LEADER CALLING RAZZLE TOWER!

RAZZLE TOWER! COME IN ABLE LEADER!

ABLE LEADER REQUESTS LANDING INSTRUCTIONS FOR FOUR! WE'RE **ROLLING IN!**

YOU'RE ROLLING IN! YOUR MISSION IS FINISHED AND YOU'RE ROLLING IN! YOU STREAK ACROSS THE FIELD AT 1000 FEET IN RIGHT ECHELON! THEN...

THEN YOU GRACEFULLY PEEL OFF... BRAKE, FLAPS AND TRICYCLE LANDING GEAR DOWN, AND YOUR SKIMMING MACHINE *TOUCHES GROUND AGAIN!*

YOU HAVE LANDED! YOU NOW TAXI YOUR JET DOWN TO THE GROUP OF WAITING CREWMEN! NEWS OF YOUR VICTORY HAS ALREADY REACHED THEM!

YOU SHOVE BACK THE CANOPY, JERK OFF THE CLUMSY HELMET AND YOU CLIMB TO THE GROUND TO INSPECT DAMAGE THE MIGS HAVE DONE TO YOUR STURDY PLANE!

AND AS YOU FINGER THE TORN ALUMINUM, YOU THINK OF THE 20 MM CANNON THE MIGS HAVE!

AND THEN YOU THINK HOW THE MIGS GO FASTER THAN YOU, AND YOU THINK HOW THE MIGS OUTNUMBER YOU...

AND YOU THINK OF THAT CLASSROOM IN THE SKY! AND THEN YOU THINK...WE'D BETTER DO SOMETHING, *SOON...*

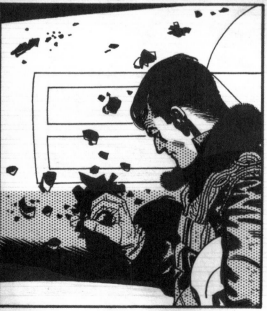

...PRETTY GOL-DARNED SOON!

ABOVE: The artist in repose, date unknown (probably early-to-mid 1950s).

PART / EIGH

HIGH STANDARDS

Some stories grow over time, becoming apocryphal in their retelling through exaggeration or embellishment: Alex Toth's departure from National is one such tale. The clash between the artist and editor Julius Schwartz took on epic proportions as it was repeated many different times, with many different variations. It has become the comics industry's version of *Rashomon*, the Akira Kurosawa film in which a violent incident is retold through four different sets of eyes, each one supposedly "the truth." Many comics professionals have repeated the juiciest version of the Toth/Schwartz confrontation, which has a livid Toth dangling Schwartz from an office window.

Certainly there is no doubt a blow-up between Alex and Julie resulted in the artist leaving National. "Julie Schwartz became a pain in the ass to Alex," said Irwin Hasen. "A thorn in his side, is that the expression? I remember they gave him a hard time when he wanted to collect money…. Unfortunately, he did the worst thing in the world you could do in those days—you don't interrupt Julie Schwartz during lunch hour, while he's playing cards. And this kid [Toth] had a big mouth—but nicely, he said, 'Where's my check?' And Julie Schwartz looked at him and said, 'Don't you dare interrupt my card game!' This was a small thing, but I think with that, with the nature of Alex—he didn't want to take it. That's all."

DC Comics Art & Design Director Mark Chiarello and John Hitchcock, guiding light behind 2006's well-received *Alex Toth Doodle Book*, counted Toth and Schwartz among their friends. Both said they separately asked each man for his version of the incident; both said each version was in sync with the other. Hitchcock recounts the event this way:

Julie was playing cards and having lunch, and there was a group of people with him when Alex came in with the original art from *Johnny Thunder*. Alex shows up, and he's obviously very, very proud of what he had just accomplished, because at that time he was really kicking it into another gear.

Alex walks in and says, "Here's my art and I want to pick up a script and I want to pick up my check," and Julie just looked at him and said, "Well, look Alex, I'm on my lunch break, just go ahead and have a seat in my office. When I've finished the lunch break, then we'll do this thing."

Now Julie was quite aware that he was playing cards with Alex's peers, so it was kind of like telling Alex to stand down in front of his peer group…. Alex was basically told to take a seat in the office and cool his heels.

When Julie did come in, he handed Alex the check and then—the way Julie worked is, he'd have a stack of scripts on his desk and they were in the order of when he needed them. So what Julie had was *Strange Adventures*. And Alex went, "I don't want to do *Strange Adventures*, I want to do *Johnny Thunder* again." And Alex was very demonstrative about that fact; he said, "Hey, that's what I want to do." And Julie said, "No, what I need is *Strange Adventures*, this is what I need." And Alex goes, "If I'm not doing *Johnny Thunder*, I'm not doing it." And Julie went, "OK, I guess you're not doing it." Alex walked out and didn't talk to the guy for twenty years.

Alex never grabbed him by the tie and hung him out the window. Most

freelancers want to believe that he grabbed an editor and hung him out the window…and then, because of Alex's temper, they assumed that Alex threatened Julie. Alex was obviously very hot, because he felt that Julie was taking his time playing his cards and eating his sandwich. And so to Alex, being around other artists, it made it look like he was being put down.

Alex apparently was not above varying the way he retold this story, depending on his mood and his audience. Comic book artist Steve Leialoha recalled hearing a version first-hand from Alex at a 1980s San Diego Comic-Con:

I was standing outside the hall chatting with [then-DC Editor-in-Chief] Dick Giordano [and others] when Alex walks up, grousing about comics going to hell and back, with Dick trying to talk Alex into doing something—anything!—for him.

Somehow that talk turned to how Julie had tried to stiff [Toth] over a paycheck. Alex was mad as hell and wasn't going to take it! Alex had shown up at DC to drop off work and pick up a paycheck just as Julie was taking his lunch

break and [Julie] told Alex to come back when he was finished. Alex threatened to toss him out the window if the check wasn't forthcoming.

It took a moment [for me] to realize this happened thirty years back! He said that was why he quit DC and moved to Hollywood. He never forgot a grudge. It was amazing that he could get so worked up about it after all that time.

Three years before his death at age eighty-six, long-time DC staffer Bob Kanigher revealed in a 1999 interview with Christopher Irving that he had become an innocent victim after a few garbled accounts led several persons to believe he, not Schwartz, had the memorable falling-out with Toth.

"A lot of people think I fired Alex Toth," Kanigher told Mr. Irving. "I couldn't have fired Alex if I wanted to…because I wasn't the editor. Julie fired him for this unbelievable reason. [Julie and I] shared an office together; I had nothing against him. Whenever he got into a jam, he asked me for a script. What I did was, since our offices were ass to ass, I built a tiny wall of books between us so I didn't have to see his face. [Schwartz] was very methodical: he always ate in and he would play cards…. Alex used to come in at noontime for work he'd already done. His check was in Julie's desk, in the top drawer. All [Julie] had to do was open

FILLER PAGE!

PEG POWLER / HORROR

PEG POWLER

BEAUTIFUL—BUT DEADLY! THAT'S PEG POWLER, THE GREEN-HAIRED HAUNT WHO LURES MEN TO DESTRUCTION—LAUGHING AS THEY DIE!

B-1119

ON THE RIVER TEES IN ENGLAND...

HELP! SAVE ME! OH, SAVE ME!

THAT WOMAN—DROWNING! I-I CAN'T SWIM TOO WELL, BUT...

SHE LED ME INTO DEEP WATER! I CAN'T STAY UP... MUCH... LONGER...

HAHAHAHAHAHA!

YOU—YOU'RE NOT HUMAN!!

STEADY ON, SIR! I'LL HAVE YOU OUT IN A MOMENT!

THANK HEAVEN!

B-BUT THAT WOMAN—SHE SEEMS TO HAVE DISAPPEARED!

AYE—SHE'S NOT REAL—!

HAHAHAHAHAHAHAHAHAHAHAHA!

THERE SHE IS AGAIN! 'TIS PEG POWLER, WHO KILLED HERSELF FOR LOVE OF A MAN, THEY SAY! NOW SHE HATES ALL MEN AND LURES THEM TO THEIR DEATHS! YOU'VE HAD A NARROW ESCAPE, SIR!

The END

I..I'M SORRY ABOUT THAT! I DIDN'T MEAN TO TEASE YOU—

JUST LEAVE ME ALONE! *PLENTY* OF REAL FEMININE FLOWERS EXIST JUST FOR THE PURPOSE OF WILTING UNDER THE SMILE OF THE RICH, HOLLYWOOD—

SEÑORITA LONIGAN!

SEÑOR GEEDINGS... HE SAY HE TIED UP FOR REST OF DAY! CAN NO MAKE IT FOR DATE!

EVE, LET ME SHOW YOU AROUND THE ISLAND... I'LL BEHAVE! I PROMISE! PLEASE—

"HOW I HATED THE WAY MY HEART LEAPED AT THE INVITATION! I GAVE AS CASUAL A 'YES' AS I COULD MUSTER...AND WE SET OFF. IT WAS AN ENCHANTING DAY, AND I DRANK DEEPLY OF THE PICTURE-BOOK SCENERY! AND, FINALLY...

WELL... THIS IS THE SUMMIT— EL YUNQUE! WHAT DO YOU THINK?

WONDERFUL! OH, LOOK! YOU CAN SEE THE BEACHES... PINEAPPLE AND SUGAR CANE FIELDS... COFFEE PLANTATIONS!

"MAYBE IT WAS THE 3000 FEET OF ALTITUDE... BUT THE WAY CHRIS LOOKED AT ME MADE ME FEEL TERRIBLY LIGHT-HEADED!

IT'S AN EDEN... A PARADISE I'D LIKE TO SHARE— WITH A CERTAIN EVE!

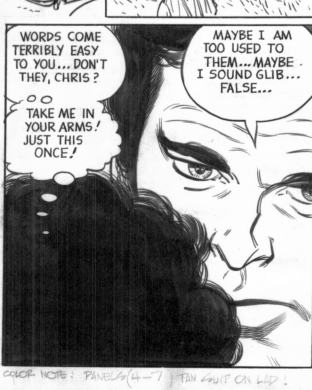

WORDS COME TERRIBLY EASY TO YOU... DON'T THEY, CHRIS?

TAKE ME IN YOUR ARMS! JUST THIS ONCE!

MAYBE I AM TOO USED TO THEM...MAYBE I SOUND GLIB... FALSE...

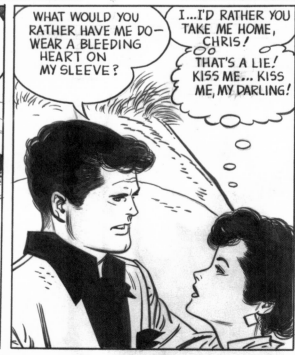

WHAT WOULD YOU RATHER HAVE ME DO— WEAR A BLEEDING HEART ON MY SLEEVE?

I...I'D RATHER YOU TAKE ME HOME, CHRIS!

THAT'S A LIE! KISS ME... KISS ME, MY DARLING!

"STRANGE, CONFLICTING EMOTIONS SURGED THROUGH ME WHEN CHRIS, SURPRIZINGLY, DROVE ME HOME! THAT UPSET MY IDEAS ABOUT MEN LIKE CHRIS ...BUT COMPLETELY! MAYBE GLAMOR BOYS WERE NOT NECESSARILY WOLVES AT ALL!

CHRIS CHRIS ? CHRIS CHRIS CHRIS CHRIS CHRIS

COLOR NOTE: PANELS (4-7) TAN SUIT ON LAD!

COMPLETELY

Gleason's line of comics, including the science fictional adventures of Hollywood's Flash Gordon, actor Buster Crabbe. He did a smattering of stories for Atlas, formerly known as Timely and later to become Marvel Comics. At St. John he turned in an installment of "Danny Dreams," a backup feature for Joe Kubert that appeared in *Tor* #3. Joe Kubert remembered the genesis of the "Danny Dreams" assignment, as well as his reactions upon seeing Alex's finished pages:

> I had a deal with the St. John Publishing Company, and we were producing these magazines, my buddy Norman [Maurer] and I. I had got in touch with a lot of the guys I knew to help me, and I approached Alex to do this particular job. And I was disappointed—I guess it was a mix of surprise and disappointment. Because I always felt size has a great deal to do with the impact of a drawing, and in all the time I'd been in the business, I was accustomed to seeing stuff large—and at that time, the originals were even larger than they are today! When this story came in, it was almost the size of the book itself. My first reaction was—and I still think I'm right—my first reaction was that Alex knew it was going to take him a helluva lot less time to do it that size than to do it full size. From that standpoint, it was a disappointment. However, as far as the storytelling and the artwork itself, it was still Alex Toth. I don't by any means mean to demean the stuff he did in terms of quality, it was just a surprise and disappointment to see the work in such a small kind of a venue, as opposed to what I was accustomed to seeing, that's all.

Alex's personal life was in upheaval at the time he left National. His marriage to Francesca became troubled, and in 1952 the couple decided to return to San Jose. In a letter written thirty years later, Alex recalled some of the more colorful moments of their drive across country:

> Hamburgers and coffee and ham 'n' eggs never tasted better than in those ol' mom 'n' pop joints. Southern fried chicken dinners in Georgia for three dollars at a lovely old place along the Lincoln Trail—"Y'all come back now, heah?" said the cashier. A road stop novelty stand with ten-inch high stylized statues of bride-&-grooms together in North Carolina which, as the giggling, fortyish saleslady pointed out while

it and give it to him. How long would that take? Five seconds.

"[Julie] refused to give it to him because [Alex] 'dared to enter the office of an editor at lunchtime.' Alex started to yell, Julie started to yell, and Julie fired him. Julie didn't have the guts to say that *he* fired him, not me. But people thought that [I had done the firing], since I created *Johnny Thunder*, which Alex drew."

Did Alex walk out on Schwartz or did Julie fire Toth? Did Alex verbally threaten to eject Julie from an office window? Did the choice of a next assignment have anything to do with the flare-up? Did Alex show up with completed artwork for a *Johnny Thunder* Western or (as some claim) an adventure featuring *Rex, the Wonder Dog*? The full details behind comics' *Rashomon* are forever lost to time—yet the bottom line is that when Alex stormed out of Julie Schwartz's office that day, he walked away from being one of the top artists at the top comic book company in America.

Of course, a star like Toth found new assignments at other publishers without difficulty. From 1952 through 1954 he produced material for publisher Lev

turning same in her hand, revealed the thing to be a sculptured penis/dildo. My young bride and I *both* blushed at *that*—didn't buy one, tho'! (Circa 1952)

The return to California agreed with Alex, but it was not enough to save the marriage: he and Francesca divorced, likely before the end of '52. At times, Alex must have felt he was living inside one of the many romance stories he was now producing for his major client, Standard Comics.

The Standard line began in 1939 as Nedor Comics, an amalgam of the given names of publishers *Ned* and *Dora* Pines. A decade later Nedor became Standard, with their new cover logo featuring a pennant (or "standard"), and this stable of titles continued for another seven years, ultimately collapsing in 1956. Standard dabbled in many genres, offering comic books devoted to horror (*Unseen, Adventures into Darkness*), cops and robbers (*Crime Files*), science fiction and fantasy (*Fantastic Worlds, Lost Worlds*), and combat (*This Is War, Battlefront, Jet Fighters*). Alex produced material for them all, yet his enduring legacy at Standard is his romance tales. The company offered readers a steady stream of hearts and flowers in titles like *Best Romance, My Real Love, New Romances, Intimate Love,* and *Thrilling Romances,* among others. In these pages Alex learned a whole new set of storytelling approaches that "quite changed my viewpoint—for keeps!" In fact, several knowledgeable fans consider Toth's Standard output the best work of his career.

Alex was suddenly focused on finding subtleties of gesture and expression to sell a story's emotional content, seeking fresh approaches to staging, pacing, and even lettering that would make a tale of love gone wrong as tense and exciting as any slam-bang adventure yarn. The depth of thought and effort that went into his romance output was reflected in a letter Alex wrote on March 11, 1978:

I was enthusiastic to try the [romance] form! Whereas adventure action pages were six to eight panels, romance could run nine panels or more, plus lots more dialogue and captions to contend with—so space-juggling became a fine art as time passed by!

My first decision re: space, layout, dialogue, and caption copy was to, experimentally, give all captions their own little vertical panels to keep caps *away* from the already top-heavy dialogue

crowding every panel—and then, I had to warm up those sterile cap panels with bits of artwork that either loosely or specifically connected with the continuity dramatics of the preceding and following panels, so all sorts of little symbols and motifs emerged of necessity.

I found the scripts of that time to be a cut above the gimmicky stuff of my superhero output. Thus, I welcomed illustrating somewhat more "realistic" situations, emotion-filled scenes, and learnt to "project" a bit more (than required by the writer) into a shot in order to make my point—subtlety came a bit later on, for me, at least!

I also discovered the fact that my girls left much to be desired—so I busily did all I could to patch up that gaping hole in my work, with moderately successful results! Now, with *that* done, how best could I draw them emoting their way through all sorts of tearful, crushed, victorious, coquettish, and wholesomely cute and "sexy" (careful!) scenes? Just pretty faces wouldn't do! It was tough, but worth it—for it forced me to study, to reach, to analyze, to open up and feel more, sense more from the writer's copy and intent, than I'd ever done before!

So—I looked at boy/girl art in the women's magazines with new eyes and came to fully appreciate the lovely, sensitive works of our great illustrators.... I set out to be more amenable an audience for the dreaded "women's movies" of the day, seeking them out so that I could see the how, why, and wherefore of responses of Bette Davis, Joan Crawford, Barbara Stanwyck, Katharine Hepburn, and company—all of which made me analyze and better interpret the pros and cons of dialogue—its delivery, shaded meanings, and its effect on its target. What did the eyes do during such readings? Or the mouth? Or the body? Or hands and arms? If seated, what would a woman do as she said a certain type of dialogue? If standing, how did body attitude enforce (or deny) those spoken words?

Storytelling techniques I'd never

SEELEY'S SAUCER

Every pilot and groundman in the air force had heard about Joe Seeley--he was the only Jet Jockey who had seen flying saucers, and rumor had it that he was "in his cups" or had "flipped his wig"!

THEY'LL THINK I'M NUTS IF I RE-PORT ANOTHER SAUCER ...

BUT I'M FOLLOWING THIS ONE ANYWAY!

FU-171

B-1440

A RADAR STATION IN NORTHERN CALIFORNIA...

WANT TO TAKE A LOOK AT THIS, LIEUTENANT? LONE OBJECT, VERY HIGH-- AND FAST!

WE HAVE NO FLIGHT PLANS FOR AIRCRAFT IN THAT AREA ...

UNIDENTIFIED AIRCRAFT IN AREA "X-RAY"-- SCRAMBLE!

NEVER FAILS! SOON AS I MAKE "BIG CASINO", THEY SCRAMBLE US FOR SOME FORMATION DRILL!

1

thought of before were now uppermost in my thoughts—and all of these tangential studies had, at their common center, the romance story!

The romances Toth enjoyed drawing most came from the typewriter of Kimball Aamodt. Kim was born February 4, 1921, in Overly, North Dakota. The son of Conrad and Maria Aamodt, Kim was the eldest of three children; brother Conrad Jr. was born in 1922, sister Carmen two years later. During his early twenties, Kim served as a pilot in the Pacific theater during the Second World War. His first known publication credits are text articles for *Chicken Farming Magazine* in the late 1940s. How Aamodt made the leap from poultry to comics is unknown (his family believes he originally moved to New York City to write for Marvel Comics during their so-called "Atlas Era"). What is known is that by 1951 he was working for Joe Simon and Jack Kirby and would also chalk up credits with Hillman and Atlas in addition to his Standard output, then moving into an editorial position at *Yachting* magazine after concluding his time in comics.

Alex praised Aamodt as "a marvelous writer who told a fine story…They were simple, well-structured stories, with very clever twists and turns and well-honed dialogue. He wrote visually. The characters' reactions are what made his story work. Subtle reactions. In his scripts, the characters' expressions were critically important to the dialogue—and there were lots of close-ups to 'plus' it with. That's what developed my bent for cueing facial expressions to dialogue…. Kim had a remarkable storytelling talent, and I worked hard to match it."

Alex's efforts were not going unnoticed. "Toth was doing the most beautiful romance stories for Standard Comics. Mike Peppe was inking him then, and it was the most staggering stuff. It was like movies on paper," said John Romita Sr., long-time art director for Marvel Comics and arguably that company's most popular *Spider-Man* artist. Romita is the best person to assess Toth's love story output, since prior to his success at Marvel, he made a living for eight years drawing romance comics at National.

In a twist of fate, the teenaged Romita had a job at a lithographic house in the same building that housed Standard. "I was working at 10 East 40th Street, where Standard Comics was," Romita said. "I think I was on the tenth floor and they were on the seventh or eighth floor, but I never tried to get any work with them. I was much too green at the time." Romita broke in with Atlas (he penciled the short-lived 1950s revival of *Captain America*) before moving to National. Once he started receiving romance assignments, Romita began examining the output of his predecessors in the genre, and Alex's work especially resonated.

"What he brought to it was such a glamour and such a dynamics. It was just amazing. I mean, the personalities on his people—the people he created were so real and so dimensional, I never got over it. His love stories were like a revelation to me, so I just started to

lean on him," Romita commented. "I started to do *everything* like Toth! I was doing his vertical captions, I was doing his hearts in the captions—everything he did, I was doing. They even had to slow me down from it—I was getting too carried away. If I could have done his style, I would have done it…. I had to do my own style, but I learned everything from him that I could. Let me tell you, it was invaluable." Romita summed up his appreciation for Toth by saying, "I think he was unmistakably a pioneer. After all the other pioneers had pooped out, he picked up the flag and started going up the hill again."

As was the case at National, Alex's Standard output was inked by other artists, primarily the company's art director, Mike Peppe. Getting his first break in the 1940s at the Jerry Iger shop, Peppe moved to Fiction House before going to work for Ned and Dora Pines, where editor Joe Archibald eventually gave Peppe art director duties in addition to his inking chores.

Comics historian Dewey Cassell has done a focused study of the inker and his oeuvre, even speaking with Mike Peppe's widow, Fern, and daughter Michele. Cassell cited Peppe's sensitivity to his pencilers as one of his greatest strengths. "Mike was able to adapt his style to whomever he was inking. If he was inking Toth, it looked like Toth, if he inked [penciler George] Tuska, it looked like Tuska. Later, he inked Steve Ditko on a couple issues of *The Creeper* and it's very nicely done and it looks like Ditko. That's one of the things I really appreciated about Mike. He tried to embellish the art, but not inflict his own approach onto it."

Peppe was well-liked and respected by his peers, as his daughter Michele told Cassell in 2006. She said, "Between Mike Sekowsky and Frank Giacoia, and of course George [Tuska] and Johnny Celardo and Alex [Toth], they were like a band of brothers, they were like family. I [also] have a lot of memories of Joe Archibald. My dad was a very conservative, reserved man, but when he was around his buddies he was the comedian. He was witty, with a great sense of timing. My father could do voice impersonations and tell jokes probably better than anybody."

Michele's mother, Fern Peppe, echoed her daughter's appraisal in a separate discussion with Cassell. "I have to think that I rubbed off on him, because I was very outgoing. When we were young, I used to feel that he was kind of introverted. Wherever I worked, when we had a Christmas party, he would say, 'I don't want to go,' and I would say, 'That's OK, honey. You stay home. I'm going.' That's all I had to say, then he was right there, and he was the life of the party. And he loved it. All the women I worked with thought, 'Oh, Mike Peppe. God, he's gorgeous.' Which he really was. He was a beautiful man."

Artist Jack Katz also drew for Standard and remembered Peppe for both his looks and his eye for the ladies: "Mike Peppe wasn't too tall. He was built beautifully, very good looking Italian type…. I'd go [to the Standard offices] and all they talked about was the women. Mike must have been in his thirties, watching the secretaries. He loved women."

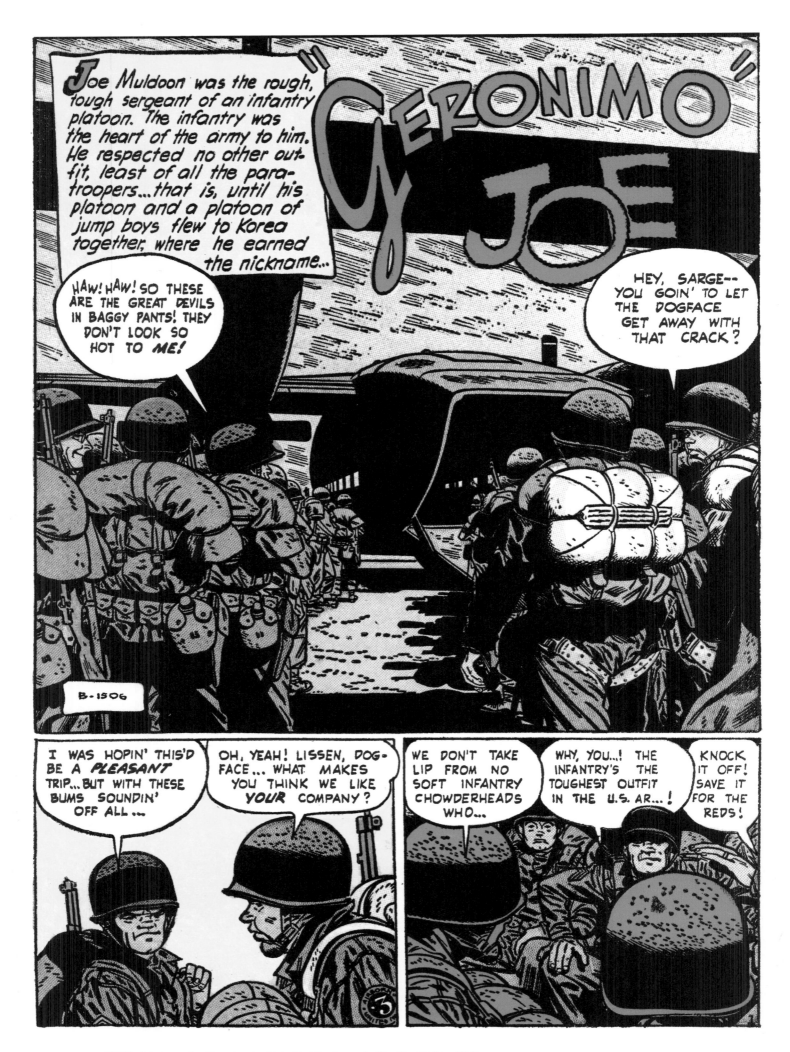

ABOVE: Splash page for "Geronimo Joe," inked by Mike Peppe, *Exciting War* #8 (May 1953).

OPPOSITE (clockwise from top left): Cover to *Fantastic Worlds* #6 (November 1952) and to *Lost Worlds* #6 (December 1952), both inked by Mike Peppe. When fellow Standard artists Ross Andru and Mike Esposito started their own publishing venture, they asked Toth to draw the cover for *3-D Romance* #1 (December 1953).

Whether being quiet or boisterous, Mike Peppe earned Alex's respect by his sensitive use of brush and pen, and by the way he encouraged his partner and friend to experiment and grow with each story. It was an effective and successful collaboration on practically every level, as Dewey Cassell noted: "During that time period, [Standard was] trying to cultivate a sort of 'house style,' and I think between Peppe's inks and Toth's pencils, that was sort of setting the standard—no pun intended—for what they were looking for. I'd heard that artists at Standard were encouraged to draw like Toth and ink like Peppe."

Cassell is also interested in debunking a modern theory that Toth was actually cool toward both Peppe and his inking. "That notion really runs contrary to everything that I heard," said Cassell. "In fact, Toth actually stayed at the Peppe home for a month or more when he was in between places to live—and when Toth finally went out to California and got involved in animation, he actually tried to get Mike to go with him! Mike's family and Fern's family were both from back East, and they just couldn't see picking up and taking off and doing that. But Mike could have ended up in animation, working alongside Toth."

Mike Esposito is one of the other artists who spent time at Standard and was a contemporary of both Toth and Peppe. Just as Peppe developed a professional relationship with Alex, Esposito was the "personal inker" for another highly regarded artist, Ross Andru. Contacted a year before his death for comments about the days at Standard Comics, Esposito shared his recollections of Mike Peppe: "Mike did a lot of work—he turned out pages like crazy! He had a gifted way, came up with a lot of short-cuts in the way he handled the inking. It was good stuff, it reproduced well. He was handling Toth. I don't think he handled that many other guys, it was basically Toth. And there weren't too many other pencilers up there he *wanted* to ink."

Though Ross Andru's sharp, angular style had little overlap with Alex's

more organic approach, the Andru/Esposito team was aware of and influenced by Toth's output during their Standard days. They first intersected in the pages of the war comic *Joe Yank*, for which Alex did occasional covers and interior stories. When Andru and Esposito developed their own *Joe Yank* assignments, they kept Alex's approach in mind.

Esposito said, "I remember 'Getting Lulu' was one story for *Joe Yank*, we gave it a lot of that Toth look, but not inked the way Toth would do it. I mean, Ross didn't design it completely that way, but he was influenced by it. Ross was very much affected [by Toth], and professionally was very high on Toth. Ross could never make the faces the way Toth did, the way to set the eyes right, the nose…when we did Superman, he always had a lantern jaw, and Wonder Woman always had 'buggy' eyes, because Ross was not a very good face man. Ross was very good on layouts, visuals—he could have been a movie director. But he didn't have an attractive face in his skills the way people like Johnny Romita, John Buscema, and Toth have."

Andru and Esposito eventually dabbled in publishing their own comics, attempting to add a new twist by bringing three-dimensional effects to romance comics. When they needed covers for *3-D Love* and *3-D Romance*, they turned to the best: Alex Toth. Intervening decades dimmed Mr. Esposito's recollection of specifics—they published only Toth's *3-D Romance* cover, though Esposito recalled both being drawn. He clearly remembered Ross Andru expressing some concerns about the finished artwork for both covers, however.

"Both those books had Toth covers. Ross was annoyed," Esposito remembered. "Ross saw things in depth, and Toth was very flat in his eye. I saw it as beautiful, the two best covers I ever saw on anything we published. Ross and I did the covers on other books, but they didn't come up to this stuff by Toth. *3-D Love* and *3-D Romance*, they were both Toth's covers, and they were beautiful. They were close-ups of the woman's face, with the guy kissing her. They were mighty good."

While Alex could not have foreseen it, he would soon be creating his own comics, just as Andru and Esposito were doing. Unlike Ross and Mike, however, Alex would do them while serving Uncle Sam.

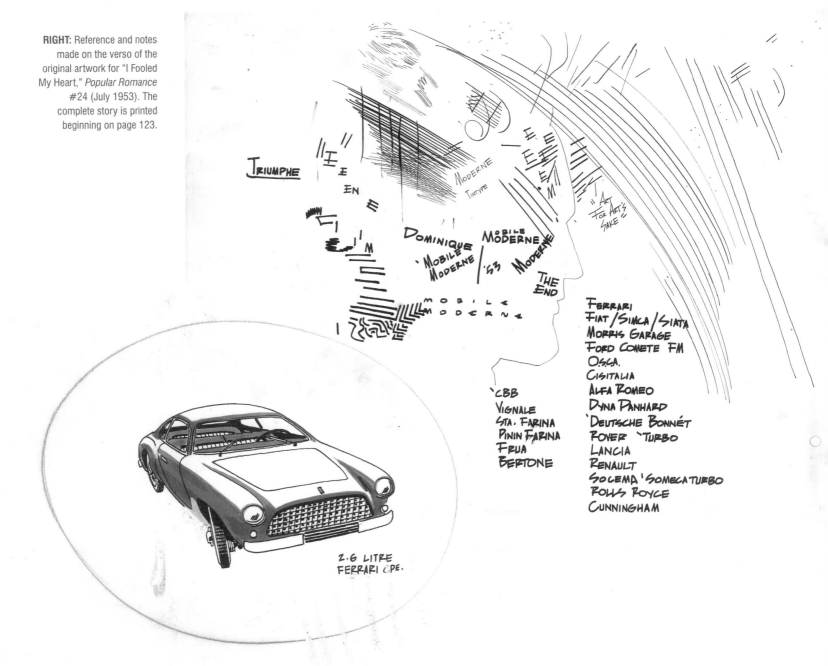

RIGHT: Reference and notes made on the verso of the original artwork for "I Fooled My Heart," *Popular Romance* #24 (July 1953). The complete story is printed beginning on page 123.

PAGES 108-113: "Unknown," an unfinished and previously unpublished story written and illustrated by Alex Toth in the 1950s. When he was shown photocopies of the story in 1973, Toth confirmed when the story was drawn, but offered no explanation why it wasn't published, or even completed. The UFO and alien abduction plot was a popular fictional theme in the 1950s. The art, he said, was "drawn on [the] reverse sides [of] page layouts for a Lev Gleason 'Buster Crabbe' book, for which I'd already done pencils, with inks by Peppe." This offers a clue to why the story wasn't completed. At the time Toth illustrated the Buster Crabbe tale, he had turned in his last job at Standard and was freelancing for Gleason and Atlas, doing crime and romance comics. There were no war or supernatural comics on his horizon. The closest he came to a war story was his imminent induction into the army, where he spent the next two years. This unfinished storyset languished in his files stateside until at some point he gave it away. What makes this story additionally interesting is that—about twenty years later—he recycled the plot as "Tibor Miko" in *Creepy* #77 (February 1976). He changed the First World War German ace to a U.S. pilot in 1928 flying a mail route from Flagstaff to Gallup. Did Toth resurrect the premise after being shown the photocopies in 1973? He made no secret of the difficulty he had writing, and so it seems likely, but there's no conclusive evidence. Regardless, this is a rare opportunity to see Toth's pencils in the 1950s and a fascinating look at his creative process. Two of his marginal drawings from the artboards are reproduced here, actual size.

1918, MARCH·· A YEAR OF WAR!! IN THE COLD GRAY GERMAN DAWN, FIVE BLOOD-RED FOKKERS WARM UP AS"

THREE DAYS OF SNOW·· TODAY WE FLY PATROL!! INTELLIGENCE REPORTS HEAVY BRITISH FIELD PIECES HAVE BEEN MOVED UP DURING THE LULL IN FIGHTING··

IT IS FOR US TO FIND THEM·· NUMBER, TYPE, LOCATIONS —

AND REPORT BACK WITH A FULL DATUM! CLEAR?

FINE! NOW ONE LAST COGNAC —

AHHH·· GOOD!

IT IS TIME·· LET'S GO!!

THE PILOTS OF FLÜGSTAFFEL NEUN FILE OUT INTO THE BITING COLD — TO CHECK THEIR PLANES WITH THEIR MECHANICS, SHOUT THEIR "AUF WIEDERSEHNS", SQUEEZING INTO THE NARROW COCKPITS, REV UP THE CACKLING ENGINES TO MAXIMUM, WAVE, AND IN SECONDS ARE BUMPING THEIR WAY DOWN THE ICED FIELD ··· LIFTING UP, AND INTO, THE BALEFUL GRAY SKIES ABOVE — THE OMINOUS, FOREBODING SKIES THAT HOLD UNKNOWN TERROR FOR THEIR PATROL INTO THE ··

ARTCOPY by ALEXANDER TOTH.

FLYING LOW OVER SNOW-COVERED, SHELL-RIPPED TERRAIN, FLIGHT-LEADER VON MUELLER SOON SEES THE TRENCHES OF THE GERMAN LINES AHEAD ···

HE ACKNOWLEDGES HIS COUNTRYMEN'S GREETINGS, DROPPING PACKAGES OF CIGARETTES AND TOBACCO ····

POOR DEVILS — I HOPE THESE LESSEN YOUR MISERIES··

1.

VON MUELLER'S PILOTS FOLLOW SUIT WITH THEIR GIFTS, AND REGROUP THEIR PLANES UP ABOVE...

A SWING TO THE NORTH ALONG ALLIED LINES REVEALS...

AS VON MUELLER'S PILOTS OBSERVE THE NEW GUNS...

A LARGE GROUP OF BRITISH "SOPWITHS" ATTACK THEM...

THE SKY IS FILLED WITH CHATTERING GUNS, TWISTING BURNING PLANES... THE RED FOKKERS, OUTNUMBERED, FIGHT A VALIANT BUT DESPERATE BATTLE AGAINST THE SPEEDY BRITISH FIGHTERS — THEN, A FOKKER BURNS...

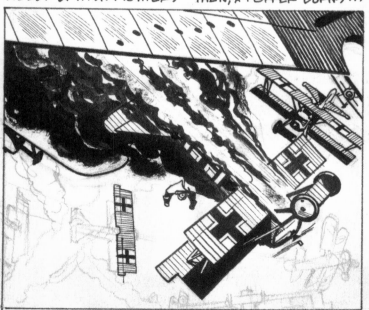

SCHMIDT FIRST — IN A MINUTE, HAUPTMANN !! FLIGHT LEADER VON MUELLER EVENS THE SCORE, KNOCKING DOWN TWO BRITISH PLANES — BUT TO NO AVAIL...

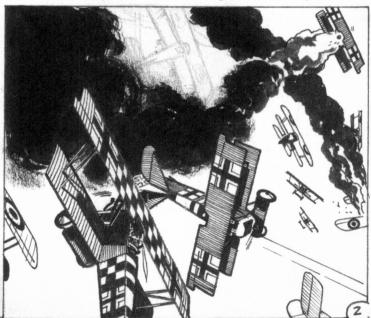

PAGES 115-122: "The Crushed Gardenia," published by Standard Comics in *Who Is Next?* #5 (January 1953). Although reprinted several times, this story—like "Battle Flag of the Foreign Legion" in 1950's *Danger Trail* #3 (see page 61)—is a watershed in Toth's career, and had a profound influence on nearly all of his contemporaries. It was *that* influential.

Even Toth, unceasingly critical of his own work, acknowledged its importance. "My drawing/storytelling/characterizations took a new road in this story—attitudinal sea change," he wrote in an annotation posted on the website *tothfans.com*. "[The] feel of it—low key, really—'til action demanded hotting-up—and design was used more agressively [sic]—so the work wasn't newsreel-literal—but had an abstract element in and out of its strung together continuity."

"This was, for me—a 'grabber,' scriptwise…. It just felt different, in the doing—to final inks!…. To me, marked something new and offbeat."

On a technical note, he explained, "I'd filed down a Speedball B-6 Flicker lettering pen nib, to not only letter—but ink—all of this storyset—I wanted a clean monotonous line—a dip pen nib gave it to me…."

The complete story is reproduced here from his original artwork so the rudimentary colors don't interfere with his penwork. The stories that follow represent the best of Toth's output at Standard, much of it reproduced from his original art boards.

JOHNNY FABER WAS MORE DANGEROUS THAN A COILED RATTLER, POISED TO STRIKE! THE SEEDS OF VIOLENCE AND DEATH RIDE IN HIS BRAIN! HE WAS BRANDED A KILLER, YET WALKED FREELY AMID HIS POTENTIAL VICTIMS! UNTIL — THE TRAGEDY OF...

the Crushed GARDENIA

I AM DR. PAUL CRANE, PSYCHIATRIST! I'M ABOUT TO PRESENT THE CASE HISTORY OF A KILLER, JOHNNY FABER — AND A QUESTION! COULD THE TRAGIC DEATH HE'D CAUSED HAVE BEEN PREVENTED? JUDGE FOR YOURSELF —

"JOHNNY CAME FROM A BACKGROUND OF POVERTY AND VIOLENCE! HE WAS MOLDED BY HIS ENVIRONMENT, BUT HE'D HAVE BECOME A KILLER NO MATTER WHAT HIS ECONOMIC AND SOCIAL LEVEL —

MIKE 'N' JOE'RE SWIMMIN' AT TH'OL' SETTLEMENT HOUSE GYM TONIGHT! HEAR IT AIN'T BAD AT ALL! WANNA GO?

NUTS! I GOT IDEAS ABOUT FUN, TOO·· 'N' IF Y'GUYS AIN'T CHICKEN, YOU'LL TAG ALONG!

WHA'D'YUH MEAN, JOHNNY?

THIS! BOUGHT IT FOR FIVE BUCKS, AN' I'M GOIN' T'EARN TH' MONEY BACK — IF Y'KNOW WHAT I MEAN —

A-A STICKUP? COUNT ME OUT!

ME, TOO!

AHHH! YOU'RE ALL YELLA! BUT THAT AIN'T GOIN' T' STOP ME FROM ACTIN'!

THAT GUY IS HEADIN' FOR BIG TROUBLE, BOYS!

YEAH, HE'S ODD! ONE MINUTE HE'S REAL QUIET — AN' TH' NEXT LOOKS LIKE HE COULD KILL YOU —!

SLAM

"LATER THAT NIGHT, JOHNNY STARTED OUT ON THE ROAD TO EASY MONEY — SO HE THOUGHT —

DRINK ZIP

WHAT IS IT, SON? YOU WANT SOMETHIN'?

YEAH—

BIG PRIZE

—YOUR MONEY!

DROP THAT GUN, PUNK! I'VE BEEN WATCHING YOU FOR TEN MINUTES! I FIGURED YOU'D TRY SOMETHIN' SOON!

THANKS, OFFICER BRUNE!

"JOHNNY WAS SENTENCED TO REFORM SCHOOL FOR EIGHTEEN MONTHS, AND ONE DAY, WHILE AT WORK —

OWWW! M-MY HAND!

GEE, I'M SORRY, JOHNNY! DIDN'T SEE YOUR HAND!

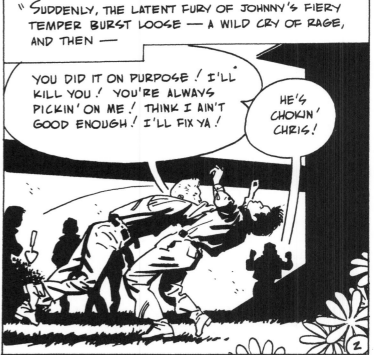

"SUDDENLY, THE LATENT FURY OF JOHNNY'S FIERY TEMPER BURST LOOSE — A WILD CRY OF RAGE, AND THEN —

YOU DID IT ON PURPOSE! I'LL KILL YOU! YOU'RE ALWAYS PICKIN' ON ME! THINK I AIN'T GOOD ENOUGH! I'LL FIX YA!

HE'S CHOKIN' CHRIS!

2

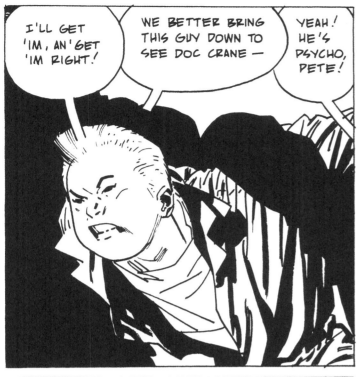

I'LL GET 'IM, AN' GET 'IM RIGHT!

WE BETTER BRING THIS GUY DOWN TO SEE DOC CRANE—

YEAH! HE'S PSYCHO, PETE!

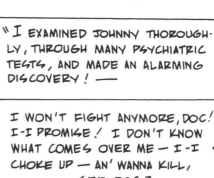

"I EXAMINED JOHNNY THOROUGHLY, THROUGH MANY PSYCHIATRIC TESTS, AND MADE AN ALARMING DISCOVERY!—

I WON'T FIGHT ANYMORE, DOC! I-I PROMISE! I DON'T KNOW WHAT COMES OVER ME—I-I CHOKE UP—AN' WANNA KILL, SEE, DOC?

WE'LL SEE, BOY, WE'LL SEE!—BETTER GET BACK TO YOUR GROUP..

THANKS, DOC—

"THE WARDEN AND I DISCUSSED JOHNNY AT LENGTH—

MY TESTS PROVE THAT JOHNNY'S A PARANOID—A POTENTIAL MURDERER, AND SHOULD RECEIVE PSYCHIATRIC TREATMENT!

NOW, DOC—THE BOY'S A HOTHEAD, I KNOW! WE'VE HAD HIS KIND BEFORE! HE'LL CALM DOWN—LOTS OF HARD WORK SHOULD FIX 'IM!

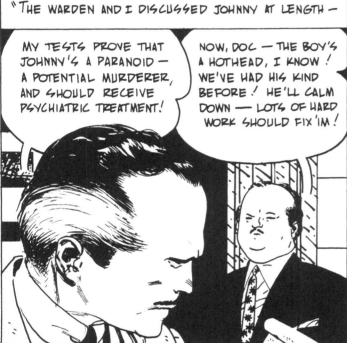

ALL RIGHT, WARDEN—I CAN'T FORCE TREATMENT ON FABER, NOR CAN I GUARANTEE THAT WE BOTH WON'T REGRET THIS, WHEN HE'S SPILLED INNOCENT BLOOD! THAT BOY'S A KILLER—FOR SURE!

DON'T LET IT WORRY YOU, DOC!

"AFTER BEING DISCIPLINED FOR FIGHTING, JOHNNY GAVE US NO MORE TROUBLE, AND WHEN FREED, GOT A JOB IN ANOTHER TOWN, WHERE HE WASN'T KNOWN, IN A GARAGE RUN BY A SAM TAYLOR—

ELLIE, DEAR—THIS IS A SURPRISE! I DIDN'T EXPECT TO SEE YOU HERE, THIS AFTERNOON!

JUST PASSING BY, DAD—AND THOUGHT I-I'D SAY—HELLO!

HAHA! ELLIE, YOU DIDN'T COME TO SEE ME—

DAD, YOU'RE AWFUL! MAY I SPEAK TO JOHNNY?

OF COURSE, ELLIE! GO AHEAD!

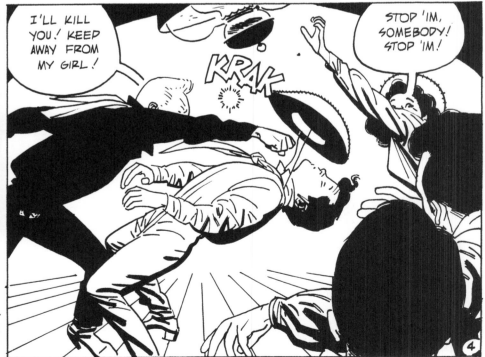

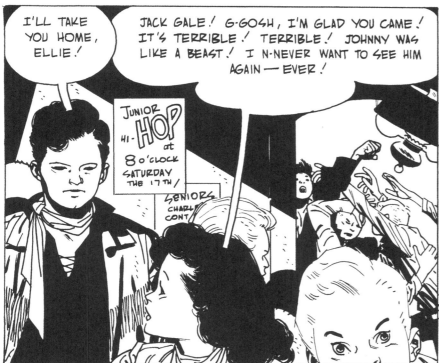

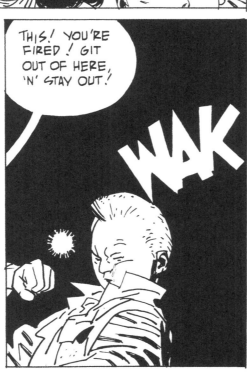

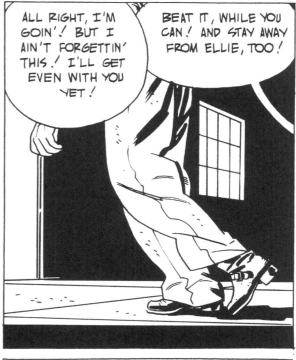

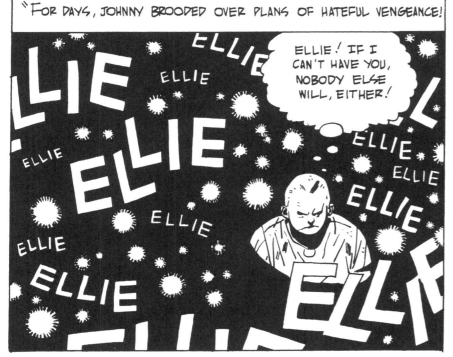

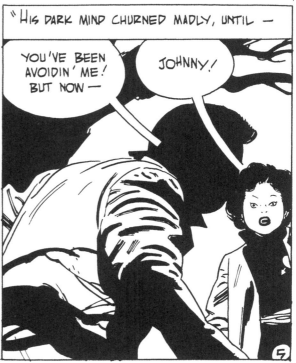

LET ME, ALONE!

WHY—YOU LITTLE··

HELP! HELP!

I'LL NEVER LET YOU GET AWAY FROM ME! NEVER! DO Y' HEAR ME?

"ELLIE REACHED HOME···HYSTERICAL, THOROUGHLY FRIGHTENED BY JOHNNY!

POLICE? SAM TAYLOR, 23 LEE! I WANT JOHNNY FABER ARRESTED, RIGHT AWAY—

POOR JOHNNY!

"ON SAM'S CHARGE, JOHNNY WAS PICKED UP FOR QUESTIONING, BUT—

NOW LOOK HERE, YOUNG FELLA, YOU STAY AWAY FROM THAT GIRL, OR WE'LL THROW THE BOOK AT YOU! YOU'RE LUCKY YOU GOT OFF WITH A SUSPENDED SENTENCE!

YES, I KNOW, SIR! GUESS I WAS A BIT TIPSY! CAN'T SEE HOW I COULD HAVE DONE IT— GUESS I REALLY FRIGHTENED ELLIE, POOR KID!

ALL RIGHT! BEAT IT—AN' STAY OUT OF TROUBLE!

YES SIR!

YOU JERKS WILL SEE BIG DOIN'S, NOW!

"JOHNNY SEEMED TO CALM DOWN AGAIN— HE TOOK A JOB IN A LOCAL FACTORY, AND LEFT ELLIE ALONE—BUT ONE NIGHT, AS SHE AND JACK GALE, WERE WALKING HOME FROM A MOVIE DATE—

WHAT'S WRONG, ELLIE? YOU KEEP STARING BACK, OVER YOUR SHOULDER!

I MAY BE WRONG, JACK— BUT I THINK SOMEONE'S FOLLOWING US—I JUST SAW HIM SLIP BEHIND A TREE BACK THERE!

THINK I'LL CHECK!

JACK— PLEASE BE CAREFUL!

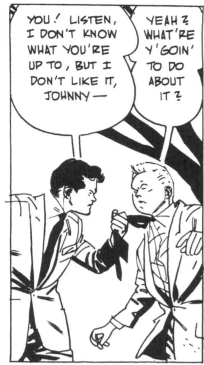

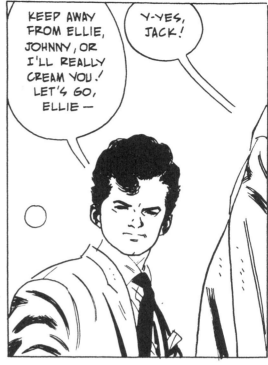

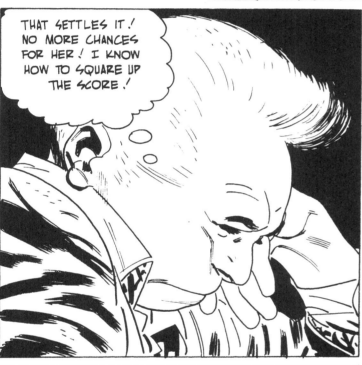

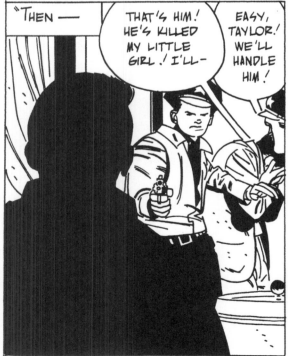

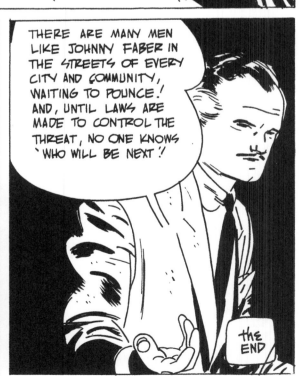

⑦ PAGE LOVE
R-790 -1
BETRAYAL OF
LOVE

Logo— STANDARD

9. Deep

My Heart

Silver Printed

13 ALEXANDER TOTH,
14050 WOODHAVEN DRIVE
SAN JOSE, CALIFORNIA

FM1

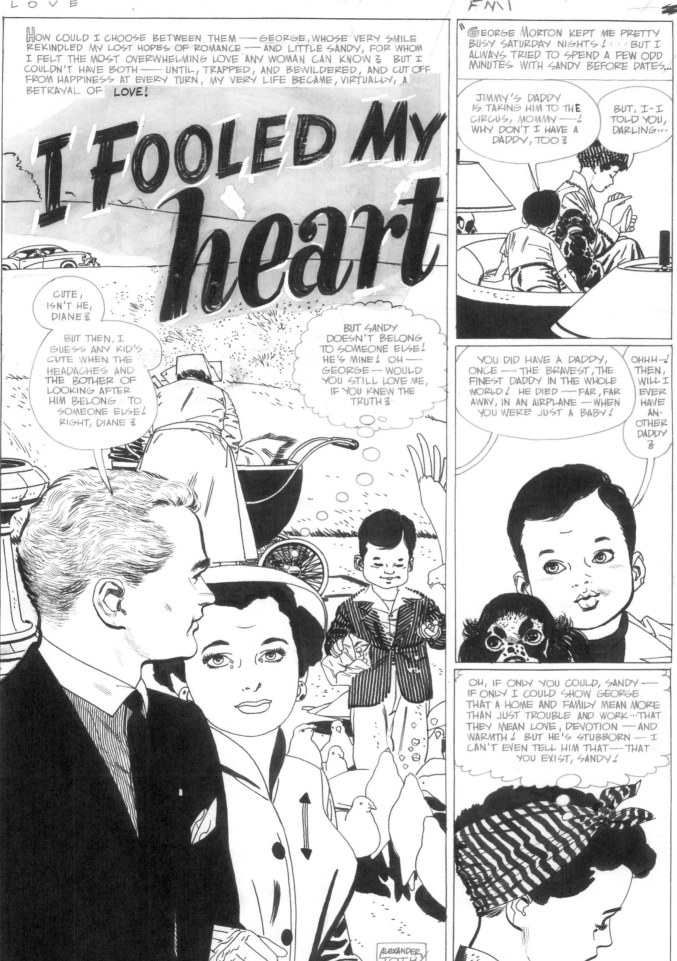

PAGES 123-129: The original artwork for "I Fooled My Heart," *Popular Romance* #24 (July 1953).

GENIUS, ISOLATED 123

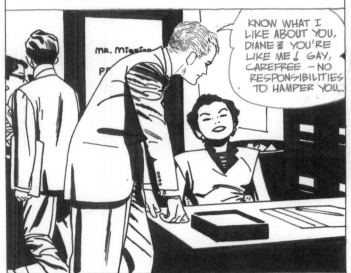

"YES, I HAD STUPIDLY CAUSED THIS HEARTACHE, BY CONCEALING SANDY, MONTHS AGO, WHEN GEORGE AND I WERE JUST FRIENDS. AND NOW, IT WAS TOO LATE FOR THE TRUTH! FOR EARLIER THAT VERY WEEK—

KNOW WHAT I LIKE ABOUT YOU, DIANE? YOU'RE LIKE ME! GAY, CAREFREE—NO RESPONSIBILITIES TO HAMPER YOU...

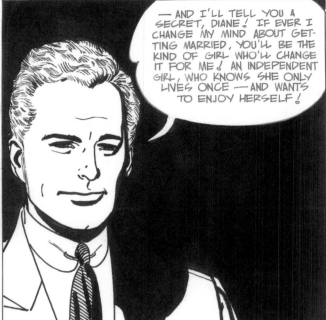

—AND I'LL TELL YOU A SECRET, DIANE! IF EVER I CHANGE MY MIND ABOUT GETTING MARRIED, YOU'LL BE THE KIND OF GIRL WHO'LL CHANGE IT FOR ME! AN INDEPENDENT GIRL, WHO KNOWS SHE ONLY LIVES ONCE—AND WANTS TO ENJOY HERSELF!

NONE OF THIS GETTING TIED DOWN—TO A HOUSE AND A FAMILY! FOR US!

US—? NO, GEORGE—ONLY YOU! I'M TIED DOWN, NOW, MORE THAN I'VE EVER DARED LET YOU KNOW!

"NO WONDER THEN, I COULDN'T ANSWER SANDY'S QUESTION!—

WELL, WILL I, MOMMY? WILL I GET ANOTHER DADDY?

HUSH, DARLING! IT'S BEDTIME... PUT AWAY YOUR BALL—AND I'LL CALL LOU!

MR. MORTON'S DUE HERE IN A HALF-HOUR, LOU! SO, IF YOU'LL ATTEND TO SANDY—!

I KNOW—! A QUICK BATH, AND RIGHT TO BED—TUCKED AWAY FROM SIGHT LIKE YESTERDAY'S NEWSPAPER!

IT'S NONE O' MY AFFAIR, I KNOW, MA'AM—BUT YOU CAN'T GO ON DENYING YOUR OWN FLESH 'N' BLOOD! MR. MORTON SHOULD KNOW ABOUT SANDY!

PLEASE, LOU—! I—I HAVE TO DRESS NOW!

"AND A HALF-HOUR LATER—

YOU GOING AWAY TONIGHT, MOMMY?

YES, DEAR! I—OH, I HEAR HIS CAR NOW! LOU—HURRY! CLOSE THE DOOR!

HELLO, DARLING! I SEE YOU'VE BEEN PLAYING BALL AGAIN!

WHAT? OH! THE BALL! DON'T BE SILLY—YOU KNOW IT'S ONE OF THE PUP'S TOYS, GEORGE! WELL—SHALL WE GO?

POPULAR ROMANCE

"BUT SOMEHOW, BEING WITH GEORGE THAT NIGHT WAS NOT AS MUCH FUN AS USUAL!

I WONDER IF SANDY GOT TO SLEEP ALL RIGHT — I OUGHT TO FIND THE TIME TO TAKE HIM TO THE CIRCUS! OH, WHAT IF LOU IS RIGHT — ?

WHY SO QUIET, DIANE? WHAT'S WRONG?

OH — N-NOT A THING!

MUST BE SOMETHING! JUST TELL OL' UNCLE GEORGE! YOU KNOW HE LOVES YOU TOO MUCH TO SEE YOU TROUBLED!

TELL HIM — THAT I'M WORRIED ABOUT THE SON HE'S NEVER EVEN HEARD ABOUT? IF ONLY I — BUT HE'D NEVER WANT TO SEE ME AGAIN!

IT'S JUST A HEADACHE, REALLY! LET'S GO HOME!

"AND AN HOUR LATER —

... YES, HE DOZED OFF, AFTER A WHILE! CRIED SOME, BUT I MANAGED TO QUIET HIM, POOR DEAR!

I'M EVERYTHING HE'S GOT — AND THE WAY I'VE LET HIM DOWN! I'LL TAKE HIM TO LUNCH, ONE DAY NEXT WEEK!

"SO, THE FOLLOWING WEDNESDAY —

— THEN I'LL BRING 'IM DOWNTOWN RIGHT NOW! YOU CAN MEET US AT NOON AND TAKE HIM TO LUNCH ... I'LL PICK HIM UP AGAIN AT 2:30!

FINE!

I'M AFRAID I'LL HAVE TO TAKE A FEW HOURS OFF THIS AFTERNOON, GEORGE! THAT WAS MY DENTIST! HE — HE THINKS HE CAN SEE ME TODAY, AND HE'S SO BUSY, I DON'T DARE REFUSE!

"GEORGE SWALLOWED MY LIE!

WHY NOT, WHEN HE HADN'T THE FAINTEST INKLING OF THE TRUTH? GEORGE PLANNED ON LUNCH IN THE OFFICE, SO MY SECRET WAS SAFE UNTIL FATE STEPPED IN...

I'LL SAVE TH' CHOC'LATE FOR LAST, BECAUSE IT'S THE BEST!

GEORGE! WHAT ARE YOU DOING HERE?

HI — IT'S SUCH A BEAUTIFUL DAY I THOUGHT I'D GET A LITTLE AIR — BUT WEREN'T YOU GOING TO THE DENTIST?

THIS IS SANDY — MY NEIGHBOR'S CHILD! HE HAD A TOOTHACHE, SO I AGREED TO TAKE HIM ALONG WITH ME! WE WERE JUST LEAVING... IT'S ONLY A SHORT WALK THROUGH THE PARK —!

GREAT! I'LL WALK ALONG WITH YOU!

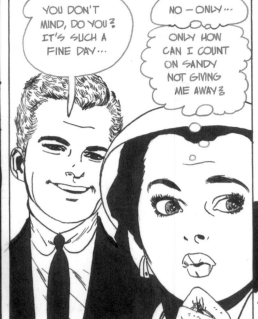

YOU DON'T MIND, DO YOU? IT'S SUCH A FINE DAY...

NO — ONLY...

ONLY HOW CAN I COUNT ON SANDY NOT GIVING ME AWAY?

I'LL NEVER FORGET THAT WALK AS LONG AS I LIVE! SANDY, GEORGE AND I...JUST AS I'D DREAMED OF FOR MONTHS —! ONLY NOW, A NAGGING FEAR OF HAVING THE TRUTH COME OUT TURNED MY DREAM INTO A NIGHTMARE!

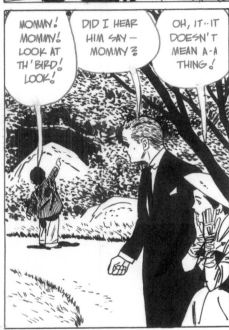

MOMMY! MOMMY! LOOK AT TH' BIRD! LOOK!

DID I HEAR HIM SAY — MOMMY?

OH, IT...IT DOESN'T MEAN A-A THING!

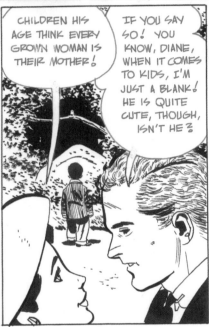

CHILDREN HIS AGE THINK EVERY GROWN WOMAN IS THEIR MOTHER!

IF YOU SAY SO! YOU KNOW, DIANE, WHEN IT COMES TO KIDS, I'M JUST A BLANK! HE IS QUITE CUTE, THOUGH, ISN'T HE?

WAIT, SANDY! I'LL GIVE YOU A BOOST!

AND MY HEART SKIPPED A BEAT AT THE SIGHT — MY SON, IN GEORGE'S ARMS!

THEY'RE GETTING ALONG SO NICELY! MAYBE - IT COULD WORK, AFTER ALL! MAYBE, NOW THAT GEORGE KNOWS AND LIKES SANDY, I COULD TELL HIM THE TRUTH —!

WELL, I'D BETTER BE GETTING BACK TO WORK! 'BYE, SANDY! THANKS FOR LETTING ME WALK WITH YOU! 'BYE, DIANE —!

G'BYE!

WHO'S THAT NICE MAN, MOMMY? IS THAT THE MAN WHO TAKES YOU OUT ALL THE TIME?

HUSH, DARLING! WE'VE GOT TO HURRY! LOU 'LL BE WONDERING WHAT HAPPENED TO US!

POPULAR ROMANCE

"BUT IT WASN'T ON LOU'S ACCOUNT THAT I HURRIED — BUT ON MY OWN! I JUST COULDN'T WAIT TO GET BACK TO GEORGE!

WELL, YOU AND SANDY CERTAINLY HIT IT OFF! HE NEVER STOPPED TALKING ABOUT YOU —

IS THAT RIGHT? HE'S A SWEET KID!

BUT I GUESS ANY KID IS SWEET, WHEN HIS CARE AND FEEDING ARE SOMEONE ELSE'S HEADACHE! I STILL LIKE THE 'FREE AND EASY LIFE'!

BUT SANDY ISN'T SOMEONE ELSE'S HEADACHE — HE'S MINE! AND MY HEARTACHE, TOO!

OH, IT WAS SO EASY TO LIE — AT THE BEGINNING... WHEN ALL GEORGE AND I WANTED OF EACH OTHER WAS AN EVENING OF FUN AND CHATTER! BUT NOW—? HOW IS IT ALL GOING TO END —?

"I TRIED TO TALK ABOUT SANDY WHENEVER I COULD, AFTER THAT! BUT GEORGE WASN'T EVEN MILDLY INTERESTED! BUT THEN, A MONTH LATER —

I HATE TO LET YOU GO, DARLING — BUT TOMORROW'S ANOTHER WORKING DAY! SO, GOODNIGHT, DIANE...

'NIGHT!

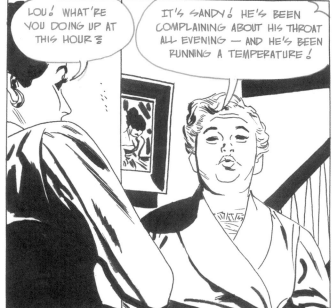

LOU! WHAT'RE YOU DOING UP AT THIS HOUR?

IT'S SANDY! HE'S BEEN COMPLAINING ABOUT HIS THROAT ALL EVENING — AND HE'S BEEN RUNNING A TEMPERATURE!

SANDY! AND ALL THIS TIME, I WAS LAUGHING... DANCING — AND PRETENDING HE'D NEVER BEEN BORN!

I CALLED THE DOCTOR! HE GAVE SANDY A SEDATIVE —TO MAKE HIM SLEEP! SAID HE'D BE BACK — IN THE MORNING!

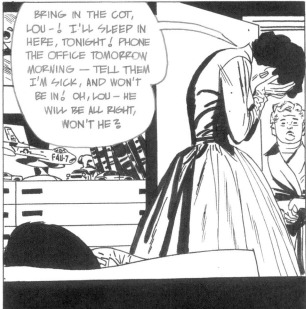

BRING IN THE COT, LOU —! I'LL SLEEP IN HERE, TONIGHT! PHONE THE OFFICE TOMORROW MORNING — TELL THEM I'M SICK, AND WON'T BE IN! OH, LOU — HE WILL BE ALL RIGHT, WON'T HE?

"BUT THE DAYS PASSED —DAYS WHEN I NEVER MOVED FROM SANDY'S BEDSIDE... HIS CONDITION DIDN'T IMPROVE! GEORGE CALLED REPEATEDLY TO ASK ABOUT ME AND 'MY HEALTH' — BUT I WOULDN'T TAKE TIME FROM MY BOY TO TALK TO HIM!

5.

SILVER PRINTED

18**7**.

R-790 -6
BETRAYAL

"UNTIL, A WEEK LATER —

IT SEEMS TO BE ONE OF THOSE TIRELESSLY STUBBORN, VIRUS INFECTIONS! AND FRANKLY, THE BEST PLACE FOR HIM RIGHT NOW, WOULD BE A HOSPITAL! I'LL CALL —

HOSPITAL?

THERE, THERE! THE DOCTOR IS RIGHT! THEY'LL LOOK AFTER HIM BETTER THAN WE EVER COULD! YOU REST — I'LL TAKE HIM THERE MY —!

NO — NO, I WILL! OH, SANDY — I'VE FAILED YOU SO MISERABLY? .. BUT YOU'VE GOT TO BE ALL RIGHT — SO I CAN MAKE IT ALL UP TO YOU, FOREVER!

"I CAN STILL REMEMBER THAT LONG, AGONIZING TRIP.. WITH SANDY'S WARM HEAD IN MY ARMS! DID I EVER THINK OF GEORGE, IN THOSE FEAR-FILLED HOURS? IF I DID, IT WAS WITH RESENTMENT AND HATE — BECAUSE OF HIM, I'D IGNORED MY GREATEST DUTY, AND MY GREATEST LOVE! MAYBE THAT'S WHY I WAS SHOCKED, WHEN SHORTLY AFTER REACHING THE COUNTY HOSPITAL —

SCREEEEEECHHHHHHHH.....

GEORGE! WHAT ARE YOU DOING HERE?

I PHONED YOU FROM THE OFFICE! WHEN I WAS TOLD YOU'D GONE TO THE HOSPITAL, I RUSHED RIGHT OVER —!

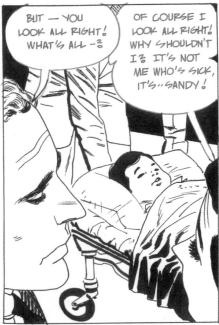

BUT — YOU LOOK ALL RIGHT! WHAT'S ALL —?

OF COURSE I LOOK ALL RIGHT! WHY SHOULDN'T I? IT'S NOT ME WHO'S SICK, IT'S .. SANDY!

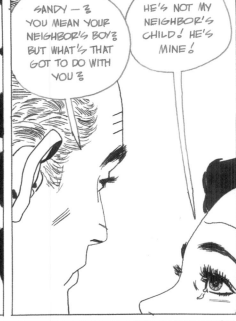

SANDY — ? YOU MEAN YOUR NEIGHBOR'S BOY? BUT WHAT'S THAT GOT TO DO WITH YOU?

HE'S NOT MY NEIGHBOR'S CHILD! HE'S MINE!

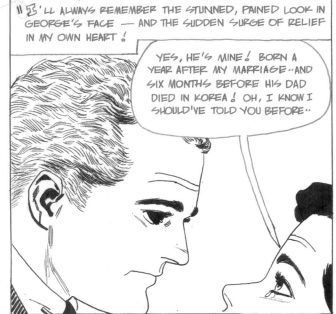

"I'LL ALWAYS REMEMBER THE STUNNED, PAINED LOOK IN GEORGE'S FACE — AND THE SUDDEN SURGE OF RELIEF IN MY OWN HEART!

YES, HE'S MINE! BORN A YEAR AFTER MY MARRIAGE .. AND SIX MONTHS BEFORE HIS DAD DIED IN KOREA! OH, I KNOW I SHOULD'VE TOLD YOU BEFORE ..

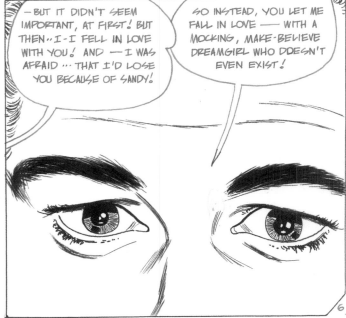

— BUT IT DIDN'T SEEM IMPORTANT, AT FIRST! BUT THEN .. I - I FELL IN LOVE WITH YOU! AND — I WAS AFRAID THAT I'D LOSE YOU BECAUSE OF SANDY!

SO INSTEAD, YOU LET ME FALL IN LOVE — WITH A MOCKING, MAKE-BELIEVE DREAMGIRL WHO DOESN'T EVEN EXIST!

6

POPULAR ROMANCE

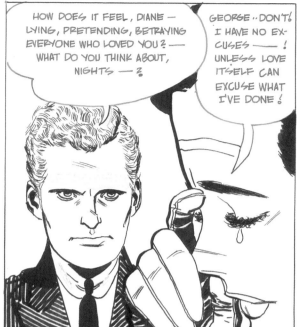

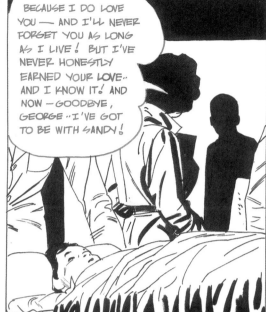

POPULAR ROMANCE

ALICE IN TERRORLAND

Was the looking glass of Alice in Wonderland just a fable, told by a gentle dreamer in a bygone age? Or was it as real and coldly scientific as a high voltage detector, or an air traffic control system? Only Richard Young and his two children knew how strange and frightening the answer could be -- for they alone found the lost world of...

HOMEWARD BOUND, RICHARD YOUNG PAUSES A MOMENT TO PONDER...

HMMMMMM-- I'VE GOT TO BUY ALICE A BIRTHDAY PRESENT THAT WILL PLEASE FREDDY, TOO... OR HE'LL FEEL SLIGHTED!

VARIETY TOYS

SALE

GREAT SCOTT! THOSE LITTLE DOLLS ARE CHARACTERS STRAIGHT OUT OF ALICE IN WONDERLAND! THEY'RE IN GOOD CONDITION, TOO!

In this Style 10/6

THESE TOYS DON'T SEEM TO BE LISTED IN OUR INVENTORY! BUT THEN-- WE GET SO MANY TOYS WE LOSE TRACK OF A FEW! THEY ARE UNUSUAL, AREN'T THEY?

I'LL SAY THEY ARE! THAT LOOKING GLASS GOES WITH THE SET, I SUPPOSE!

PAGES 130-134: The original artwork for "Alice in Terrorland," inked by John Celardo, *Lost Worlds* #5 (October 1952).

GOT 'EM FOR A SONG! IMAGINE! THE WONDERFUL LEWIS CARROLL CHARACTERS SO DEAR TO CHILDREN EVERYWHERE!

PAR HABLA ESPAÑOL

AT THAT VERY MOMENT, AT RICHARD YOUNG'S HOME...

POP SAYS IF TOYS COST TOO MUCH THEY'RE NOT REAL TOYS! WHAT DOES HE MEAN BY THAT?

MOM SAYS IT'S REALLY BECAUSE HE'S WORRIED ABOUT MONEY! HE WANTS TO SAVE MONEY TO SEND US THROUGH COLLEGE WHEN WE GROW UP!

EREKTO

AW— OTHER KIDS GET NEW TOYS ALL THE TIME!

YOU SHOULDN'T TALK LIKE THAT! HE'S THE BEST DADDY IN ALL THE WORLD!

HE WANTS ME TO BE AN INVENTOR-- JUST LIKE HE IS! BUT HE WON'T EVEN BUY ME A NEW ERECTO SET!

FREDDY! LOOK! IT'S DADDY! HE'S GOT A PRESENT FOR US!

HELLO, KIDS! TAKE A LOOK AT THE MAD HATTER! HE CAME STRAIGHT FROM THE OTHER SIDE OF THE LOOKING GLASS!

AWW! THEY'RE ONLY DOLLS! GIRL'S TOYS!

IT'S THE MOCK TURTLE! OH, DADDY--

I BROUGHT THOSE TOYS FOR YOU TOO, SON! YOU SEE, THEY'RE NOT JUST DOLLS-- BUT LIFELIKE MECHANICAL FIGURES MADE TO LOOK LIKE ALICE IN WONDERLAND CHARACTERS!

OH, DADDY, YOU'RE WONDERFUL!

ALICE CAN HAVE THEM! I DON'T WANT TO PLAY WITH THEM! I LIKE TO BUILD THINGS!

BUT THAT NIGHT...

FREDDY! WHAT'RE YOU DOING?

I'M GOING TO TAKE THE DOLLS DOWNSTAIRS TO POP'S WORKSHOP! HE SAID THEY'RE MECHANICAL! MUST HAVE WIRES 'N' THINGS INSIDE!

LET THEM ALONE! THEY'RE MINE!

AWWW, GO BACK TO BED! I'VE GOT A RIGHT TO USE POP'S TOOLS IF I WANT TO!

2

SOON... SHE STOPPED MAKIN' A FUSS WHEN I SAID I'D TELL MOM ABOUT THE COOKIE JAR! GIRLS ARE A PAIN...

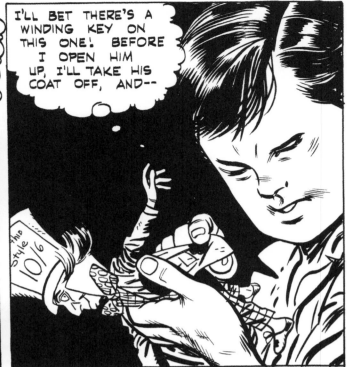

I'LL BET THERE'S A WINDING KEY ON THIS ONE! BEFORE I OPEN HIM UP, I'LL TAKE HIS COAT OFF, AND--

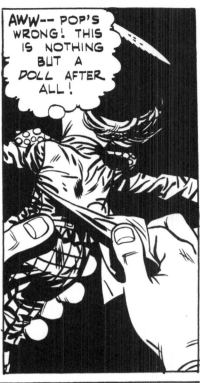

AWW-- POP'S WRONG! THIS IS NOTHING BUT A DOLL AFTER ALL!

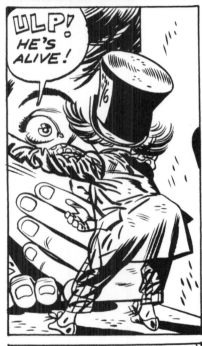

ULP! HE'S ALIVE!

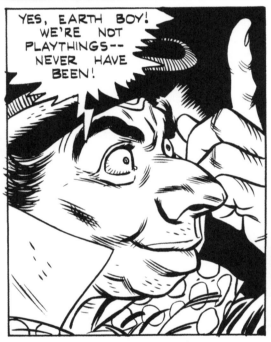

YES, EARTH BOY! WE'RE NOT PLAYTHINGS-- NEVER HAVE BEEN!

I-- I THOUGHT ALICE IN WONDERLAND WAS JUST A STORY! POP SAID IT WAS WRITTEN BY AN INVENTOR LIKE HIMSELF!

LEWIS CARROLL WASN'T AN INVENTOR, EARTH BOY! HE WAS A GENTLE FOOLISH MAN WHO TAUGHT MATHEMATICS TO EARTH MEN LONG DEAD!

WE VISITED EARTH BEFORE WE MET ANOTHER ALICE AS FOOLISH AS YOUR SISTER! WE BEGGED HER TO COME WITH US TO OUR WORLD OF BEAUTY AND WONDER! BUT WHEN WE SHOWED HER OUR WORLD ON A SCREEN SHE RAN SCREAMING FROM US!

THE EARTH MAN, CARROLL, BELIEVED HER, AND WROTE A BOOK WHICH WAS SILLY, TOO! LOOK, BOY, THAT ISN'T REALLY A LOOKING GLACE! IT'S A SPACESHIP! WE'RE SCIENTISTS IN OUR OWN WORLD, WHICH LIES IN ANOTHER SPACE DIMENSION!

WITH YOUR FATHER'S TOOLS, WE'LL REPAIR THE SHIP AND RETURN TO OUR WORLD! COME WITH US, BOY! WE HAVE THE POWER TO MAKE YOU SMALL! IN OUR WORLD YOU'LL BE FREE TO BUILD WONDERFUL MECHANICAL THINGS! IF YOU WANT, WE'LL TAKE YOUR SISTER TOO--!

SEE! WITHIN OUR SHIP, BEHOLD OUR OWN WORLD MIRRORED!

NO, LET ME ALONE! I DON'T WANT TO GO WITH YOU!

COME BACK, YOU LITTLE FOOL-- OR I SHALL BE FORCED TO USE THIS WEAPON!

I'LL TELL MY FATHER! HE-HE DOESN'T KNOW WHAT YOU ARE!

A BLINDING FLASH OF LIGHT--AND AN ALIEN WEAPON OF SCIENCE COMES INTO PLAY!

POP! HELLLLP!! OHHHHHH!

IT'S *FREDY!* SCREAMING!

DADDY, DADDY! FREDDY'S DOWN IN THE CELLAR SCREAMING FOR HELP...

GOOD GRIEF! STAY HERE, ALICE!

MEANWHILE... OUR PURPOSE WAS TO SEIZE AND STUDY AN EARTH CHILD IN OUR LABO-RATORY AT ZIS! WE'VE HAD A SET-BACK, BUT HE SHALL BE OURS IF WE KEEP THE BEAM TRAINED UPON HIM UNTIL WE ARE READY TO DEPART!

MAKE HASTE! WE MUST REPAIR THE SPACESHIP WITH THE TOOLS WE HAVE HERE! THEY ARE EXCELLENT TOOLS! THE BOY'S FATHER IS A GREAT SCIENTIST!

IT WAS YOUR STUPID NAVIGA-TIONAL BLUNDER WHICH SET FIRE TO THAT TOYSHOP! IF WE HAD EMERGED FROM OUR SPACE DIMENSION IN AN OPEN FIELD THE SHIP WOULDN'T HAVE BEEN WRECKED!

SUDDENLY...

FREDDY! WHAT'S GOING ON HERE, SON?

THE HAND'S of Don José

DON JOSÉ SEVILLE WAS THE GREATEST MATADOR IN ALL OF SPAIN, FAMOUS FOR HIS QUICK, AGILE HANDS, WHICH HAD SLAIN 200 BULLS... BUT WHEN HE MET THE BEAUTIFUL SEÑORITA ISABELLA MORENO, STRANGE THINGS BEGAN TO HAPPEN... DEADLY THINGS...

AT THE BULL RING IN BARCELONA, SPAIN...

Today SPAIN'S GREATEST MATADOR DON JOSÉ SEVILLE
HIS REMARKABLE HANDS HAVE SLAIN 200 BULLS!
PAR

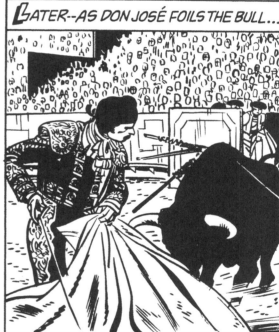

LATER--AS DON JOSÉ FOILS THE BULL...

AND IN AN OFFICIAL'S BOX...

ARE YOU ENJOYING THE FIGHT, MY DEAR ISABELLA?

SI, GENERAL MARTINEZ!

PAGES 135-142: The original artwork for "The Hands of Don José," inked by Mike Peppe, *Adventures Into Darkness* #9 (April 1953).

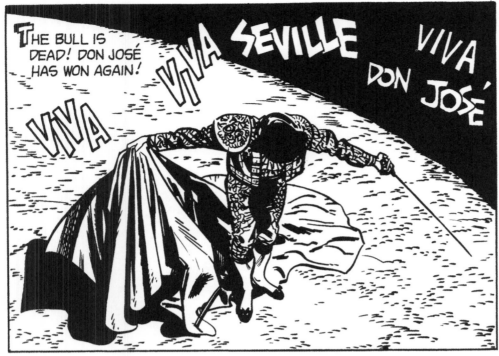

THE BULL IS DEAD! DON JOSÉ HAS WON AGAIN!

VIVA SEVILLE VIVA VIVA DON JOSÉ VIVA DON JOSÉ

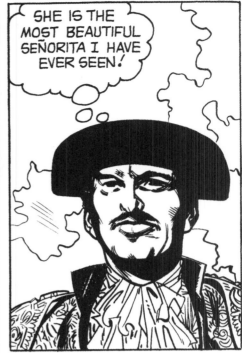

SHE IS THE MOST BEAUTIFUL SEÑORITA I HAVE EVER SEEN!

CUTTING OFF THE BULL'S EARS, DON JOSÉ THROWS THEM UP TO SEÑORITA ISABELLA -- THE GREATEST HONOR A MATADOR CAN GIVE...

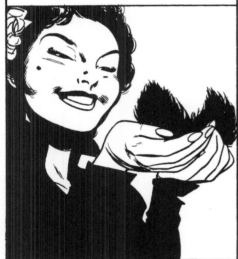

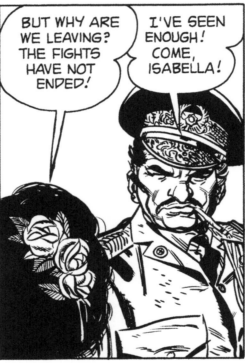

BUT WHY ARE WE LEAVING? THE FIGHTS HAVE NOT ENDED!

I'VE SEEN ENOUGH! COME, ISABELLA!

I MAY NEVER SEE THE LOVELY SEÑORITA, AGAIN!

DAYS LATER, IN DON JOSÉ'S HOTEL ROOM...

A LETTER, DON JOSÉ!

MANY THANKS, AMIGO!

Don José Seville... I am the one to whom you threw the Bull's ears! I must see you immediately. It is urgent! Please come!! My address is...

Prado y Santo Tomas No. 17

Señorita Isabella

2

ONE HOUR LATER...

WHAT IS TROUBLING YOU, SEÑORITA?

GENERAL MARTINEZ! HE WANTS ME TO MARRY HIM! I *HATE* HIM! HE'S CRUEL--

BUT HOW CAN *I* HELP YOU?

TODAY'S NEWSPAPER! IT SAYS YOU LEAVE FOR MEXICO NEXT WEEK! TAKE ME WITH YOU!

PLEASE! *PLEASE!* TAKE ME WITH YOU!! THIS IS MY ONE CHANCE TO BE FREE OF THAT TYRANT!

YES -- I SEE! ALL RIGHT! I'LL TAKE YOU TO MEXICO CITY WITH ME!

GOOD *EVENING*, ISABELLA!

AND WHAT A SURPRISE -- THE GREAT DON JOSÉ SEVILLE! I AM HONORED, SEÑOR!

C-CONRADO!

TELL ME, DON JOSÉ -- HOW DOES IT FEEL TO BE OUT IN THE PLAZA DE TOROS WITH A MAD BULL?

I-I NEVER GAVE IT MUCH THOUGHT, GENERAL!

DID HE HEAR US? I WONDER...

IT IS GROWING LATE! I MUST BE LEAVING NOW! GOOD NIGHT, SEÑORITA, IT HAS BEEN-- *MOST* PLEASANT!

WAIT, DON JOSÉ! *I AM LEAVING, TOO!* MY CHAUFFEUR WILL DROP YOU OFF AT YOUR HOTEL! GOOD NIGHT, ISABELLA!

NEXT DAY, A PACKAGE ARRIVES FOR ISABELLA...

AHHHHHHHHHHHHHH!

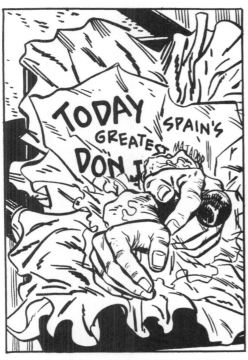

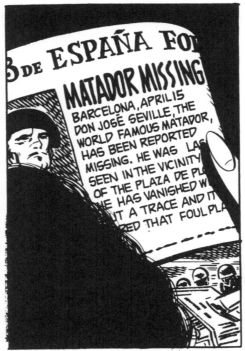

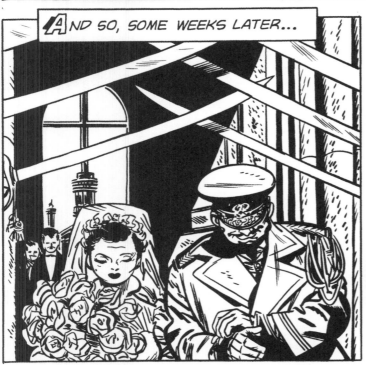

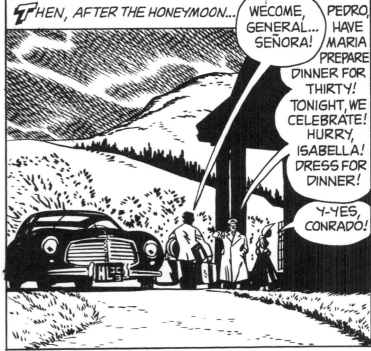

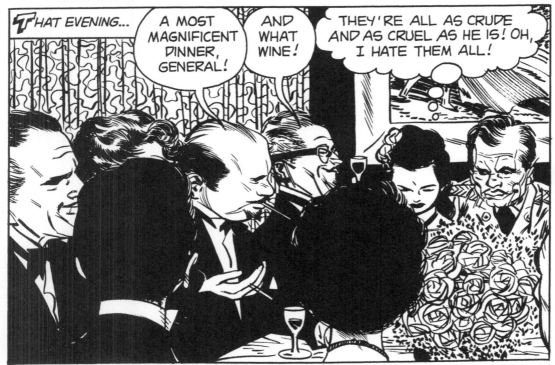

THOSE SCREAMS! -- FROM THE GENERAL'S ROOM!!

DIOS MIO!! HE -- HE LOOKS AS IF HE'S BEEN MANGLED AND GORED TO DEATH -- BY A *BULL*!!

I CANNOT UNDERSTAND IT, PEDRO! H- HOW COULD TH- THIS HAPPEN?

I-I DON'T KNOW! HE WAS SO GAY -- TOMORROW HE WAS TO BE *GUEST OF HONOR* AT THE *DON JOSÉ MEMORIAL FIGHT*!!

The End

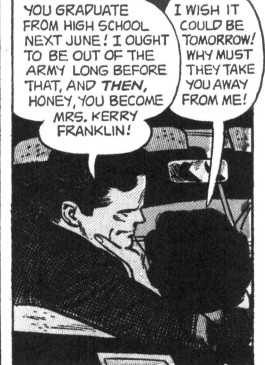

PAGES 143-152: "Free My Heart," inked by Mike Peppe, *Popular Romance* #23 (April 1953).

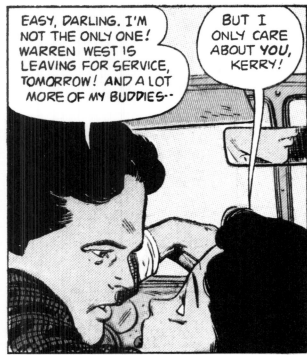

EASY, DARLING. I'M NOT THE ONLY ONE! WARREN WEST IS LEAVING FOR SERVICE, TOMORROW! AND A LOT MORE OF MY BUDDIES--

BUT I ONLY CARE ABOUT *YOU*, KERRY!

DON'T THINK IT'S EASY FOR ME TO LEAVE YOU, EITHER, MARCIA! BUT IT'S LATE--ONE MORE KISS GOOD NIGHT?

"WE KISSED IN A WAY THAT SAID, 'I'LL WAIT FOREVER ...I LOVE ONLY YOU!' AND THEN HE WAS GONE...

"TIME DRAGGED BY SLOWLY... WITHOUT KERRY. BUT I WROTE HIM EVERY SINGLE DAY...

"KERRY WROTE ME OFTEN, TOO--AND I TREASURED EACH WORD, RE-READ THE LETTERS COUNTLESS TIMES. FOR ALMOST A YEAR, I KNEW KERRY ONLY THROUGH HIS LETTERS AND A FEW WEEK-END LEAVES. THEN HE WAS COMING HOME FOR A *WHOLE THIRTY-DAY FURLOUGH*!

"MEETING HIM AT THE STATION...

KERRY, DARLING! AND, WARREN--YOU'RE HOME, TOO!

HI, MARCIA!

COME ON, KID--IT'S OUR TIME TO HOWL! WE'RE GOING TO MAKE THIS A MONTH TO REMEMBER!

OH, YES, KERRY! THERE'S SO MUCH LOST TIME TO MAKE UP FOR!

JOIN US, WARREN? I'D LIKE TO GRAB A SODA AT THE OL' CAMPUS SHOPPE FIRST THING!

THANKS! I'D LIKE TO!

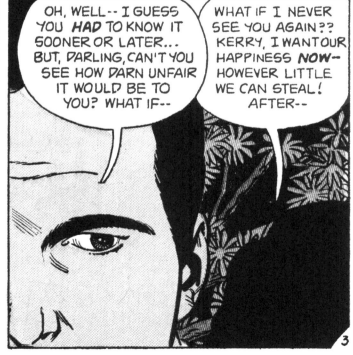

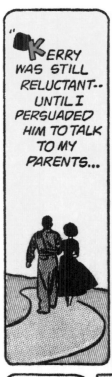

"KERRY WAS STILL RELUCTANT-- UNTIL I PERSUADED HIM TO TALK TO MY PARENTS...

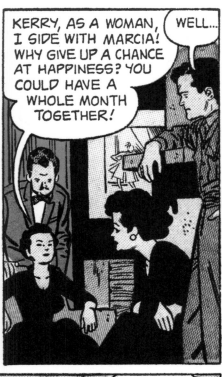

KERRY, AS A WOMAN, I SIDE WITH MARCIA! WHY GIVE UP A CHANCE AT HAPPINESS? YOU COULD HAVE A WHOLE MONTH TOGETHER!

WELL...

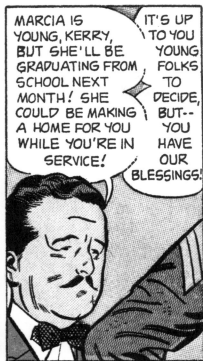

MARCIA IS YOUNG, KERRY, BUT SHE'LL BE GRADUATING FROM SCHOOL NEXT MONTH! SHE COULD BE MAKING A HOME FOR YOU WHILE YOU'RE IN SERVICE!

IT'S UP TO YOU YOUNG FOLKS TO DECIDE, BUT-- YOU HAVE OUR BLESSINGS!

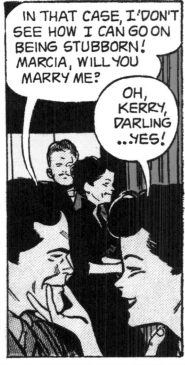

IN THAT CASE, I DON'T SEE HOW I CAN GO ON BEING STUBBORN! MARCIA, WILL YOU MARRY ME?

OH, KERRY, DARLING ...YES!

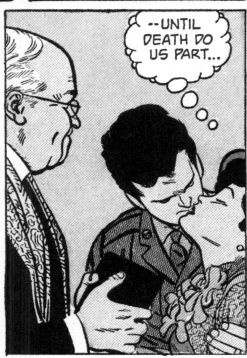

"WE WERE MARRIED MAY 19, 1951. IT WAS JUST A SMALL WEDDING... MY FOLKS, KERRY'S ...WITH WARREN ACTING AS BEST MAN...

--UNTIL DEATH DO US PART...

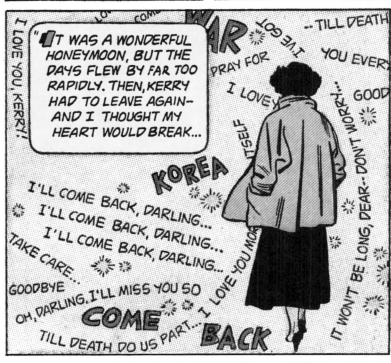

"IT WAS A WONDERFUL HONEYMOON, BUT THE DAYS FLEW BY FAR TOO RAPIDLY. THEN, KERRY HAD TO LEAVE AGAIN-- AND I THOUGHT MY HEART WOULD BREAK...

I LOVE YOU, KERRY!

KOREA

I'LL COME BACK, DARLING...
I'LL COME BACK, DARLING...
I'LL COME BACK, DARLING...
TAKE CARE...
GOODBYE
OH, DARLING, I'LL MISS YOU SO
TILL DEATH DO US PART... I LOVE YOU MORE

COME BACK

WAR

PRAY FOR
I LOVE
--TILL DEATH
YOU EVERY
I'VE GOT
GOOD
IT WON'T BE LONG, DEAR--DON'T WORRY...

don't mother... again... you remember what... promised you. You've been gone more than a month now... it's a little bit easier to be brave. School is over with... and I've landed a salesgirl position at Drury's ...ment Store... and

YOU'VE ONLY BEEN HERE A WEEK, MRS. FRANKLIN, BUT YOU'VE ALREADY SET A NEW HIGH IN READY-TO-WEAR SALES-- KEEP IT UP!

THANK YOU, MISS JARVIS!

ASS'T SUPER OFFICE

MISS ADELE JAR

"I FOUND AN APARTMENT THAT I HOPED TO TRANSFORM INTO A HOME FOR MYSELF AND KERRY...

IT'S SMALL, MOTHER, BUT I CAN REALLY FIX IT UP. WITH MY SALARY AND THE ALLOTMENT CHECK, I CAN MAKE OUT JUST FINE!

"THEN ONE DAY I GOT SOME NEWS FROM DR. PETERS...

ARE YOU HAPPY ABOUT IT, DEAR? OR SORRY?

I-- OF COURSE I'M HAPPY, MOM! AFTER ALL, IT'S KERRY'S BABY -- IT'LL BE ALMOST LIKE HAVING A BIT OF *HIM* HERE!

IT'S ONLY THAT I'LL HAVE TO GIVE UP MY JOB SOON -- STOP DECORATING THE APARTMENT. I WAS IN LINE FOR A PROMOTION AT DRURY'S, TOO...

...OH, KERRY, AM I MATURE ENOUGH, STRONG ENOUGH TO BEAR THIS ALONE?

"IT WAS HARD..SKIMPING ALONG ON JUST MY ARMY ALLOTMENT ALL THOSE MONTHS. BUT I'D HELD OUT SO LONG...THE BABY WAS DUE SOON...

M-MOTHER, I-I THINK... I THINK YOU'D BETTER COME RIGHT OVER! C-CALL DR. PETERS!

"MOTHER STAYED WITH ME THROUGH IT ALL. THEY TELL ME I CALLED FOR KERRY OVER AND OVER AGAIN! AND THEN, FOR THE FIRST TIME, I SAW HIM!

WARD

"KERRY FRANKLIN, JR." LITTLE KERRY, YOU'LL HAVE TO BE THE MAN OF THE HOUSE UNTIL DADDY COMES HOME...

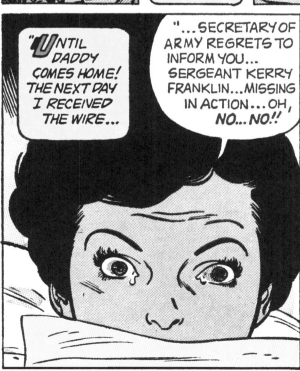

"UNTIL DADDY COMES HOME! THE NEXT DAY I RECEIVED THE WIRE...

"...SECRETARY OF ARMY REGRETS TO INFORM YOU... SERGEANT KERRY FRANKLIN...MISSING IN ACTION...OH, NO...NO!!

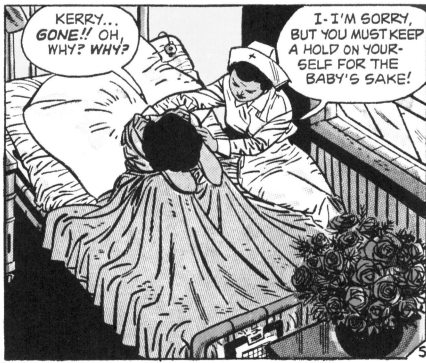

KERRY... GONE!! OH, WHY? WHY?

I-I'M SORRY, BUT YOU MUST KEEP A HOLD ON YOUR-SELF FOR THE BABY'S SAKE!

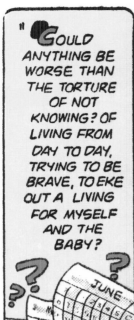

LOOK, I KNOW I'M NO KERRY, MARCIA-- BUT MAYBE IF I JUST DROPPED IN OCCASIONALLY-- JUST TO MAKE YOU FEEL THERE'S A MAN AROUND THE HOUSE--

WOULD YOU, WARREN? I'VE BEEN SO LONELY... I'D LIKE IT SO MUCH!

"I'D BEEN SO LONELY! WHAT HAPPENS TO A LONELY WOMAN WHEN A MAN COMES CALLING?

'EVENING, BEAUTIFUL! BROUGHT YOU SOME POSIES TONIGHT!

YOU'RE A DEAR. SIT DOWN -- I'VE GOT DINNER ALMOST READY!

IT'S ALMOST LIKE HAVING A HUSBAND COMING HOME TO DINNER THESE NIGHTS. AND HE'S LIKE A FATHER TO LITTLE KERRY...

"MOTHER UNDERSTOOD HOW IT WAS. SHE BABY-SAT FOR ME ONE NIGHT WHILE WARREN TOOK ME TO DINNER...

STILL PINING FOR KERRY, MARCIA?

YES. I'LL NEVER BE ABLE TO STOP THAT. BUT--

"BUT I KEPT THINKING THAT KERRY AND I HAD HAD SO LITTLE TIME TOGETHER. WE NEVER HAD THE CHANCE TO DATE LIKE MAN AND WIFE -- TO LIVE IN OUR OWN PLACE WITH THE BABY- LIKE A REAL FAMILY...

YOU MUST KNOW WHAT YOU MEAN TO ME -- YOU AND THE BABY. AFTER ALL I'VE BEEN THROUGH, THIS QUIET, SORT OF FAMILY LIFE IS LIKE HEAVEN!

YOU'VE HAD MORE OF THAT LIFE THAN KERRY HAD, WARREN! COMING HOME FOR DINNER, PLAYING WITH THE BABY. THAT SORT OF THING!

MARCIA, LET'S FACE THE TRUTH! IT'S BEEN NEARLY TWO MONTHS! SOONER OR LATER, YOU'LL GET THAT FINAL TELEGRAM!

I GUESS I WILL! I THINK I'VE RESIGNED MYSELF TO THAT!

THEN, MARCIA-- WHEN IT COMES, WHEN YOU KNOW FOR SURE, WILL YOU LET ME BE A REAL HUSBAND AND FATHER? WILL YOU MARRY ME THEN, DARLING?

I--WHAT CAN I SAY? WHEN I KNOW FOR SURE...

...YES--THEN I- I'LL MARRY YOU, WARREN!

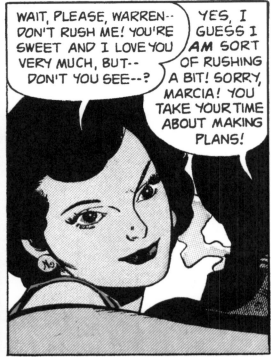

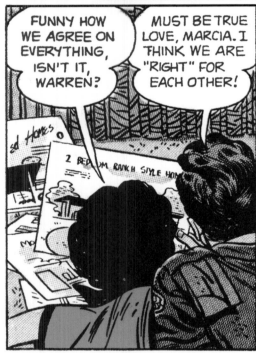

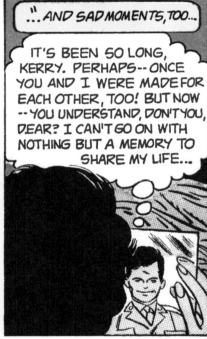

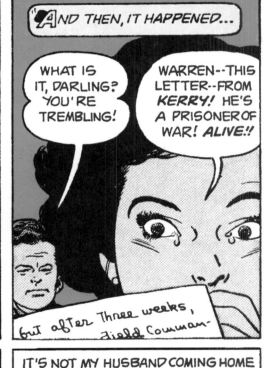

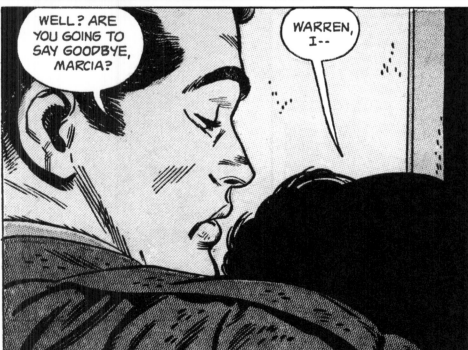

WHILE, WARREN--I KNOW HIM, I LOVE HIM, AND SO DOES KERRY, JR.! I NEED HIM, THE PROTECTION, THE SECURITY OF A MAN! AND WARREN IS HERE -- WHILE IT MAY TAKE YEARS BEFORE KERRY IS FREE!

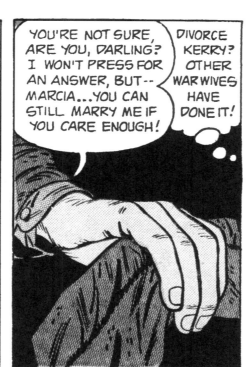

YOU'RE NOT SURE, ARE YOU, DARLING? I WON'T PRESS FOR AN ANSWER, BUT-- MARCIA...YOU CAN STILL MARRY ME IF YOU CARE ENOUGH!

DIVORCE KERRY? OTHER WAR WIVES HAVE DONE IT!

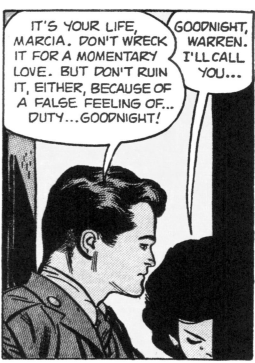

IT'S YOUR LIFE, MARCIA. DON'T WRECK IT FOR A MOMENTARY LOVE. BUT DON'T RUIN IT, EITHER, BECAUSE OF A FALSE FEELING OF... DUTY...GOODNIGHT!

GOODNIGHT, WARREN. I'LL CALL YOU...

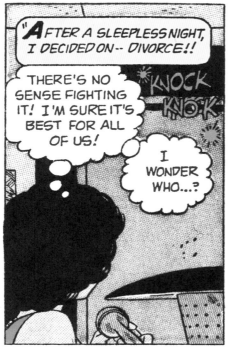

"THAT NIGHT WAS FILLED WITH BEWILDERING THOUGHTS FOR ME. KERRY HAD BECOME A STRANGER! DID HE STILL LOVE ME? DID I WANT HIM? WARREN, SO RELIABLE, CLOSE, FAMILIAR... HE'D BE A GOOD HUSBAND, AND A DEVOTED FATHER TO MY BABY! WOULDN'T THAT BE BEST FOR HIM?

"AFTER A SLEEPLESS NIGHT, I DECIDED ON-- DIVORCE!!"

THERE'S NO SENSE FIGHTING IT! I'M SURE IT'S BEST FOR ALL OF US!

I WONDER WHO...?

KNOCK KNOCK

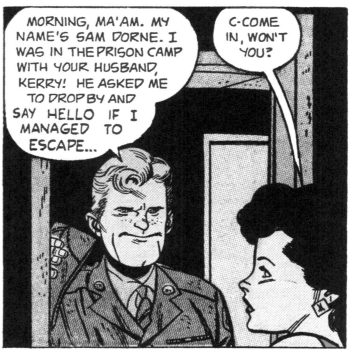

MORNING, MA'AM. MY NAME'S SAM DORNE. I WAS IN THE PRISON CAMP WITH YOUR HUSBAND, KERRY! HE ASKED ME TO DROP BY AND SAY HELLO IF I MANAGED TO ESCAPE...

C-COME IN, WON'T YOU?

I WAS SUPPOSED TO CHEER YOU UP, MRS. FRANKLIN. 'FRAID I'M NOT MUCH OF AN EXPERT ON CHEER, THOUGH!

TELL ME ABOUT IT, CORPORAL ...WAS IT VERY BAD?

OVER THERE? IT WAS MISERABLE--STILL IS FOR GUYS LIKE KERRY, WHO'RE STILL PRISONERS! BUT HE KNOWS HE'LL COME OUT SOMEDAY, AND HE'LL COME BACK TO...

TO WHAT, SAM?

...TO A FAITHFUL WIFE, A HAPPY HOME! WE'RE NOT ALL THAT LUCKY, MA'AM!

WH-WHAT'S WRONG? YOU SOUND SORRY TO BE BACK HOME!

WELL, MAYBE I AM...A *LITTLE*! I CAME BACK TO FIND MY WIFE *DIVORCING* ME, MRS. FRANKLIN! SHE'S GOING TO MARRY A BOY WHO STAYED AT *HOME*!

OH...

CAN'T BLAME HER *TOO* MUCH! WE ONLY HAD A WEEK BEFORE I SHIPPED OUT! SHE GOT LONELY AND WENT OUT ON A COUPLE OF DATES WITH THIS FELLOW. NATURAL SHE FELL FOR HIM, I GUESS...

BUT, YOU SEE-- SHE DIDN'T GIVE *OUR* MARRIAGE A CHANCE...IF SHE'D WAITED, SHE MIGHT'VE FOUND OUT THAT SHE LOVED *ME* MORE THAN SHE CAN EVER LOVE THIS *OTHER* GUY!

PERHAPS... PERHAPS A GIRL WHO'D *FAIL* YOU LIKE THAT WASN'T *WORTH* YOUR LOVE IN THE *FIRST* PLACE!

THAT'S WHAT I KEEP *TRYING* TO TELL MYSELF, MA'AM, BUT IT'S *HARD* TO COME HOME AND FIND YOUR *HOPES*, YOUR LIFE GONE... *DESTROYED*-- MA'AM? YOU'RE CRYING!

"*WHEN* SAM DORNE HAD GONE, I CALLED WARREN AND ASKED HIM TO COME OVER...

...AND THAT'S THE ENTIRE STORY, WARREN! I THANKED GOD THAT THAT POOR SOLDIER CAME WHEN HE DID... AND SHOWED ME WHAT A WEAK, SELFISH FOOL I'VE BEEN...

...I NEVER GAVE KERRY *OR* OUR MARRIAGE A CHANCE! I WAS ALONE, SO I FOOLISHLY GRASPED AT THE FIRST THING THAT REMINDED ME OF THE WAY I WANTED MY MARRIAGE TO BE!

I'VE LOVED YOU DEEPLY UP TILL NOW, MARCIA, BUT I LOVE YOU EVEN *MORE* FOR THIS DECISION. I- I COULDN'T HAVE EVER RESPECTED YOU COMPLETELY, IF YOU'D HAVE DROPPED KERRY WITHOUT GIVING HIM HIS TURN AT BAT.'

THANKS, WARREN, FOR TAKING IT THAT WAY!

I'LL ALWAYS LOVE YOU--AS A VERY DEAR FRIEND! THIS IS GOODBYE, WARREN...

GOODBYE, MARCIA. I HOPE SOMEDAY, SOMEHOW, I'LL FIND A WIFE AS WONDERFUL... AS FAITHFUL AS KERRY'S!

"*AND* THEN, I KNEW EVERYTHING WAS GOING TO BE FINE... JUST FINE!"

LITTLE KERRY, DARLING-- I'VE GOT NEWS FOR YOU! YES! DADDY'S COMING HOME! AND WE'LL BE RIGHT HERE, WAITING FOR HIM, WON'T WE? BOTH OF US-- HIS WIFE AND HIS SON!

The End

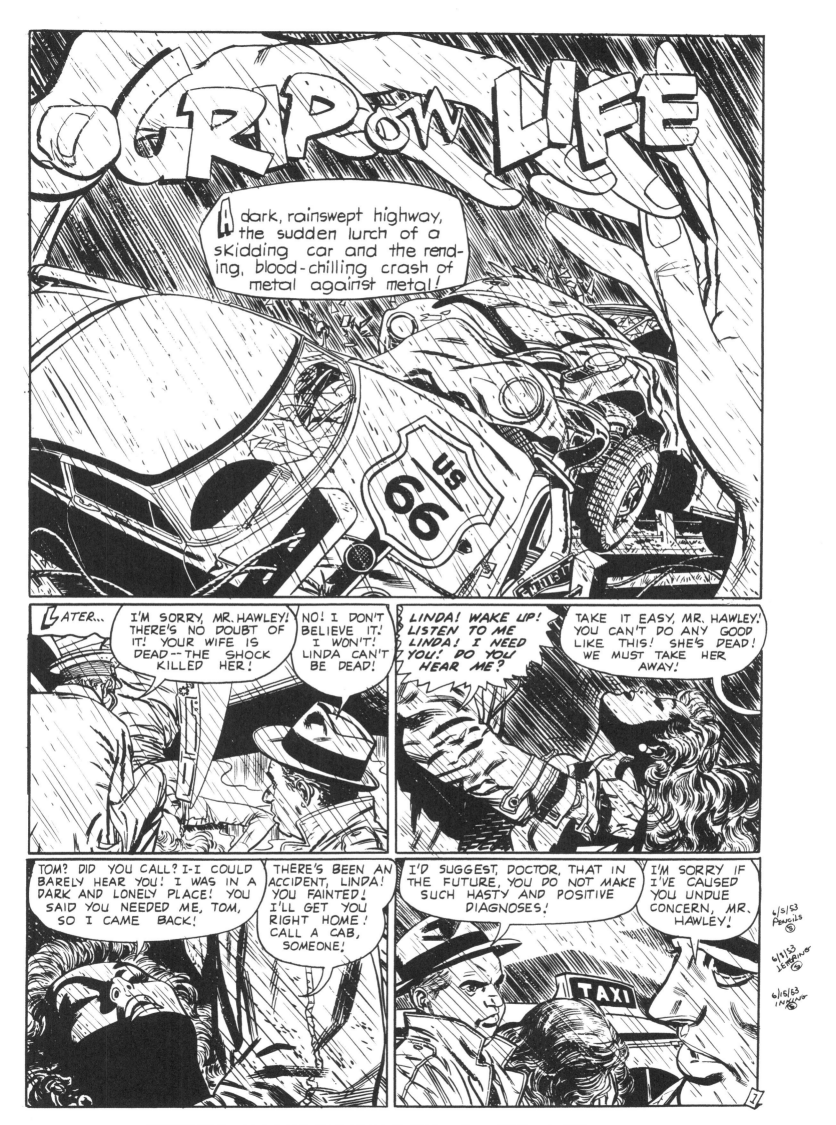

PAGES 153-156: The original artwork for "Grip On Life," inked by Mike Peppe, *Unseen* #12 (November 1953).

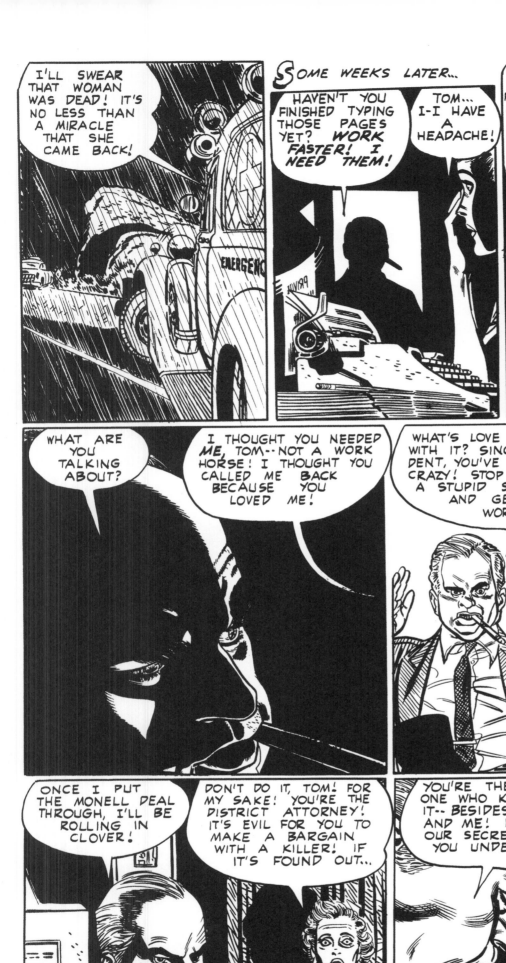
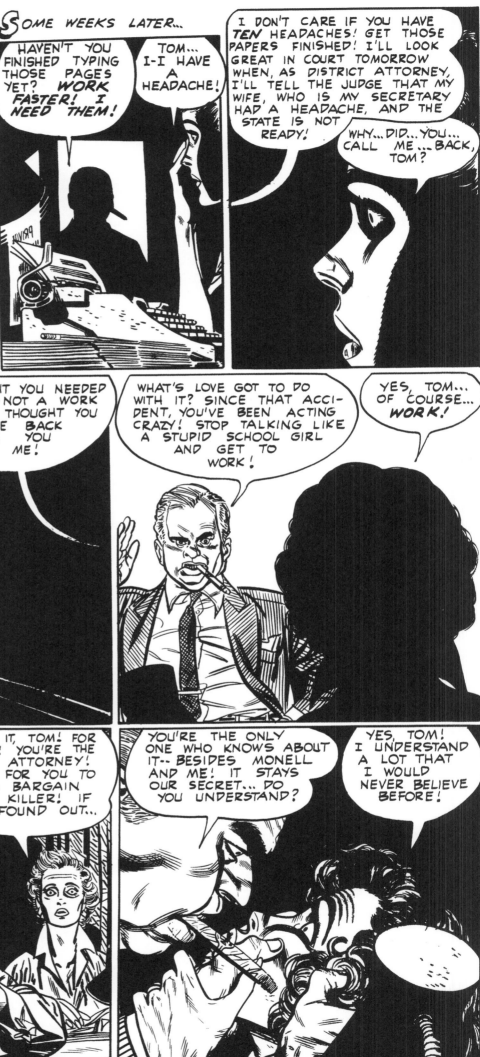

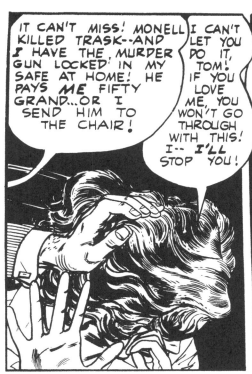

IT CAN'T MISS! MONELL KILLED TRASK--AND I HAVE THE MURDER GUN LOCKED IN MY SAFE AT HOME! HE PAYS ME FIFTY GRAND...OR I SEND HIM TO THE CHAIR!

I CAN'T LET YOU DO IT, TOM! IF YOU LOVE ME, YOU WON'T GO THROUGH WITH THIS! I-- I'LL STOP YOU!

YOU'LL STOP ME? FORGET THIS LOVE DRIVEL! WHEN I COLLECT THE FIFTY GRAND, I'M GOING TO TAKE OFF--AND LIVE! I'M TIRED OF YOU AND YOUR STRAIGHT-LACED WAYS! NOW GET THAT WORK FINISHED! I'M GOING DOWN FOR A DRINK!

I SHOULDN'T HAVE ANSWERED HIS CALL! HE DOESN'T NEED ME OR WANT ME! I CAN'T LET HIM GO ON LIKE THIS! A LETTER TO MONELL, AND--

THE NEXT DAY, IN MONELL'S APARTMENT...

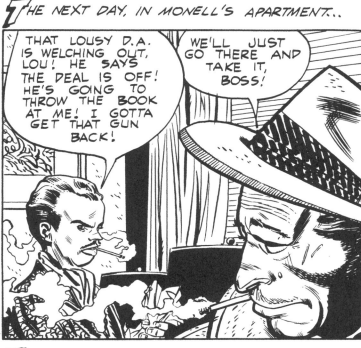

THAT LOUSY D.A. IS WELCHING OUT, LOU! HE SAYS THE DEAL IS OFF! HE'S GOING TO THROW THE BOOK AT ME! I GOTTA GET THAT GUN BACK!

WE'LL JUST GO THERE AND TAKE IT, BOSS!

YEAH! AN' WE'LL TREAT HAWLEY THE WAY A RAT OUGHT TO BE TREATED!

THAT NIGHT, IN HAWLEY'S SUBURBAN HOME...

MONELL! WHAT ARE YOU DOING HERE?

AS IF YOU DIDN'T KNOW! YOU WROTE ME CALLING THE DEAL OFF! I WANT THE ROD! IT'S THE ONLY EVIDENCE AGAINST ME!

OPEN THE SAFE AND HAND IT OVER!

SEE WHAT I MEAN?

THERE'S SOME MISTAKE! I DIDN'T WRITE ANY LETTER! THE GUN'S HERE! BELIEVE ME-- I DON'T KNOW WHAT YOU'RE TALKING ABOUT!

③

Later... after the killers flee...

How many of us have ever passed a boarded-up brownstone mansion without wondering what may be happening inside? Was the owner of such a place really away for the winter-- or was he perhaps looking out at us through a crack in the drawn blinds? Those dusty halls one echoed to violins and laughing voices, but what kind of laughter is heard there now?

Danny Nash, blackmailer and confidence man extra-ordinary, with his wife Helen, hid out in such a place to avoid a murder investigation. This is what happened to them in...

MURDER MANSION

A FEW BLOCKS AWAY FROM THE OLD SYLVESTRE MANSION, DANNY NASH AND HIS WIFE CLOSE OUT A LONG STANDING ACCOUNT--

YOU ROTTEN BLACKMAILERS! FOR YEARS I'VE PAID TO SAVE MY FAMILY'S GOOD NAME AND NOW MY MONEY'S GONE! I'M THROUGH! WHAT YOU DO ABOUT IT IS UP TO YOU!

OKAY, CARSON! THEN YOU'RE NO USE TO US, ARE YOU?

STOP! STOP IT, NASH! YOU CAN'T KILL ME IN COLD BLOOD!

OH, CAN'T I?

THAT'S RIGHT, DANNY! GIVE IT TO HIM GOOD! I'M SICK OF HIS WHINING --

BLAM!

PAGES 157-164: The original artwork for "Murder Mansion," inked by Mike Peppe, *Adventures Into Darkness* #5 (August 1952).

AFTER THEIR HASTY ACTION, THE TWO SEEK A HIDEOUT...

WHERE TO NOW, DAN?

EVER HEARD OF THE SYLVESTRE PLACE? NOBODY WILL EVER THINK OF LOOKING FOR US THERE! IT'S A CINCH!

NO WATCHMAN ON THE PLACE, IS THERE?

I'VE ALREADY TAKEN CARE OF HIM! COME ON, KID--HOP IN! HAVEN'T GOT ALL NIGHT!

UGH! IT'S SURE SPOOKY IN HERE! -- WHERE'S THE MAN WHO LIVES HERE?

OLD SYLVESTRE'S IN FLORIDA RIGHT NOW! NOTHING TO WORRY ABOUT UNTIL MAY--

WELL--WHAT DO YOU THINK OF IT, KID? THIS IS THE UPSTAIRS LIBRARY! OFF THERE IS OUR BEDROOM, AND THAT DOOR LEADS TO THE SITTING ROOM!

IT'LL DO! RIGHT NOW IT LOOKS LIKE A CYCLONE HIT IT!

BUT DANNY'S ATTENTION IS DRAWN TO AN OPEN BOOK LYING ON THE FLOOR...

WELL--WHAT DO YOU KNOW! AN OLD HAND-LETTERED BOOK! FIVE OR SIX HUNDRED YEARS OLD IF IT'S A DAY!

OKAY, BRIGHT BOY! SO YOU WERE HONOR MAN IN COLLEGE! NOW HOW ABOUT RUSTLING UP SOME GRUB! I'M STARVED!

GO ON--LAUGH! I HAPPEN TO KNOW THAT THE SALE PRICE OF A BOOK LIKE THIS COULD KEEP US EATING FOR YEARS! LISTEN TO THIS, HELEN...

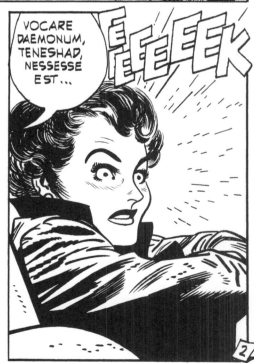

VOCARE DAEMONUM, TENESHAD, NESSESSE EST...

EEEEEEK

DANNY FINDS THAT HE HAS CALLED UP A DEMON FROM THE HALF WORLD!

I AM TENESHAD, SLAVE OF HIM WHO CALLS MY NAME!

HOW CAN I SERVE YOU, GOOD FRIENDS? ASK, AND I SHALL BRING YOUR HEART'S DESIRE!

DANNY! GET THAT-- THAT-- THING OUT OF HERE!

YOU KNOW-- IT MIGHT WORK! VERY WELL, MY FRIEND, BRING US SOMETHING TO EAT! THE BEST!

THIS IS MORE LIKE IT! I SAID THE BEST AND HE BROUGHT IT!

FOR YEARS I SERVED MR. SYLVESTRE, SIR! I BROUGHT HIM WEALTH, FAME, AND EVEN THIS HOUSE! COMMAND ME, AND ALL THESE THINGS SHALL BE YOURS!

DAN -- THAT CREATURE IS MAKING ME SO NERVOUS THAT I CAN'T EAT! ASK HIM TO GO!

OKAY, ANYTHING YOU SAY! TENESHAD, WHILE WE FINISH UP HERE, SEE THAT THE BEDROOM IS DONE OVER FIT FOR A KING AND HIS QUEEN!

AT ONCE, MASTER!

UPON ORDER, THE DEMON TRANSFORMS THE BEDROOM INTO A DREAM FROM THE ARABIAN NIGHTS...

NO COMPLAINTS NOW, EH? TOMORROW WE'LL HAVE COMPLETE NEW OUTFITS... SPORT CLOTHES... FORMALS...

GEE... I MUST BE DREAMING!

DANNY NASH AND HIS WIFE WERE A LONG TIME GETTING TO SLEEP THAT NIGHT, BUT NEXT MORNING...

AAGGHHHH

NOW WHAT?

LOOK-- IN MY BED!

UGH!

...AND AT BREAKFAST...

GREAT SCOTT!

ANOTHER ONE!

ONCE DANNY HAD REVIVED HELEN, THEIR DECISION WAS QUICKLY MADE...

WE'RE GETTING OUT OF HERE RIGHT NOW!

WAIT TILL I GET MY NEW CLOTHES! I WON'T LEAVE WITHOUT THEM!

THEY'RE LIKE RATS!

AAAARRRGGHH!

THEY'RE GUARDING ALL THE DOORS AND WINDOWS! WE'LL NEVER GET OUT!

LOOK AT 'EM! SPOIL- ING FOR A FIGHT! GO BACK UPSTAIRS! FAST!

DANNY AND HELEN TRY TO COME TO SOME UNDERSTANDING WITH TENESHAD...

...AND SO I ORDER YOU TO CALL OFF YOUR PETS AND LET US GO FREE!

YOU ORDER ME? A BIG FELLOW LIKE ME? COME! I LIKE YOU! YOU MUST STAY HERE, WITH ME-- AND MY PETS!

BUT AT THESE WORDS, HELEN'S OVERWROUGHT NERVES GIVE WAY COMPLETELY!

I'VE HAD ENOUGH! DO YOU HEAR? I WON'T STAY HERE AND YOU CAN'T KEEP ME HERE!

HEY! WHAT GOES ON IN THE SYLVESTRE HOUSE?

THE TROUBLE SEEMS TO BE UPSTAIRS, SERGEANT! BUT WHAT'S TO BE DONE ABOUT THIS MOB? SOLID GOLD DISHES DON'T COME THEIR WAY EVERY DAY!

LOOK AT THIS! SOLID GOLD!

HELP! HELP!

IT'S A DAME, SARGE!

GET ME OUT OF HERE! MY HUSBAND'S UPSTAIRS! WE KILLED HOWARD CARSON!

SEARCH THE HOUSE, MEN!

A THOROUGH SEARCH DISCLOSED NOTHING OUT OF ORDER IN THE ENTIRE HOUSE, NOR WAS THERE A TRACE OF DANNY OR THE DEMON...

ALL IN ORDER ON THIS FLOOR, SERGEANT!

ALL OKAY DOWN HERE!

BUT I TELL YOU, OFFICER, MY HUSBAND IS IN THAT HOUSE!

LET'S GET DOWN TO HEADQUARTERS, MEN! I THINK THIS LITTLE GIRL HAS A LOT TO TELL US!

6

AFTER THE POLICE LEAVE, TENESHAD AND DANNY RETURN TO THE LIBRARY FROM THE HALF WORLD...

AAAAGGHH! WHAT A PLACE! WHAT DEMONS!

WHY, DANNY--HOW CAN YOU TALK LIKE THAT ABOUT MY HOME?

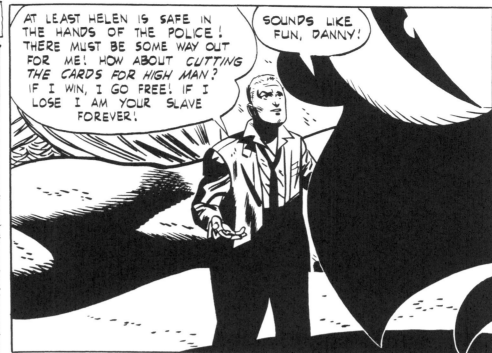

AT LEAST HELEN IS SAFE IN THE HANDS OF THE POLICE! THERE MUST BE SOME WAY OUT FOR ME! HOW ABOUT CUTTING THE CARDS FOR HIGH MAN? IF I WIN, I GO FREE! IF I LOSE I AM YOUR SLAVE FOREVER!

SOUNDS LIKE FUN, DANNY!

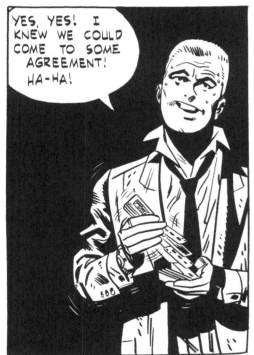

YES, YES! I KNEW WE COULD COME TO SOME AGREEMENT! HA-HA!

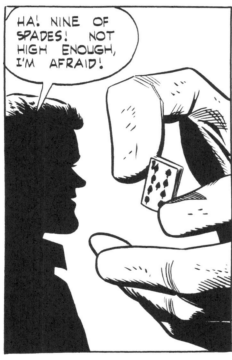

HA! NINE OF SPADES! NOT HIGH ENOUGH, I'M AFRAID!

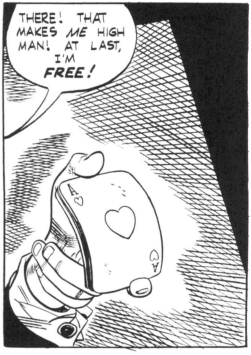

THERE! THAT MAKES ME HIGH MAN! AT LAST, I'M FREE!

COME, MR. NASH! YOU'RE NOT PLAYING FAIR WITH ME! I THINK YOU'RE CARRYING OTHER CARDS ABOUT YOU--PERHAPS IN YOUR CLOTHES!

THEN WHY DON'T YOU SEARCH ME?

BUT YOU KNOW I COULD NEVER CARRY THAT MANY CARDS ABOUT ME! YOU PRODUCED THOSE CARDS BY MAGIC!

OF COURSE, MR. NASH!

COME ALONG, DANNY! I WANT YOU TO MEET MR. SYLVESTRE, THE OWNER OF THIS HOUSE!

AND SO, DANNY IS LED AWAY, A CAPTIVE OF THE DEMON HE HAD CALLED UP...

THIS IS A SUB-CELLAR THAT VERY FEW PEOPLE KNOW ABOUT, DANNY! UTTERLY SOUND-PROOF, TOO!

SAY 'HELLO' TO DANNY, MR. S!

MAKE AN END, TENESHAD, AND LET ME DIE, I BEG YOU!

WH-WHAT ARE THOSE DARK SHADOWS MOVING ON MR. SYLVESTRE'S BODY? I CAN'T SEE VERY WELL...

SORRY, DANNY! WE MUST HAVE MORE LIGHT!

THOSE DARK FORMS--THEY WERE YOUR PETS?

OF COURSE! THE POOR LITTLE ONES WERE HUNGRY AND WE DISTURBED THEM!

AND THEN, DANNY NASH SCREAMS AND SCREAMS--FORGETTING PERHAPS THAT THE CELLAR IS SOUND-PROOF, JUST AS TENESHAD SAID IT WAS!

AEEEEE!

THE END

BLINDED BY LOVE

"EVER SINCE MUD-PIE DAYS, IT HAD BEEN LON, PAUL AND ME--THE THREE MUSKETEERS, ONE AND INSEPARABLE! THE BONDS THAT KEPT US TOGETHER HELD FIRM, EVEN WHEN FRIENDSHIP FLAMED INTO LOVE, TURNING OUR LOVE INTO A GENTLE TRIANGLE. LIKE OSTRICHES, WE TRIED TO HIDE OUR HEARTS FROM THE TRUTH-- THAT MARRIAGE WAS FOR TWO ALONE. AND SO, ONE AND ALL, WE LEARNED THE SORROW AND HEARTACHE OF OUR FOLLY..."

PAUL ALLEN, SERIOUS-MINDED, SOLID--UTTERLY FAITHFUL TO

DEBBY RAINEY, CAREFREE, LIGHT-HEARTED! FOND OF PAUL, BUT IN **LOVE** WITH

LON FARRELL, EASY-GOING, HAPPY-GO-LUCKY, NEVER WORRYING ABOUT TOMORROW!

"I WONDER IF ANY GIRL HAS EVER KNOWN A FULLER, MORE GOLDEN CHILDHOOD! I BASKED IN THE SECURITY AND LOVE OF PARENTS WHO COULDN'T DO ENOUGH FOR THEIR ONLY CHILD... AND, FROM TOMBOYHOOD TO MY FIRST PARTY DRESS, LON AND PAUL WERE MORE THAN BROTHERS TO ME. FIERCELY LOYAL, WE STUCK TOGETHER THROUGH THE THICK AND THIN OF YOUTHFUL ADVENTURES!"

YIPES! OLD LADY WINKLER'S HOUSE!

DEBBY, IF A BIG LEAGUE SCOUT EVER SEES YOU--

"THE WIDOW WINKLER WAS NOTORIOUSLY ILL-TEMPERED! PAUL AND I RAN, BUT..."

C'MON, DEB! SCRAM! BALL OR NO BALL!

GOSH! I DON'T KNOW MY OWN STRENGTH, HUH?

HEY! HOLD IT!

PAGES 165-174: The original artwork for "Blinded By Love," inked by Mike Peppe, *Popular Romance* #22 (January 1953).

GENIUS, ISOLATED **165**

I'M NOT AFRAID OF THE OL' LADY! I'M GETTIN' OUR BALL BACK!

"I REMEMBER HOW APPREHENSIVELY PAUL AND I WAITED-- AS LON, COCKY, DEFIANT, DISAPPEARED INSIDE THE WOMAN'S HOUSE! AND, AS USUAL, HIS GLIB CHARM DID THE TRICK! FOR SOON...

GOSH! WASN'T SHE FURIOUS?

NAW! A LITTLE SORE, WAS ALL! I TALKED REAL FAST AN' BEFORE YOU KNEW IT, I HAD OUR BALL-- AND AN APPLE!

BUY BONDS

GOT YOUR KNIFE, PAUL? SPLIT IT THREE WAYS!

OKAY! THEN WE'D BETTER GO OVER TO DEBBY'S, AND DO OUR ARITHMETIC HOMEWORK! IT'S HARD TODAY.

"MULTIPLY THAT EPISODE BY THOUSANDS, AND YOU'LL HAVE A FAIR IDEA OF OUR RELATIONSHIP. AND AS WE GREW UP, I FOUND MYSELF IN THE ENVIABLE POSITION OF HAVING TWO FULL-TIME RIVALS FOR MY HAND AND HEART! OFTEN, WE DATED TOGETHER-- EVEN WENT TO...

...THE SENIOR PROM AS A TRIO!

GOSH... HOW I'M GOING TO MISS ALL THIS! I FEEL SORT OF SAD, DON'T YOU?

A LITTLE...WE HAD LOTS OF FUN! BUT I'M ANXIOUS TO GET STARTED ON A CAREER!

YOU KNOW EXACTLY WHAT YOU WANT OUT OF LIFE, DON'T YOU, PAUL?

I KNOW I WANT YOU TO SHARE IT, DEBBY!

UH-UH! NO TIME FOR SERIOUSNESS! NOT TONIGHT! C'MON, WE'RE DUE BACK TO JOIN LON!

IT'S ABOUT **TIME** YOU GOT BACK WITH MY GIRL, PAUL!

YOURS? WELL, I LIKE THAT!

THAT'S RIGHT, **SPOIL** ME! SEE IF I CARE!

TO OUR HAPPY PAST AND OUR MERRY FUTURE! AND MAY WE KICK AROUND AS BACHELORS, PAUL, UNTIL--

UNTIL DEBBY'S IDENTICAL **TWIN** SHOWS UP! **CHEERS!**

"*LAUGHTER AND CAREFREE BANTER, RAINBOW-COLORED LIGHTS AND SOFT MUSIC... HOW GAY IT WAS! IF ONLY THERE WERE NO TOMORROWS! BUT DAWN SOON CAME, MARKING THE BEGINNING OF ONE TOMORROW, AT LEAST!*

PAUL...

OKAY, FRIEND, MOVE OVER!

LON...

LET THE OL' PROFESSOR DEMONSTRATE!

YOUR TIME'S UP!

FUNNY... IT'S ALMOST LIKE SAYING GOOD-BYE TO SOMETHING-- NOT JUST **GOOD NIGHT...**

THANK YOU BOTH! IT WAS A PERFECT EVENING!

"*PERHAPS IT HAD BEEN A PREMONITION THAT SOMETHING HAD PASSED INTO MEMORY! FOR WAR CLOUDS HAD BLOWN UPON THE SCENE AND IT SEEMED NO TIME BEFORE I WAS A "WAR WIDOW" OF SORTS-- SPENDING THE LONELY HOURS WRITING LETTERS...*

"... SO GOOD NIGHT, DEAREST LON, AND HAPPY LANDINGS!" I WILL WRITE PAUL, TOO, TONIGHT...

LON IN THE AIR FORCE, PAUL IN THE ARMY! I ALMOST WISH THEY WEREN'T SO HEALTHY! UNCLE SAM COULD'VE SPARED ME **ONE!**

"*THE WEEKS DRAGGED BY... MISERABLE, LONELY WEEKS! I SUPPOSE THAT ACCOUNTS FOR THE WAY MY HEART FLIP-FLOPPED WHEN A CERTAIN ARMY PRIVATE FINISHED BASIC TRAINING AND CAME HOME ON FURLOUGH!*

DEBBY!

OHHH! PAUL... PAUL!

YOU BIG, WONDERFUL, HANDSOME *GENERAL* YOU!

I CAN'T BELIEVE IT! THE ARMY'S DONE *WONDERS* FOR YOU, *MAJOR!*

PRIVATE ALLEN, MA'AM! NOT THAT I MIND... I KIND OF *LIKE* PRIVACY!

PRIVACY IS WHAT I WANT... WITH YOU! LOTS OF IT! THEM'S ORDERS, DEBBY...

YES, SIR! LEAD ON, CAPTAIN!

"*THOSE DAYS WITH PAUL WERE PRECIOUS, QUIET DAYS! WE DID SIMPLE THINGS, WALKING IN THE RAIN... HOLDING HANDS ...LISTENING TO SYMPHONIES, TO HIM TALKING--AND HOW HE TALKED ABOUT THE FUTURE!*

THAT'S IT, KITTEN! AFTER THIS FRACAS, A GOOD ENGINEER'S JOB, A HOME, AND...

AND WHAT, PAUL?

YOU, DEBBY! I DON'T WANT AN ANSWER NOW...NOT UNTIL I GET BACK FROM BUILDING BRIDGES...

...OR BLOWING 'EM UP-- OR WHATEVER ENGINEERS DO! BUT, I LOVE YOU! DON'T EVER FORGET IT!

"*ALL TOO SOON...*

I'LL WRITE EVERY DAY I CAN!

GOOD-BYE FOR NOW, DARLING! MY LOVE WILL FOLLOW YOU...WHEREVER YOU ARE! OH, P-PAUL... PAUL!

"*A* TENDER PARTING, MY PICTURE, A PROMISE, TEARS...THOSE WERE THE CASUAL FAVORS I BESTOWED ON MY SOLDIER OFF TO WAR! CASUAL? I SAY THAT NOW...LOOKING BACK ON THE NEXT NEW CHAPTER IN MY LIFE! FOR, THOUGH I WAS SURE I LOVED PAUL, I SOON FOUND OUT HE WAS SECOND BEST IN MY HEART...

"...FOR ONE EVENING..."

I'M COMING! WONDER WHO--?

DON'T YOU **EVER** ANSWER YOUR DOOR-BELL, MISS?

LON!

CAN'T YOU SAY HELLO, YOU PRETTY, PRETTY BABY?

H- HELLO--AND W- WELCOME HOME, MY DARLING!

IF THAT ISN'T **JUST** LIKE A WOMAN! **TEARS** AT A TIME LIKE THIS!

"*C*AN ANY-ONE EXPLAIN SHOCK, TEARS OF JOY, COMPLETE LOSS OF EQUILIBRIUM TO SOMEONE WHO IS **NOT** ANOTHER WOMAN? I DIDN'T TRY! HERE WAS MY SIR LANCELOT-- MY DASHING CAVALIER! HERE WAS THE MAN WHO WAS MY **LIFE**!

IT'S THE UNIFORM! IT HAS TO BE! WHY, I REMEMBER YOU WHEN--

NO TIME FOR THAT! UNTIL I REPORT FOR ADVANCED JET TRAINING, WE'RE GOING ON ONE **MAD** WHIRL!

ON WITH YOUR GLAD RAGS, KITTEN! WE'RE OFF TO THE RACES! WHAT DO YOU SAY TO THAT?

AS THEY SAY IN OLD FASHIONED NOVELS:"WHY, SIR, THIS IS **SO** UNEXPECTED!"

"*E*VEN NOW, AFTER ALL THE BITTERNESS THAT FOLLOWED, I CAN'T BLAME MYSELF FOR COMPLETELY LOSING MY HEAD! FOR THERE WAS THE HYSTERIA OF WAR...OF SO LITTLE TIME...OF BEING YOUNG--OH, SO TERRIBLY YOUNG! WE SEIZED EVERY MOMENT FOR AS MUCH ECSTATIC LIVING AS POSSIBLE!

"*T*HE WORLD WAS CREATED FOR US...**ALONE**!

5

"*IT WAS DELIRIUM, MADNESS! IT WAS THE ANSWER TO MY ROMANTIC CRAVINGS! THIS WAS WHAT I'D ALWAYS WANTED... NOT PAUL'S COMFORTABLE FIRESIDE OFFER! POOR PAUL FLITTED IN MY CONSCIENCE...AND DISAPPEARED! 'MARRY ME!' SAID MY BOLD KNIGHT OF THE SKY! A GIDDY ENGAGEMENT PARTY FOLLOWED...*"

A TOAST TO THE LOVELIEST BRIDE-TO-BE EVER!

HEAR, HEAR!

TO DEBBY-- AN AIRMAN'S ONLY REASON FOR EVER WANTING TO BE GROUNDED! MY DEBBY...!

MY DARLING... OHH, LON!

"*THIS IS THE WINE OF LIVING, I THOUGHT, AS WE RACED HOME THROUGH THE NIGHT...*"

FASTER, LON! I WANT THE WIND IN MY HAIR! I WANT TO FEEL THE NIGHT!

TONIGHT IS OURS... EVEN IF TOMORROW MEANS GOOD-BYE FOR AWHILE! I--

LON! WATCH WHERE YOU'RE GOING!!

"*HEADLIGHTS BEARING FOR US... STRAIGHT AHEAD! THE SQUEAL OF BRAKES--TOO LATE! THE HARSH SCREAM OF METAL COLLIDING IN VIOLENCE! THEN... FOR ME...BLACKNESS! A WORLD OF VELVET, SUFFOCATING DARK...*"

DEB... CAN YOU HEAR ME

A LONG TIME MUST HAVE PASSED BEFORE THE BLACK TURNED GRAY... BEFORE I BECAME AWARE OF VOICES...!

DEBBY DEBBY DEBBY DEBBY

M- MY BABY! MY POOR, POOR BABY!

PLEASE! MRS. RAINEY!

MAMA! LOOK! SHE'S COMING TO!

LON... WHERE.. CAR... FAST...

WHY ARE YOU ALL--! OH! NOW I REMEMBER!

OH, HONEY! YOU HAD US WORRIED!

THERE, THERE, MOTHER! SHE'LL BE ALL RIGHT...JUST AS GOOD AS NEW!

"THERE WAS GREAT REJOICING, TO SAY THE LEAST! FOR, ALTHOUGH LON HAD MIRACULOUSLY COME THROUGH WITH BUT A MINOR SCRATCH, MY STORY HAD BEEN ONE OF BARE SURVIVAL WITH HORRIBLE FACIAL INJURIES! HOW TENDERLY, SOLICITOUSLY, LON STAYED AT MY BEDSIDE..."

IT-- IT WAS ALL MY FAULT!

HUSH, DARLING! EVERYTHING WILL BE ALL RIGHT! I *KNOW* IT!

SURE...SURE, BABY! LOOK...I'M WAY OVERDUE AT THE BASE! I'LL HAVE TO SAY *GOOD-BYE* FOR AWHILE!

OF COURSE, DARLING! JUST KISS ME! HAPPY LANDINGS!

"HE LEFT THEN... AND AS THE DAYS WENT BY, I LEARNED THE PRIVATE HORROR OF LIVING WITH A SCARRED, DISFIGURED FACE! ONLY THE HOPE OF PLASTIC SURGERY KEPT ME GOING. HOW NERVOUS AND EXCITED I WAS... THE DAY THE BANDAGES WERE REMOVED..."

WE DID OUR BEST, DEB! YOU MUSTN'T BE DISAPPOINTED IF--

OH... HURRY! LET ME SEE!

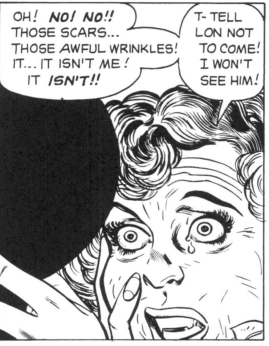

OH! *NO! NO!!* THOSE SCARS... THOSE AWFUL WRINKLES! IT... IT ISN'T ME! IT *ISN'T!!*

T- TELL LON NOT TO COME! I WON'T SEE HIM!

"IT WAS THE STORY OF THE UGLY DUCKLING IN REVERSE! A LOVELY SWAN HAD WON HER MATE... AND NOW...? I DREADED LON'S VISIT, HOPING I WOULDN'T SEE IN HIS FACE ...WHAT I FELT *WOULD* BE THERE!

YOU...YOU PALED L-LIKE A GHOST... WHEN YOU SAW ME THIS MORNING AT THE STATION!

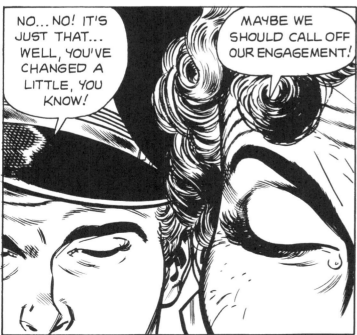

NO... NO! IT'S JUST THAT... WELL, YOU'VE CHANGED A LITTLE, YOU KNOW!

MAYBE WE SHOULD CALL OFF OUR ENGAGEMENT!

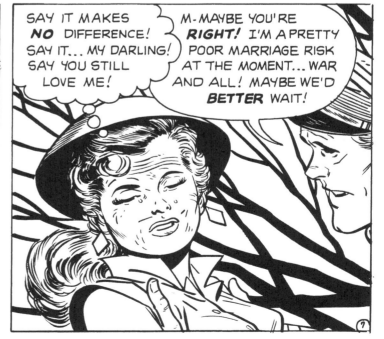

SAY IT MAKES *NO* DIFFERENCE! SAY IT... MY DARLING! SAY YOU STILL LOVE ME!

M-MAYBE YOU'RE *RIGHT!* I'M A PRETTY POOR MARRIAGE RISK AT THE MOMENT... WAR AND ALL! MAYBE WE'D *BETTER* WAIT!

"DON'S halting, lame excuses tore my heart to shreds! I barely remembered his brief kiss when he left-- so eager to go! But I do remember the nights filled with my tears... how I clutched at the straw of Paul's letters... so regular... so beautiful!

"...ARE YOU LOOKING AT THE STARS OVERHEAD? FOR THOSE SELF-SAME STARS... HERE, OVER KOREA..."

"...ARE THE SAME STARS WATCHING **YOU**, MY BEAUTIFUL DARLING...

BEAUTIFUL! IF... IF HE ONLY **KNEW!**

IF HE ONLY **KNEW**...

SOB P-PAUL!

"BUT LIFE HAS A WAY OF GOING ON, DESPITE OBSTACLES AND HEARTBREAKS. AND, PLUNGING INTO VOLUNTEER WORK AT THE LOCAL VETERANS' HOSPITAL, I LEARNED, SOMEHOW, TO ACCEPT MY FATE. I EVEN FOUND SOLACE, COMFORT, A STRANGE NEW HUMILITY IN HELPING OTHERS!

HI, GANG!

FLORENCE NIGHTINGALE! HOW 'BOUT CHECKERS?

YOU PROMISED TO FINISH READING THAT MYSTERY TO ME!

DON'T WORRY, BOYS! I'LL GET TO EACH OF YOU SOON!

AND THANK YOU... FOR LETTING ME FEEL THAT I'M **NEEDED**... THAT LIFE IS STILL GOOD!

"THAT WAS MY LIFE... FOR A TIME! AND THEN, A NEW VOID ENTERED! **PAUL'S LETTERS STOPPED!** I BECAME FRANTIC... IT DIDN'T MAKE SENSE! UNTIL ONE DAY, WHEN I BUMPED INTO HIS MOTHER...

...AND PAUL JUST STOPPED WRITING! WHY, MRS. ALLEN?

HE WAS BADLY WOUNDED! HE DOESN'T WANT TO HEAR FROM... OR SEE **ANY** OF US AGAIN!

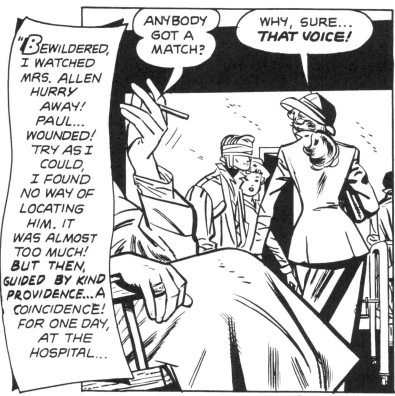

"BEWILDERED, I WATCHED MRS. ALLEN HURRY AWAY! PAUL... WOUNDED! TRY AS I COULD, I FOUND NO WAY OF LOCATING HIM. IT WAS ALMOST TOO MUCH! BUT THEN, GUIDED BY KIND PROVIDENCE...A COINCIDENCE! FOR ONE DAY, AT THE HOSPITAL...

ANYBODY GOT A MATCH?

WHY, SURE... THAT VOICE!

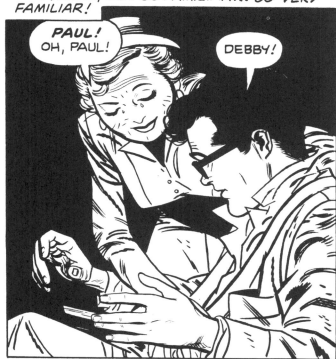

"THAT BATTLE-WORN FACE... SO LIKE THE OTHERS, BUT SO FAMILIAR... SO VERY FAMILIAR!

PAUL! OH, PAUL!

DEBBY!

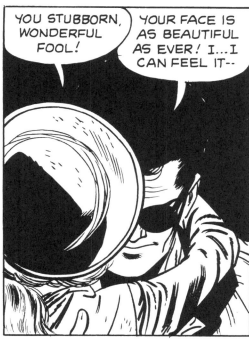

YOU STUBBORN, WONDERFUL FOOL!

YOUR FACE IS AS BEAUTIFUL AS EVER! I...I CAN FEEL IT--

"HIS WORDS STOPPED ME SHORT. EVERYTHING CLICKED SUDDENLY! PAUL... MY PAUL WAS BLIND! I VOWED THEN THAT I'D SPEND ALL MY TIME NURSING HIM BACK TO HEALTH... AT LEAST TO MENTAL HEALTH!

YOU'VE ALWAYS BEEN SPECIAL TO ME...YOUR LETTERS KEPT ME GOING WHEN THE FIGHTING GOT TOUGH!

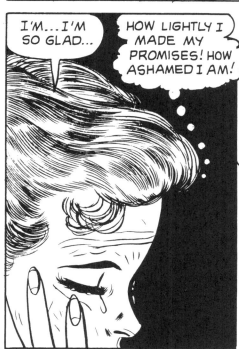

I'M...I'M SO GLAD...

HOW LIGHTLY I MADE MY PROMISES! HOW ASHAMED I AM!

IT'S BEEN A LONG TIME SINCE THE THREE OF US WERE TOGETHER! LON'S AN ACE! AND MARRIED! SOME WAR DEPARTMENT GAL HE MET IN TOKYO ON LEAVE!

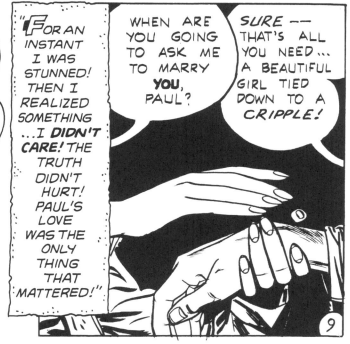

"FOR AN INSTANT I WAS STUNNED! THEN I REALIZED SOMETHING ...I DIDN'T CARE! THE TRUTH DIDN'T HURT! PAUL'S LOVE WAS THE ONLY THING THAT MATTERED!"

WHEN ARE YOU GOING TO ASK ME TO MARRY YOU, PAUL?

SURE -- THAT'S ALL YOU NEED... A BEAUTIFUL GIRL TIED DOWN TO A CRIPPLE!

9

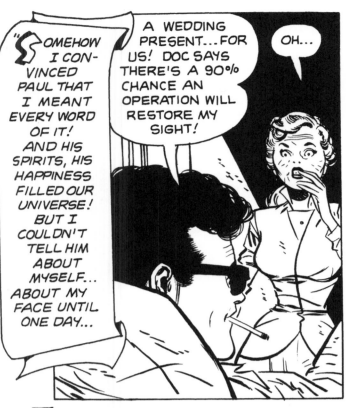

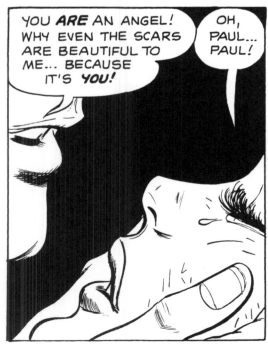

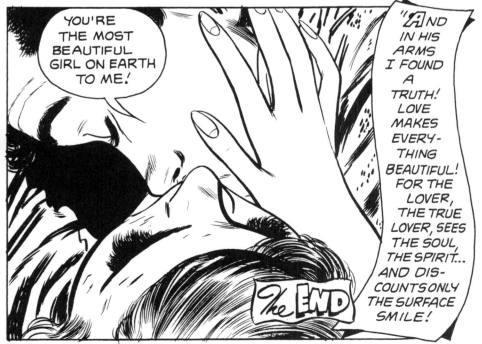

The End

the PHANTOM SHIP

What was the horrible secret of the treasure map that led two murderers to a hidden temple in the wilds of the lower Nile? And what was the meaning of the even stranger events that followed? Only Circe, legendary evil sorceress would tell--But to hear the terrifying, ghastly answer from her mocking blood-red lips meant--**DEATH!**

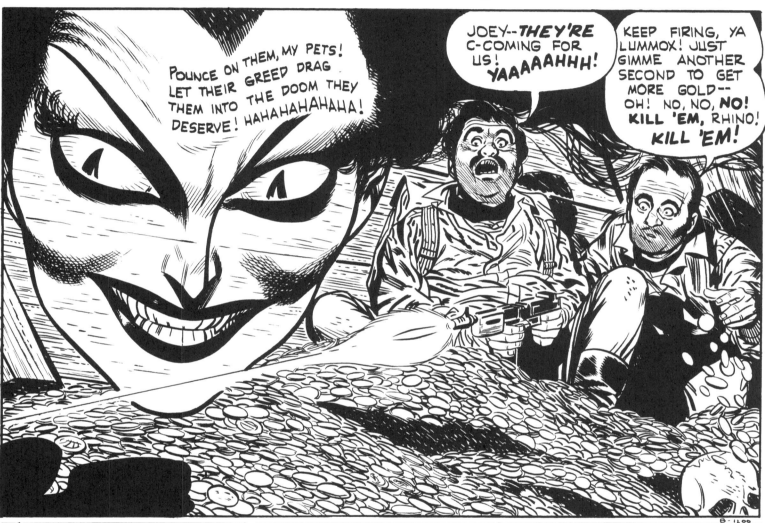

POUNCE ON THEM, MY PETS! LET THEIR GREED DRAG THEM INTO THE DOOM THEY DESERVE! HAHAHAHAHAHA!

JOEY--*THEY'RE* C-COMING FOR US! *YAAAAAHHH!*

KEEP FIRING, YA LUMMOX! JUST GIMME ANOTHER SECOND TO GET MORE GOLD-- OH! NO, NO, **NO!** KILL 'EM, RHINO! *KILL 'EM!*

A CHEAP TAVERN IN CAIRO'S EASTSIDE...

YOU FELLERS CAN'T FOOL ME! YOU TWO'RE FROM THE STATES! IN TROUBLE WITH THE LAW, I'LL BET!

UH-- LET'S FORGET ABOUT THAT, POP! TELL US MORE ABOUT YOUR MAP!

HO! SO IT'S MY MAP, IS IT? MATIES, IT'S WORTH *MILLIONS!* GOLD-- A TREASURE FOR ANYONE SHARP ENOUGH TO TRY HIS LUCK!

IS THAT SO? HERE... NOW ABOUT THAT MAP!

I'M THE ONLY ONE THAT HAS IT-- NO ONE ELSE-- HEE HEE HEE...

PAGES 175-182: The original artwork for "The Phantom Ship," inked by Mike Peppe, *Out of the Shadows* #6 (October 1952).

POP, HOW 'BOUT JOINING US AT OUR TABLE BACK HERE? RHINO AN' I LIKE YOUR COMPANY!

SURE, MATIES! HEE, HEE-- REMINDS ME O' THE TIME I SHIPPED OUT ON THE SEA QUEEN...

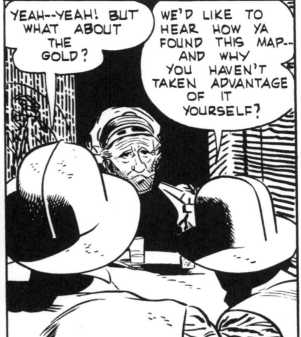

YEAH--YEAH! BUT WHAT ABOUT THE GOLD?

WE'D LIKE TO HEAR HOW YA FOUND THIS MAP-- AND WHY YOU HAVEN'T TAKEN ADVANTAGE OF IT YOURSELF?

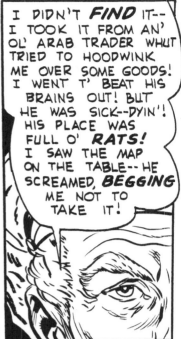

I DIDN'T FIND IT-- I TOOK IT FROM AN' OL' ARAB TRADER WHUT TRIED TO HOODWINK ME OVER SOME GOODS! I WENT T' BEAT HIS BRAINS OUT! BUT HE WAS SICK--DYIN'! HIS PLACE WAS FULL O' RATS! I SAW THE MAP ON THE TABLE--HE SCREAMED, BEGGING ME NOT TO TAKE IT!

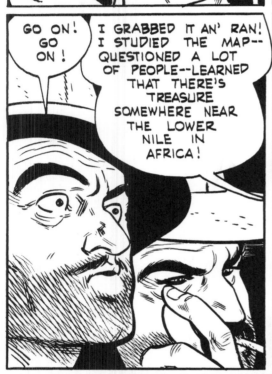

GO ON! GO ON!

I GRABBED IT AN' RAN! I STUDIED THE MAP-- QUESTIONED A LOT OF PEOPLE--LEARNED THAT THERE'S TREASURE SOMEWHERE NEAR THE LOWER NILE IN AFRICA!

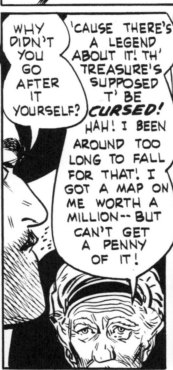

WHY DIDN'T YOU GO AFTER IT YOURSELF?

'CAUSE THERE'S A LEGEND ABOUT IT! TH' TREASURE'S SUPPOSED T' BE CURSED! HAH! I BEEN AROUND TOO LONG TO FALL FOR THAT! I GOT A MAP ON ME WORTH A MILLION-- BUT CAN'T GET A PENNY OF IT!

I LIKE YOU, POP! COME ON--LET'S GO FOR A LITTLE WALK!

OKAY, MATES! YOU SURE ARE NICE FELLERS!

THE TWO KILLERS LURE THE OLD SAILOR INTO THE BACK ALLEY...

KRAK!

UKK!

THE OLD JERK WON'T DO NO MORE GABBIN'! GOT THE MAP?

YEAH! LET'S GO!

2

SQUEAK! SQUEAK!!

UGHH! LOOK, JOEY! A... A GIANT RAT! IT'S *WATCHING* US! I--I CAN'T STAND 'EM!

OKAY-- YOU CAN'T STAND 'EM, AND I *HATE* 'EM! NOW LET'S BEAT IT!

WOK!

JOEY FERRANTI AND HIS PARTNER "RHINO" ANHEIM MAKE ARRANGEMENTS AND BEGIN THEIR JOURNEY! DAYS OF ARDUOUS TRAVEL FOLLOW--AS THEY HACK DEEPER AND DEEPER INTO THE JUNGLE!

WE'RE ALMOST THERE, ACCORDING TO THE MAP!

WHAT'D I TELL YA? LOOK! A TEMPLE IN THAT CLEARING! THE MAP SAYS FURTHER DIRECTIONS ARE INSIDE AN IDOL! WE'RE GOING IN THERE!

INSIDE THE ANCIENT TEMPLE...

WHEW! WHAT IS THAT--THING? IT MUST BE OVER TWENTY FEET TALL!

THAT'S THE IDOL! THE MAP'S GENUINE! OKAY-- LET'S GET TO WORK!

UGHH! THIS THING AIN'T MOVIN', JOEY! I'M PUSHIN' AS HARD AS I CAN...

PRESS HARDER! WHATEVER WE'RE LOOKIN' FOR IS IN THIS EYE! THAT'S WHAT THE MAP SAYS!

SUDDENLY...

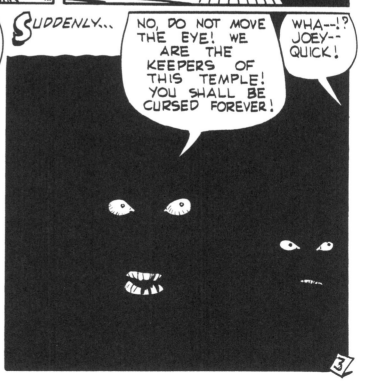

NO, DO NOT MOVE THE EYE! WE ARE THE KEEPERS OF THIS TEMPLE! YOU SHALL BE CURSED FOREVER!

WHA--!? JOEY-- QUICK!

3

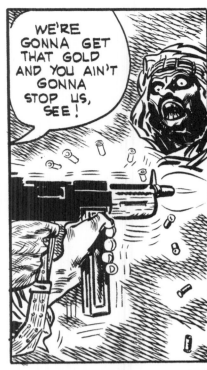

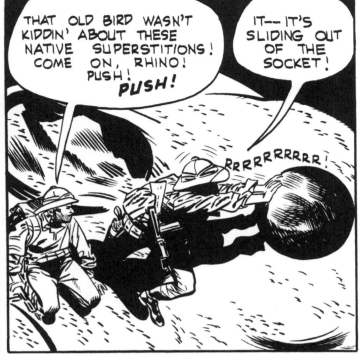

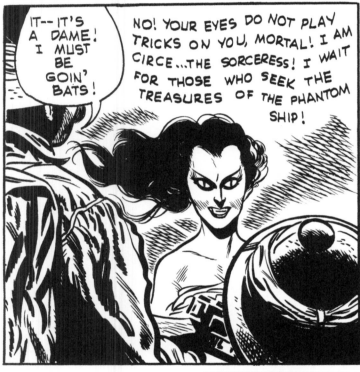

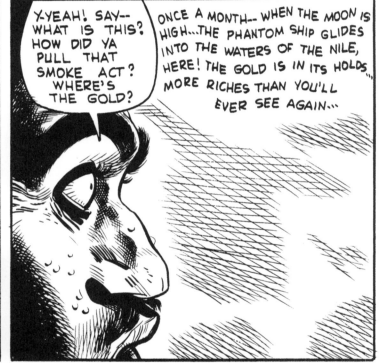

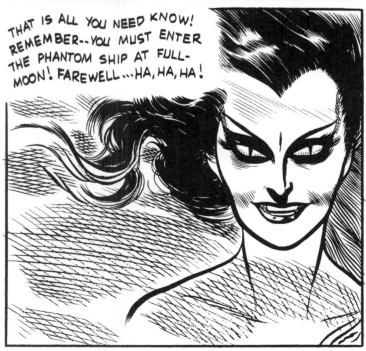

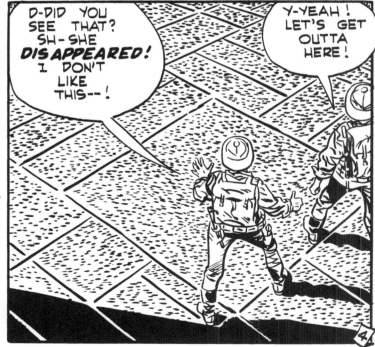

THE TWO MAKE CAMP AT THE TEMPLE-- AND FOR DAYS, AWAIT THE SIGN OF THE PHANTOM SHIP...

THIS IS CRAZY! THE MAP-- EVERY-THING-- THEY WERE ALL PHONY! BAH! *PHANTOM SHIP!*

BUT, JOEY-- HOW 'BOUT THE DAME DISAPPEARIN' LIKE THAT? THAT WAS THE MC COY! I KNOW IT! *JOEY!... THERE! IT'S THE SHIP!*

GET THOSE PACKS AND GUNS, QUICK!

OKAY-- I'LL CATCH UP TO YOU! GO AHEAD!

HURRY! IF WE MISS IT, WE'LL NEVER GET ANOTHER CHANCE!

PUFF-- PUFF! KEEP GOIN'! I'M RIGHT BEHIND YOU!

I GOT THE STRANGEST FEELING, JOEY! SOMETHING'S QUEER HERE! TOO QUIET!

COME ON-- STOP THE CHATTER! GET UP THERE!

WELL... I'LL BE —!

THIS TUB MUST BE TWO THOUSAND YEARS OLD! I SEEN PICTURES OF SHIPS LIKE THIS IN BOOKS WHEN I WAS A KID!

AN EERIE SIGHT GREETS THE DUO... A SIGHT BEYOND DESCRIPTION... FROM ANOTHER WORLD...

THE JEWELS AND STONES IN THOSE WEAPONS ARE WORTH A FORTUNE! LOOK AT 'EM, JOEY!

AW, THAT'S JUST CHICKEN FEED! REMEMBER WHAT THAT DAME SAID-- THERE'S GOLD INSIDE THIS OLD TUB!

COME ON! DOWN THESE STEPS! AN' KEEP YER EYES OPEN!

OKAY! I GOT YA COVERED IN CASE ANYONE'S DOWN THERE!

DOWN THE RICKETY, CREAKING STEPS THEY GO... CAUTIOUS, TENSE... SEARCHING EACH NOOK AND CRANNY, GUNS COCKED! THEN... THE MAIN HOLD! THERE IT IS -- GOLD!

GOLD! GOLD! WE'RE RICH, JOEY--! WE'RE RICH! HA HA HA HA HA!

HA HA-- ALL THIS IS OURS! HAHAHA!

AND THEN...

SQUEAK!

WHAT W-WAS THAT?

IT'S A RAT! A GIANT RAT! THE SAME ONE I SAW IN THAT ALLEY!

RATATATATATAT!

IT'S DEAD, RHINO! SEE? I KILLED IT! NOW GRAB HOLD OF YOURSELF!

AI/EEEE!

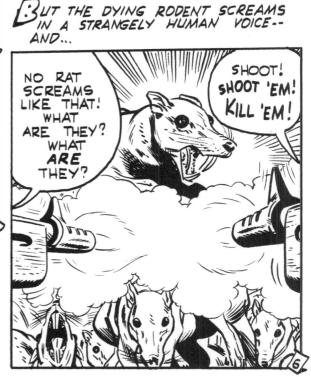

BUT THE DYING RODENT SCREAMS IN A STRANGELY HUMAN VOICE-- AND...

NO RAT SCREAMS LIKE THAT! WHAT ARE THEY? WHAT ARE THEY?

SHOOT! SHOOT 'EM! KILL 'EM!

THE TWO MEN FIGHT DESPERATELY FOR THEIR LIVES!

SSSWWWIIIIISSHHHHHH

SQUEAK! SQUEAK!!

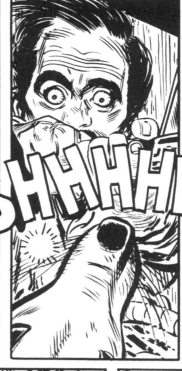

HHHH!

COME ON-- LET'S GO UP ON DECK! WE GOT A CHANCE THERE!

WELCOME, MY FRIENDS! WELCOME TO THE PHANTOM SHIP! DO YOU FIND MY--PETS INTERESTING? HAHAHAHAHAHAHHAHAHAHAHAHA?

YAAH! IT'S HER!

I--I'M GETTIN' OFF THIS CRAZY SHIP!

HOLD IT! THE GOLD! WE FORGOT IT, RHINO! I DROPPED IT BACK THERE! I'M GOING BACK FOR IT!

NONONONO! LET IT ALONE! WE'VE GOT ENOUGH IN OUR POCKETS, JOEY! THEY'RE RIGHT BEHIND YOU!

PICK 'EM OFF! IT'LL ONLY TAKE A FEW SECONDS! WE'LL RE RICH, RHINO-- RICH!

SQUEAK! SQUEAK!

ATTACK THEM, MY PETS! THEIR GREED LEADS THEM TO THEIR DOOM! HAHAHAHAHAHAHA!

THEY'RE ON US NOW! HELLLLP!

WE'RE RUNNING OUT OF A-AMMO! WHAT'LL WE DO?

SQUEAK! RATATATATAT! SQUEAK!

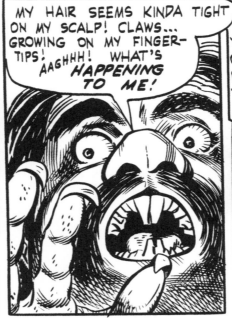

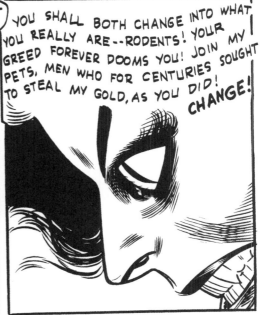

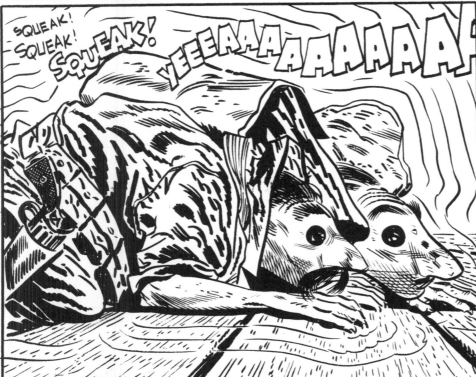

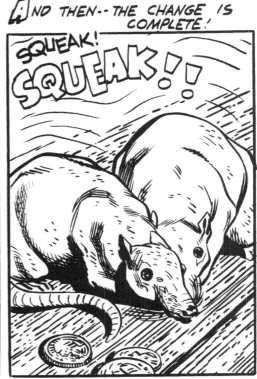

PAGES 183-188: The original artwork for "Images of Sand," inked by Mike Peppe, *Out of the Shadows* #12 (March 1954).

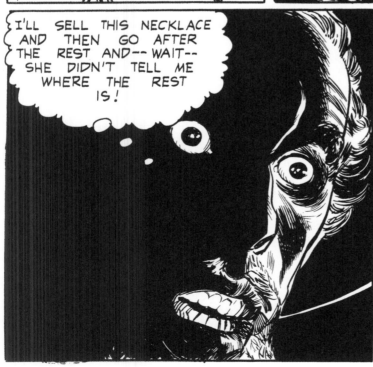

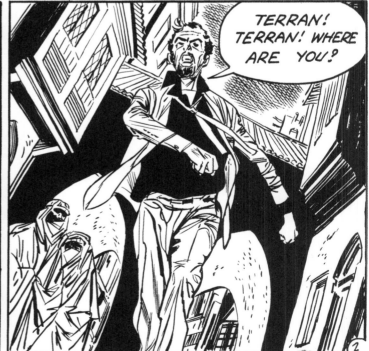

HENRI RAN WILDLY THROUGH THE TOWN TRYING TO FIND TERRAN! FINALLY, EXHAUSTED, HENRI WENT TO THE CAFE OMAR FOR A DRINK...

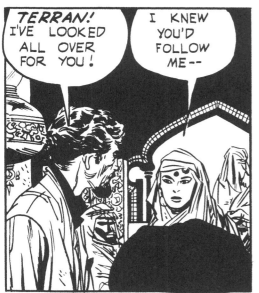

TERRAN! I'VE LOOKED ALL OVER FOR YOU!

I KNEW YOU'D FOLLOW ME--

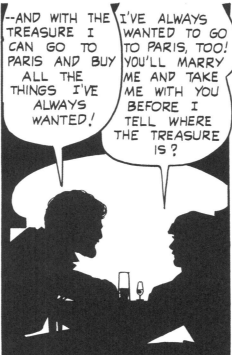

--AND WITH THE TREASURE I CAN GO TO PARIS AND BUY ALL THE THINGS I'VE ALWAYS WANTED!

I'VE ALWAYS WANTED TO GO TO PARIS, TOO! YOU'LL MARRY ME AND TAKE ME WITH YOU BEFORE I TELL WHERE THE TREASURE IS?

AND SO THE NEXT DAY...

HENRI MONARD AND TERRAN AL KHOURI, I NOW PRONOUNCE YOU MAN AND WIFE!

AND NOW WE WILL BE VERY HAPPY, HENRI!

FIRST, WE MUST GET TO THE TREASURE BEFORE SOMEONE ELSE GETS IT! I'LL GET A SAFARI READY AS SOON AS POSSIBLE!

THE MOUNTAIN CAVE IS UP AHEAD BUT IT IS TABOO! I'M FRIGHTENED! LET'S GO BACK!

NO! WE'LL NOT GO BACK! THERE ARE NO SUCH THINGS AS CURSES!

THERE, IN THAT MOUNTAIN IS THE CAVE, BUT I'M FRIGHTENED!

WE GO ON! NOTHING WILL KEEP ME FROM BEING RICH!

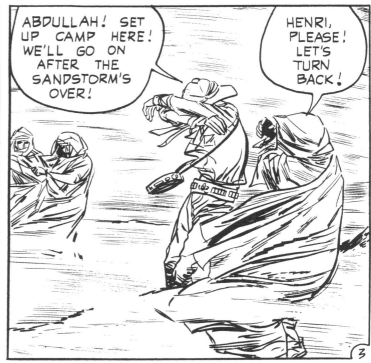

ABDULLAH! SET UP CAMP HERE! WE'LL GO ON AFTER THE SANDSTORM'S OVER!

HENRI, PLEASE! LET'S TURN BACK!

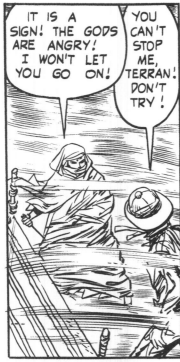

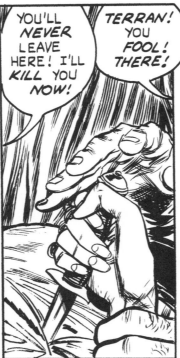

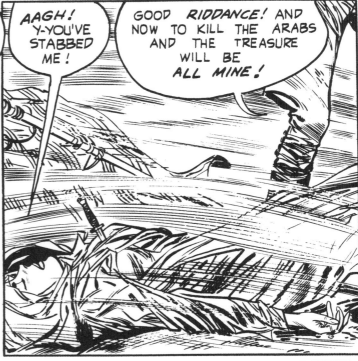

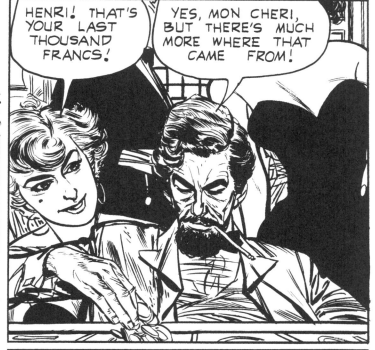

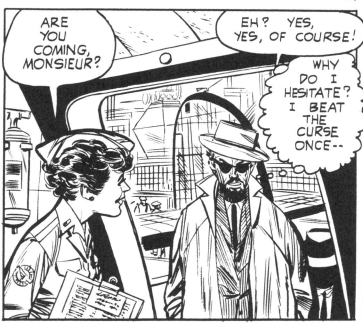

• COLOR NOTE / GHOST (PANEL 1) THRU-OUT STORY IS *RED* — EXCEPT FOR *EYES* — *WHITE* !!

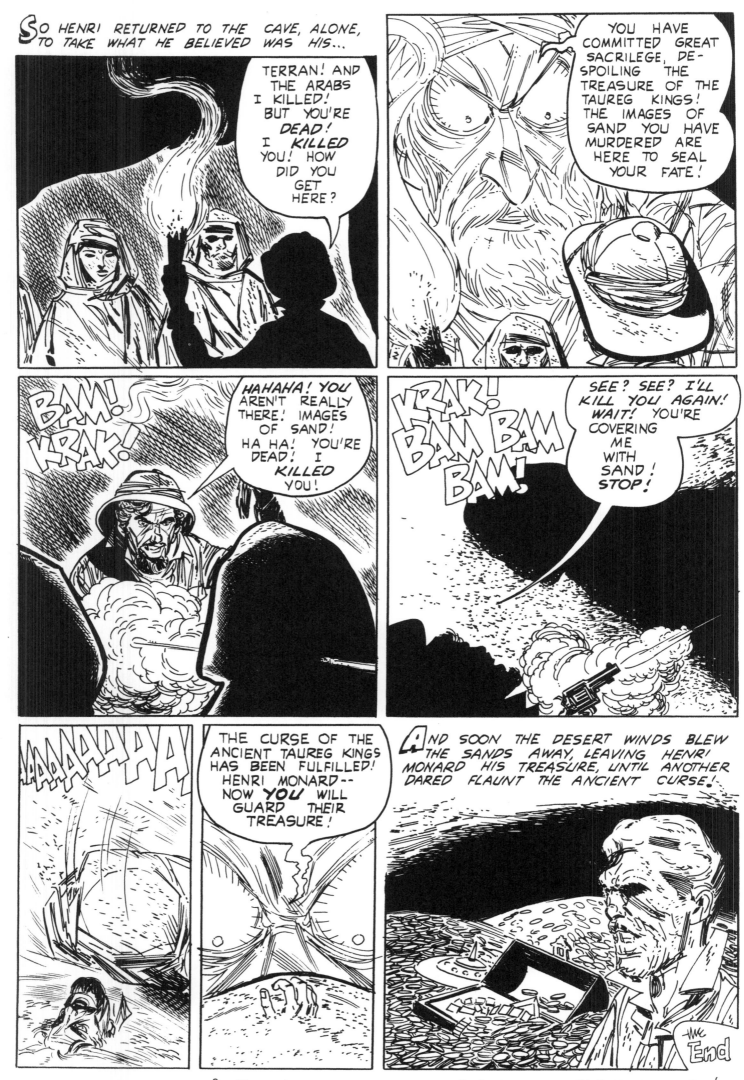

ABOVE: "Five State Police Alarm," *Crime Files* #5 (September 1952).

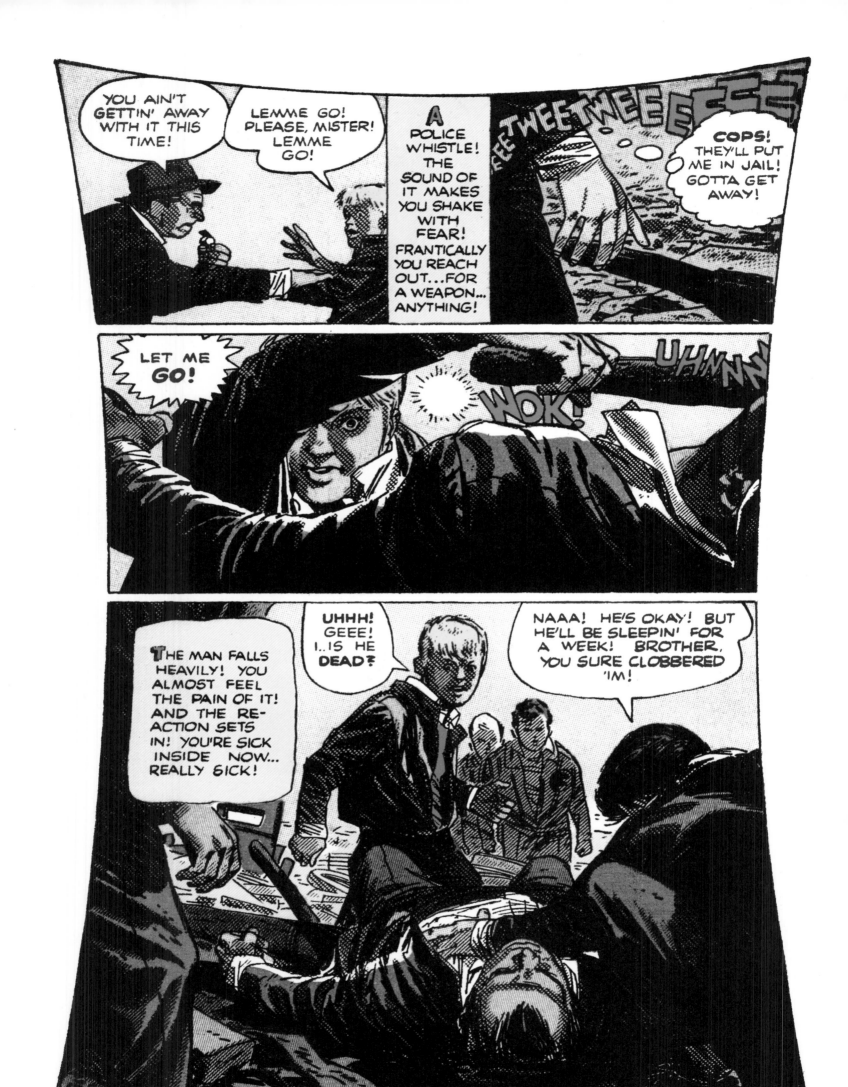

ABOVE: PFC Alexander Toth, circa 1956.

UNIFORM DAYS

The United States Army welcomed Toth into its ranks in 1954; he was almost twenty-six years old at the time. Those Americans familiar only with an all-volunteer Army surely find the concept of the draft a foreign one; those who remember the inductions of the 1960s and '70s—when young men in their teens and early twenties were swept up and shipped off for combat duty in Vietnam—puzzle over how Alex came to be drafted at what seems an "advanced" age. This question was posed to a number of military sources during research into Toth's Army years; Luther David Hanson of the U.S. Army Quartermaster Museum offered these thoughts in an e-mail: "I suspect that Mr. Toth was drafted as his birth date number came up and it said he hadn't been previously called to duty. I believe they could draft you 'til age twenty-six in those days. During World War II, it was to age thirty-six."

Whatever the process, the end result is clear: for two years Alex Toth was the property of the United States Government. On balance he enjoyed his hitch— it appealed to his deep sense of patriotism and perhaps healed an eight-year-old wound created when the Navy rejected him. It also helped that he would not be entering a shooting war, since the Armistice ending the Korean conflict was signed in late 1954.

The second and most mysterious of Alex Toth's four marriages occurred prior to the artist being called to serve. Dedicated research, plus questions asked in over twenty separate interviews, failed to yield either the bride's name or the couple's exact wedding date. Alex's third wife, Christina Hyde, had this to say about the mystery woman:

> I think the second one was a San Jose girl, and while Alex was in the service she worked in a factory—a pickle factory, maybe—and she met someone there. So that was a hard time for him. He didn't say

anything bad about her, but well, I think the second one really hurt him, because she found someone else. He just didn't say a whole bunch [about those early marriages].

Christina and Alex's second child, Carrie Toth Morash, offered other choice tidbits about Alex's second wife. "All I remember is, she was blonde—I heard that. And [years later,] when we lived in Pasadena, I want to say that she was somewhere in town, like in a beauty salon one time, and somebody saw her." And third child Eric contributed information his father had volunteered throughout the years about this time in his life:

> [Alex and his second wife] had a little house that he did some work to. I think he was proud of that. He did physical work, like he built this little kind of entryway— he either sketched it for me or showed me a photo of it at some point, so I have an image of what that was. And I could tell that was important, it meant something to him that he did that. He definitely wasn't a weekend-projects guy, but he could obviously visualize it and the few times in his life he did it, I think it was significant to him. That short time he had with her, I think he enjoyed their having that little house together.
>
> He also enjoyed her brothers, his brothers-in-law. If I remember correctly, they were kind of into cars, so he had things like that he was interested in talking to them about.

The Army put an ocean between Toth and his second wife: in 1955 Alex found himself stationed in Japan, attached to the Quartermasters Corps out of

Tokyo. His post's eight-page weekly newspaper, *The QM Depot Diary*, employed one staff artist, a Japanese civilian called "Omi," whose job consisted of lettering headlines and recreating the *Diary* logo for each new edition.

Aside from Omi, the *Diary*'s staff consisted solely of Army writers. That changed when Toth talked the paper's sponsors into creating and giving him an Art Editor position. It fell to Alex to "dress up" the newspaper by producing a variety of editorial cartoons dealing with issues and problems on the post, light-hearted gag images, and illustrations about life in the service; he did this "out of need—the paper's and my own," as he put it in 1973, implying that Army life had begun to pale without an avenue for artist expression. Alex knew doing panel cartoons would scratch part of his itch; the rest could be scratched by some form of ongoing narrative feature…and since the *Diary* was a newspaper, what could be more natural than adding a comic strip to its pages?

Alex reached into his portfolio for a concept he had developed in the 1940s: Jon Fury. Originally conceived as a sprawling adventure series to be sold to one of the major newspaper syndicates, the Fury idea and associated character sketches, logo, and storyline notes had been set aside as Alex began turning assignments from National into steady employment.

Now Toth resurrected Jon Fury, bringing him to Japan in search of his missing twin brother. Alex's presentation for a sixteen-week story was approved by the post adjutant and for the first time anywhere, comics were published that were conceived, written, drawn, and lettered solely by Toth, making *Jon Fury* a key milestone in Alex's career. Alex faced several logistical problems and overcame them all, producing the Fury strip from the months of April 1955 to April 1956. The artist would always recall this twelve-month period as a high-water mark in his long and varied career; *Jon Fury* may have helped divert Alex from the marital troubles brewing at home. Toth attributed the sense of fulfillment to the fact "the strip was completely my own. I wrote it all, and somehow the writing came easy for me week to week. The paper would be distributed to all the barracks on Friday afternoons and by chow time I'd know if I had a hit or a miss. Immediate reaction. The guys in the mess hall let me know, one way or the other. The strip was a kick; I enjoyed doing it."

Alex also told his friend John Hitchcock how much he valued "instant exposure and recognition from his audience," even an audience as small as the *Diary*'s six-hundred-copy press run. Is it possible Alex remembered and tried to recreate, after a fashion, these conditions amidst a small-but-devoted audience as he charted a path during the later years of his life?

• • • • •

Jon Fury helped *The QM Depot Diary* win back-to-back All-Army Awards in 1955 and 1956 (the only awards won by the paper, Alex would forever observe

with pride). As *Diary* Art Editor, Alex assumed more and more of "Omi's" duties on the newspaper; he was also named the post's Information Officer, writing news stories about life in the service. These responsibilities consumed most of Toth's daytime hours, forcing him to burn the midnight oil to meet *Jon Fury*'s weekly deadline.

Additionally, Alex's position within the Army provided latitude to exercise his restless intellect and pursue interests near and dear to his heart. One of those interests was the American Volunteer Group of World War II—the famed "Flying Tigers," under command of General Claire Chennault. As an American fighter squadron crucial to the defense of China before America's formal entry into "the Big One," the Tigers shot down over two hundred Axis fighter craft while sustaining minimal losses. They preserved the tactically vital "Burma Road" supply line and counted among their number such larger-than-life personalities as Greg "Pappy" Boynton (portrayed by actor Robert Conrad on the mid-'70s TV series *Baa Baa Black Sheep*) and Charles Older, who in later life served as presiding judge at Charles Manson's trial for the lurid murder of actress Sharon Tate.

Aside from their aerial derring-do, the Tigers held a fascination for Alex because one of their number, Bert Christman, had joined Chennault's outfit after building a career in comics. Christman drew the *Scorchy Smith* strip after Noel Sickles and before Frank Robbins; he also provided art for National's "Sandman" feature that appeared in *Adventure Comics* starting with issue #40. Christman was one of the few casualties experienced by the Flying Tigers, being shot down and machine-gunned to death during an intense firefight.

With the Tigers' charismatic leader in Taiwan during Toth's Japanese tour of duty, the hero-worshipping artist arranged a meeting:

> I interviewed General Claire Lee Chennault in Formosa for my post newspaper while on leave, plane-hopping to Hong Kong. I asked him about [Bert] Christman, the man and the pilot.
>
> Christman had quit *Scorchy Smith* to become one of the first twenty-five members of Chennault's…Flying Tigers, before the Second World War. Chennault remembered Christman, a youngster insistent and eager for combat, but just not ready for it, and so was kept in rear areas, training. Chennault yielded to Christman's urgings twice, resulting in Christman's loss of two P-40s. It was back to training missions until the day he went up for his third and last combat mission: eighteen [Tigers] defended Rangoon against a seventy-two-plane Japanese attack force— and it was then that Christman bought it. He was only twenty-six.

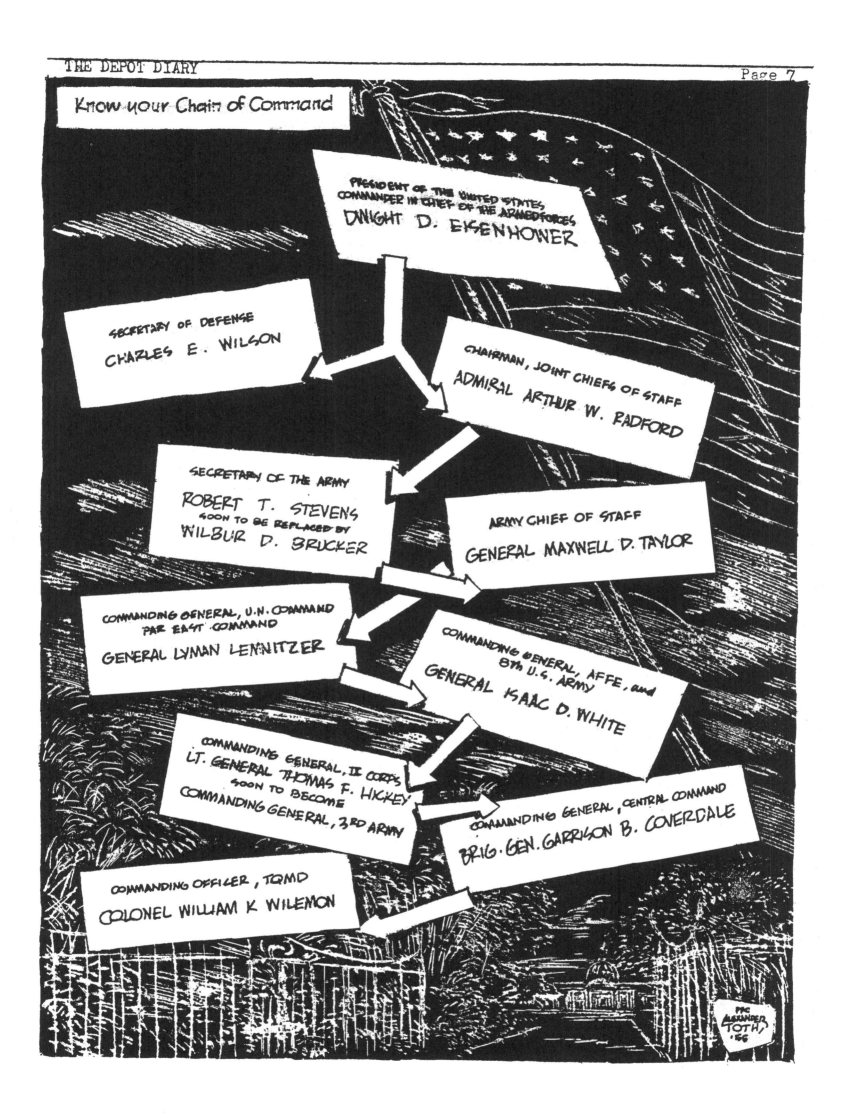

THE DEPOT DIARY

Authorized Publication, Tokyo
Quartermaster Depot

An authorized publication published weekly by and for the personnel of the Tokyo Quartermaster Depot, 8080th AU, APO 1051, by the TI&E Section. Editorial views and opinions are not necessarily those of the Department of the Army. (Copy deadline for next issue, 18 April 1955.)

Colonel William K. Wilemon, C. O.

Capt L. F. Christensen, TI&E, OIC

Cpl F. S. Leichter, Managing Editor

Pfc Alexander Toth, Art Editor

Chaplain E. M. Tainton, Jr.

Let us Worship on Mother's Day

Chaplain Charles Fisher

By Chaplain Charles Fisher

ABOVE: Headers for *The Depot Diary.*

OPPOSITE: Bongo player drawn in December 1957 (note the faint "Merry Christmas" and "Happy New Year" on the bongo skins).

Toth's military career ended on May 11, 1956. "Back to civvy life—oh, what a happy day it was! (But I had a good time of it, overseas)!" he noted in a letter written on the twenty-fifth anniversary of his discharge. Returning stateside was a joy, but the climate Alex found within the comics industry upon his return was far from pleasant.

Dr. Frederic Wertham's 1954 anti-comics screed, *The Seduction of the Innocent*, had helped fuel U.S. Senate hearings concerning a possible connection between comics and juvenile delinquency. Though the Senate subcommittee's final report pointed to no such connection, the publicity surrounding the hearings caused comics to be banned from many households. The industry instituted the Comics Code Authority in an effort to prove itself a home for wholesome children's entertainment, though to many young readers the bland, formulaic comics of that period were as boring as they were wholesome. Sales drooped across the board, with some lines forced to suspend publication altogether. Alex talked about this sad state of affairs with Jim Amash:

I briefly visited New York and business was terrible. Stan Lee said, "Alex, get out of the business, because it's dead or dying. There isn't any work to go around. Sales are off. Nobody knows what to do to save it. Get into something else that you can make money on."

He said, "We've cut our rates to twenty-two dollars a page. I don't dare offer you or any other pro that. What can I do? I'm using kids out of art school who'll take it."

The rates were low, but the need for work was great: Toth produced a small number of Western and romance stories for Lee's Atlas line of comics ("He wasn't too crazy about them," Alex remembered). He also landed an assignment to adapt a portion of the CBS News documentary series *Air Power* into a giveaway comic for the Prudential Insurance Company. Sequences featuring prototype airplanes and World War I dogfights were interspersed with shots of civilians dancing the Charleston, flocking to cinemas, and helping to create what would eventually become known as popular culture. The assignment also gave Alex the opportunity to demonstrate his facility for caricature as he provided several excellent likenesses of *Air Power*'s narrator, the estimable Walter Cronkite. To assist the artist, CBS provided a sixteen-millimeter print of the documentary and a tabletop film editing machine, which Toth used to isolate specific frames that would serve as the basis for his comic book panels. For a major film buff, this was a unique and fun assignment.

Unfortunately, one cannot live on fun alone. With the New York scene so depressed and depressing, Alex again moved west to California, initiating a series of events that would forever shape both his personal and professional lives.

PAGES 202–245: Alex Toth originally created the weekly "Jon Fury" for his camp newspaper, *The Quartermaster Depot Diary*, while he was on active military duty in 1955 and 1956.

The challenge of restoring "Jon Fury" from Toth's near-complete set was considerable. The sketchy quality of the original multigraph publication was complicated by the fact that these photocopies were made at a time when copying technology was in its infancy. As seen in the typical example below, the pages needed extensive digital work. We have restored—rather than remastered—these pages, preserving Toth's original intent, and giving a sense of what it was like for men in the barracks to read the weekly installments. In cases where Toth's intent was unclear, we have left it to the reader's imagination.

BELOW: Alex Toth explains the process used in creating the strip in this 1973 essay from the fan magazine *Wonderworld*.

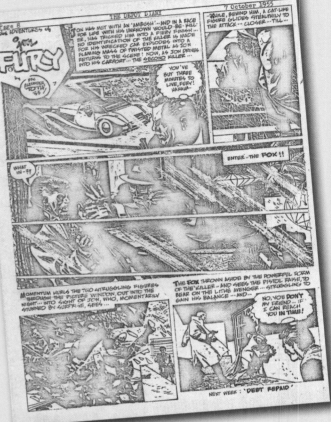

About JON FURY...

Jon Fury was created back in the late '40s, and I, in my youthful naivete, intended to sell him as a "Sunday page only." I had title, logo, storylines, sketches, and formats for page designs all worked up—but soon, caught up in heavier comic book workload, "Jon Fury," like many other original adventure strip "workups," was filed away for "future use."

Years later, 1955, I found myself in the U.S. Army, in Tokyo, Japan. The Art Editor post on our camp newspaper was created so that I might lend a hand. The weekly was 8-pages, printed on multigraph machines, 600 copies at a time, and it had one artist—a Japanese civilian employed to redraw the logo each issue and letter new article headlines!

Out of "need"—the paper's and my own—I drew all sorts of gag, editorial, and service cartoons to dress up the pages of typed columns. Remembering "Jon," I set out to recreate him and to write and draw a 16-week storyline, one full page a week. WAC Capt. "Millie" McNulty, our adjutant, gave me an okay on my presentation—and I went off to work out ways and means of drawing the strip for the multigraph process...

I discovered that I'd have to draw print size, about 6" x 9", and in multigraph pencil on wax-surfaced multigraph paper!

Terrible news, this! Erasures ruined the wax layer...thus, I blue-penciled as lightly as possible, and then used the multigraph pencil for the "finish"—a disaster! As the first five weekly pages will show. I kept badgering "Omi," the staff artist, and the gang in the press room to suggest an ink that would allow me the use of my rapidograph pens. But I was told that inked drawings on the wax-surfaced paper would "lift" and "tear" the images, and we'd have to discard the original before the end of our 600-print run. Damn!

I borrowed a jug of press ink, and began to mix up varying proportions of it and the Pelikan font ink I normally used in my rapido-graph, to find a balanced mixture thick enough to flow through my pen without fouling the very thin ink valve inside!

After many tries and a few ruined pens, I hit it!

Test runs proved it worked without "tearing up" the drawn image—on 50-odd prints. But would it work for our 600-print run? We had to chance it, as time was too short for longer test runs. So—we did it! I can't remember if it was the fifth or sixth page that was the first "inked" job...but the change is noticeable. My pen was fine-line, and allowed me detail and lettering consistency impossible to achieve with the multigraph pencil of yore. So one more wrinkle ironed out! In the year I wrote and drew "Jon Fury," my pens were corroded by the creosote-based press ink, and I went through many of 'em—all at my own expense.

Re: that year. It was one of the happiest, most fulfilling years in memory, for the strip was well-received by the men on our post, and was the first item read by them at evening chow on Fridays—our distribution day. (And "Jon Fury" won our paper two consecutive awards for entertainment features in the annual Department of Defense service-wide newspaper competition!).

I was delighted with the men's good-natured comments, pro and con, and their questions about "next week," etc., while in that evening mess—and I felt assured about writing my own continuity, on a "demand deadline" basis. (I remember writing about six weeks' dialogue/scene description on one very happy day. This was in the second 16-week adventure, wherein I first introduced "The Fox.") My flurries of writing, since then, have been few and far between—my eternal frustration, in fact!

I loved every minute of it, tough or easy, from day to day, between my other duties on the paper. I was taking on much more responsibility for the work previously assigned to our civilian artist, and the added job of Non-Com P10, covering and writing news stories in and relating to our service life, working with Army photographers, and so on, all chewed up most of my 8-to-5 time—and necessitated many long nights on the drawing board to keep ol' "Jon" on deadline!

The period of the mid-'50s had an idiom so different from today's. Thus, my writing in "Jon Fury" reflects some of it. The world was younger, so was I—both a bit less jaded than we are today. The Korean War had cooled down, and prospects of all kinds, for all of us, then, seemed brighter. I fancied "Jon Fury" sold, syndicated, and successful—but he just didn't make it. And other American Indians, like "Jon," didn't either. In war, in peace...or in print!

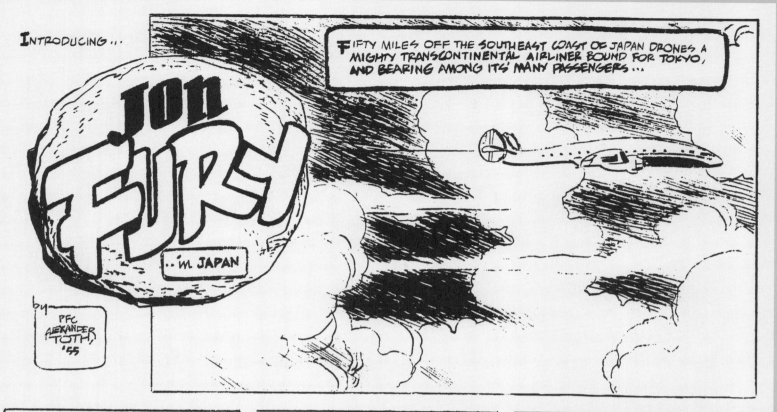

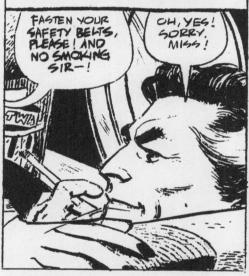

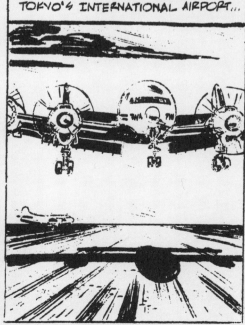

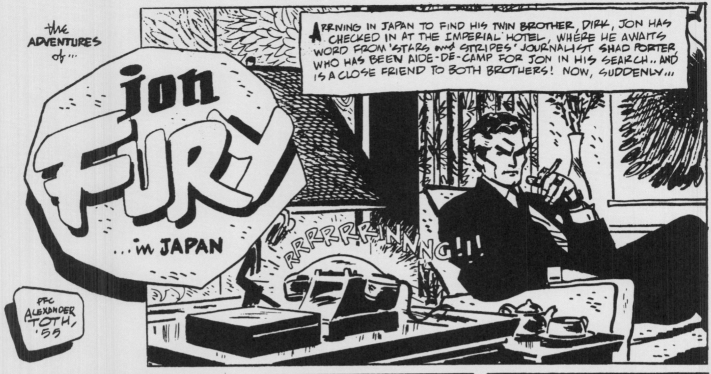

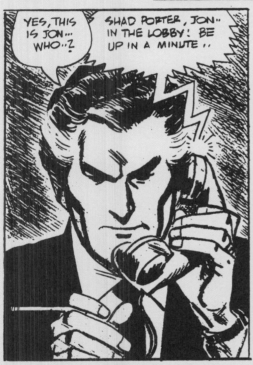

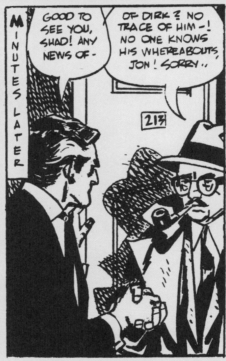

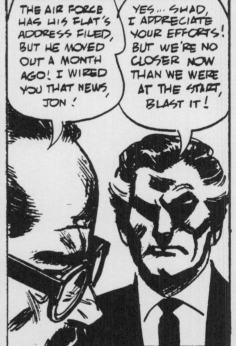

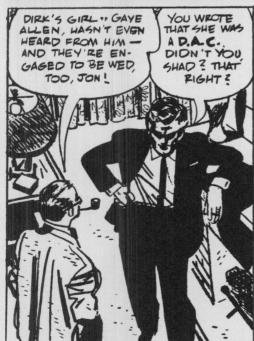

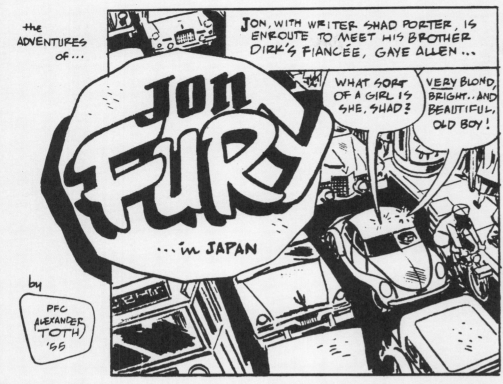

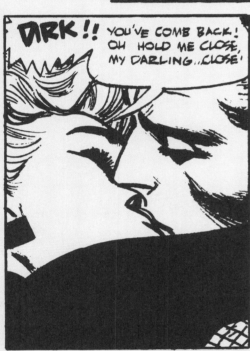

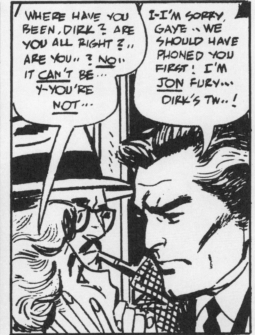

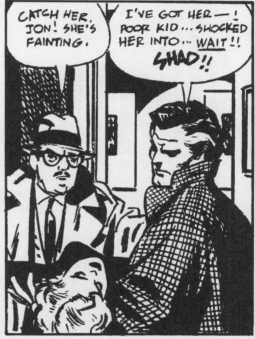

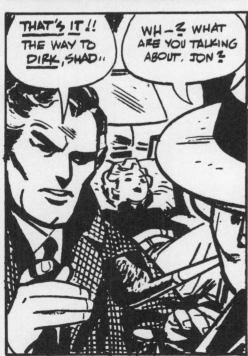

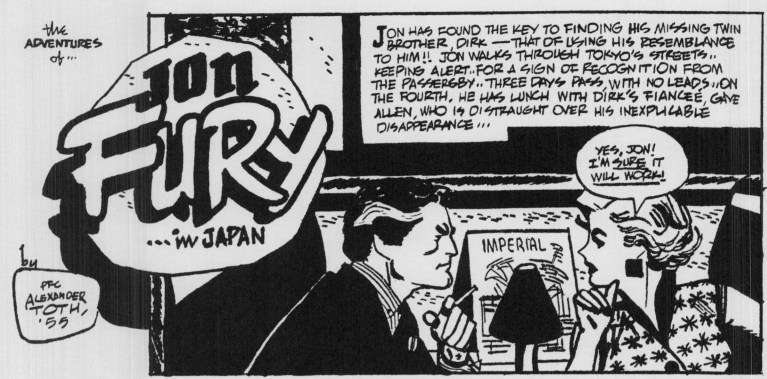

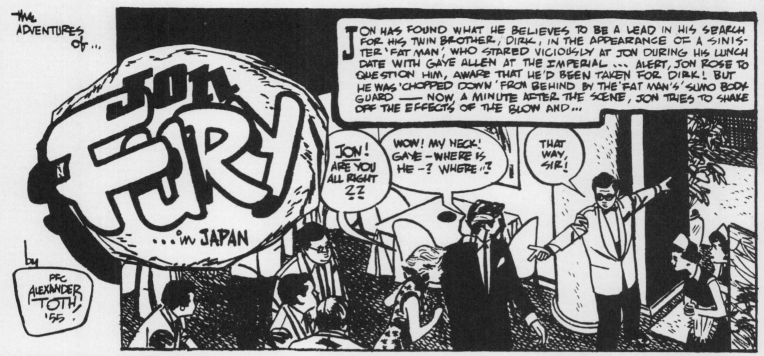

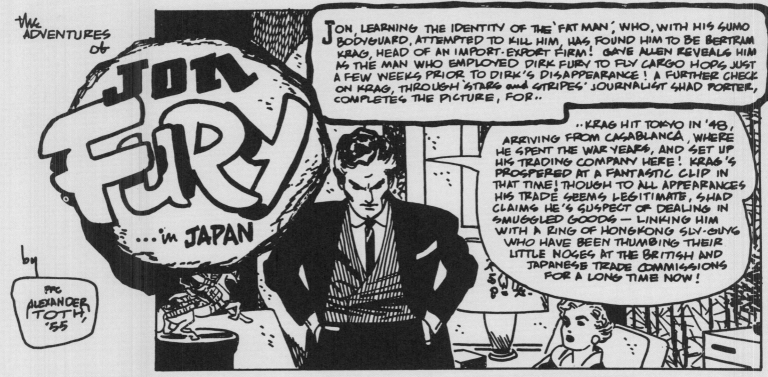

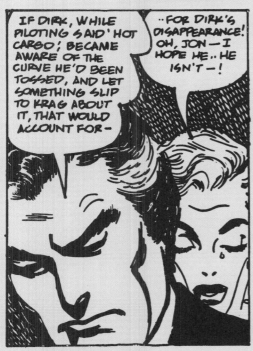

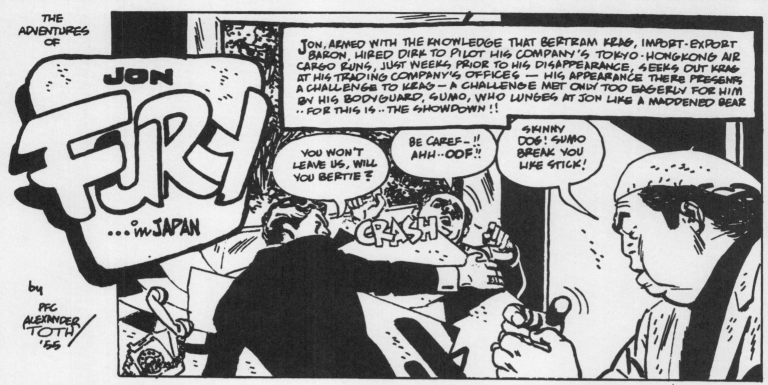

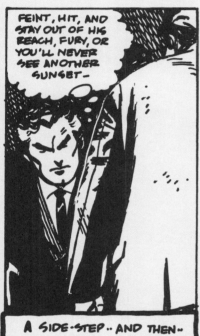

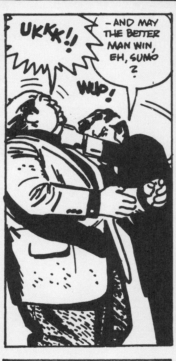

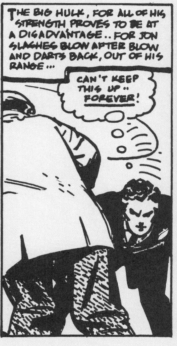

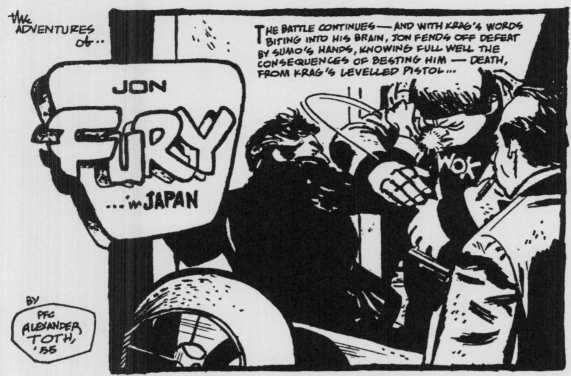

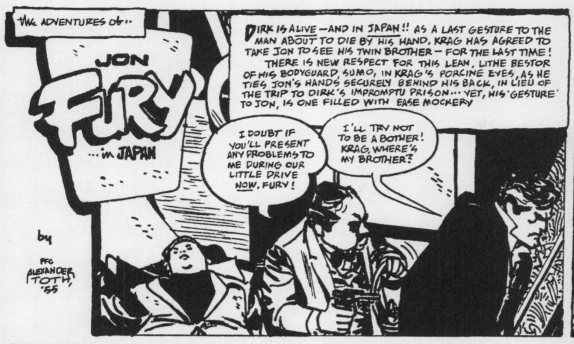

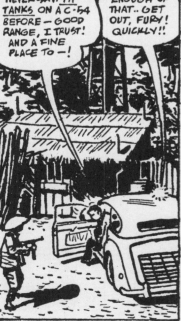

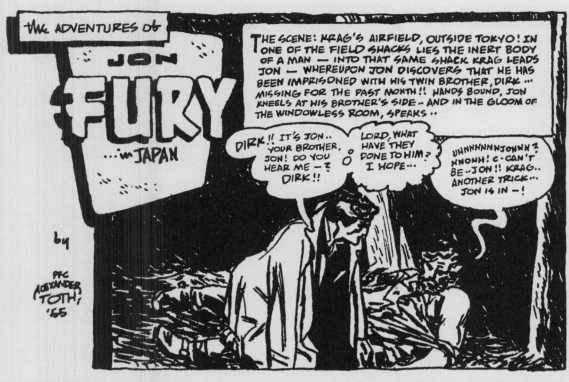

THE SCENE: KRAG'S AIRFIELD, OUTSIDE TOKYO! IN ONE OF THE FIELD SHACKS LIES THE INERT BODY OF A MAN — INTO THAT SAME SHACK KRAG LEADS JON — WHEREUPON JON DISCOVERS THAT HE HAS BEEN IMPRISONED WITH HIS TWIN BROTHER, DIRK — MISSING FOR THE PAST MONTH!! HANDS BOUND, JON KNEELS AT HIS BROTHER'S SIDE — AND IN THE GLOOM OF THE WINDOWLESS ROOM, SPEAKS —

DIRK!! IT'S JON — YOUR BROTHER, JON! DO YOU HEAR ME — ? DIRK!!

LORD, WHAT HAVE THEY DONE TO HIM? I HOPE —

UHNNNNNNJONNN? NNOHH! C-CAN'T BE—JON!! KRAG — ANOTHER TRICK — JON IS IN—!

by

PFC ALEXANDER TOTH, '55

DIRK, LOOK AT ME! WE HAVEN'T MUCH TIME LEFT!

JON—!!—IT IS YOU—BUT—YOU WERE BACK IN— H-HOW DID YOU FIND—? HOW—??

LATER, DIRK—MY HANDS—UNTIE THEM WHILE WE TALK! LISTEN—KRAG PLANS TO DO US IN! ARE YOU STRONG ENOUGH TO MAKE A LAST DITCH STAND?

I-I THINK I MIGHT BE ABLE TO HELP—SOMEHOW, JON—

AFTER WHAT SEEMS LIKE HOURS, DIRK'S SHAKING HANDS FREE JON'S FROM THE BITING ROPES —

FINE, DIRK! NOW THEN — THERE'S NO WAY OUT OTHER THAN THAT DOOR—AND AN ARMED GUARD SITS OUTSIDE IT—WE'VE GOT TO TRICK HIM, SOMEHOW—! I'VE GOT IT!! THE ROOF—IT'S THATCHED—AND IF I'VE STILL GOT MY LIGHTER—YES!! DIRK—BACK INTO THAT CORNER—I'M GOING TO FIRE THE ROOF!

JON FIRES ONE CORNER OF THE ROOF—! THE DRY THATCH CRACKLES ABLAZE IN SECONDS!

I'M BANKING ON THE GUARD PANICKING AND OPENING THAT DOOR—! IF I'M WRONG WE'RE BARBECUED BEEF, AU NATUREL! HOPE DIRK CAN HOLD OUT LONG ENOUGH TO CLEAR THE FIELD —

SOON, OUTSIDE THE SHACK—

AIYYEEEEE!! KAJI!! KAJI!! —TATSUKETE!!! HAYAKU!!

YOU'VE KEPT US WAITING, FRIEND! COME ON, DIRK!!

MAKE WAY FOR THE BEARDED BUMPKIN—

I'VE GOT HIS LITTLE POP GUN!

KRAK!

DOWN, DIRK! THERE'S MORE OF THEM—WHA—? KRAG'S PLANE IS ON THE STRIP, WARMING UP!! THERE HE IS—MAKING TRACKS TO IT!! GOT TO STOP HIM—DIRK, COVER ME—!! IF I CAN MAKE IT TO KRAG'S CAR, I MIGHT BE ABLE TO — UGHNNNN—HIT!!

ZING POW!

JON! WHERE?

SHOULDER!! UGHH!! COVER ME — CAN'T LET BERTIE HAVE THE LAST INNING — 'BYE FOR NOW, BLACKBEARD THE PILOT!

JON!! NO!! YOU CAN'T MAKE IT—!!

KAPOWWW

ZING

* NEXT WEEK —— R. BERTRAM KRAG

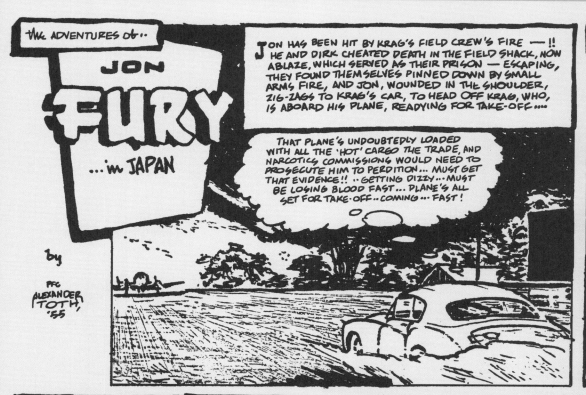

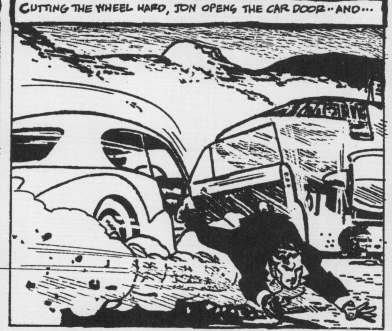

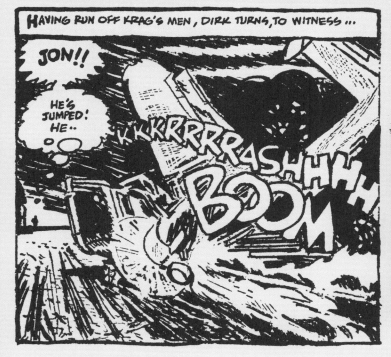

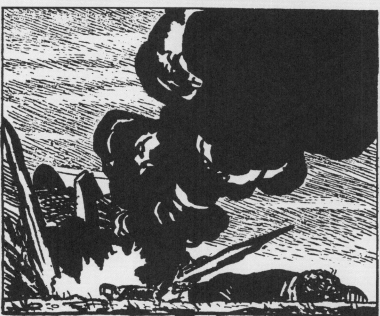

NEXT WEEK — 'VENI, VIDI, VICI'...

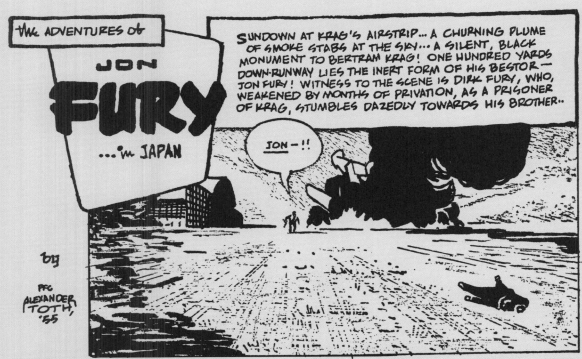

THE ADVENTURES OF JON **FURY** ...IN JAPAN

by PFC ALEXANDER TOTH, '55

SUNDOWN AT KRAG'S AIRSTRIP... A CHURNING PLUME OF SMOKE STABS AT THE SKY.... A SILENT, BLACK MONUMENT TO BERTRAM KRAG! ONE HUNDRED YARDS DOWN-RUNWAY LIES THE INERT FORM OF HIS BESTOR— JON FURY! WITNESS TO THE SCENE IS DIRK FURY, WHO, WEAKENED BY MONTHS OF PRIVATION, AS A PRISONER OF KRAG, STUMBLES DAZEDLY TOWARDS HIS BROTHER..

JON—!!

BUT EXHAUSTION OVERTAKES DIRK... AND WINS OUT...

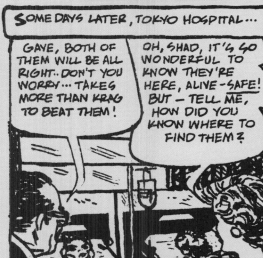

SOME DAYS LATER, TOKYO HOSPITAL...

GAYE, BOTH OF THEM WILL BE ALL RIGHT.. DON'T YOU WORRY... TAKES MORE THAN KRAG TO BEAT THEM!

OH, SHAD, IT'S SO WONDERFUL TO KNOW THEY'RE HERE, ALIVE-SAFE! BUT — TELL ME, HOW DID YOU KNOW WHERE TO FIND THEM?

A FIRE, AT KRAG'S FIELD, CALLED IN BY THE LOCAL VILLAGE SPOTTER STATION, WAS FORWARDED TO THE JAPANESE POLICE, BECAUSE OF KRAG'S BEING INVOLVED — ONE OF THE DETECTIVES, ENROUTE TO THE SCENE, CALLED, AND PICKED ME UP—

"WE ARRIVED TO FIND THE FIREMEN DOUSING THE FIRE OF KRAG'S PLANE CRACKED UP ON THE RUNWAY — BOTH DIRK AND JON LYING UNCONSCIOUS NEARBY... AS I SEE IT, JON FREED DIRK, STOPPED KRAG BY RAMMING A CAR INTO HIS PLANE TO PREVENT KRAG'S TAKING OFF.. WHICH ENDED KRAG'S CAREER — FOR KEEPS! WE SEARCHED THE SHIP — FOUND MORE THAN A HALF-MILLION DOLLARS WORTH OF NARCOTICS... A TIDY NEST-EGG TO START ANEW ELSEWHERE FOR KRAG... BUT JON WOULD HAVE NONE OF THAT—SOOO...

—SOOO, "VENI, VIDI, VICI" FOR THE FURY BROTHERS!

"THEY CAME, THEY SAW, THEY CONQUERED"... JON, IN A MATTER OF WEEKS, WRAPPED IT ALL UP, WITH NO LOOSE ENDS! AH, HE'S UP...

WH—? WELL, HELLO, PEOPLE! YOW..SHOULDER, AND.. DIRK!! IS HE—ALL RIGHT? WHAT HAP-?

JON, THANKS TO YOU, A SHAVE, SOME REST, AND GOOD FOOD IS ALL HE NEEDS!

YOU FORGOT AN ITEM WENCH!

WHAT'S THAT?

WHAT HE NEEDS MORE THAN ANY-THING ELSE IS.. YOU, GAYE!

YOU'RE MAKING ME WONDER IF I'M MARRYING THE RIGHT 'TWIN'—

HEAR, HEAR!!

WE COULD ELOPE BEFORE THEY REMOVE THE COBWEBS FROM HIS HEAD

• NEXT WEEK — 'BEST MAN'

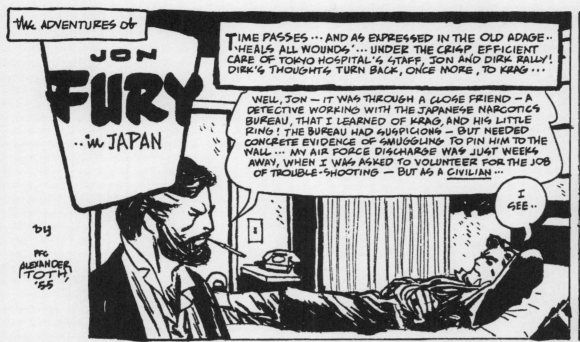

THE ADVENTURES OF JON FURY ...in JAPAN

by PFC ALEXANDER TOTH, '55

TIME PASSES ··· AND AS EXPRESSED IN THE OLD ADAGE·· 'HEALS ALL WOUNDS'··· UNDER THE CRISP EFFICIENT CARE OF TOKYO HOSPITAL'S STAFF, JON AND DIRK RALLY! DIRK'S THOUGHTS TURN BACK, ONCE MORE, TO KRAG ···

WELL, JON — IT WAS THROUGH A CLOSE FRIEND — A DETECTIVE WORKING WITH THE JAPANESE NARCOTICS BUREAU, THAT I LEARNED OF KRAG, AND HIS LITTLE RING! THE BUREAU HAD SUSPICIONS — BUT NEEDED CONCRETE EVIDENCE OF SMUGGLING TO PIN HIM TO THE WALL ··· MY AIR FORCE DISCHARGE WAS JUST WEEKS AWAY, WHEN I WAS ASKED TO VOLUNTEER FOR THE JOB OF TROUBLE-SHOOTING — BUT AS A <u>CIVILIAN</u> ···

I SEE··

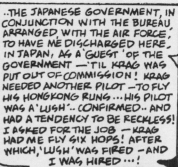

··THE JAPANESE GOVERNMENT, IN CONJUNCTION WITH THE BUREAU, ARRANGED, WITH THE AIR FORCE, TO HAVE ME DISCHARGED HERE, IN JAPAN, AS A 'GUEST' OF THE GOVERNMENT — 'TIL KRAG WAS PUT OUT OF COMMISSION! KRAG NEEDED ANOTHER PILOT — TO FLY HIS HONGKONG RUNG ··· HIS PILOT WAS A 'LUSH'·· CONFIRMED·· AND HAD A TENDENCY TO BE RECKLESS! I ASKED FOR THE JOB — KRAG HAD ME FLY SIX HOPS! AFTER WHICH, 'LUSH' WAS FIRED — AND I WAS HIRED ···! ·BOUT TIME I SHAVED··

··I KEPT MY EYES OPEN — MY MOUTH SHUT··· KRAG WAS SMOOTH·· PASSED THROUGH CARGO CHECKS AT EACH END OF THE RUN··· NOTHING SUSPICIOUS! BUT THOSE TIP-TANK UNITS ON THE C-54 INTRIGUED ME, JON··

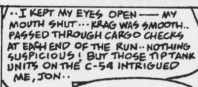

DITTO! THEY MADE FINE CONTAINERS FOR CERTAIN SMALL, 'HOT' CARGO PACKAGES, HMMMH?

RIGHT!! SUMO CAUGHT ME CHECKING THEM ONE NIGHT, AND IT WAS THE 'BASTILLE' FOR ME··· AFTER I'D BEEN FORCED TO CALL GAYE TO SAY I'D BE GONE FOR ONE MONTH··· CLOSED MY FLAT··· I COULDN'T HAVE HER SUSPECT ANYTHING, OR THEY'D HAVE KILLED HER··! NOW — ALL'S WELL! TAKE A BOW, JON··! WITH YOUR HELP, AND A FAT CHECK FROM THE JAPANESE GOVERNMENT, I'M READY TO STEP INTO MY NEW ROLE AS HUSBAND TO THE SWEETEST BLONDE IN THE FAR EAST!

YOU DON'T DESERVE HER, YOU 'PROBLEM CHILD'!

I KNOW IT, AND YOU KNOW IT ··· IT'LL BE <u>OUR</u> SECRET, EH? SAY, JON — HOW DO I LOOK WITH A 'COOKIE-DUSTER'?

LIKE A WALRUS! SHAVE IT OFF!!

JUST THEN, GAVE ···

HI, DARL —! WELLLL ··· JON, WON'T YOU DO ME THE HONOR OF INTRODUCING ME TO MR. FLYNN?!

DON'T FLATTER HIM, GAYE ··· THERE'LL BE NO LIVING WITH HIM!

DO YOU MIND, HON'? I'VE BECOME RATHER ATTACHED TO THE THING!

AFTER ALL — IF I DON'T MAINTAIN <u>SOME</u> DISTINCTION OVER MY 'CARBON COPY' HERE, YOU WON'T BE ABLE TO TELL THE GROOM FROM THE BEST MAN WITHOUT A SCORE CARD!!

WHAT A TRAGEDY THAT WOULD BE —!

PERHAPS SOME LI'L BLUE RIBBONS IN IT WOULD HELP, DIRK! I LOVE YOU YOU BIG LUG·· MUSTACHE AND ALL —!

AND AS FOR <u>YOU</u>, JONATHAN! YOU HAVE BEEN RELEGATED THE OFFICE OF 'BEST MAN' — AND SHALL BE CALLED UPON TO EXERCISE YOUR DUTIES, AS SUCH, NEXT SUNDAY MORN' AT 10, AT TOKYO CHAPEL, WITHOUT FAIL! CHECK?

CHECK! IT SHALL BE AN HONOR, AND AN EVEN GREATER PLEASURE TO DO SO!

I GROW THE MUSTACHE — AND HE MAKES ROMANTIC SPEECHES!

ALRIGHT, DON JUAN — INTO YOUR CLOTHES, <u>BOTH</u> OF YOU·· THE HOSPITAL'S DISCHARGED YOU BOTH! HURRY — ONLY SICK FOLKS ALLOWED HERE! HAYAKU, NE?

GREAT! WE'LL HAVE SOMETHING TALL AND COOL, IN A GLASS, AT THE IMPERIAL, BEFORE I SEE MY TAILOR 'BOUT SOME NEW CLOTHES, EH?

CHAMPION IDEA, DIRK! GAYE — IF YOU'LL EXCUSE US FOR A BIT, WE SHALL DO OUR LEVEL BEST TO BE DRESSED, IN TWO SECS! <u>OUT WITH YOU</u>!

NEXT WEEK 'THE WEDDING' ···

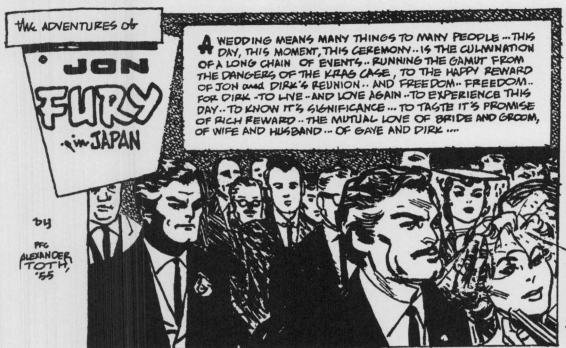

THE ADVENTURES OF JON FURY in JAPAN

BY PFC ALEXANDER TOTH '55

A WEDDING MEANS MANY THINGS TO MANY PEOPLE ... THIS DAY, THIS MOMENT, THIS CEREMONY ... IS THE CULMINATION OF A LONG CHAIN OF EVENTS ... RUNNING THE GAMUT FROM THE DANGERS OF THE KRAS CASE, TO THE HAPPY REWARD OF JON AND DIRK'S REUNION .. AND FREEDOM .. FREEDOM .. FOR DIRK -TO LIVE -AND LOVE AGAIN -TO EXPERIENCE THIS DAY .. TO KNOW IT'S SIGNIFICANCE ... TO TASTE IT'S PROMISE OF RICH REWARD .. THE MUTUAL LOVE OF BRIDE AND GROOM, OF WIFE AND HUSBAND ... OF GAYE AND DIRK

AS THE MARRIAGE VOWS ARE REPEATED IN THE SOFTLY WHISPERED WORDS OF LOVERS, OVERTONED BY THE PADRÉ'S CLEAR, CRISP VOICE.. THE FACE OF JON FURY REVEALS .. A NEW REFLECTION OF MOOD .. FOR HERE, IN THIS CHAPEL, IN TOKYO, VIEWING HIS BROTHER AND BRIDE TAKING THEIR TROTH, A PANG OF LONELINESS BITES INTO HIS VITALS ...

FOR THOUGH HIS LIFE HAS BEEN A FULL, AND ADVENTUROUS ONE .. ONE OF GREAT SUCCESS, PROFESSIONALLY AND SOCIALLY .. IT HAS BEEN, AND REMAING TO BE, BUT A SOLITARY EXISTANCE ... WITH NO ONE TO SHARE HIS SUCCESSES, OR HIS TRIBULATIONS .. BUT .. "PERHAPS" .. "PERHAPS" THINKS JON, "FATE HAS SO ORDAINED IT" .. THAT HE SHOULD WALK ON, ALONE .. ALONE AMONG MANY ...

AS MERELY AN OBSERVER OF OTHERS' HAPPINESS ... PERHAPS ... BUT SOON, SO VERY SOON, HE MUST LEAVE JAPAN ... LEAVE DIRK AND HIS BRIDE TO THEIR OWN PATHS, TO THEIR EUROPEAN HONEY-MOON ... LEAVE SHAD PORTER, OLD FRIEND AND CONFIDANTE, WITHOUT WHOSE AID THIS DAY MIGHT NOT HAVE COME TO PASS .. LEAVE THIS RADIANT SCENE BEHIND ...

TAKING WITH HIM THE MEMORIES OF IT ALL .. THE HURTS, THE FEARS, THE JOYS, AND THE SADNESS .. FOR TOMORROW, A SLEEK TWA CONSTELLATION SHALL BE CARRYING HIM BACK .. BACK TO HIS DESK ... BACK -TO 'FURY PRODUCTIONS, INC.' .. BACK TO HIS STAFF AND BUSINESS ASSOCIATES .. TO THE RESTFUL QUIET OF HIS BEACH HOUSE .. TO HIS FEW CLOSE FRIENDS .. BUT, SOMEHOW, 'ANTICIPATION' IS AS A STRANGER TO JON ... FOR ONCE AGAIN, HE SHALL BE ..

AS HE IS NOW ... ALONE .. AMONG MANY ...

CONGRATULATIONS, DIRK .. AND ALL THE HAPPINESS IN THE WORLD TO YOU TWO HONEYMOONBUGS! I'D LIKE ...

HEY, LET US AT 'EM, JON .. IT'S OUR TURN! HAHA!

ALL THE BEST, KIDS!

OH, JON THANKY-!

KISS THE BRIDE, GAYE?

IT WAS SUCH A BEAUTIFUL—

LOTS OF LUCK, DIRK ..

YOU LOOK LONELY, GAYE —!

LUCKY GUY, DIRK!

HOLD STILL, NOW!

THE MERRY CROWD WEDGES JON OUTSIDE OF IT .. AWAY FROM DIRK AND GAYE ... HE STARES QUIETLY AT THE SCENE FOR A BIT, REMEMBERING EVERY LITTLE DETAIL ... AND WITH AN ALMOST IMPERSCEPTIBLE SMILE AND A SQUARING OF SHOULDERS, TURNS, AND IN SECONDS IS OUTSIDE .. IN THE STREET .. WALKING SLOWLY ... AWAY ...

THE END

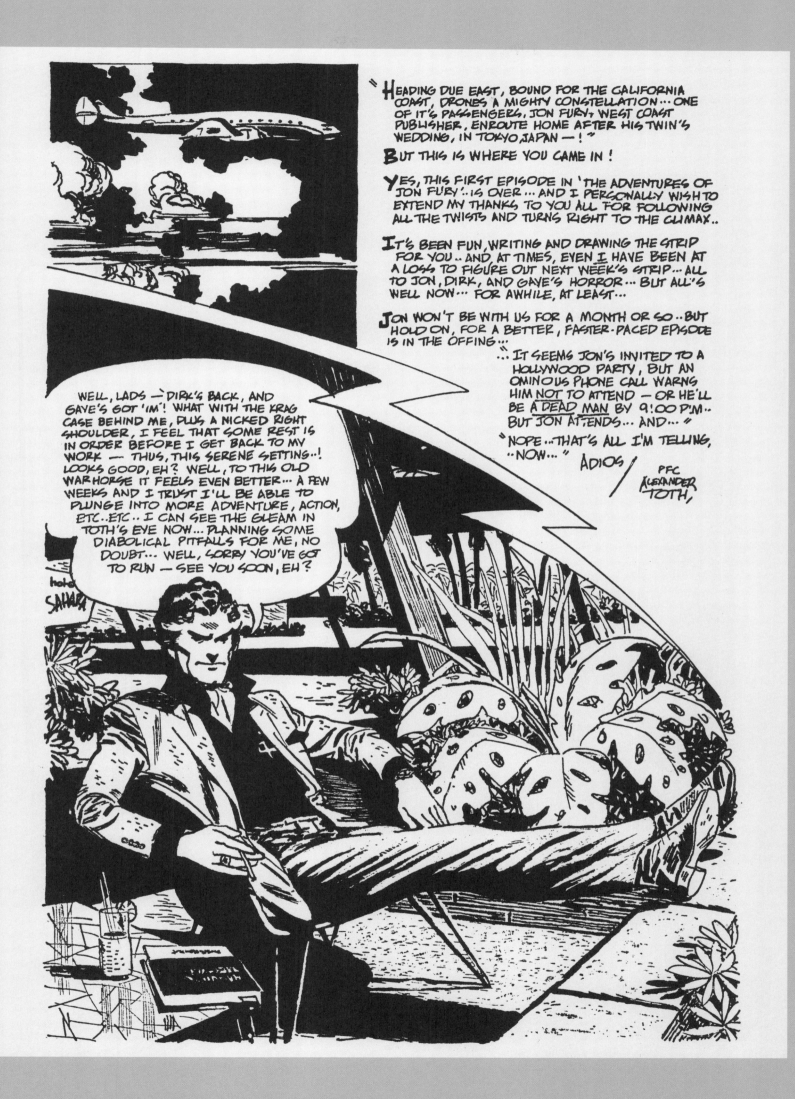

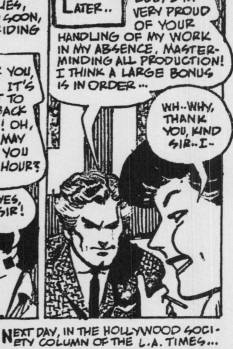

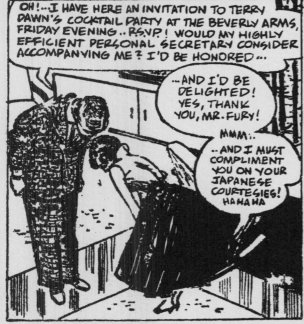

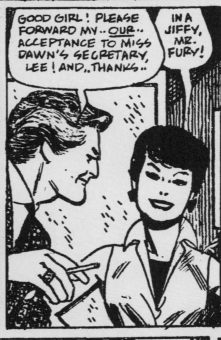

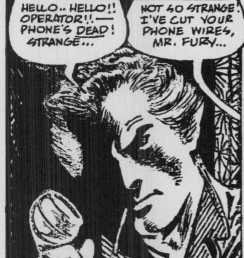

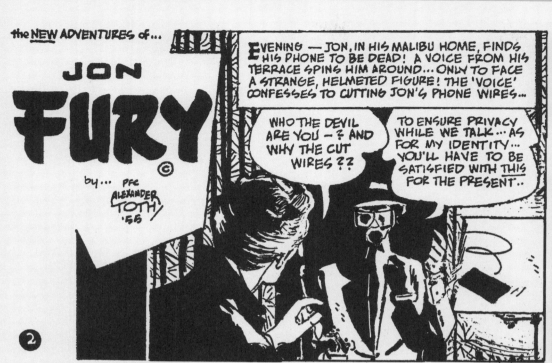

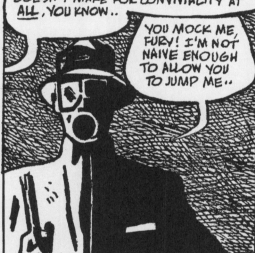

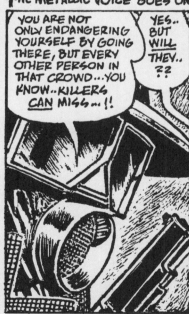

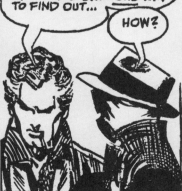

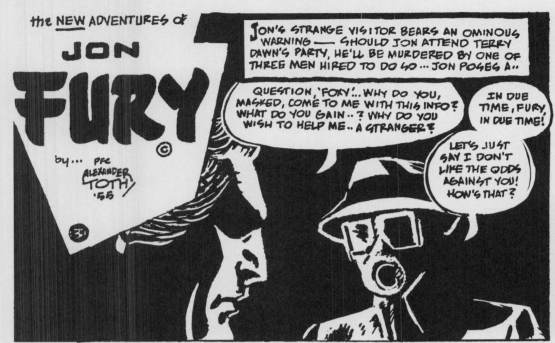

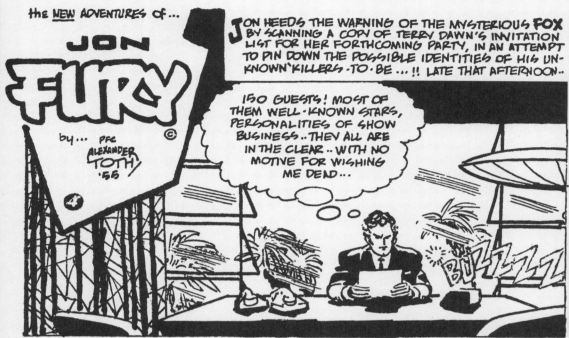

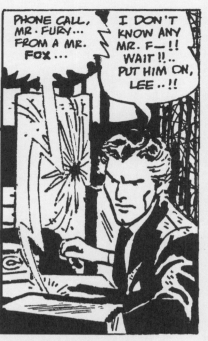

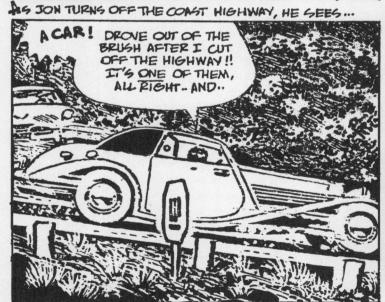

the NEW ADVENTURES of...

JON FURY

© by... Pfc ALEXANDER TOTH '56

ONCE AGAIN, THE FOX CONTACTS JON.. PHONING TO WARN JON OF A CHANGE IN HIS MURDER'S TIMING! THE THREE WOULD-BE-KILLERS HAVE RECEIVED ORDERS TO KILL JON TONIGHT.. AND AS HE HEADS FOR HOME, HE NOTICES..

A CAR!! PICKED ME UP AS I CUT OFF THE HIGHWAY... CLOSING FAST!! COME ON, OLD BOY — WE'VE TEN MILES OF WILD ROAD AHEAD..

JON'S SPEEDOMETER SURGES ... BUT THE SECOND CAR HAS MATCHED HIS SPEED.. STAYING IN SIGHT !! JON'S ONLY HOPE IS HIS BETTER-HANDLING CAR ON THE MANY TURNS AHEAD, TO PUT HIM OUT OF RANGE OF HIS FOLLOWER'S FIRE ...

AHEAD NOW, A LONG STRAIGHTAWAY, AT ITS END, A SHARP, BLIND TURN ...

JON 'GUNS' HIS ROADSTER INTO THE TURN-

THE 'KILLER'S' CAR ATTEMPTS THE SAME

I'M BETTING ALL ON HIS UNFAMILIARITY WITH THIS ROAD...

HE THINKS HE'S GOT ME NOW ... MOVING IN FOR THE BIG "KILL"...

SCRRREECHHHHHH

SCREEEEEECH

FOR A MOMENT, THE CAR 'TRACKS' WELL, THEN THE REAR WHEELS 'BREAK' WITH THE ROAD, THE REAR END KICKS AROUND IN A DIZZY SLIDE ...AND..

SCREEEE...WUMPP!! KERRASHHBAM

"NEXT WEEK..." THREE MINUTES TO LIVE"

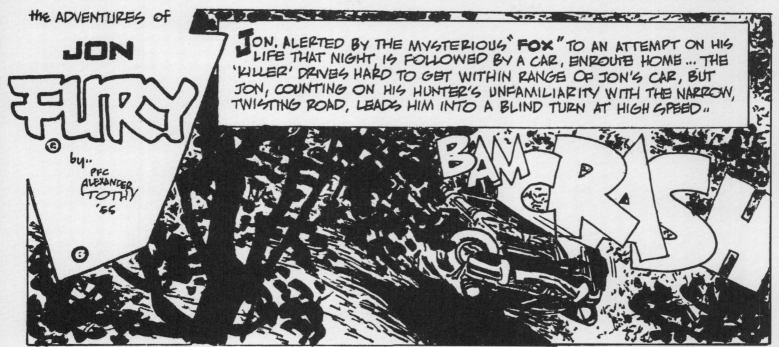

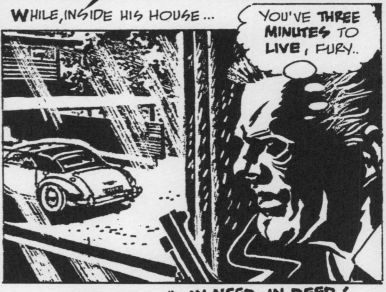

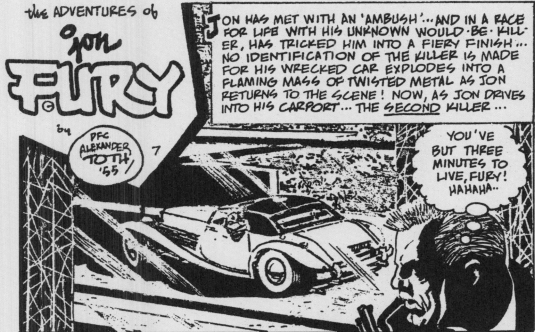

the ADVENTURES of

Jon FURY

by PFC ALEXANDER TOTH '55 / 7

JON HAS MET WITH AN 'AMBUSH'...AND IN A RACE FOR LIFE WITH HIS UNKNOWN WOULD-BE-KILLER, HAS TRICKED HIM INTO A FIERY FINISH... NO IDENTIFICATION OF THE KILLER IS MADE FOR HIS WRECKED CAR EXPLODES INTO A FLAMING MASS OF TWISTED METAL AS JON RETURNS TO THE SCENE! NOW, AS JON DRIVES INTO HIS CARPORT...THE SECOND KILLER...

YOU'VE BUT THREE MINUTES TO LIVE, FURY! HAHAHA..

"WHILE, BEHIND HIM, A CAT-LIKE FIGURE GLIDES STEALTHILY TO THE ATTACK...CLOSER...TILL...

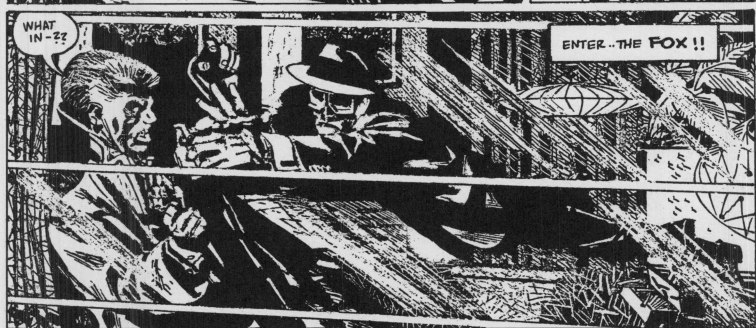

WHAT IN--??

ENTER...THE FOX !!

MOMENTUM HURLS THE TWO STRUGGLING FIGURES THROUGH THE PICTURE WINDOW, OUT INTO THE NIGHT...INTO SIGHT OF JON, WHO, MOMENTARILY STUNNED BY SURPRISE, SEES...

THE FOX THROWN ASIDE BY THE POWERFUL FORM OF THE 'KILLER'...AND SEES THE PISTOL RAISE, TO BEAR ON THE LITHE AVENGER...STRUGGLING TO GAIN HIS BALANCE...AND...

NO, YOU DON'T MY FRIEND...IF I CAN REACH YOU IN TIME!

NEXT WEEK : 'DEBT REPAID'

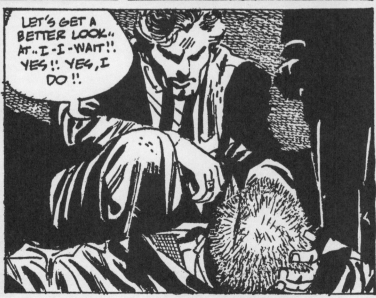

the ADVENTURES of...

JON FURY

by PFC ALEXANDER TOTH,

JON RECOGNIZES THE KILLER.. HE AND THE FOX SEARCH HIM FOR IDENTIFICATION PAPERS A WALLET AND DRIVERS LICENSE ...JON, HAVING INFORMED THE FOX OF HIS ESCAPE FROM THE 'HIGHWAY KILLER' MAKES A SURPRISING DISCOVERY AS TO THE SECOND KILLER'S IDENTITY ...

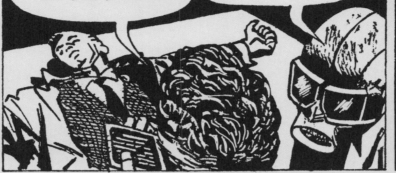

HIS NAME- RECTOR THOR!! OF COURSE!! A WASHED-OUT MOVIE VILLAIN.. HIT THE SKIDS YEARS AGO BECAUSE OF HIS HEAVY DRINKING AND INSANE EGO — TRIED TO THROTTLE A DIRECTOR ONCE, WAS THEN JAILED, BLACK-BALLED FROM THE INDUSTRY FOR LIFE... NOW A HIRED KILLER- I GUESS THIS IS THE END OF THE ROAD FOR HIM!

HE CAME CLOSE TO MAKING GOOD, AS A KILLER ...BUT NO TIME FOR CHIT-CHAT, FURY! THE PARTY'S TOMORROW NIGHT, AND EXCLUDING THE TWO HOODS WHO ATTACKED TONIGHT, YOU STILL HAVE ONE LEFT TO FACE.... BE DOUBLY CAUTIOUS IN YOUR MOVEMENTS, AT ALL TIMES — NOW, I-

YOU'VE SAVED MY LIFE, FOX.. A THING NOT EASILY FORGOTTEN.. I OWE YOU MUCH FOR ALL YOU'VE DONE.. BUT YOU OWE ME A BIT IN RETURN — AN EXPLANATION !! WHO ARE YOU? WHAT PIPE LINE DO YOU HAVE TO THE ONE HIRING THESE MEN TO KILL ME? THIS IS IMPORTANT TO ME — AND APPARENTLY, TO YOU...

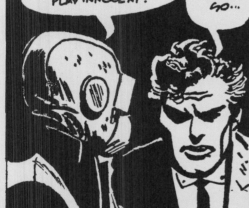

FURY, I MUST ASK YOU TO FORGET THOSE QUESTIONS FOR AWHILE ..JUST TRUST ME, AND KEEP A SHARP EYE 'TIL THIS IS ALL OVER.... HM? NOW TIE UP 'ELMER' AND CALL THE POLICE.... IF HE MENTIONS ME...IT WOULD BE WISE TO PLAY INNOCENT!

FOX, YOU DON'T GO 'TIL I FIND OUT WHO YOU ARE! NOW!! GO...

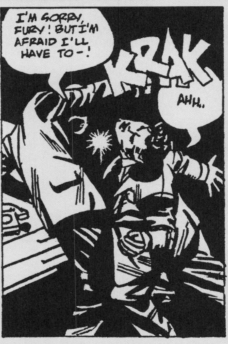

I'M SORRY, FURY! BUT I'M AFRAID I'LL HAVE TO-!

KRAK

AHH..

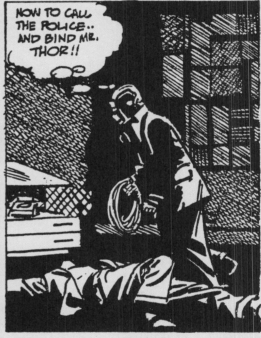

NOW TO CALL THE POLICE.. AND BIND MR. THOR!!

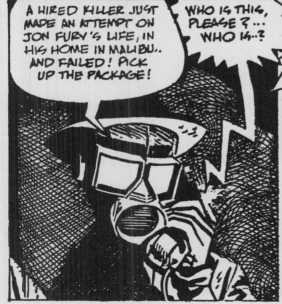

A HIRED KILLER JUST MADE AN ATTEMPT ON JON FURY'S LIFE, IN HIS HOME IN MALIBU.. AND FAILED! PICK UP THE PACKAGE!

WHO IS THIS, PLEASE?... WHO IS..?

AFTER TYING RECTOR THOR'S HANDS AND FEET, THE FOX LEAVES.... AS-

..ATTEMPTED 209 AT LODGE ROAD, MALIBU! KILLER APPREHENDED: AWAITING PICK UP... KMA 359...

THAT'S US, MIKE!

GO TO IT, GENTLEMEN.. RECTOR THOR IS WRAPPED AND READY FOX EXPRESS SHIPMENT TO THE CITY JAIL....

COMPLIMENTS OF THE FOX !

NEXT WEEK : "THE PARTY"

the ADVENTURES of...
JON FURY 10

by PFC Alexander TOTH,

THAT FATEFUL NIGHT HAS ARRIVED.. WITH IT.. DANGER! JON, WITH HIS SECRETARY, LEE HUNT, ARRIVE AT THE HUGE BEVERLY ARMS HOTEL, WHERE MEMBERS OF THE MOVIE-WORLD CALLED HOLLYWOOD, LAUNCH THE FESTIVITIES FOR TERRY DAWN, NEW STAR ON ITS' TECHNICOLORED HORIZON.. THE GREAT, AND THE NEAR-GREAT, FILL THE SPACIOUS BALLROOM WITH THEIR GAY-ETY AND ELEGANCE...

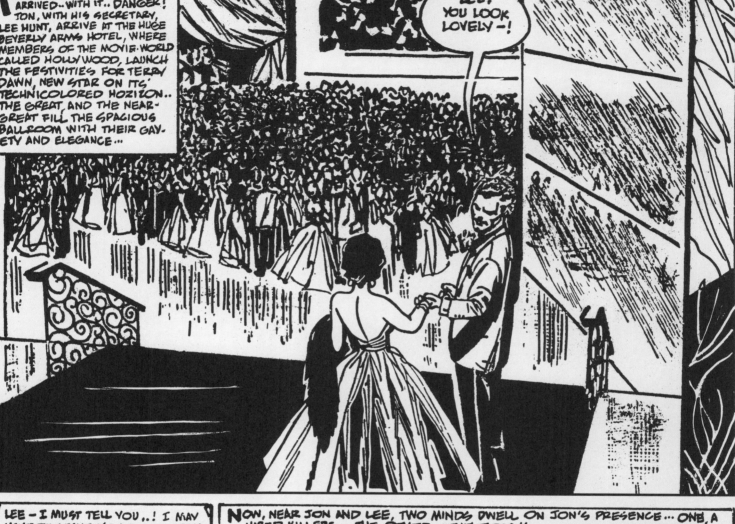

LEE, YOU LOOK LOVELY –!

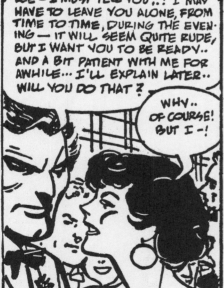

LEE – I MUST TELL YOU ..! I MAY HAVE TO LEAVE YOU ALONE, FROM TIME TO TIME, DURING THE EVEN-ING — IT WILL SEEM QUITE RUDE, BUT I WANT YOU TO BE READY.. AND A BIT PATIENT WITH ME FOR AWHILE... I'LL EXPLAIN LATER.. WILL YOU DO THAT ?

WHY.. OF COURSE! BUT I –!

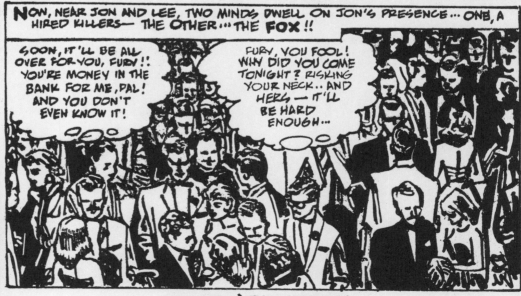

NOW, NEAR JON AND LEE, TWO MINDS DWELL ON JON'S PRESENCE ... ONE, A HIRED KILLER— THE OTHER ...THE FOX !!

SOON, IT'LL BE ALL OVER FOR YOU, FURY !! YOU'RE MONEY IN THE BANK FOR ME, PAL! AND YOU DON'T EVEN KNOW IT!

FURY, YOU FOOL! WHY DID YOU COME TONIGHT? RISKING YOUR NECK.. AND HERS — IT'LL BE HARD ENOUGH...

NEXT WEEK : 'THE ATTACK'

the ADVENTURES OF...
JON FURY (11)

...by PFC ALEXANDER TOTH,

HERE, AT TERRY DAWN'S PARTY, JON HAS COME TO FACE HIS "KILLER"... WHO IS ALREADY MOVING TO FINISH HIS JOB.. BUT, TOO, THE FOX IS IN THE CROWD OF HOLLYWOODITES.. AND INTENT ON KEEPING JON IN SIGHT — AND FREE FROM HARM... AND JON'S DATE, THE CHARMING LEE SCOTT, HIS SECRETARY...

AFTER MINGLING WITH MANY OF HIS CLOSE FRIENDS, JON EXCUSES HIMSELF, AND LEAVING LEE, WALKS TO THE BALLROOM STAIRS, MOUNTS THEM SLOWLY..

I MUST DRAW OUT THE KILLER... THIS SHOULD BE OPPORTUNITY ENOUGH FOR HIM TO..

"STRIKE! WHA-? HE HAS!! SILENCER ON HIS GUN, EH?

PHTTT PHTTT

TURNING, JON LEAVES THE MAIN BALLROOM, WALKING SLOWLY.. DEEPER, DEEPER, INTO THE OMINOUS GLOOM OF THE UNUSED BANQUET ROOM WING OF THE HOTEL.. AND SOON...

SOFT FOOTSTEPS PAD BEHIND HIM AND JON KNOWS THEM TO BE THE KILLER'S ... AND THEY ARE!! IN ONE STEP, JON MELTS INTO THE BLACK SHADOWS OF A BANQUET ROOM..

CLOSER, CLOSER, THE STEPS COME.. THEN, SUDDENLY.. THEY STOP!! JON'S HEARTBEATS POUND WITHIN HIM LIKE A DRUM AS PRESSED AGAINST THE WALL, HE NOW FEVERISHLY AWAITS THE UNKNOWN...

WHAT IN BLUE BLAZES IS HE WAITING FOR? HE HAS THE GUN..!! CALM DOWN, FURY.. DON'T PANIC· BUTTON THIS WHOLE DEAL.. OR IT'S FLYING LEAD FOR YOU!

HE'S NOT TOO SURE OF MY POSITION.. EVENS UP THE ODDS A BIT.. BUT NOT TOO MUCH..

BEHIND JON, AN INSIDE ENTRY DOOR OPENS NOISELESSLY... JUST A CRACK.. THEN MORE.. THE BARREL OF A PISTOL, WITH SILENCER, FILLS THE GAP.. AND A GLOVED FINGER TIGHTENS ON THE TRIGGER...

NEXT WEEK..."TRIANGLE"

the ADVENTURES of... JON FURY ©

by..

PFC ALEXANDER TOTH,

AS NERO FIDDLED WHILE ROME BURNED, SO HOLLYWOOD SOCIALITES DANCE AND CHAT ON, AS A HIRED KILLER STALKS HIS PREY IN AN EMPTY BANQUET ROOM IN THE BEVERLY ARMS HOTEL, SCENE OF TERRY DAWN'S SWANK PARTY... A DOOR HAS OPENED SILENTLY.. A PISTOL, SILENCED, IS NOW LEVELLED AT THE TENSE FIGURE OF JON

WHY THE DEVIL IS HE WAITING ??

FROM BEHIND THE DOOR...

DROP IT.. OR YOU'RE I'LL DROP YOU..

A LOW WHISPER SPINS JON AROUND..

WHO..??

THE DOOR SWINGS OPEN.. AND...

MAY 'WE' COME IN, FURY?

FOX!! IN THE 'NICK' AGAIN 'EH?

THE FOX'S POCKET-LITE REVEALS,...

BLAZES!! IT'S ONE OF THE PARTY WAITERS!!

THE THIRD KILLER —!!

WHO HIRED YOU TO KILL ME —? TALK!! TALK!!

I-I DON'T KNOW HIS NAME.. BUT I COULD I..

PFFFT PFFT

WH-? HE'S DEAD —!!

DOWN, FURY!! 'HE'S' HERE.. IN THIS ROOM..TO FINISH YOU HIMSELF!! BE STILL!!

PFFFT

AT LAST WE MEET, 'HOTSHOT'..

FURY — GET THE WAITER'S GUN... WE'RE NOT GOING TO WAIT FOR 'HIM' TO GET US!!

• NEXT WEEK "BLIND ASSAULT"

JON FURY

by PFC ALEXANDER TOTH,

THE FOX AND JON, IN A DARKENED BANQUET-ROOM, QUESTION A HOTEL WAITER, THE THIRD KILLER, ONLY TO HAVE HIM DIE BY TWO SILENCED GUN-SHOTS.. ANNOUNCING THE PRESENCE OF THE PERSON WHO HIRED THE 'TERROR TRIO' TO KILL JON... NOW, SECONDS LATER.. ATTEMPTING TO DETERMINE THE MASTER KILLER'S POSITION...

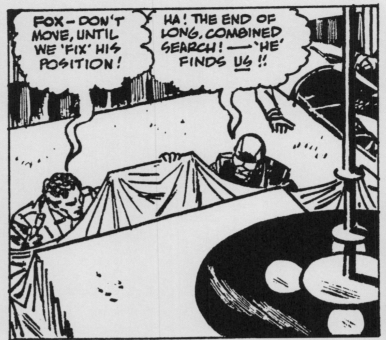

FOX—DON'T MOVE, UNTIL WE 'FIX' HIS POSITION!

HA! THE END OF LONG, COMBINED SEARCH! — 'HE' FINDS US!!

MINUTES PASS —THEN..

A NOISE! DOWN THERE, BY THE HEAD OF THE TABLE! LET'S GO!

TAKE THE LEFT, WHILE I CIRCLE RIGHT... CAREFUL!

TENSION MOUNTS, AS THE TWO MEN NOISELESSLY CRAWL FORWARD-

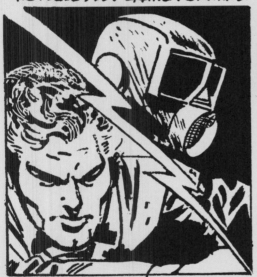

CLOSER.. AND CLOSER.. UNTIL-

SUDDENLY, AN EXPLOSION OF MOVEMENTS REVEALS...

HE'S MAKING A BREAK FOR THE DOOR!!

SO HE IS..!!

THE TWO LEAP FOR THE FIGURE...

AND...

GOT 'IM!! FURY—!

YEP—I'M GETTING THE LIGHT SWITCH!

HERE THEY ARE—!

WH-? NOT YOU—!!

• NEXT WEEK: 'POLICY TALK'...

JON FURY©

by

PFC ALEXANDER TOTH,

The FOX and Jon have captured the man they believe to be the 'brain' behind the murder plot on Jon's life — as Jon flips the deserted banquet room's lights on, he sees the face of...

14

KENDALL MOORE... IMPOSSIBLE!! HE'S A TOP HOLLYWOOD INSURANCE AGENT!!

HE'S GOING TO NEED A LITTLE INSURANCE HIMSELF.... __NOW__!!

KEN—!! WHY.. HOW?

STOP THIS NONSENSE, JON! I'M NOT WHO YOU THINK I AM—!!

FURY.. I'VE A HUNCH—!! SEARCH HIM FOR KEYS!!

RIGHT—!! DON'T MOVE, KENDALL..

TAKE YOUR PICK, FOX!

NOW LISTEN, FURY — DRIVE MOORE TO HIS OFFICE, SUNSET AND ALEXANDRIA AND I'LL MEET YOU THERE IN 20 MINUTES...

BUT WHY?

LATER, AS JON STEERS MOORE THROUGH THE HOTEL BALLROOM...

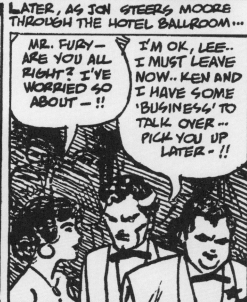

MR. FURY— ARE YOU ALL RIGHT? I'VE WORRIED SO ABOUT—!!

I'M OK, LEE.. I MUST LEAVE NOW.. KEN AND I HAVE SOME 'BUSINESS' TO TALK OVER... PICK YOU UP LATER—!!

AT MOORE'S OFFICES..

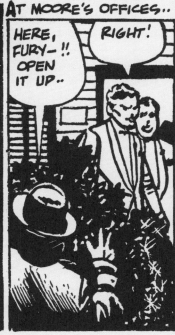

HERE, FURY—!! OPEN IT UP..

RIGHT!

NOW, IF YOU'LL CHECK THE FILES, IN THE 'F'S, I'M SURE YOU'LL FIND SOME INTERESTING INSURANCE DATA...

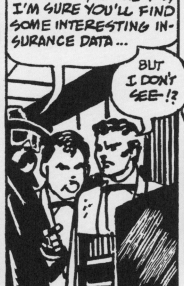

BUT I DON'T SEE—!?

THE FILES REVEAL A 'FURY' FILE..

THREE $20,000 LIFE INSURANCE POLICIES MADE OUT IN MY NAME!! BUT I DIDN'T—!!

DOUBLE INDEMNITY CLAUSES TOO, I'LL WAGER — NOW LOOK AT YOUR BENEFICIARY LISTING!!

WELL, I'LL BE—!!

●NEXT WEEK "DETAILS"

15

by PFC Alexander Toth,

KEN MOORE'S OFFICE FILES REVEAL THREE $20,000 DOUBLE INDEMNITY LIFE INSURANCE POLICIES..JON AS THE INSURED.— HERETOFORE UNKNOWN TO JON! NOW, PRODDED BY THE FOX, HE CHECKS THE LISTING OF BENEFICIARIES...TO DISCOVER...

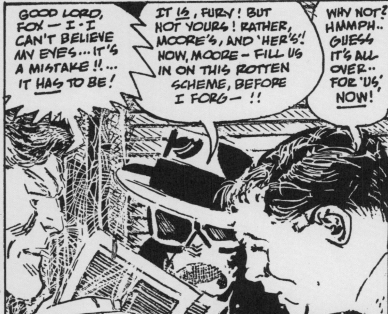

GOOD LORD, FOX — I·I CAN'T BELIEVE MY EYES...IT'S A MISTAKE !!... IT HAS TO BE!

IT IS, FURY! BUT NOT YOURS! RATHER, MOORE'S, AND 'HER'S'! NOW, MOORE — FILL US IN ON THIS ROTTEN SCHEME, BEFORE I FORG—!!

WHY NOT? HMMPH... GUESS IT'S ALL OVER... FOR 'US' NOW!

YES — I'M IN LOVE WITH 'HER'..NOTHING I WON'T DO FOR HER..I GUESS I'VE PROVED THAT !! SHE'S SHARP — COOKED IT ALL UP, AND HAD ME PUT THROUGH THE THREE POLICIES, AND HAD A FOURTH IN MIND...AND FORGING YOUR NAME WAS A SNAP, JON...

...MY COMPANY DOESN'T REQUIRE 'PHYSICALS', SO I WAS ABLE TO KEEP YOU OUT OF THE 'KNOW' ALL THE WAY! THE POLICIES, TOTALLED, COVER YOU FOR $60,000, WITH DOUBLE-INDEMNITY $120,000! 'DEATH BY VIOLENCE'!...I WAS ON THE 'INSIDE' OF THE DEAL, COVERING ALL THE FINE POINTS TO ENSURE A NICE, LEGALLY AIR-TIGHT POLICY...

I HAD SOME 'DIRT' ON THE TRIO WE HIRED TO REMOVE YOU, JON.. ALL THREE, EX-CONS...A BIT OF BLACKMAIL, PLUS A 5 GRAND BONUS TO THE ONE WHO'D 'COOL' YOU, PUT THE STARS BACK IN THEIR EYES — MADE 'EM WORK AT IT..WITH RELISH...

I NOTICED!

I DON'T KNOW WHO YOUR "MAN FROM MARS" IS, BUT IF HE PUT YOU WISE TO ALL THIS, I'D LIKE TO KNOW WHO HE IS, AND HOW HE DID IT?

YOU'RE NOT ALONE, MOORE.. GO ON !!

..WE HAD IT ALL SET BEFORE YOUR RETURN FROM THE FAR EAST... ALL OF IT...THEN TERRY DAWN'S 'INVITE' TO YOU CINCHED IT — I GOT THAT HOTEL WAITER IN ON IT AS THE THIRD 'GUNHAWK' — BUT I GOT TOO JUMPY WHEN YOU WERE 'PUMPING' HIM, AND SHOT HIM !! NO WITNESS LEFT NOW, IS THERE ? YOU 'DID IN' THE FIRST TWO...? HAVEN'T HEARD A WORD FROM 'EM MYSELF...

WRONG, MOORE — !! RECTOR THOR IS IN L.A.P.D. HANDS RIGHT NOW! HE'LL IDENTIFY YOU AS THE BIG 'HIRING BOSS' OF THIS PLOT ON MY LIFE...HE'LL TELL PLENTY !!

WHY THAT BROKEN DOWN RUM DUM !! WELL, WHAT NOW?

A PHONE CALL TO THE POLICE TO PICK YOU UP — AND I'VE GOT TO KEEP A DATE WITH A LOVELY YOUNG WENCH WHO'S WORRY-ING HERSELF TO A FRAZZLE OVER ME! RIGHT, FOX?

VERY RIGHT, FURY! MAKE TRACKS!

• NEXT WEEK "SURPRISE, SURPRISE"

JON FURY

by
PFC ALEXANDER TOTH,

JON, AWARE OF THE IDENTITY OF THE BIG "BRAINS" BEHIND HIS MURDER-INSURANCE PLOT, STOPS IN AT LOS ANGELES POLICE HEAD-QUARTERS WITH LEE.. TO FILE CHARGES A-GAINST KENDALL MOORE and HIS ACCOMPLICE... NOW, IN THE CORRIDOR OUTSIDE OF THE ROOM MOORE IS IN, LEE TURNS

MR. FURY — MUST I GO IN THERE? I·I'M FRIGHTENED!! I·I·DON'T·!

YOU'RE FRIGHTENED, ARE YOU? I'M NOT SURPRISED.. BUT I'M AFRAID I MUST INSIST! COME..

HOMICIDE BUREAU

DT LT GRIFFIN

AFTER YOU, MY DEAR LEE!

YOU'RE HURTING MY ARM, MR. F—! OHHH!!

LEE!!

WE'RE WASHED UP, LEE! THEY—

SHUT UP KEN!! YOU FOOL!

TSK TSK!

WELL NOW, ISN'T THIS "NICE" FOR YOU TWO ??

ALL RIGHT, MISS LEE SCOTT— MY BRAINY YOUNG BENEFICIARY OF $120,000 WORTH OF 'HOT' LIFE INSURANCE ON MY LIFE.. STATE YOUR CASE !! BUT BEFORE YOU DO, ALLOW ME TO SAY HOW VERY CLEVER I THINK YOU ARE! FOR FEW WOULD QUESTION YOUR ROLE AS "BENEFICIARY"— THOUGH THE "IMPLICATIONS" ARE MORE THAN SUGGESTIVE OF A RELATIONSHIP FAR CLOSER THAN THE "NORMAL" EMPLOYER- EMPLOYEE TYPE...

I'VE — NOTHING TO SAY!

YOU REALLY DON'T HAVE TO, LEE.. KEN MOORE'S SAID IT ALL — ISN'T THAT RIGHT, LT. GRIFFIN?

RIGHT, JON! MOORE'S SWORN STATEMENT IS FILED! WE'VE ALL THE PHYSICAL EVIDENCE WE NEED TO INDICT YOU, AND CONVICT YOU ...

I HATE YOU!! ALL OF YOU".. I'LL KILL YOU, ..MYSELF!!

WATCH IT, JON!!

GOT 'ER, GRIFF'!!

WHY, LEE - ?? WHY DID YOU DO IT -?? IF YOU WERE IN TROUBLE — NEEDED MONEY.. YOU COULD HAVE TOLD ME-!

OH, STOP IT!! D- DON'T PITY ME!!

PITY -?? WITH TWO DEATHS ON YOUR HANDS, AS A RESULT OF YOUR RUTHLESSNESS, I FIND LITTLE TO JUSTIFY PITY, LEE... JUST ANGER ...FIRST, FOR BEING BETRAYED — ANGER, FOR YOUR WASTING YOUR YOUTH, BEAUTY, INTELLIGENCE AND TALENT, IN THIS ACT OF GUILE — JUST A COLD ANGER ...TAKE HER OUT OF MY SIGHT, GRIFF! AND HIM, TOO —!!

*NEXT WEEK / WHAT'S IN A NAME?

jon FURY by PFC ALEXANDER TOTH,

THE BEGINNING OF A NEW YEAR..LIVES GO ON..SOME CHANGED..OTHERS NOT..WHILE PLANNING THE FUTURE ONE REFLETS..REEVALUATIONS..WITH THE PAST AS GUIDE..AND IN THE SECLUSION OF HIS HOLLYWOOD FLAT, JON FURY, ALONE WITH HIS THOUGHTS, STARES OUT HIS WINDOW AS THE CITY GLOWS WITH THE HIGHLIGHTS CAST BY THE SETTING SUN..AS THE VIBRANT STRAINS OF A VIOLIN CONCERTO DANCE THROUGH THE ROOMS... ABSORBING SIGHT AND SOUND ABOUT HIM, JON DRAGS ON A CIGARETTE...

..AND LIES DOWN..TO STARE UP..AND OUT..OF THE ROOM..OF HIMSELF...TO THE PAST..OF WHAT LIFE HAS MEANT TO HIM..WHAT IT HAS GIVEN TO HIM.. AND TAKEN AWAY..AND HIS EYES TIRE..AND CLOSE

..AND SLEEP COMES TO HIM..AS THE HI-FI PLAYS ANOTHER RECORDING...THE HOURS PASS...NIGHT FALLS OVER THE CITY..AND JON'S APARTMENT...

WHAT DO WE KNOW OF THIS TALL, RANGY MAN? HIS APARTMENT TELLS US PART OF HIS STORY..A WELL THUMBED LIBRARY THERE HOLDS MANY VARIED BITS OF INFORMATION ABOUT THE MAN WE CALL JON FURY ..BIOGRAPHIES OF COMPOSERS, PHILOSOPHERS AND ARTISTS..BOOKS ON AVIATION..SCIENCE..GLOBAL AFFAIRS..PEOPLES AND LANDS..AND TWO SHELVES..

..FILLED WITH VOLUMES ON THE SOUTHWESTERN TRIBES OF NORTH AMERICA...THE PLAINS TRIBES ..THE DESERT TRIBES..AND, IN PARTICULAR.. BOOKS ABOUT THE APACHE..THE FIERCE. BLOODY WARRIORS WHO ONCE CLAIMED THE SOUTHWEST AS THEIR OWN..WHO FOUGHT TO THE DEATH TO HOLD IT..THE APACHE..WHO LOST SO MUCH OF THEIR LIEF'S BLOOD....THE SAME BLOOD THAT FLOWS THROUGH THE VEINS OF..JON FURY..APACHE...

on FURY

by

PFC ALEXANDER TOTH /

...THE YOUNG APACHE COUPLE, TO WHOM THE TWIN BOYS WERE BORN, REJOICE..FOR LIFE HAS GRANTED THEM GOOD FORTUNE..THE BABIES ARE HEALTHY AND WELL-FORMED...THEY ARE NAMED JON AND BISH-BI-NAHA DENA-DO-THE, THE APACHE EQUIVALENT OF JON AND DIRK FURY...FRIENDS, NEIGHBORS, AND THE TWINS' GRANDFATHER, JOIN IN THE CUSTOMARY PARTY GIVEN IN HONOR OF THE NEWLY ARRIVED..

SUMMER..1922..ON A RANCH OUTSIDE THE SMALL TOWN OF SAN JON, NEW MEXICO, THE QUIETUDE OF A SUNNY AFTER-NOON IS BROKEN..BY THE INITIAL CRY OF A NEWBORN CHILD..THEN..IN MINUTES.. ANOTHER CRY IS ADDED TO THE FIRST...AND TWO NEW LIVES ENHANCE THE MIRACLE OF BIRTH..AND OF LIFE...

SPEECHES ARE NUMEROUS, AND SHORT..HAPPILY SO...THE YOUNG MOTHER RESTS WITH HER SONS AS TRIBAL CHANTS EXPRESS IN WORDS THAT WHICH THE DANCERS EXPRESS IN SUGGESTIVE MOTIONS...THE REVELRY GOES ON..AND ON...

BUT TRAGEDY SOON STRIKES..IN THE FORM OF A RANCH-FIRE, SNUFFING OUT THE LIVES OF THE TWO HAPPY PARENTS IN A CRUEL TWIST OF FATE

..AND THE TWINS, NOW ORPHANED, ARE CARED FOR BY NEIGHBORS AFTER THE BLAZE..AND WORD OF THE DISASTER IS SENT TO THEIR GRANDFATHER...HE BEGINS THE TREK TO SAN JON, WHERE, MERE WEEKS BEFORE, MUSIC, SINGING, AND GAY LAUGHTER FILLED HIS MIND AND HEART..NOW, ONLY A GHOSTLY ECHO OF THAT NIGHT BEATS WITHIN HIM..BUT HE SETS HIS JAW..GRIM DETERMINATION IN EVERY LINE..FOR A BATTLE IS FORTHCOMING..AND HE IS AWARE OF THE STRENGTH OF THE ENEMY.. FOR THE STATE'S LOCAL CHILDREN'S WELFARE OFFICE IN SAN JON IS ALREADY PRESSING FORWARD IN THEIR PLAN TO INTERN THE TWINS IN AN ORPHANAGE...THE BATTLE LINES HAVE BEEN DRAWN.. THE OBJECT IS CLEAR..THE WEAPONS CHOSEN...AND AN OLD WARRIOR PREPARES FOR THE ONSLAUGHT

jon FURY

by

pfc alexander TOTH / 56

THE ORPHANED BABIES REST WITH NEIGHBORS AFTER THE FIRE...THEIR GRANDFATHER ON HIS WAY TO FIGHT OFF THEIR BEING PLACED IN A HOME BY THE STATE...FOR, HE ALONE, IS KIN TO THEM, AND IT IS HIS DUTY TO BE THEIR GUARDIAN...AND THAT HE WILL BE, IF THE GODS ABOVE WISH IT SO, AND DO PROVIDE HIM THE STRENGTH WITH WHICH TO WIN...

DAYS LATER..IN THE CONFINES OF A HOT, AIRLESS ANTEROOM IN THE SAN JON CITY HALL, A BOARD, COMPOSED OF FIVE MEMBERS, HEARS THE WORDS OF AN OLD APACHE...WORDS TELLING OF HIMSELF, HIS LAND, HIS HOPES.

THE WORDS DO NOT COME EASILY.. BUT WHAT IS SAID, IS SINCERE, AND HEART*FELT...THE *COYINGLY* SMUG VISAGES OF THE MEMBERS DO NOT REMAIN SO FOR LONG...FOR AFTER QUESTIONING THE APACHE FOR TWO HOURS, HE SUDDENLY AND DELIBERATELY..

..RISES FROM THE HARD*BACKED CHAIR, TO FACE THE GROUP MEMBERS DIRECTLY..AND WITH A VENGEANCE...

YOU TIRE AN OLD BRAVE WITH YOUR MANY QUESTIONS..FOR HOURS I HAVE BEEN PATIENT..BUT YOUR WORDS HAVE BEEN BUT THE NOISE OF OLD WOMEN. NOW, YOU WILL LISTEN..AND I WILL SPEAK...

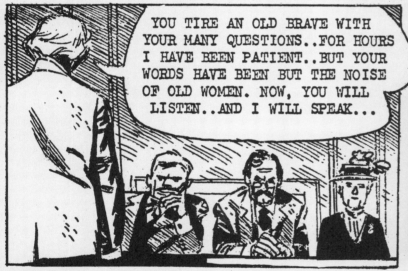

YOU SEEK TO TAKE FROM ME THESE TWO BOYS..WHO ARE NOT OF YOUR BLOOD, BUT OF MINE..MY DEAD SON'S AND MINE..I'M OF THEIR FLESH..APACHE..YOU'RE NOT.. I WILL REAR THEM AS MY OWN SONS, NOT AS ORPHANED WARDS, BUT AS LOVED ONES..CAN YOU OFFER THIS...?

THEIR HERITAGE IS A GREAT ONE..AND THEY SHALL BE TAUGHT THIS...I AM OLD, AND HAVE SEEN MUCH IN MY YEARS..I HAVE LEARNED AND RETAINED MANY THINGS FROM YOU..AS HAVE YOU FROM US...I SAY, LET ME TAKE THE BOYS, AND RAISE THEM TO BE STRONG AND BRAVE..FEARING NOTHING..NO ONE....WHAT THEY ARE NOW..AND WHAT THEY WILL BECOME, WILL PROVE YOUR DECISION TO BE RIGHT..IF YOU SAY 'YES' TO MY REQUEST...DO I TAKE THEM..?

GLANCES ARE EXCHANGED..AN IMPATIENT WAVE OF MOVEMENT BREAKS OVER THE BOARD MEMBERS..AS CHAIRS CREAK, HURRIED WHISPERINGS FILL THE AIR..MINUTES PASS SLOWLY..TILL..AT LAST, A HUSH FALLS OVER THE ROOM...A NERVOUS COUGH AND THE DECISION IS GIVEN BY THE HEAD OF THE BOARD..

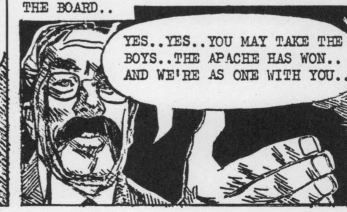

YES..YES..YOU MAY TAKE THE BOYS..THE APACHE HAS WON.. AND WE'RE AS ONE WITH YOU..

JON FURY

by pfc alexander TOTH / 56

THE TWO ORPHANS HAVE NOW GROWN TO BE OF SCHOOL AGE, HERE ON A HORSE AND CATTLE RANCH FOR WHICH THEIR GRANDFATHER WORKS, AND THEIR FIRST SCHOOL-DAY SEES THEM, WITH THEIR BOOKS IN HAND, MOUNTED ON THEIR COW-PONY..READY FOR THIS NEW ADVENTURE...WITH ALL CONCERNED WISHING THE BOYS WELL................

THE RESTRICTING CLOSENESS OF THE SULTRY ONE ROOM SCHOOLHOUSE TELLS ON THE TWINS, FOR DURING RECESS, WHEN THE OTHER YOUNG "ADVENTURERS" ARE PLAYING..TWO FIGURES ON HORSEBACK CAN BE SEEN URGING THEIR MOUNT, ALONG THE TRAIL LEADING BACK TO KINGMAN RANCH...HOME...FIVE MILES AWAY

THEIR PREMATURE ARRIVAL CREATES MUCH CONCERN FROM THEIR GRANDFATHER, THE KINGMAN'S, AND THE RANCH CREW...AND AN UNRELENTING CHASE OF THE TWO DELINQUENT CULPRITS ENSUES, WITH THE BOYS TAKING FULL ADVANTAGE OF EVERY CORNER THAT AFFORDS CONCEALMENT..ALL THE WHILE ENJOYING THE NEW GAME, UNTIL, WINDED, THE ADULT CONTINGENT HIT ON NEW STRATEGY..

UP ABOVE, IN THE WATER TOWER, TWO WIDE-EYED FACES PEER AT THE SCENE BELOW..OBLIVIOUS TO THEIR FATE, THEY LAUGH AT THE EASE WITH WHICH THEY HAD BESTED THE OTHERS, IN THIS WONDERFUL NEW GAME....

IT'S TWO O'CLOCK..IN FOUR HOURS, IT'S DINNER-TIME..GIVE THEM THAT AND THEY'LL BE BACK..YOU'LL SEE...THEY'LL BE BACK

BUT, SOON..THE SUN MOVES ACROSS THE CRISP NEW MEXICAN SKIES, AND DROPS TO THE HORIZON...THE DESERT BREEZE BLOWS COOLER TONIGHT, IT SEEMS..AND THE AROMA OF GOOD HOT FOOD IS FANNED UPWARD TO THE TOWER, WHERE IT IS RECEIVED BY TWO APPRECIATIVE NOSES...AND TWO VERY EMP-TY, GROWLING STOMACHS....

LATER..AS THE HOT MINCE PIE IS BEING SERVED IN THE KITCHEN OF THE RANCH-HOUSE, THE DOOR OPENS AND SILHOUETTED IN THE LIGHT OF THE OIL LAMPS, STAND TWO YOUNG, AND VERY HUNGRY, RENEGADES.....

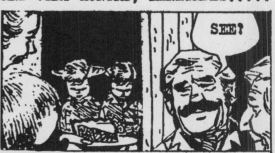

SEE?

NEEDLESS TO SAY, THE TWINS, THEREAFTER, HAD THE FINEST OF CLASS ATTENDANCE RECORDS

jon FURY
by
pfc alexander TOTH /

THE YEAR '37, JON AND DIRK REACHED THEIR FIFTEENTH YEAR..THAT SAME YEAR TOOK THEIR GRANDFATHER... THE MAN, WHO WITH GREAT STRENGTH AND CHARACTER, HAD MOLDED THEM INTO PROUD YOUNG MEN, TOUGH AS SADDLE LEATHER..WITH INTELLIGENCE SUPERIOR TO OTHERS OF LIKE AGE, THEY SEEMED OLDER THAN THEIR YEARS..THUS..

THE TWO LADS WERE QUITE A STUDY..SHARING A VISAGE IDENTICAL TO BOTH THEY ALSO SHARED SIMILAR INTERESTS, WITH BUT FEW EXCEPTIONS...PRIMARILY, BOTH..

..WERE FASCINATED BY THE EVER-GROWING FIELD OF..AVIATION AND ITS' FUTURE ROLE IN TRAVEL AND WARFARE, READING EVERY BOOK AND MAGAZINE RELATED TO THE SUBJECT ..SOON, WITH MONEY SAVED FROM A YEAR'S WORK AT THE KINGMAN'S, AT FULL PAY, THEY UNDERTOOK FLYING LESSONS AT A NEARBY 'PORT......

THEY PROGRESSED RAPIDLY..AND SOON, SOLOED

AFTER WHICH, DIRK, WITH A FLAIR FOR DASH, PROMPTLY BOUGHT HIMSELF RIDING BREECHES, A PAIR OF HIGH-TOPPED BOOTS, A FLYING JACKET, AND WITH ASCOT AND SWAGGER-STICK, IN THE MANNER OF ALL HOLLYWOOD PILOT-HEROES, STRUTTED AROUND LIKE A PEACOCK, AFFECTING ALL SORTS OF RAKISH POSTURES..TO THE AMUSE-MENT OF HIS UNIMPRESSED BROTHER, AND THE RANCH-FOLK...

AH, BUT THE GIRLS IN TOWN WERE OF ANOTHER ILK AND OPINION, AND WERE ENTHRALLED WITH THE RECKLESS MANNER OF THIS YOUNG DEVIL.. BUT IT WAS ALL TO END TOO SOON..FOR......

..ONE DAY, WHILE "BUZZING" AND "HEDGE-HOP-PING" VARIOUS RANCHES AND THEIR BUILDINGS, DIRK MISJUDGED A ROOFTOP, RIPPED FREE HIS LANDING GEAR. NOSED DOWN INTO A HERD, AND STAMPEDED THEM BY PLOWING UP THEIR GRAZE ACREAGE WITH THE NOSE OF HIS PLANE..LATER, WHEN JON AND THE KINGMANS ARRIVED AT THE SCENE, A MUCH-DEFLATED YOUNG "HERO" MET THEM...

..DIRK HAS NEVER QUITE FORGOTTEN THE DAY

jon FURY

by PFC ALEXANDER TOTH /

TOO, 1937 BROUGHT WORLD UNREST..CIVIL WARS, AND MOBILIZATION FOR WARS.. EACH BATTLEFIELD BECAME A BLOODY CLASSROOM..TO LEARN THE LESSONS OF COMBAT..TO DIE, LEARNING THEM..IN 1938, AND, UNDER-AGE AS THEY WERE, JON AND DIRK TOOK ENTRANT'S EXAMS FOR COLLEGE...AND PASSED..APPLYING THEMSELVES WITH FERVOR, THEY BECAME TOP STUDENTS..AND

..THEN, MONTHS BEFORE THEY WERE TO GRADUATE..PEARL HARBOR..WAR ..THE TWO, NOW 19 YEARS OLD, ENLISTED FOR SERVICE IN THE ARMY. AFTER RECEIVING COMMISSIONS AS 2ND LIEUTENANTS, DIRK WAS TAKEN INTO THE AIR FORCE..JON, THE RANGERS...

THE TWO FOUGHT HARD..AND WELL.. JON, IN EUROPE...AND DIRK, IN THE CHINA-BURMA-INDIA THEATER..

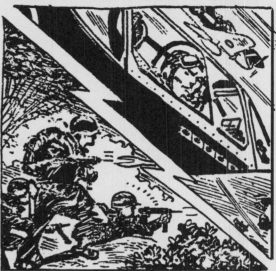

THEN, IN THE INVASION YEAR, '44, JON, DURING AN ATTACK ON A GERMAN STRONGHOLD, WAS CRITICALLY WOUNDED..AFTERWARD, WAS RETURNED TO A HOSPITAL IN THE 'STATES FOR FURTHER SURGERY, AND REASSIGNED TO G-2, WASHINGTON, DC, HOLDING THE RANK OF MAJOR...

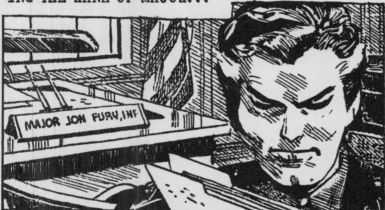

A MUCH-SOBERED MAN, AND BEARING THE MARKS OF WAR ON HIS LEAN FACE..AND PREMATURE GRAYING ON HIS HAIR..JON ADJUSTED HIMSELF TO HIS NEW RESPONSIBILITIES..AS THE HELLISH WAR RAGED ON..AND ON..UNTIL, IN 1945..

..FOLLOWING THE HOLOCAUST OF HIROSHIMA AND NAGASAKI, THE WAR WAS AT LAST DECLARED AT AN END..DIRK WAS ENROUTE TO WASHINGTON, TO MEET WITH JON..TO LIVE, TO LAUGH, IN PEACE, ONCE AGAIN...

SO IT WAS, THAT ON THEIR BIRTHDAY, SEATED IN THE FINEST SUPPER CLUB IN WASHINGTON.. CAPTAIN DIRK FURY, USAAF, AND MAJOR JON FURY, US ARMY, TOASTED ONE ANOTHER'S GOOD HEALTH AND FORTUNE...ABLY ASSISTED BY TWO VERY CHARMING WELL-WISHERS...

"AFTER THE WAR AND SIX"

1946 — AND THE TWO FURY BROTHERS RELAX IN THEIR PEACEFUL ROOM ON THE KINGMAN RANCH...WHERE, AS CHILDREN, THEY HAD KNOWN SO MANY ENJOYABLE HOURS..READING, PLANNING THEIR ADULT YEARS... AND NOW, THOSE YEARS ARE WITH THEM..THE YEARS HAVE BROUGHT THEM EDUCATION..AND ADVENTURE... AND PEACE DUE TO RESTLESS YOUNG CONQUERORS...

WHILE DIRK ENTERS A PERIOD OF TESTING AND LICENSING, IN ORDER TO ENABLE A CAREER IN COMMERCIAL AVIATION...WITH SUCCESS, FOR IN LESS THAN THREE MONTHS, HE'S CO-PILOT ON A PAA FLAGSHIP...

THE GOING IS ROUGH AND THE EXPENSES HIGH... BUT JON'S MAGAZINES CATCH THE PUBLIC'S EYE, AND THE RETURNS GAIN..MONTH BY MONTH..UNTIL MORE STAFF MEMBERS ARE NEEDED, MORE SPACE.. BETTER PRODUCTION TECHNIQUES..MORE ADVERTIZING SPACE SOLD IN EACH ISSUE..AT HIGHER RATES..NATIONAL DISTRIBUTION..AND SUCCESS..

JON, AFTER YEARS OF PREPARATION, HAS SET HIS SIGHTS ON A CAREER IN PUBLISHING, AND AFTER POUNDING ON MANY DOORS, IS GIVEN A POSITION WITH A MAGAZINE PUBLISHER IN ALBUQUERQUE, NEW MEXICO...

THE YEARS PASS..AND AFTER WRITING AND EDITING FOR HIS PUBLISHER, JON, ARMED WITH MUCH EXPERIENCE AND KNOWLEDGE OF THE FIELD AND ITS' MECHANICS, AND BURNING WITH THE IDEAS FOR A MAG OF HIS OWN FORMAT, DECIDES TO MOVE TO LOS ANGELES..AND SET UP HIS OWN COMPANY..

..IT ALL COMES ABOUT...DIRK CONTINUES HIS CAREER WITH PAA, NOW PILOT, FLING HIGH ON ADVENTURE, ROMANCE, AND FILLED WITH STORIES OF HIS STAYS IN THE CITIES OF THE WORLD... THUS, IN THIS YEAR, 1950, THE TWO MEN ARE HAPPY WITH THEIR LOT IN LIFE...

jon FURY

25 JUNE 50 — 28TH BIRTHDAY OF THE FURY BROTHERS...THE DAY THAT INITIATES WAR AND SUFFERING IN A SMALL COUNTRY, THOUSANDS OF MILES AWAY..NAMED..KOREA. U.S. MILITARY AID IS COMMITTED IN DEFENSE OF SOUTH KOREAN FORCES..AND JON AND DIRK, HOLDING RESERVE STATUS, VOLUNTEER FOR DUTY IN FOLLOWING WEEKS..DIRK IS ACCEPTED, AND RECEIVES JET TRAINING AT LACKLAND AFB..BUT

JON, BECAUSE OF OLD INJURIES, IS REFUSED... A VISIT TO HIS FORMER COMMANDING OFFICER IN WASHINGTON PRODUCES NO CONCRETE RESULTS....

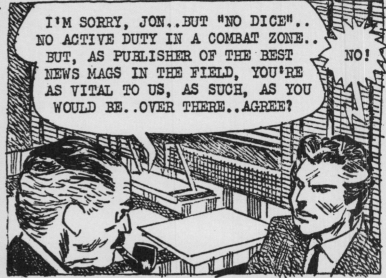

I'M SORRY, JON..BUT "NO DICE".. NO ACTIVE DUTY IN A COMBAT ZONE.. BUT, AS PUBLISHER OF THE BEST NEWS MAGS IN THE FIELD, YOU'RE AS VITAL TO US, AS SUCH, AS YOU WOULD BE..OVER THERE..AGREE?

NO!

BUT, IF YOU AGREE TO AN ALTERNATIVE PLAN..THAT OF MY GOING OVER AS NEWS CORRESPONDENT FOR MY OWN MAGAZINES, I COULD MAKE IT WITHIN TWO MONTHS..

SO IT IS, THAT JON RETURNS TO HOLLYWOOD TO ASSIGN KEY PERSONNEL WITHIN HIS COMPANY TO MANAGE OPERATIONS DURING HIS ABSENCE..THIS DONE, JON CLEARS ALL PAPERWORK WITH WASHINGTON, AND IN WEEKS, IS ON A PLANE BOUND FOR KOREA...

..WHILE DIRK, ALREADY ASSIGNED TO A FIGHTER/BOMBER WING IN JAPAN, RECEIVES HIS PRE-COMBAT BRIEFING..PRIOR TO TAKE-OFF FOR AN ATTACK ON NORTH KOREAN SUPPLY ROUTES......

..ASSURED OF HIS POSITION TO, IN HIS OWN WAY, CONTRIBUTE IN THE BATTLE FOR KOREA, JON THINKS AHEAD..TO THE WORDS THAT WILL FLOW FROM HIS HAND..THE FILMS ON WHICH HE WILL CAPTURE THE IMPACT..AND THE IMAGE, OF WAR..A GRAPHIC REPORT FOR MILLIONS TO READ AND SEE..AND KNOW..THE COST OF MAINTAINING PEACE...

jon FURY

by alexander TOTH

...ON MEXICO CITY'S AIRPORT INTERNACIONALE.....

IN THE SUMMER OF 54 JON DECIDES TO TAKE A VACATION—FLIGHT TO MEXICO CITY, TO VISIT HIS OLD FRIEND, FREE LANCE WRITER-ARTIST, JACK MENDELLSOHN..A WIRE SENT FROM THE FIELD IN BURBANK INFORMS JACK OF HIS ARRIVAL...AND SO, FIVE HOURS AFTER TAKEOFF, JON TOUCHES DOWN.....

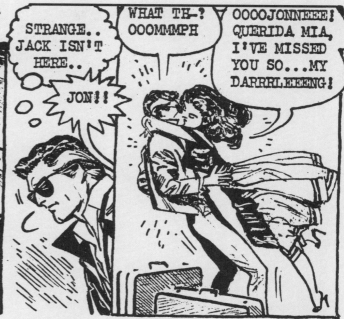

STRANGE.. JACK ISN'T HERE..

JON!!

WHAT TH–? OOOMMMPH

OOOOJONNEEE! QUERIDA MIA, I'VE MISSED YOU SO...MY DARRRLEEENG!

NOW..OOMMPHH, SEE HERE..MY PET..YOU'VE MADE SOME... MISTAKE...

BOT, JONNEEE.. NO, NO..

NOW, HOLD STILL A MINUTE...HEYY,HOLD IT UP!

HONNEEE, YOU MUST NOT MAKE A SCENE HERE, WEETH ALL THESE...

...JOST BECAUSE YOUR LOVING WIFE KISSES YOU UPON YOUR SAFE RETURN TO MEXICO..AFTER BEING AWAY FOR SOOOOOOOO LONG!

wife..? WIFE???

WIFE?!!

GOME, BRAVO..WE HAFF A SUITE AT THE DEL PRADO...WHERE I CAN HAFF YOU ALLLL TO MYSELF...ALONE!!

SUITE?? DEL PRADO? NOW, JUST HOLD ON, KITTEN—

AHH—EES THERE..AH SOMETHEENG WRONG..??? SENOR..

WHAT COULD BE WRONG??? THEES EES MY DEEARR HOSSBAND, OFFICER!!

COME, MY JONNEEE.. MY CAR...

I'D BEST PLAY ALONG, OR I'M DEAD..

JONNEE, YOU LOOK MORE HANDSSOM' NOW THAN BEFORE..AND I....

YOU CAN STOP ALL THIS NOW, HONEY..

EEF YOU WEEL OPEN MY PURSE, ON THE SEAT HERE, JONNEEE, YOU WEEL SEE THAT THEES EES NO JOKE..

YIPE!! MARRIAGE LICENSE.. MINE!!!

jon FURY

by PFC alexander TOTH/

JON LANDS AT MEXICO CITY'S AIRPORT AND IS MET BY AN EXCITED MISS WHO, AFTER CONSIDERABLE DISPLAYS OF AFFECTION TOWARDS HIM, DOES INFORM HIM OF THE FACT THAT SHE IS NONEOTHER THAN..HIS WIFE!!! NOT WILLING TO CREATE FURTHER FUROR AMIDST THE AIRPORT CROWDS, JON GOES TO HER CAR..ONLY

..TO BE SHOWN HIS MARRIAGE LICENSE, CERTIFYING THAT HE AND THE LATIN MISS ARE, IN THE EYES OF MEXICAN COURTS ..ONE....

THIS IS CRAZY—I WON'T BE MADE TO BELIEVE...IT'S.. NUTS!!!

JONNEEE.. DON'T YOU LOFF MEE ANYMORE??

THIS MUST BE SOME JOKE..IT'S GOT TO BE...

BUT, NO, JONNEEE... YOU SAW THE...

YES, KITTEN.. I SAW...TELL ME, DOLL..AM I TOO CURIOUS IF I ASK FOR YOUR NAME..??

LITA, OHH..

..JONNEEE.. YOU FORGOT? HOW COULD YOU???

OH, FOR PETE'S SAKE..

LET ME OUT, LITA FURY..GOT TO MEET A MAN..

WE'RE IN FRONT OF DEL PRADO, JONNEEE..

THAT'S GREAT! CAN'T THINK OF A NICER SPOT FOR A SECOND HONEYMOON..!BYE..

COME BACK, DARRLEEENG.. SO SWEET..

AH, SENOR.. YOU MUST BE MEESTER FURY. IS THERE..??

YES, THERE IS..

YOU CAN TELL ME WHERE A GOOD "HEAD" DOCTOR MAY BE FOUND?

SENOR?? OH..HAH, HAH, YOU MAKE THE JOKE, EH? FONNY..

I AM THE JOKE, MY FRIEND...

THEES IS THE BEST SUITE IN THE HOTEL..

..EENSIDE, MY LOFF.. AHHH, NOW WE MAY BE PRIVATE, NO? COME, MY DARRLEENG..COME TO ME...

HEY!! YOU'VE LOCKED US IN!!

jon FURY

..AFTER DINNER, A CHANGE OF CLOTHES, AND THE THREESOME MEET AGAIN, BOUND FOR AN EVENING OF FUN IN THE BRIGHT, EXCITING CAPITAL CITY OF MEXICO......

LITA CORDOVA IS A CHARMING COMPANION FOR THE EVENING, CHIDING JON FOR HIS PART AS THE SURPRISED "BRAVO"..

AND SO, JON'S FRIEND, JACK MENDELLSOHN, HAS BEEN REVEALED AS THE CULPRIT BEHIND THE INCREDULOUS PRACTICAL JOKE CARRIED THROUGH BY LITA, THE LOVELY MEXICAN GIRL POSING AS JON'S "WIFE"..AND THE RELIEVED LAUGHTER HAS GIVEN WAY TO CALM WORDS OF GREETING, AND DISCUSSION...A DINNER AND WINE IS PREPARED.. AND SENT TO THE SUITE

JONNEE, YOU HAD THE LOOK OF THE SICK PUPPYDOG.. HAHAHA..FONNY..

HA, DID I, LITA? THINK I'M WELL ENOUGH TO DANCE A RUMBA?

JONNEE..YOU DANCE VERY WELL..CAN IT BE THE WINE? HAHA

I THANK YOU, "WIFE"..AND NO, IT'S NOT THE WINE.... JUST YOU, AND THE NIGHT... AND MEXICO..

THAT EVENING, ALONG WITH MANY, MANY OTHERS, ADDED UP WITH AFTERNOONS BOATING AND SWIMMING..THE BULLFIGHTS, AND LEISURELY DRIVES THROUGH THE SURROUNDING COUNTRYSIDE..CREATE THE STUFF MEMORIES ARE MADE OF..MEMORIES THAT WILL LINGER WITH JON ALWAYS..

BUT, SOON..THE DEMANDS OF HIS BUSINESS MATTERS AT HOME PRESS JON..AND HE MUST TAKE HIS LEAVE OF JACK, AND LITA..AND MEXICO...

JONNEE.. JONNEE.. I--I-..

I KNOW, KITTEN,, I FEEL THE SAME WAY....

JON BREAKS FROM LITA..WAVES TO JACK, A TROUBLED SMILE ON HIS FACE..ENTERS HIS PLANE.. ..AND IN MINUTES..TAKES OFF

JONNEE, YOU WEEL COME BACK, WON'T YOU? PLEASE PROMISE US, JONNEE?

I WILL, LITA..AND THAT IS A PROMISE. THANK YOU, JACK..I HAD A GREAT TIME.. WELL, ADIOS, KIDS.

HEADING BACK..BACK HOME.....

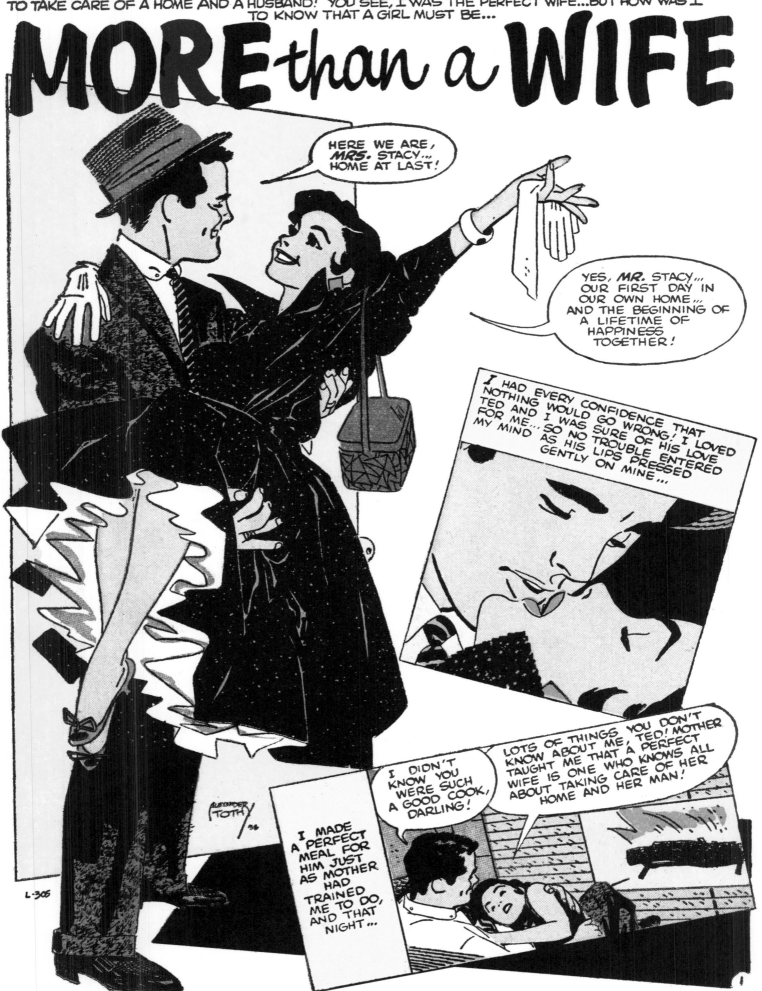

ON THE DAY THAT TED CARRIED ME ACROSS THE THRESHOLD OF OUR NEW HOME, I THOUGHT I HAD EVERYTHING A GIRL COULD WANT! I HAD THE MAN I LOVED...AND A WHOLE FUTURE OF LOVE AND HAPPINESS AHEAD OF ME! AND...I WAS WELL-TRAINED TO BE A GOOD HOUSEKEEPER...I KNEW HOW TO TAKE CARE OF A HOME AND A HUSBAND! YOU SEE, I WAS THE PERFECT WIFE...BUT HOW WAS I TO KNOW THAT A GIRL MUST BE...

MORE than a WIFE

HERE WE ARE, *MRS.* STACY... HOME AT LAST!

YES, *MR.* STACY... OUR FIRST DAY IN OUR OWN HOME... AND THE BEGINNING OF A LIFETIME OF HAPPINESS TOGETHER!

I HAD EVERY CONFIDENCE THAT NOTHING WOULD GO WRONG! I LOVED TED AND I WAS SURE OF HIS LOVE FOR ME...SO NO TROUBLE ENTERED MY MIND...AS HIS LIPS PRESSED GENTLY ON MINE...

I DIDN'T KNOW YOU WERE SUCH A GOOD COOK, DARLING!

LOTS OF THINGS YOU DON'T KNOW ABOUT ME, TED! MOTHER TAUGHT ME THAT A PERFECT WIFE IS ONE WHO KNOWS ALL ABOUT TAKING CARE OF HER HOME AND HER MAN!

I MADE A PERFECT MEAL FOR HIM JUST AS MOTHER HAD TRAINED ME TO DO, AND THAT NIGHT...

PAGES 246-249: Back from his military service, Toth illustrated three stories for Stan Lee and Atlas Comics. This one, probably written by Lee, was published in *My Love Story* #7 (April 1957). Soon he was working full-time drawing movie and TV adaptations for Dell. He was thankful for the employment. "Our office is visited every week by ex-Stan Lee boys," he wrote in a July 1957 letter. "I wish there was something for 'em—business must be on a jungle basis now with so many good men knocking on doors, vieing [sic] for jobs."

AND SO PASSED THE FIRST FEW MONTHS OF OUR MARRIAGE! TED WORKED IN AN ENGINEER'S OFFICE, WHILE I TENDED HOUSE! MOTHER VISITED ME OFTEN...

YOU'RE A GOOD WIFE TO TED, MARION! I'VE NEVER SEEN A HOUSE KEPT SO PERFECTLY!

THANKS TO YOU, MOTHER! YOU SHOWED ME HOW TO DO IT!

WELL, THE MOST IMPORTANT THING IS TO KEEP AN EFFICIENT AND CLEAN HOUSE-HOLD...

I'M VERY PROUD OF YOU, DEAR! ALL THE OTHER MOTHERS ARE ENVIOUS OF ME!

AND ALL THE BOYS ARE ENVIOUS OF ME! HELLO, LADIES!

TED! DARLING!

I MUST SAY YOU'RE A LUCKY BOY, TED! NOT EVERY GIRL'S LIKE MARION!

YOU'RE TELLING ME? DARLING, LET'S EAT OUT TONIGHT! IT'S VENISON NIGHT AT THE RATHSKELLER!

OH, I CAN'T, DEAR! TONIGHT'S THE NIGHT I POLISH THE SILVERWARE! YOU GO... I KNOW HOW MUCH YOU LIKE VENISON!

AND SO TED WENT OUT ALONE FOR THE FIRST TIME SINCE OUR MARRIAGE! A WEEK LATER, HE GOT A DAY OFF AND CAME HOME IN A FLURRY OF EXCITEMENT!

GET YOUR COAT! I'VE GOT TWO TICKETS FOR THE ALL-STAR GAME!

GET ONE OF THE BOYS TO GO WITH YOU, DEAR! I'VE GOT AN AWFUL LOT OF WORK TO DO!

WORK, WORK, WORK! IS THAT ALL YOU ENJOY DOING?

NOW, DEAR, YOU WANT A PERFECT WIFE, DON'T YOU? I ENJOY WORKING... WHEN IT'S FOR YOU! NOW RUN ALONG TO YOUR BALL GAME!

I WAS SO BUSY LIVING UP TO MY MOTHER'S IDEA OF A PERFECT WIFE THAT I HAD NO TIME FOR MY HUSBAND... AND NO TIME TO STOP AND THINK OF WHAT WAS HAPPENING TO OUR MARRIAGE! THEN, A FEW WEEKS LATER...

AND I FOUND THESE WONDERFUL PILLOWS! WHAT A BARGAIN, DEAR! MOTHER HEARD ABOUT THE SALE AND I RUSHED RIGHT OVER TO BUY THEM!

YEAH! UH-HUH! SURE!

TED! YOU'RE NOT EVEN PAYING ATTENTION!

PILLOWS! SALES! IS THAT ALL WE'VE GOT TO TALK ABOUT? WHAT *IS* MARRIAGE, ANYWAY? A HOUSEKEEPING INSTITUTION?

IT WAS OUR FIRST QUARREL AND IT HURT DEEPLY! TED STORMED OUT OF THE HOUSE WHILE I CRIED!

OF COURSE, THE FIRST THING I DID WAS CALL MOTHER AT ONCE!

MAYBE YOU MADE SOMETHING FOR DINNER THAT HE DOESN'T LIKE! THAT COULD UPSET A MAN!

NO! IT WAS HIS FAVORITE... LAMB STEW!

WELL GO OVER EVERYTHING YOU'VE DONE, DEAR! YOU'LL FIND OUT WHAT YOU DID WRONG! AND DON'T WORRY! HE'LL COME BACK TO HIS "PERFECT" WIFE!

YES, MOTHER!

BUT I COULDN'T IMAGINE WHAT I HAD DONE THAT WAS WRONG! I WORKED ONLY FOR HIM AND FOR OUR HOME! WHY WAS HE SO UPSET, UNLESS...

OH, *NO!* THERE *COULDN'T* BE ANOTHER WOMAN!

I COULDN'T GO TO SLEEP WITH THAT AWFUL FEAR GNAWING AWAY AT ME! AND SO I WAITED..., AND WONDERED..., AND CRIED!

WHAT DOES HE WANT FROM ME? I WORK MY FINGERS TO THE BONE FOR HIM! WHAT GIRL COULD DO MORE? OH, TED, COME BACK TO ME AND TELL ME WHAT I DID THAT'S WRONG!

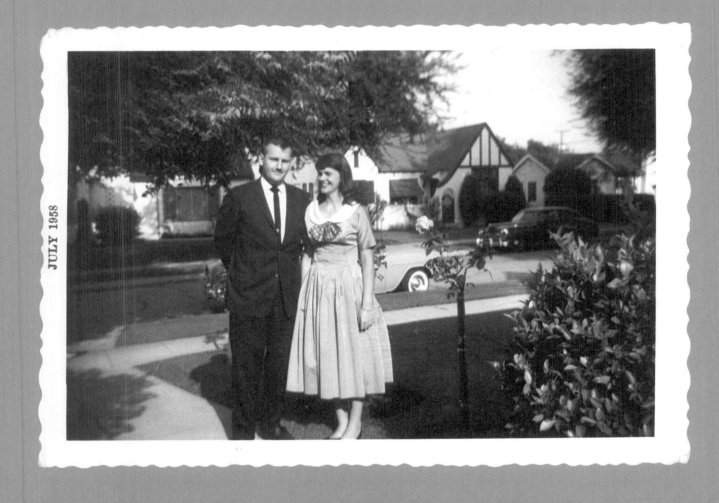

JULY 1958

ABOVE: Proud parents Alex and Christina visiting her mother, July 1958.

WE ARE FAMILY

"There's gold in them there hills!"

That familiar catchphrase extended back to the California Gold Rush of 1849; more than a century later, it rang true for Alex Toth. Facing an economically depressed comics business, the artist again looked westward and found gold in them there hills…in this case, Beverly Hills.

The Western Printing and Lithographing Company was a sprawling publishing empire that kept editorial offices in both New York and Los Angeles. Western was the home of the Betty Crocker cookbook as well as the low-cost Little Golden Books that helped generations of American toddlers build a love of reading. For older children, Western offered Big Little Books, coloring books, and prose mystery/adventure titles featuring characters ranging from teen-sleuth Trixie Belden to that heroic collie, Lassie.

Dell Publishing—a force to be reckoned with in the magazine and paperback book arenas—financed and distributed its comic books in partnership with Western, which was responsible both for creating editorial content and for the physical printing of the line. Western's offices in Beverly Hills perfectly positioned them to sign and maintain deals with major Los Angeles film studios. Western licensed Bugs Bunny and the Looney Tunes from Warner Brothers, plus familiar faces like Woody Woodpecker and Andy Panda from the Walter Lantz Studio; they published comics featuring Edgar Rice Burroughs's stable of adventure characters (Tarzan most notable among them), as well as Walt Disney's mainstays. The deals with Disney were more convoluted than most, but resulted in Western producing *Walt Disney's Comics and Stories*, which in its heyday consistently sold in the millions of copies. That means the grand "Duck Man," Carl Barks—whose tales of Uncle $crooge and Donald Duck are internationally beloved—was a Western employee.

And before the end of 1956, so was Alex Toth.

"I was there the day Alex walked in with his samples," said artist Richard T. "Sparky" Moore. "Don MacLaughlin was there, Chase Craig, myself, and maybe one or two other people. Everybody was totally impressed. [Alex] was taken on immediately, and went on to bigger and better things. Alex was rather subdued, like any artist looking for work; he just put [his stuff] up there for approval. Knowing what I know now, I realize he was quite confident that unless these idiots didn't know what they were looking at, they were going to hire him." Sparky spent a quarter-century at Western, providing illustrations for projects ranging from *The Three Stooges* to the first-ever prose *Star Trek* novel, *Mission to Horatius*. Alex's Western career similarly spanned a wide range of projects appearing on newsstands across America from 1957 to 1961. His artwork graced titles such as *Roy Rogers and Trigger*, *Jace Pearson's Tales of the Texas Rangers*, and *Western Roundup*. By the end of his tenure at Western, Toth's output reflected the growing presence of television in American homes as he produced material based on TV series such as *The Rifleman*, *Wagon Train*, *Wyatt Earp*, and *Maverick*. Alex also drew single-image illustrations for a 1959 prose *Maverick* novel written by Charles Coombs that Whitman published in its young-readers book line, and he was favorably disposed toward this Warner Brothers show, which starred a young James Garner as Bret Maverick and Jack Kelly as brother Bart, a pair of wily gamblers who tried to out-think, rather than out-shoot or out-fight, their enemies. The artist wrote about *Maverick* in a July 1957 letter to Jerry DeFuccio:

> I'm throwing titles at 'em constantly—Kirk Douglas's production of *The Vikings* would be a dandy book…but the execs are slow-moving about running down the releasing company…for clearance and percentage woes.

> We missed getting [rights to the movie] *Lafayette Escadrille* at Warners, and that reminds me—our little group of execs, my Art Director, and I are conferring with Warners now about doing books on two new hour-long TV series slated for fall release—we went out to the studio for

screenings of 'em…and they're *great*!

Maverick and *Sugarfoot* are excellent works…and so, along with *Cheyenne*, Warners'll have three winners on TV come fall. I favor *Maverick*—it's scripted, directed, acted, and filmed beautifully. *Quality*—and a light, humorous touch throughout…. You'll like it, I'm sure—watch for it in September.

This passage points out one of the benefits of employment at Western—a student of film like Toth greatly enjoyed the feeling of being an "insider," even if drawing comics adaptations meant he had only a few toes wedged within Hollywood's doors.

Along with the benefits came challenges, of course. In Alex's early years at Western artists labored anonymously, forbidden to sign their work. One of the other hurdles he struggled to overcome was a dictated page design: Western's books followed a rigid panels-per-page layout. Alex had this to say when John Hitchcock complimented the artist's ability to create striking imagery within this static framework:

[Western] eschewed the fanciful page layouts of "those New York City comics" for plain-jane, six-panel layouts for adventure books and the eight-to-ten-panel page layout for the funny, bigfoot, animated cartoon character books—

I felt restricted by the set-in-cement layout—but came to like it, for forcing me to rely all the more on each panel's interiors, much like the unchanging static frame of the motion picture or TV screen. It's what one frames within it that counts, and not the size and shape of that frame. Well, though that's all changed since the '50s, I did my bit to make it work, with mixed results, up and down, good and mediocre…

The fact that Alex was both penciling and inking during this period provided a great incentive to master the constraints of Western's fixed-page layouts. "Working for [Western] is a real kick," Toth wrote in a 1957 letter, "for there is no 'team' system…. I pencil and ink my own work, *every* job. Good or bad, it's all mine. I want to letter my jobs, but am happy with 'house lettering.'" Paid a piecework rate—Alex once said he earned fifteen dollars for a penciled page and twelve dollars for inks, far less than he felt he was worth—the steady flow of assignments in a depressed market and an employee profit-sharing plan helped make Western the best place for Alex to ply his trade as the 1950s prepared to give way to the Swinging Sixties.

Alex was going through divorce proceedings after he started at Western, and as his second marriage officially ended he found another reason to favor his new employer in the person Christina Schaber, a vivacious "jane of all trades" who also worked in the

Beverly Hills offices. Today that gracious lady is known as Christina Hyde. She remembered the conclusion of one of her earliest discussions with Alex: "I said to him after he got his divorce, 'Well, I wouldn't doubt it if you'll be married within the year.' Not thinking it was going to be to me!" Christina Schaber became the third Mrs. Alex Toth on December 30, 1956.

Christina had started at Western by running errands, picking up artwork, and checking materials in and out of the publishing morgue. She met Alex after she also assumed select payroll duties. "[Western] had several artists who got paid weekly and I would make out those checks. From then on I was kind of like a bookkeeper," she said.

"Bookkeeper" was the term Toth used when he wrote to Jerry DeFuccio of his new bride. "I married a lovely Swiss miss named Christina and we're both very happy—to say the least. I married my bookkeeper. A wise move! But really, Jerry, I'm living in the state that holds much that I place great value in—and the future looks promising…"

What Alex may not have known was that their relationship almost never reached the first-date stage, as Christina revealed. "When he asked me out, I said yes, I would go. But as the time came I got really nervous about it, and I didn't go to work that day and I told him that I had a really bad earache.

"In other words, I was trying to break the date. But bless his heart, he sent me a beautiful bouquet of flowers, and do I need to tell you how bad I felt about that? From then on it got better and I did go out with him. I had never really been with anyone that was really creative, as he was, and he was different. You know, he was moody and he spoke out, and—" She sighed. "Yeah. He was just completely different."

The Toths initially set up housekeeping at 1629 North Formosa in Hollywood, though they would eventually settle in a small house in suburban Pasadena, located east of Los Angeles in the San Gabriel Valley. They had need of more room, because as Toth informed Jerry DeFuccio during the middle of 1957, "Chris will present me with an heir(ess) to the Toth fortunes next January or February, and we're both very happy over same. We're running through names for our little 'schatzi,' but none look or sound good with 'Toth,' dammit!"

Early in 1958 Christina and Alex welcomed their first child, a daughter. Toth wrote of "the warm wonderment" that suffused the day of her birth and concluded with a line that only he would write: "Sköl, Dana Christine, by yimminee!" Those sentiments would be echoed a year later, when another daughter, Carrie, joined the family. Like all the Toth children, Carrie was interviewed for this project, and she recalled a personal connection with her father that began in her pre-school days:

[Daddy] used to call me "De De," and that feels important to me, I think because I was the only one [of the four Toth children] with a nickname. Dana actually

ABOVE and OPPOSITE: Various photo covers of *Four Color* issues containing Toth artwork.

BELOW: Christina Schaber in the mid-1950s, around the time she met and married Alex Toth.

made up that name because she couldn't say "Carrie" when I was born. But Daddy called me that until I think I went to kindergarten or first grade, and then I asked him to call me "Carrie" because I was a big girl. But it was sweet, and he would still write to me that way sometimes, and it was just a little, you know, a little personal thing.

The joy of new life was tempered by distressing news. In the years between Alex's first and third marriages, his parents had divorced. Both had relocated to California; "[Sandor] lived over in Arcadia with his second wife," Christina Hyde recalled. "We'd go over there and visit." But by September of 1957, when Christina was in her second trimester with Dana, Alex learned his father was facing an insurmountable struggle.

"Two months ago, my dad was operated on for removal of a tumor in his esophagus," Alex wrote in a November 1957 letter. "The surgeon discovered cancer—too widespread to be stopped there—in the back and ribs and right side…. He's unaware of the complete truth as of this writing, but the consistent losing of pounds, the pain, and the x-ray treatments, given daily, are spelling it out for him to see.

"To be witness to the physical disintegration of a man as robust and virile as my dad, in his fifty-fifth year, is cruel. We cajole and encourage him about his weight…but humor is not a very potent salve, after all.

"It might be weeks…or months…. If God is kind, it will be weeks, or days, but being strong, heart-wise, etc., his resistance rides high!"

Sandor Toth lived long enough to see the birth of his first grandchild: almost six months after the initial

operation, he died of cancer on April 1, 1958. It was a cruel April Fool's Day for Alex, coming at a time when professional dissatisfaction was gnawing his insides.

In addition to producing pages for Western/Dell's ongoing comics titles, Alex was a frequent contributor to the longest-running anthology in comic book history: *Four Color Comics* (also known by the more unwieldy name, *Four Color Series*). It was an anthology only true aficionados knew about, since the name *Four Color* appeared in tiny type, if at all. Each issue spotlighted something different, with no issue-to-issue continuity of characters or creators. "Donald Duck Finds Pirate Gold," Carl Barks's landmark first Disney story, appeared as 1942's *Four Color* #9; twenty years later the final *Four Color*, #1352, featured an adaptation of the then-current TV series *Calvin and the Colonel*. In between were issues devoted to popular newspaper comic strip characters (*Steve Canyon, Smokey Stover*)—literary, film, and TV adaptations (*Hunchback of Notre Dame, Francis the Talking Mule, Leave it to Beaver*)—topical or seasonal themes (*Man in Flight, Santa Claus Funnies*)—and "try out" concepts that might spin off into regular Dell series (*Little Lulu* and *Porky Pig* were among those that made the grade).

Toth is documented as contributing to twenty-nine issues of the series. Many of his *Four Color*s were movie adaptations: John Ford's *Wings of Eagles*; *Gun Glory*, starring Stuart Granger; *No Time for Sergeants*; Howard Hawks's *Rio Bravo*; *Darby O'Gill and the Little People*. He was especially happy with his third *Four Color* issue, an adaptation of *The Land Unknown*, which he described as a "monster, sci-fic, and sex film."

"Since I am very much affected by my subject matter," Alex noted about *The Land Unknown*, "whatever successes I enjoyed in this artwork may well be credited to the varied locales, characters, etc.…plus good 'picture scripting' by our Bob Ryder, who adapted from the shooting script, and [with] whom I'd seen the film at the studio last May. He wrote into it many four-panel spreads and paced the action rather well."

By the early '60s, adapting TV series became Alex's *Four Color* bread and butter: from the "hip" *77 Sunset Strip* to *Oh! Susanna* (Gale Storm as a cruise director, with erstwhile silent film actress Zazu Pitts playing the typical best-friend role) and the eponymous *Danny Thomas Show* (a family sitcom featuring Thomas as a nightclub singer). Toth would grumble when the sixty-six-year-old Pitts squawked about the number of wrinkles her comic book likeness sported, and when Thomas complained his nose was drawn too big (to which Alex retorted, "It wasn't me who did that, it was Nature did it first!").

The Whitman work with which Alex is most identified began in *Four Color* #882, featuring the swashbuckling swordsman, Zorro; the artist produced eight issues of "the Fox's" exploits for Whitman. These stories have truly become timeless, reprinted in the 1980s, 1990s, and early 21st Century. While *Zorro* started out as a dream project, it would sour for Alex and undoubtedly fueled a growing dissatisfaction with Western that roiled within the artist like volcanic magma.

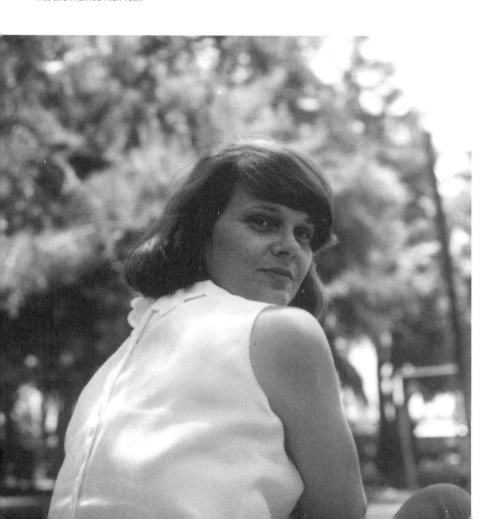

DARBY HURRIES ALONG A DARK, SHADOWY PATH NEAR THE MANOR HOUSE...

STOP!

WH-WHATTT ...??

WHAT AILS YOU, LAD? IS IT BLIND YOU ARE?

IT'S *YOU!* I SAW A MAN RUNNIN' WITH A GAME BAG! I THOUGHT IT WAS A POACHER! I'M SORRY, DARBY!

I PROMISED HIS LORDSHIP TO STOP THE POACHING! SO YOU'LL HAVE TO LET THE RABBIT GO, DARBY!

RABBIT, INDEED! I'LL SHOW YOU! GET READY FOR A GRAND SURPRISE, LAD!

YOU ARE LOOKIN' AT BRIAN OF KNOCKNASHEEGA, KING OF ALL THE LEPRECHAUNS!

'TIS ONLY A RABBIT I SEE! YOU NEED REST, DARBY! YOU'VE HAD A HARD DAY!

LET ME LOOK! WHY, 'TIS BRIAN, HIMSELF, WITH HIS WEE GOLD CROWN! I WISH YOU COULD SEE HIM, LAD!

YOUR WISH IS GRANTED! THAT'S YOUR SECOND ONE, DARBY O'GILL!

WHY, YOU TRICKY, CONNIVIN' SPALPEEN! NOW, MAKE YOURSELF VISIBLE TO MICHAEL!

I *AM* VISIBLE TO HIM! HE SEES ME AS A RABBIT! HE'LL SEE THE *REAL* ME IN HIS DREAMS TONIGHT!

ABOVE: Original artwork from "Darby O'Gill and the Little People," *Four Color* #1024 (August 1959).

Alex received the *Zorro* assignment from Western's art director, Chuck McKimson—like brothers Bob and Tom, Chuck was an alumnus of "Termite Terrace," the long-time home of the Warner Bros. animation unit. McKimson was familiar with his prize artist's love of swordplay and derring-do; he knew *Zorro* and Toth would be the perfect pairing of material and talent, and Alex himself was initially excited by the assignment. When Alex first discussed *Zorro* in a letter to Jerry DeFuccio, even a time crunch could not dampen his excitement:

> I'm ripping through *Roy Rogers* #119, 120, and 121 as fast as possible to clear the decks for Disney's new book, *The Mark of Zorro*, based on the TV series bowing in the fall [on the ABC network], running thirty-nine weeks—which, it's rumored, will far outdo any successes *Davy Crockett* had!
>
> The studio started shooting today and I asked to be granted a spot on the sound stage, where I could make notes of the costumes used, for we haven't received any stills from them as yet, and our script for the book (based on the first and second show scripts) is done…and waiting…for me…leaving me very little time to draw this "plum," and for [Western] to release the book "on cue" with the show's debut.
>
> Errol Flynn's (Warner's) old fencing master, Fred Cavens, [is] coaching the Disney Zorro in his scenes, promising us some fine foiling and toiling on TV. I'll have a field day drawing this—I love the work involved in mapping out each duel. I'm hoping our script has left me room for much action.

ABOVE: A printed page from "Darby O'Gill and the Little People," *Four Color* #1024 (August 1959), and two from "The Lennon Sisters: The Mystery of Lonesome Farm," *Four Color* #1014 (July 1959).

ABOVE: With wife Christina expecting their first child in early 1958, Alex decided he should have a workplace outside the home. In November 1957, he leased studio space at 1600 North La Brea in Los Angeles. He took this photo of his studio in May 1958; on his drawing board are pages from "The Eagle's Brood" (opposite), published in *Four Color* #960 (December 1958).

OPPOSITE: A sampling of Alex Toth *Zorro* comics. The black-and-white panels are Toth's gray tones added for the 1988 collection, "correcting" the original coloring that ignored his light sources and emphasis. The improvement in the second panel is particularly noticeable.

As was their policy with all TV and movie adaptations, Dell used photo covers, such as these with actor Guy Williams on *Four Color* #920 and #933.

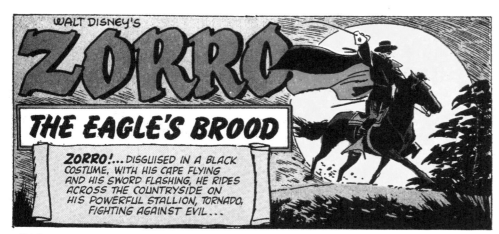

WALT DISNEY'S ZORRO
THE EAGLE'S BROOD

ZORRO!...DISGUISED IN A BLACK COSTUME, WITH HIS CAPE FLYING AND HIS SWORD FLASHING, HE RIDES ACROSS THE COUNTRYSIDE ON HIS POWERFUL STALLION, TORNADO, FIGHTING AGAINST EVIL...

MAN OF COURAGE... MAN OF MYSTERY... ZORRO!

ONLY BERNARDO, THE TRUSTED MUTE, KNOWS THE TRUE IDENTITY OF THE MAN CONCEALED BEHIND THE BLACK MASK...

TO ALL OTHERS, THIS MAN IS DON DIEGO DE LA VEGA, SON OF A RESPECTED AND INFLUENTIAL LANDOWNER!

GREEDY MEN ARE ZORRO'S ENEMIES, AND AT THIS VERY MOMENT, IN THE LITTLE SEACOAST TOWN OF MONTEREY, SINISTER PLANS ARE IN THE MAKING...

10169-605
W.D. ZORRO #2-662

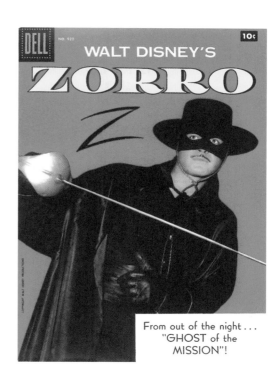

From out of the night...
"GHOST of the MISSION"!

MAN OF COURAGE... MAN OF MYSTERY... ZORRO!

ONLY BERNARDO, THE TRUSTED MUTE, KNOWS THE TRUE IDENTITY OF THE MAN CONCEALED BEHIND THE BLACK MASK...

TO ALL OTHERS, THIS MAN IS DON DIEGO DE LA VEGA, SON OF A RESPECTED AND INFLUENTIAL LANDOWNER!

GREEDY MEN ARE ZORRO'S ENEMIES, AND AT THIS VERY MOMENT, IN THE LITTLE SEACOAST TOWN OF MONTEREY, SINISTER PLANS ARE IN THE MAKING...

WALT DISNEY'S ZORRO

ZORRO KEEPS A MYSTERIOUS MEETING TO DISCOVER... "GARCIA'S SECRET!"

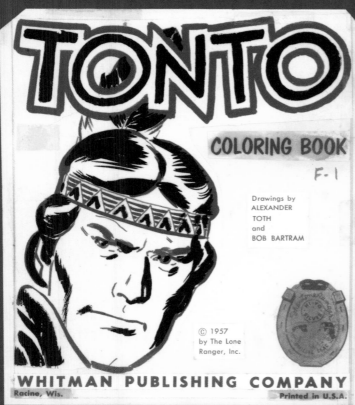

ABOVE: Original artwork for *Tonto* and *Buffalo Bill, Jr. and Calamity* coloring books, 1957.

Alas, no. There was initial enthusiasm—"Our *Zorro* is hot!" Toth gushed while following up with DeFuccio. "First issue sold out fast!! I'm on record now…Zorro is now my ever-present *compañero*!! *Viva el* Zorro! *Morte el* Boredom!!"—but a pall of dissatisfaction quickly fell over the assignment.

In a Foreword for the 1980s *Zorro* reprinting from Eclipse Books, Toth said, "The writers, a team of long tenure, did fine work on TV's *Lassie* series for years and could write whole half hours and hour specials of pantomime adventures for the collie that used to fascinate my kids and me. Like silent movies, the visual action, clear and simple, told the stories well, evoking any mood, making every story point understood. I respected that—always did, and do today. Yet these very same gents were layering pounds of lumpenly stilted, flowery, semi-early Spanish/California idiomatic dialogue into the TV series of *Zorro* and shoehorning the stuff into our comic book scripts to a faretheewell, driving me nuts!"

Blind to office politics and the considerations of others (even others who might be misguided yet sincere), Alex appointed himself the sole arbiter of the best way to present Zorro on the comics page. He began editing the copy, removing captions and reworking dialogue to create a finished product more in line with his vision. Alex's instincts for good comics were exceptional; his instincts for interpersonal relationships and chain of command far less so. As a result he was called on the carpet by Western's editors for unilaterally altering the script. "What do you know about writing?" he was asked. "You're just the artist."

In his Eclipse Foreword, Alex recalled his response to that condescending comment: "Breathing fire and smoke, I riposted…with a clear rundown of my job's responsibilities and [the editor's], and told him to replace me, fast, because from that day forward, until he did so, I would hack the hell out of *Zorro*…. A character

so unique, so dashing, deserved better, but the cards were stacked." As part of a letter in which he groused about Western's page rates, Alex penned a page-long diatribe against the injustices he encountered on *Zorro* and the parties creating those injustices. "Our comics and script editor is a man of denuded imagination, possessing not one iota of the acumen necessary to do his job properly," it begins. "I've yakked, over and over, about cutting meaningless, clumsy dialogue and caps from the scripts we must work from. I've fought for full splash pages for each [issue of] *Zorro*—to no avail…"

Toth consistently claimed the bulk of his *Zorro* output was far less than his best, but the synergy between the smiling, heroic fictional rogue and the artist who grew up on Tyrone Power movies and *Renfrew of the Mounted* radio shows made even second-best work unforgettable. In his Introduction to the Eclipse *Zorro*, artist and writer Howard Chaykin observed, "Toth's *Zorro* is Alex at his very best…a gift of staging, of the placement of figures and objects in space, combined with an uncanny strength of characterization, making Alex an object of envy for any artist with half a brain." And Eric Toth, eldest of Alex's two sons, recalled a conversation he had with his father years later about *Zorro*:

> [Dad] told me that story about just hacking it out, and I was like, "But—but, Dad, there's some beautiful compositions here." I've taken some of that artwork and blown it up and put it on the wall at my house for my son. Because it's just beautiful. His speed—you can see it in the line work, and that's part of what makes it just brilliant, you know? He was still inspired so much by the character—despite what he *thought* he was doing, he did a great job. Yeah. Yeah, I love that stuff.

Toth's unhappiness with his *Zorro* experience extended even to the coloring. Library of American Comics creative director Dean Mullaney, editor of the definitive 1988 Eclipse *Zorro* collection, recalls, "The only thing Alex hated more than Disney's giving Zorro a bright red underbelly to his cape ("How could he blend into the night with a bright red cape?!") was the coloring of the original comics, which he felt muddied and obfuscated his art." Mullaney had located the negatives to the original series in a Western Publishing warehouse and used them to make an offer Alex couldn't refuse: the chance to make it right, using clean black-and-white artwork from the negatives. Thirty years after originally drawing the stories and fifty years after admiring Roy Crane's skill at "crafting grays to enhance his spare black and white art," Alex Toth eagerly painted gray tones onto every *Zorro* page (see page 257).

Former comics journalist and editor cat yronwode recalled how *Zorro* figured into her first telephone conversation with Toth during her 1970s tenure as columnist for the semi-professional industry newspaper, *The Buyer's Guide*.

My phone rang, and it was two o'clock in the morning. I slept up in a loft in a big old log cabin, and I ran down the ladder in the dark. I get the phone, which was over near the door, and I say, "Hello?" He goes, "Hi, this is Alex Toth." And I go, "The guy who drew *Zorro*?" He growls, "That was some of the worst work I ever did," and he started yelling at me, and I go, "But I loved it!" He says, "*Ahh-h-h*, you were just a child back then, what did you know?" And that's how Alex and I became friends.

Toth and Western executives crossed swords over more than just *Zorro*. Sparky Moore discussed another dust-up:

Alex and I also worked for Don MacLaughlin, an art director who put together a bunch of little sports booklets with illustrations; he didn't do any comics. Alex couldn't do them all, so I did some.

Toth blew up at [the art director], which was a mistake, because MacLaughlin went right back at him. [MacLaughlin's] one statement was, "I'm sick of looking at your goddamned simplified drawings where your hands look like a bunch of bananas."

Toth said to me later, kind of like a chastised little boy, "You think my hands look like bananas?" I said, "Well, Alex, you do have everything slimmed to a simplified form, and bananas look like fingers if you look at them right."

By the time daughter Dana was an infant and Christina was pregnant with Carrie, Alex was characterizing Western's editors and art directors as "a quagmire of gay quacks pretending a professional knowledge." He acknowledged that Chuck McKimson was "very good to work for," but when McKimson was lured back into the animation field, Alex (like all of Western's comic book artists) was left to the tender mercies of Chase Craig. During his tenure as art director for Western's comics, Craig became, in Sparky Moore's words, "one of the most disliked men in the business… Chase got his position by simply outliving everybody else—he didn't get it by talent. Everybody that'd had the job either quit or left."

Though there were occasional bright spots—such as the time editor Del Connell tasked Alex with producing a series of images from *Arsenic and Old Lace* as part of a presentation to launch a line of illustrated plays—the pervading atmosphere was contentious, the feelings of satisfaction increasingly difficult to come by. Again, writing to Jerry DeFuccio:

With each panel, the anger and frustration increases. I detest working just to get it done, for just the deadline—there must be the *wanting* to do the best you've got to give, for we all share in the good work of one another.

I've often tried, when unhappy with a situation similar to the present one, to not care of quality, for *they* don't. They don't *need* it, *want* it, or *recognize* it when they've *got* it in their hands.

I love giving of me to my work, for men I respect, who respect me and my work in turn—who unshackle my hands and say, "just do your best, in your own way."

These words were never uttered to me [at National] by [Julius] Schwartz, [Bob] Kanigher, [Whitney] Ellsworth, [Murray] Boltinoff, or [Jack] Schiff. They *were* uttered by Mike Peppe at Standard Publications— and there, unburdened by do's and don'ts and mediocrity of imposed tastes, I did my best, most imaginative strips, and I had the good fortune to work from fine scripts. I'll never forget Kim Aamodt's romance scripts, and the fun I had expressing in art his wonderful moods of word.

But Standard was gone, Aamodt and Peppe part of the past. Western and Chase Craig were the present, the artistic and personal abuses (real and perceived) were mounting until one day in 1961, Vesuvius erupted.

Armed with a hand-written list describing Chase Craig's many inadequacies, Toth strode the Western halls in righteous fury, heading for the office of the head of Western's Beverly Hills operation. According to Sparky Moore, Alex stopped in Craig's door long enough to invite the hated art director along for the showdown, an invitation Craig accepted.

Inside the executive office, Alex labeled Craig an incompetent. He said he had grievances he wanted to put on the record, then ticked off his list, item by item. It was a display of courage mixed with equal parts foolhardiness—senior management terminates junior management at the behest of the hired help only under the most extraordinary circumstances. Alex's tantrum may have been emotionally satisfying, but as the confrontation unfolded, he must surely have seen it could end only one way.

As published in *Alter Ego*, Sparky Moore summed up that day. "[Alex] said he had eleven things that, in particular, he wanted to say. He read them all off, and then more or less told them to go screw themselves, and walked out. That was the end of his career with Western."

Despite its acrimonious finale, Toth's career at Western gave him a new wife, the beginnings of a family, and a passing familiarity with the inner workings of Hollywood studios. It was, in its way, a stepping stone toward the next evolutionary stage of his career.

THE MONTHS FOLLOWING THE "TEA PARTY" SEE MORE BRITISH TROOPS ARRIVE FROM ENGLAND—— SENT TO KEEP CLOSE WATCH AND GUARD OVER THE REBELLIOUS COLONIES...

EVERY TIDE SEEMS TO BRING ANOTHER WAVE OF REDCOATS! WILL IT NEVER END?

I FEAR NOT, PAUL...

NOT UNTIL THEY HAVE ENOUGH TROOPS HERE TO BLUFF THE COLONISTS INTO THINKING ANY UPRISING WOULD BE FATAL!

TIME PASSES... NIGHT AND DAY THE RED-COATS PATROL THE STREETS OF BOSTON...

I'VE BEEN LOOKING FOR YOU, JOHNNY!

WHAT IS IT, PAUL? IS ANYTHING WRONG?

I DON'T KNOW! I RECEIVED A MESSAGE FROM DR. WARREN! HE WANTS TO SEE US AT ONCE!

I SAW YOU FROM THE WINDOW! COME IN, GENTLEMEN...I HAVE SERIOUS NEWS!

ABOVE: A page from "Paul Revere's Ride," *Four Color* #822 (August 1957).

ABOVE: A page from "Gun Glory," *Four Color* #846 (October 1957).

ABOVE: A page from "Frontier Doctor: Storm Over King City," *Four Color* #877 (February 1958).

ABOVE: A page from "Clint and Mac," *Four Color* #889 (March 1958).

"I PRESSED THE LEVER FORWARD AND THE TIME DIAL WHIRLED...

"I SAW THE SUN RISE AND FALL IN AN ARC IN LESS THAN A MINUTE...

"THE MOON RACING THROUGH TUMULTOUS CLOUDS IN AN INSTANT...

"IT BECAME INTOXICATING...TO SEE AN ENTIRE STORM IN A FEW SECONDS! I PUSHED THE LEVER ON TOWARD EVEN GREATER SPEEDS...

"THIRTEEN YEARS HAD PASSED...FOURTEEN... FIFTEEN...SIXTEEN...AND THEN...

"IN THE YEAR 1917, I STOPPED...

ABOVE: A page from "The Time Machine," *Four Color* #1085 (March 1960).

THE WALT DISNEY STUDIOS
Present
ZORRO
in Zorro's Secret Passage

THIS IS THE LAST ONE, SERGEANT GARCIA!

GOOD! I MUST REPORT TO COMMANDANTE MONASTARIO!!

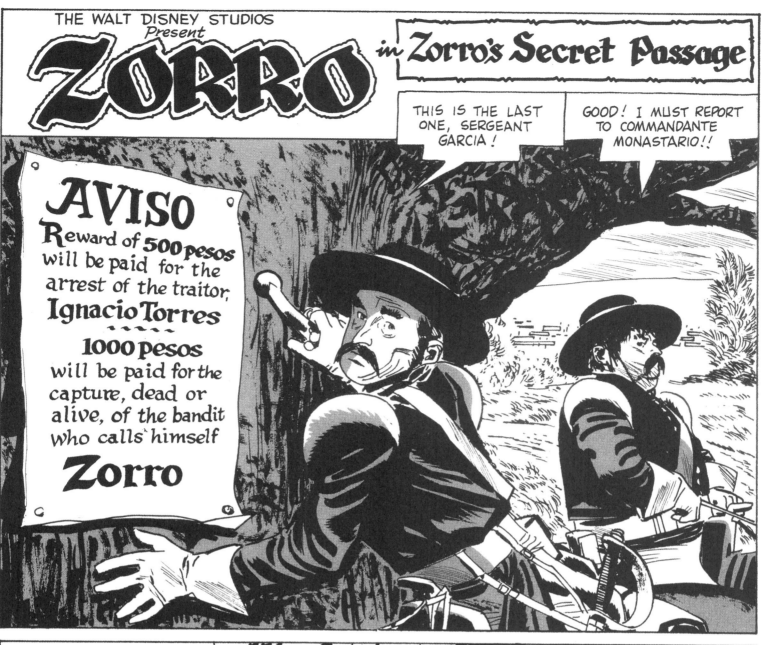

AVISO
Reward of **500 pesos** will be paid for the arrest of the traitor, **Ignacio Torres**

1000 pesos will be paid for the capture, dead or alive, of the bandit who calls himself **Zorro**

MI CAPITAN! ALL POSTERS HAVE BEEN PUT UP!

VERY WELL! NOW WE **WORK!**

MORE WORK... **THIS MORNING?**

YES, SERGEANT! I DON'T PLAN TO SIT BACK AND WAIT UNTIL SOMEBODY BRINGS THEM IN! WE'LL **SEARCH** FOR THEM!

BUT HOW WILL WE KNOW **ZORRO?** HE'S **MASKED!**

I HAVE A PLAN! FIND **ZORRO**... AND WE FIND **TORRES!** HAVE FOUR OF YOUR BEST LANCERS READY TO RIDE **IMMEDIATELY!**

MEANWHILE, AT CASA DE LA VEGA...

AHA! BERNARDO! YOU ARE SURPRISED TO SEE ME, EH? YOU WONDER HOW I RETURNED WITHOUT COMING IN THE DOOR?

PAGES 269-282: "Zorro's Secret Passage," originally published in *Four Color* #882 (February 1958). This gray-toned version created by Alex Toth in 1988.

PRESENTLY... NOW... WE'RE UNDER THE HOUSE! A LITTLE FURTHER AND WE'LL BE UNDER THE STABLES! THEN YOU'LL HEAR THE HORSES' HOOFS ABOVE!

IT'S ALL RIGHT, BERNARDO! ONLY *BATS*!

WE'VE COME ABOUT A *QUARTER MILE* THROUGH THE PASSAGE! REMEMBER THAT, AND ALSO HOW LONG IT TAKES!

GURGLE GURGLE

HA! YOU HEAR THE UNDERGROUND SPRING, BERNARDO! THIS CAVERN'S A PERFECT HIDING PLACE FOR *TORNADO*!

GURGLE GURGLE

HOLA, *TORNADO!*...WE MUST SEE THAT HE HAS AN AMPLE SUPPLY OF GRAIN, BERNARDO! I DIDN'T HAVE TIME YESTERDAY!

THE ENTRANCE IS HERE! AND *THIS* SERVES TO KEEP TORNADO FROM WANDERING OUT! LET'S GO OUTSIDE THE BARRIER!

THIS IS JUST BIG ENOUGH FOR A HORSE WITH RIDER! THE OUTSIDE OPENING IS COVERED WITH VINES!

HERE WE ARE!

OUT THERE IS A CANYON! YOU'LL EXERCISE TORNADO THERE DAILY! HA! ALL THIS MAY EVEN OUR CHANCES AGAINST THE MIGHT OF MONASTARIO, EH?

YES, BETWEEN THE THREE OF US, WE SHOULD FIGHT WELL! BUT NOW I MUST GO TO THE MISSION, TO MAKE SURE TORRES ARRIVED THERE SAFELY! LET US GO BACK!

HA! HA! BERNARDO! SURELY YOU HAVEN'T LOST THE ENTRANCE?

WUNK

HERE IT IS! IT WON'T TAKE LONG FOR YOU TO REMEMBER THE EXACT SPOT, MY FRIEND!

SOME TIME LATER, DIEGO ARRIVES AT MISSION DE SAN GABRIEL...

DIEGO, MY YOUNG FRIEND! WHAT A HAPPY SURPRISE!

PADRE FELIPE! IT IS GOOD TO SEE YOU AGAIN!

I'VE BROUGHT YOU SOME BOOKS FROM SPAIN!

VERY THOUGHTFUL OF YOU, MY SON!

I WANTED TO TALK TO YOU OF SEÑOR TORRES! I HAVE SEEN POSTERS FOR HIS CAPTURE AND ALSO THE BANDIT, *ZORRO!* DO YOU KNOW WHO THIS *ZORRO IS?*

NO! BUT I HAVE GOOD NEWS ABOUT TORRES! HE IS HERE AND SAFE!

DON NACHO·TORRES! I THANK HEAVEN YOU ARE SAFE!

AND *I*, DIEGO! BUT I WISH OUR MEETING WERE UNDER HAPPIER CIRCUMSTANCES!

EVEN *MONASTARIO* WOULD NOT DARE TO INVADE CHURCH SANCTUARY! BUT IS THERE ANYTHING I CAN DO, DON NACHO?

YES... TELL MY FAMILY I AM SAFE, BUT FOR THEIR OWN SAKES, DO *NOT* TELL THEM WHERE I AM!

I'LL CALL ON THEM ON MY WAY HOME!

COME, LET'S SIT IN THE GARDEN! I'LL BRING FRESH FRUITS!

AFTER LEAVING THE MISSION, DIEGO STOPS AT CASA DE TORRES...

DON DIEGO! IS THAT YOU?

YES! AND YOU ARE ELENA! I HARDLY RECOGNIZED YOU, YOU'VE GROWN SO!

I HAVE NEWS OF YOUR FATHER! HE IS SAFE! HE SENDS HIS LOVE AND ASSURANCES!

I AM SO GLAD! SOLDIERS SEARCHED HERE THIS MORNING! BUT WHERE IS FATHER?

THAT I CANNOT TELL YOU! ONLY THAT HE IS WELL!

THEN I THANK YOU, DIEGO! I MUST TELL MOTHER! SHE IS SO WORRIED!

RETURNING TO HIS CASA, DIEGO SEES A STRANGE HORSE TETHERED THERE...

PEPITO! DO YOU KNOW OUR VISITOR?

NO, PATRON! I DIDN'T SEE HIM ARRIVE!

WELL, I'LL SOON FIND OUT!

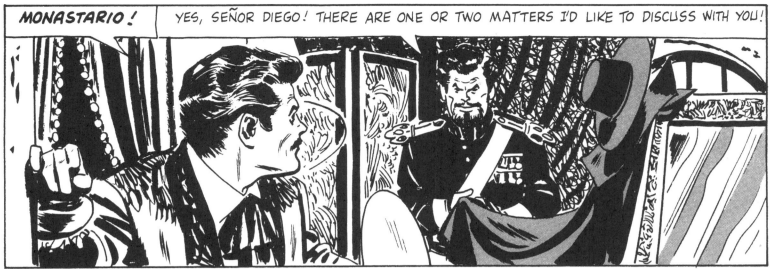

MONASTARIO!

YES, SEÑOR DIEGO! THERE ARE ONE OR TWO MATTERS I'D LIKE TO DISCUSS WITH YOU!

THIS IS... ER ... AN UNEXPECTED SURPRISE! BUT THE COSTUME YOU HOLD... I DO NOT UNDERSTAND!

YOU WILL! I'M LOOKING FOR AN OUTLAW NAMED ZORRO! IT'S POSSIBLE I MAY FIND HIM HERE!

THIS COSTUME IS A COPY OF ZORRO'S! WHEN I FIND THE RIGHT MAN, I'LL KNOW HIM BY HIS BEARING AND STYLE WITH THE SWORD!

I SEE!

ALL YOUR VAQUEROS HAVE BEEN INTERROGATED EXCEPT ONE...BENITO AVILA! HE IS A VERY LIKELY SUSPECT!

YOU MUST BE MISTAKEN! THERE ARE MANY WHO FIT ZORRO'S DESCRIPTION! MYSELF FOR EXAMPLE!

HA! I FIND THAT VERY AMUSING! BUT COME, WE WILL SEE HOW ADEPT A SWORDSMAN YOU ARE! EN GARDE!

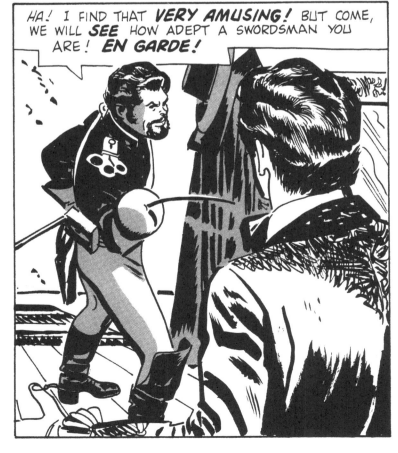

VERY WELL!

I FEAR THE YOUNG DON HOLDS HIS SWORD RATHER CLUMSILY!

ZZZZZIPP

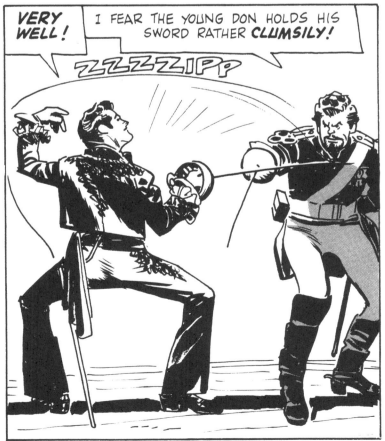

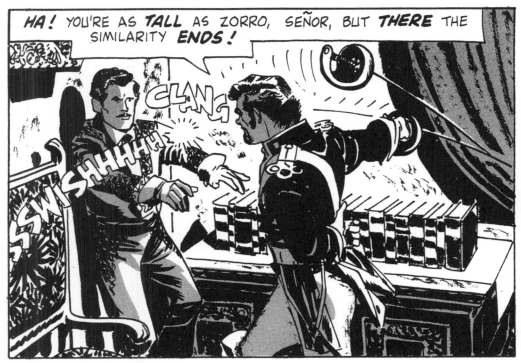

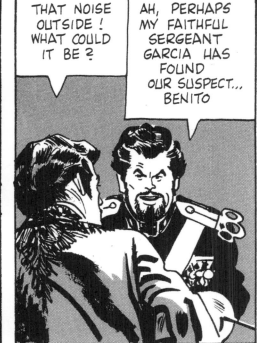

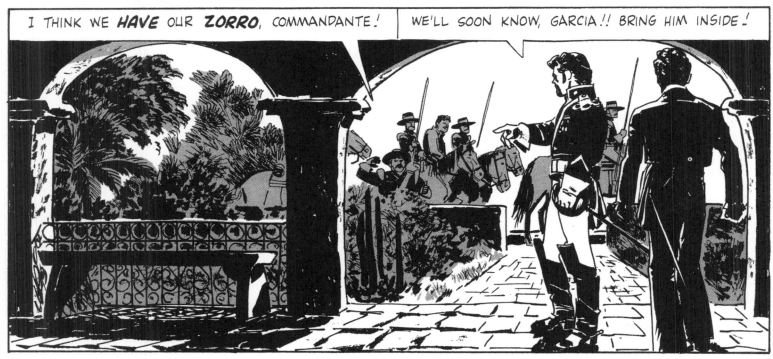

VERY **CONVENIENT**, MY YOUNG FRIEND! DID ANYBODY SEE YOU ON THIS TRIP TO THE HILLS?

I—I WENT **ALONE!**

YOU **LIE**, BENITO! **YOU** ARE THE OUTLAW, **ZORRO!** **ADMIT IT!**

NO! **NO!** BENITO IS **NOT** AN OUTLAW! I SAW HIM LAST NIGHT! HE WAS WALKING WITH **SEÑORITA TORRES!**

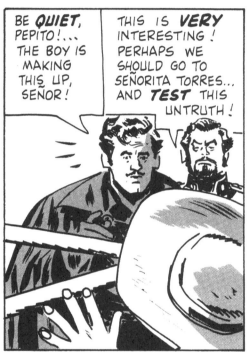

BE **QUIET**, PEPITO!... THE BOY IS MAKING THIS UP, SEÑOR!

THIS IS **VERY** INTERESTING! PERHAPS WE SHOULD GO TO SEÑORITA TORRES... AND **TEST** THIS UNTRUTH!

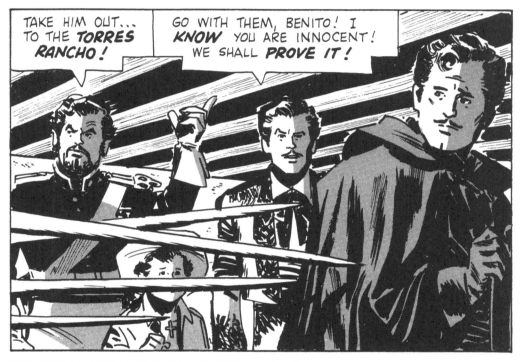

TAKE HIM OUT... TO THE **TORRES RANCHO!**

GO WITH THEM, BENITO! I **KNOW** YOU ARE INNOCENT! WE SHALL **PROVE IT!**

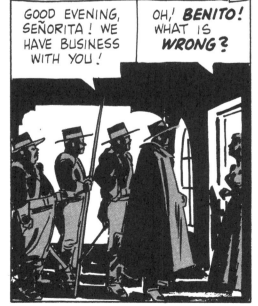

IT IS DARK AS MONASTARIO'S MEN, WITH BENITO, REACH CASA DE TORRES...

GOOD EVENING, SEÑORITA! WE HAVE BUSINESS WITH YOU!

OH,! **BENITO!** WHAT IS **WRONG?**

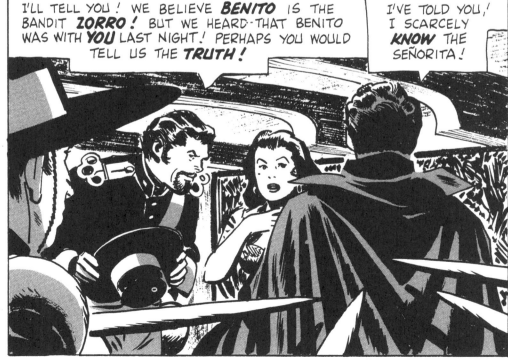

I'LL TELL YOU! WE BELIEVE **BENITO** IS THE BANDIT **ZORRO!** BUT WE HEARD THAT BENITO WAS WITH **YOU** LAST NIGHT! PERHAPS YOU WOULD TELL US THE **TRUTH!**

I'VE TOLD YOU,! I SCARCELY **KNOW** THE SEÑORITA!

IN *THAT* CASE, WE MAY ASSUME THAT YOU *ARE* ZORRO AND *WERE* IN THE PUEBLO *LAST NIGHT!*

NO... *NO!* BENITO IS *NOT* A BANDIT! HE *WAS* WITH ME LAST NIGHT! I SWEAR IT!

ENOUGH OF THIS! I WILL TRY ONCE MORE TO PROVE WE HAVE THE RIGHT MAN! GARCIA, STATION YOUR MEN ABOUT THE HOUSE! IF HE IS ZORRO I CAN TELL BY HIS *SWORDSMANSHIP!*

YES, COMMANDANTE!

AT THAT MINUTE, RIDING HIS GREAT BLACK STALLION ACROSS THE PLAINS... *ZORRO!*

WHO MINUTES LATER, IS OVERLOOKING THE TORRES RANCHO...

I HEAR SWORDPLAY INSIDE THE HOUSE... AND THERE IS SERGEANT GARCIA! I'LL HAVE TO REMOVE HIM TEMPORARILY!

I WONDER... I DON'T SUPPOSE HE'D WANT TO LOSE HIS HORSE AND HAVE TO WALK BACK TO THE CUARTEL... BUT...

WAP

WHINNEEE

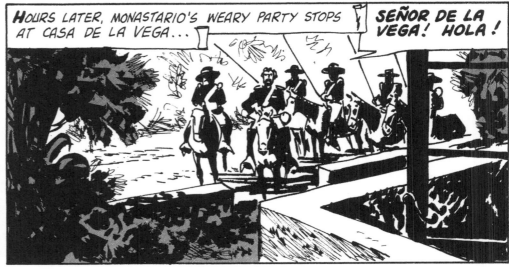

77 SUNSET STRIP
SAFARI IN TROUBLESVILLE

PAGES 283-300: "77 Sunset Strip: Safari in Troublesville," *Four Color* #1066 (January 1960). Reproduced from an Australian black-and-white edition.

SHORTLY... I JUST CAN'T MAKE THE SCENE TODAY, DOLL...THESE PRIVATE INVESTIGATORS NEED ME TO WORK WITH 'EM ON A BIG CASE!

BUT, KOOKIE... YOU PROMISED!

I'M WITH IT, BABY, BUT YOU'RE NOT READING ME...THIS IS, LIKE *IMPORTANT!* INVOLVES A LOT OF DANGEROUS JAZZ LIKE COOLING A BIG SMUGGLER OR SOMETHING...

THEN BE CAREFUL, KOOKIE...I'D HATE TO HAVE ANYTHING HAPPEN TO —

GOT TO BUZZ OFF NOW, CHICK! I'LL SEND MORE LATER...

DOCTOR CYCLOPS?

HUH?

OH, THAT? JUST DOING SOME EYE EXERCISES...

YOU'RE MR. BAILEY, THEN?

STUART BA PRIVAT

NO, STU HAD TO GO DOWNTOWN ON BUSINESS! HE ASKED ME TO TAKE OVER FOR HIM...YOU THE CHICK WHO CALLED?

YES...MY NAME IS CANDY CARVER!

SEEMS TO ME LIKE YOU'VE LATCHED ON TO SOMETHING WORTH A LOT OF LOOT AND YOU STAND TO MAKE A MINT! WHY THE NEED FOR A PRIVATE INVESTIGATOR?

BECAUSE OF THE *THREATS!*

YOU MEAN SOMEONE'S BUGGING YOU WITH THE SCARE ROUTINE?

I'VE HAD ABOUT TEN CALLS... A STRANGE VOICE KEEPS TELLING ME THE KUYIAKI PAINTING IS CURSED...IT HAS SOME SPELL ON IT WHICH WILL MEAN DEATH!

SOME CREEPY SQUARE IS JUST PLAYING GAMES, DOLL!

I'M NOT SURE IT'S A GAME, KOOKIE! LAST NIGHT SOMEONE TOOK A SHOT AT ME!

DID YOU GO TO THE FUZZ? THE POLICE?

I THOUGHT ABOUT IT... BUT THERE'S NOT MUCH THEY CAN DO WITHOUT PROOF...IT ALL SOUNDS SO CORNY, ANYWAY!

YOU'VE JUST GOT TO HELP ME! PLEASE...WITH LUCK, I COULD END THIS PROBLEM TODAY!

TODAY? I DON'T DIG...

I'M SUPPOSED TO TAKE THE PAINTING TO A MAN WHO LIVES IN LAUREL CANYON...HE'S A REPUTABLE ART BUYER, BUT I'M STILL WORRIED!

AND YOU WANT AN ESCORT, IS THAT IT, DOLL?

I HOPE SO...

I'M PREPARED TO GIVE YOU TWENTY THOUSAND DOLLARS...

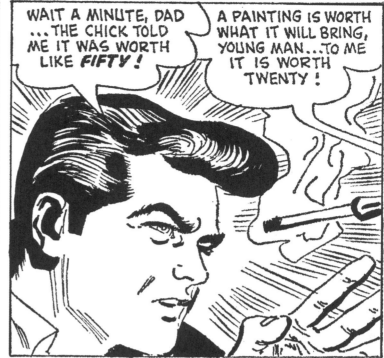

WAIT A MINUTE, DAD ...THE CHICK TOLD ME IT WAS WORTH LIKE *FIFTY*!

A PAINTING IS WORTH WHAT IT WILL BRING, YOUNG MAN...TO ME IT IS WORTH TWENTY!

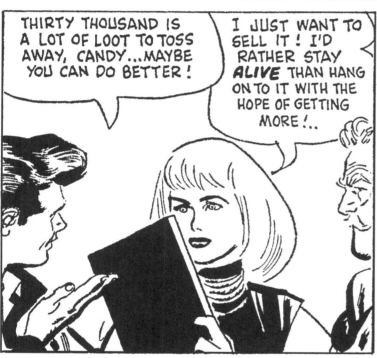

THIRTY THOUSAND IS A LOT OF LOOT TO TOSS AWAY, CANDY...MAYBE YOU CAN DO BETTER!

I JUST WANT TO SELL IT! I'D RATHER STAY *ALIVE* THAN HANG ON TO IT WITH THE HOPE OF GETTING MORE!..

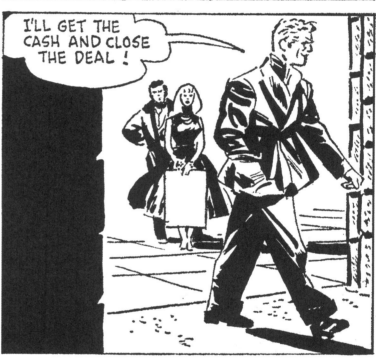

I'LL GET THE CASH AND CLOSE THE DEAL!

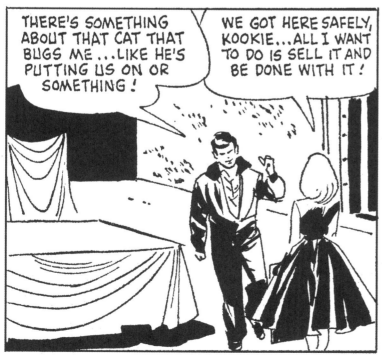

THERE'S SOMETHING ABOUT THAT CAT THAT BUGS ME...LIKE HE'S PUTTING US ON OR SOMETHING!

WE GOT HERE SAFELY, KOOKIE...ALL I WANT TO DO IS SELL IT AND BE DONE WITH IT!

WONDER WHY ALL THIS STUFF IS COVERED? LIKE MAYBE THIS CAT IS MOVIN' OUT OR SOMETHING...

A SHORT WHILE LATER...

CANDY CARVER?

YES, MR. BAILEY... WE'VE GOT TO *HURRY!*

I STILL DON'T SEE WHY KOOKIE GOT INVOLVED IN ALL THIS... I TOLD HIM JUST TO GET THE INFORMATION FROM YOU!

HE ONLY DID WHAT HE THOUGHT BEST... AFTER ALL, HE *IS* YOUR ASSOCIATE!

MY *WHAT?*

OH, I KNOW ALL ABOUT HIS UNDERCOVER WORK... AND HIS POSE AS A PARKING LOT ATTENDANT... YOU DON'T HAVE TO WORRY! I'LL NEVER TELL ANYONE!

HE'S LIABLE TO BE *UNDERCOVER* ALL RIGHT... BUT RIGHT NOW I'M AFRAID IT WILL BE IN A GRAVEYARD!

NEAR VENTURA...

THERE'S HIS CAR... I'D BETTER PARK NOW AND WAIT FOR STU...

END FREEWAY

DETOUR ▷

IN THE CAR AHEAD...

I CAN'T FIGURE WHAT'S KEEPING FRANK...HE SHOULD BE HERE BY NOW!

MAYBE HE RAN INTO TROUBLE!

THAT CAR BACK THERE...

SOMETHING WRONG?

I'D SWEAR IT WAS THE SAME ONE THAT BELONGED TO THAT GUY THAT WAS WITH THE GIRL...

YOU'RE JUST JUMPY, BRANDON...

I'M GOING TO MAKE SURE, JUST IN CASE!..

SSSCREEECH!

OH-OH, LOOKS LIKE TROUBLESVILLE!

VVRRROARR!

AS KOOKIE STARTS UP...

SCREEECHH

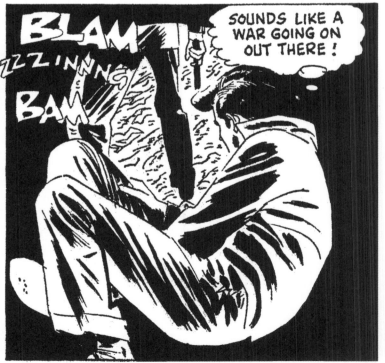

AS BRANDON REACHES THE ROAD THE POLICE ARE ON THE SCENE...

AND AS HE TURNS TO FLEE...

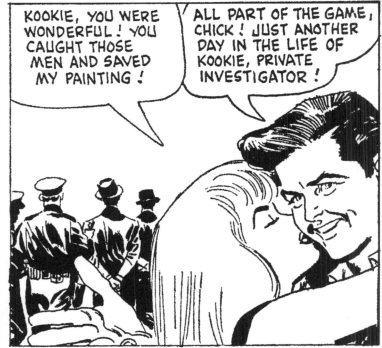

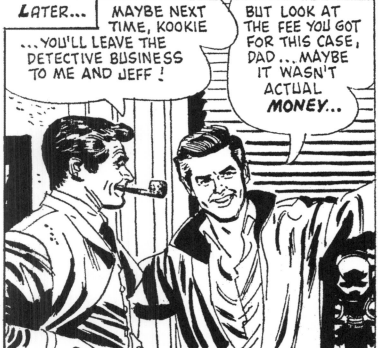

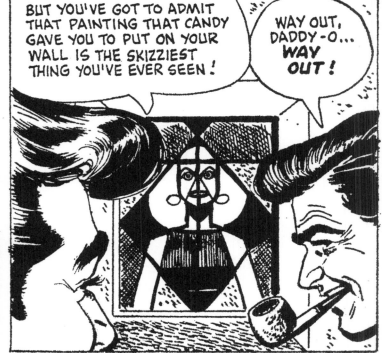

WARNER BROS.

MAVERICK

Based on the Warner Bros. Television Production
starring James Garner and Jack Kelly

By

CHARLES I. COOMBS

Illustrated by

ALEXANDER TOTH

Authorized Edition

WHITMAN PUBLISHING COMPANY
RACINE. WISCONSIN

PAGES 301-307: Toth's twenty-four illustrations for a *Maverick* children's novel published by Whitman/Western, 1959.

GENIUS, ISOLATED **301**

"That's him!" cried the excited woman. "That's the one!" And she pointed an accusing finger straight at the dismayed Bret Maverick!

Bret counts on plenty of problems when he sets off for the once-prosperous Rocking H ranch at the request of Ward Harper, now suddenly dead. But little does he expect that stopping to help a stranger on the way will plunge him deeply into trouble—trouble which finds him behind bars before he can prove that he, Bret Maverick, is on the right side of the law.

And even when he has his freedom again, his job is by no means easy. As new foreman of the heavily mortgaged Rocking H, Bret fights to keep his young friend Andy Harper and his sister Linda from losing their ranch. He searches for the robbers of the stagecoach—and he puzzles over the rustlers who broke his friend Ward Harper and then killed him.

A small window, a tricky jail break, and the wreck of a buckboard are exciting clues to the answers being sought in this thrilling new adventure of *Maverick*.

JUL · 59

ABOVE: Proud parents a second time. Christina and Alex with baby Carrie, July 1959.

PART/ELEVEN
OLD HAUNTS
& NEW HORIZONS

By the early 1960s Alex was famed throughout the comics industry as much for his opinionated and often prickly personality as for his bravura artwork. There were those who had been on the receiving end of his volcanic temper and others who had witnessed eruptions a safe distance from the blast zone, yet tongues wagged as incidents were recounted first-, second-, third-, or even fourth-hand.

Psychology and psychiatry had only begun making in-roads into society at this time—the American public was still a decade away from turning Flora Rheta Schreiber's book, *Sibyl*, into a best-seller and warmly embracing psychologist Bob Hartley and his quirky patients on the top-rated CBS comedy *The Bob Newhart Show*. As fascination with the mind and its workings became part of the cultural zeitgeist, those who knew Alex speculated on the artist's state of mind.

School chum Jack Katz had one theory: "[Alex] had hypoglycemia; he had low blood sugar. When he had a drink he'd become extremely belligerent. If I saw he put sugar in his coffee, I'd get out of there, because in ten minutes he'd go bananas." Editor cat yronwode had a different opinion, saying, "I guess you could say he had OCD [Obsessive Compulsive Disorder]." During their late 1980s and 1990s phone conversations, Jim Amash said he and Toth occasionally touched upon the artist's many moods. "We talked about it seriously more than once. And I'd said, 'Alex, why don't you go to a doctor?' and he'd say, 'I'm not gonna go to no goddammed sawbones!'… I thought that was indicative of his whole

feeling about it. He said, 'I know they would give me medications that would make me feel better, but I'm just not gonna go.' I'd say, 'Well, that's being stubborn,' then he'd say, 'Hell, yeah!'"

Alex's children take a different view. "It's kind of like the weather," said Toth's youngest son, Damon. "You talk about the weather, but you never label it—it just is. And I think to a certain extent, that's kind of what Dad was. To label him doesn't benefit anything, because what he was is what he was, for good or bad. You look at [him] giving away jobs or not taking jobs or leaving jobs because of disagreements, or whatever. His integrity was way more important to him than dollars and cents, and he lived by that his whole life. I think Dad was true to himself. I think he had a lot of guilt that he carried with him, almost to the end. But that's one of the beautiful things at the end—he kind of 'got' everything and accepted his relationships with his family."

Another factor likely contributing to Toth's mercurial moods was the frustration and sense of isolation that is the burden of those possessed of singular talent: it is difficult to communicate with others who cannot see what is, to a genius, plainly visible.

This burden is not unique to Alex: it affects other outstanding practitioners in their fields. Honored fantasist Harlan Ellison opens the 2007 documentary film *Dreams with Sharp Teeth* by running down a checklist of improbable stories told about him (some real, some fabrications), including the rumor that he dropped one of his more belligerent fans down an empty

elevator shaft, a tale as tall as the story told about Toth dangling Julie Schwartz out an open window.

Had Alex enjoyed major league baseball, he would have recognized a kindred spirit in Boston Red Sox left fielder Ted Williams, lionized then and now as the greatest hitter who ever lived. Author David Halberstam examined the lifelong friendship between Williams and fellow Red Sox stars Bobby Doerr, Dominic DiMaggio, and Johnny Pesky in his 2003 book *The Teammates*. In it, Halberstam had this to say about "The Kid":

> When he was generous there was no one more generous, and when he was petulant there was no one more petulant, and sometimes he was both within a few seconds…. To understand him, to get along with him and earn his trust, you had to take him on his terms. You couldn't change him. It was like trying to change a force of nature. You had to accommodate to him, he could not accommodate to you…. He did not know how to do the small, political things that would have eased so many difficult situations with sportswriters and fans. Everything became an issue of personal honor and integrity. He was in those days—as Pesky often said of him, choosing a relatively mild word— cantankerous…. He was so easily wounded, yet he could also just as easily wound other people without realizing it.

No one could hit a ball like Ted Williams—no one makes words sing on paper like Harlan Ellison—and no one could tell a comics story like Alex Toth.

It can be lonely at the top.

• • • • •

Alex may have used his impatience and temper to figuratively shoot his way out of Western, but with a family to support he was not about to walk away without other sources of income upon which he could rely.

He made a minor return to syndicated newspaper comics at the end of 1960 by producing two dozen *Roy Rogers* newspaper strips, filling in for ailing regular artist Mike Arens. In early 1961 Toth ate a small amount of crow and renewed his relationship with National, by that time more commonly referred to as DC Comics. Nearly a decade had passed since the flare-up between Alex and Julius Schwartz, but the intervening years had done nothing to assuage that wound—Alex conducted business not with Schwartz, but with Jack Schiff and his associate editors, Murray Boltinoff and George Kashdan. For the next three years Toth art graced the pages of DC's *Rip Hunter, Time Master*; *House of Mystery*; *My Greatest Adventure*; and *House of Secrets*, including a consecutive string of appearances from issue #63 to #67 of the latter title.

Perhaps Alex's most famous comic from this period is the book-length partnering of two costumed heroes, the Flash and the Atom, originally printed under the title, "The Challenge of the Expanding World" in *The*

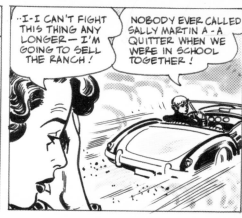

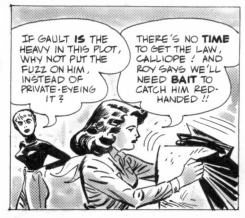
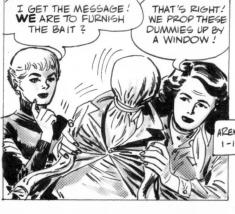
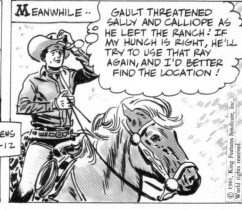

ABOVE: Original art for three *Roy Rogers* daily strips Toth ghosted for an ailing Mike Arens. December 27-28, 1960, and January 12, 1961.

OPPOSITE: Splash page from *The Brave and the Bold* #53 (April 1964).

Brave and The Bold #53. Certainly this remains one of the most-reprinted of Toth's DC tales, having first been re-published in 1971 across two issues of *Action Comics* before appearing in a 1990 hardcover (*The Greatest Team-Up Stories Ever Told*) and most recently in 2005's *The Brave and The Bold Team-Up Archives*, Volume 1. The story marked the artist's return to superhero stories and was his first such effort in the so-called "Silver Age of Comics," generally accepted to have begun in 1956 when a sleekly modern, revamped version of the Flash bowed in the fourth issue of the anthology title *Showcase*, signaling the resurgence of the superhero. Alex brought a naturalistic touch to the material— his superheroes looked and acted like real persons in costumes, not like the chiseled, idealized figures regularly produced by fellow artists such as Gil Kane

or Carmine Infantino. Not every reader was enamored of the Toth rendition of the Scarlet Speedster and the Mighty Mite, as comics fan David Armstrong can attest:

> I had seen Alex's stuff in *House of Secrets*, miscellaneous stories here and there. Because I was a superhero collector, the first time I actually recognized [his work] was when I saw the *Brave and Bold* "Atom and Flash" story.... I wasn't impressed much. I didn't think much of it. I didn't get it. I mean, I didn't get it *at all*.
>
> And the problem was, I was looking for illustrative artwork and I was getting storytelling, and I didn't recognize it for what it was. But you gotta realize, an

eleven-year-old kid's just looking for entertainment; he's not looking for masterful storytelling!

Armstrong grew out of his pre-teen sensibilities to become not only an admirer of Toth's art, but also one of the artist's close, long-time friends.

• • • • •

Though Alex loved the comics medium as much as ever, he continued to chafe over the politics, deadlines, and demands of the industry. There was work to be had in the field, and money to be made, but if maintaining a presence in comics meant "working just to get it done," new outlets had to be found, new places where Alex could again feel "the wanting to do the best you've got to give."

Fortunately, the artist loved other things almost as much as he loved comics—movies among them. He was living in greater Los Angeles, the Baghdad of motion picture dreams, and his time at Western had given him a toehold inside Hollywood. Alex pushed one of his feet through that door during a brief alliance with Joe Kubert's old friend, Norman Maurer; he shouldered all the way inside thanks to television's demand for original animated cartoon shows, and thanks to one small outfit working to meet that demand, Cambria Studios.

It was 1960 when Toth "backed into" work at Cambria, learning the art of animation layout on the last handful of *Clutch Cargo* episodes the studio was contracted to produce. "It was limited animation (very limited)," the artist wrote about those days in a 1981 letter. "We had a six-man production department!"

Cambria was owned by Clark Haas Jr., a former pilot who worked in Florida during the War years as a civilian instructor for the air wing of the U.S. Army (at the time, the Air Force did not exist as a formal, stand-alone branch of the American military). While in the Sunshine State, Haas met famed cartoonist Roy Crane, justly revered for creating the comic strips *Wash Tubbs*, *Captain Easy*, and *Buz Sawyer*. Haas spent time ghosting both *Buz Sawyer* Sunday pages for Crane and *Tim Tyler's Luck* for artist Lyman Young (the brother of Chic Young, of *Blondie* fame). After briefly producing a strip under his own name, Haas founded Cambria and tried

his hand in the animation game. He partnered with a man named Edwin Gillette, whose career in Hollywood began with a job as secretary to pioneering motion picture writer/director Preston Sturges (*Sullivan's Travels*, *The Lady Eve*, *The Palm Beach Story*, and other comedy classics).

Gillette produced films for Uncle Sam during the Second World War, earned his film degree from the University of Southern California, and began experimenting with ways to project split-beam images of moving mouths onto otherwise-static pictures of faces to create a "realistic" appearance of speech in the final composite. The result was Gillette's patented "Synchro-Vox" film technique, which Cambria used in the production of *Clutch Cargo* and subsequent animated series. An uncorroborated story circulating for decades around the fringes of animation suggests that Gillette had a deaf daughter who was unable to read the lips of fully-animated characters; Synchro-Vox was supposedly his attempt to inject real speech into cartoons in order to allow his daughter to enjoy them. Perhaps there is a degree of truth to the story, but Gillette first used the technique to create commercials featuring apparently-talking animals, which casts doubts upon its veracity.

Toth referred to Cambria's approach to animation as "cheating the hell out of it," but Gillette preferred to stress the studio's inventiveness. "With a camera capable of zooming, walkers that jog, and judicious cutting away from costly animated movement, we manage to do things which otherwise would be impossible. With fewer than a dozen men we produce the equivalent of a half-hour film every week," he was quoted as saying in a 1960 *TV Guide* article about *Clutch Cargo*.

Clutch himself was a white-haired, cartoon version of *Terry and the Pirates*'s Pat Ryan—ostensibly a writer, he traveled the world in search of adventure, accompanied by a youthful ward, Spinner. Stories were primarily written by Cecil Beard and structured in five-chapter arcs, with each chapter covering five minutes of air-time. Cambria's theory was that a station could run a *Clutch* episode each day on weekdays, then combine all five episodes to fill a half-hour block on a Saturday or Sunday. The concept proved successful enough to support fifty-two separate stories and convince Haas and Gillette to hire Alex to help finish the final *Clutch* episodes, help design Cambria's next series, *Space Angel*,

and head up that show's art department. Alex's closest mentor at Cambria was Hiram "Hi" Mankin, like Toth a veteran of the comic book and comic strip scenes. As a Cleveland teenager, Mankin got his start in the business by inking *Superman* stories as one of the artists assisting Jerry Siegel and Joe Shuster. He moved on to assist Zack Mosley on the aviation strip *Smilin' Jack* and contributed to strips as varied as *Bringing Up Father* and *Bugs Bunny* in addition to producing comic book pages for National, Western, and Lev Gleason's crime comics. Hi Mankin was quieter and more introverted than Alex, but they got along: they came from similar professional backgrounds and spoke the same professional language—albeit at two different decibel levels.

If *Clutch Cargo* was Cambria's answer to the globe-trotting excitement of *Terry*, the new series, *Space Angel*, was their riff on *Flash Gordon*'s star-spanning action. Surely working for Cambria on these two series must have stirred Alex's boyhood memories of reading his father's *New York Daily News* or his later analyses of comic strips under Frank Robbins's tutelage.

It was hard work, but challenging and even fun. It was also the perfect on-the-job training, for Alex's future held assignments at bigger studios that would make his name as important in the world of animation as it was in the world of comics.

ABOVE: Decal for *Space Angel*, circa 1962.

BELOW: *Space Angel* production drawing, circa 1962.

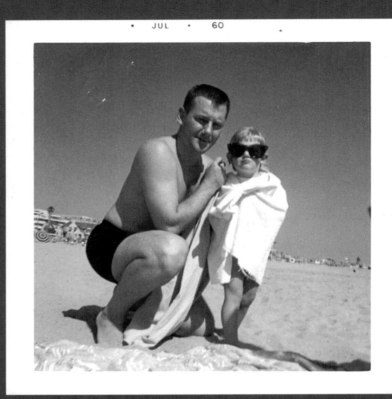

ABOVE: Alex and firstborn, Dana. Second-born Carrie with her little brother, first son Eric, who arrived on the scene in 1963. The fourth child, son Damon, would be born in 1964.

PART / TWELVE
THE TIES UNBIND

Alex Toth was learning the animation ropes at Cambria Studios and drawing stories for DC Comics because he had a greater need than ever for a solid cash flow. It was not because he was interested in building a nest egg—in fact, his son Eric observed when interviewed, "[My Dad] wasn't someone who had a mind for business in terms of investing and such. He told me, and I think he told a lot of people, that money for him was this abstract notion. He worked and always wanted to make an honest living, but money wasn't important to him just for the sake of having more." What motivated Alex were the increased responsibilities that came along with a growing family.

Four years after the girls, Alex and Christina welcomed Eric into the world, with their fourth and final child, son Damon, following the next year.

A big family had always been part of Christina's plans. "My mom was from Germany and my dad was from Switzerland, but they both came to the United States and that's where they met," said Christina. "I was really raised as an only child, since I was seventeen when my sister, Darleen, was born—and then I was twenty-two when I married Alex. [Though he had been married twice previously] he had never had any children, and I *did* tell him that was the only thing that was very important to me. I even told him I wanted six children. The poor man almost passed out!"

Being Alex Toth meant dealing with all manner of stress generated from any number of directions. He had sharp opinions based on the latest gossip out of the comic book, comic strip, and Hollywood industries— he put in long hours to meet his deadlines—he could be mercilessly critical of his own work, still judging his best as not good enough to please past critics such as Martin Tittle or Shelly Mayer. He followed current events through newspaper, radio, and television, and the major stories of the day could send him into a blue funk, as daughter Dana confirmed:

"I can see one thing that'll shut me down for the whole day, and I have to work really hard to overcome it and bury it and not look at it, because I'm a sponge. I just take it in. Dad was that way. Those were major things, to him—they weren't minor. He saw everything as crucial, and he saw things very clearly. If somebody, if a politician did a stupid thing, it killed him. All my childhood, it was like he'd say to my mother, 'Damn it! Let's just get [the kids] out of here, Chris! Let's take them to Canada! Let's move to England! Let's go to Australia!' And you know, I was like, 'Do they have boys there, in these places you want to go?'

"There's a movie [starring Harrison Ford] that reminds me of my dad—*The Mosquito Coast*. Now *that's* my dad! If he'd let himself run loose, that's my dad. Insulate, insulate, insulate—'Oh, my Gawd, the outside world is still infiltrating!'—insulate, insulate. That's my dad."

Toth never acted on those occasional impulses to live abroad, and more than two decades would pass before he began to live out his own version of *The Mosquito Coast* and sequester himself away from the world. Throughout the early 1960s he struggled, searching for the elusive balance between his professional and family life.

Aside from a single weekend trip after Dana was born—"to Running Springs or Crestline or Arrowhead, some place like that," according to Christina—the Toths took no family vacations. In fact, the former Mrs. Toth went on, "Once I had to go down to the drugstore with the kids and we just walked down and he walked with us. That, to me, was so wonderful. I wanted—" She laughed at the memory. "I wanted to play house, and that was not for him, but he probably didn't know that until he tried it. That's the thing. And I wasn't smart enough to know that. I wasn't someone he could sit down with. Alex needed someone he could sit with and talk about things. My world was, you know, quite limited compared to his."

From their children's perspective, the gap between Christina and Alex was not as wide as she believes.

"My mom doesn't…my mom could be the best interior decorator," Damon Toth said when interviewed about his family, "but she doesn't give herself credit. She could take a box and make it into a home in a matter of hours, you know? It's amazing what she can do, but she doesn't think of that as being creative, though it is." Damon's sister, Dana, added, "My mom—she's kind of like a Martha Stewart, she can take anything and make it into something. And she's the one—you know, Dad might take us to the galleries and museums, but it's my Mom that took a hollow-core door and turned it over on two cinder blocks and put a bunch of crayons on it and made us draw every day."

The pressures Alex felt were exacerbated by the number of assignments he fulfilled while working at home, in a small house filled with four children, all less than ten years of age.

"I only have a few memories of him working at the house," said Eric Toth. "He would work right, I believe, in the den, which was kind of open—at one point it probably used to be a patio that had been enclosed. He would just sit at a couch, with his drawing board on his lap—that board has been described, I think, as the back of a cupboard door or a cabinet door. He had a couple, actually, I think, and they had brush strokes and pen marks all around, where he would test something before he would use it. That's my most vivid memory of Dad working at home."

Dana has memories of her own. "I remember Daddy at the drawing table. I remember his blue pencil and I remember his gray eraser that he would pull on and pull on and pull on as I was sitting with him, you know. I always understood my father was an artist. I was always very, very respectful and mystified by the fact that he could practice so many mediums. Even as a child, I recognized that in him, and I loved that. But, see, my dad never brought us over to the table and said, 'Let me show you something.' What I knew of my dad's job was that it sort of was all-consuming for him. And he really didn't know how to relate to children. So we couldn't quite meet him at his level, and he couldn't quite come to ours. It left a very small window."

"It's like Dad never worked with kids in learning things," added Damon. "I believe he just thought that because he was able to pick things up and learn on his own that everyone learned that way. His only reference to being able to learn was his own ability. And so I think that with his kids, he never took the time to really help us in learning stuff. He just thought we should know things. Like, 'Oh, by going to school, you should know that.' I don't think that he really understood that it didn't come as easy for us as it did for him."

When deadlines loomed—and they were always looming—Alex burned the midnight oil. His temper would quickly fray in the early-morning hours, as his household came to life while he tried to catch up on sleep. His displays of temper carved deep scars in his relationship with his wife.

"I know the kids loved him dearly, yet he hurt them," Christina Hyde sighed. "I think he felt sometimes they weren't good to him, you know, I really do. I think his defense was his anger. His anger…if you were eating cereal and you crunched it too loud, he'd scream, 'You're eating that cereal too loud!' And it does get to you after a while—you're afraid to eat a potato chip!

"He'd stay up all night working, then he wanted to sleep all day. And it was funny, because I'd hear, 'The kids were too loud, I couldn't sleep!' But if I had them quiet, it was, 'Well, I couldn't sleep because it was so damned quiet!'

"I think his artistic side was so well developed that the other part of him didn't get developed really well. I don't know where all that anger came from, but he did have a lot of anger inside of him. Sometimes I wonder if he didn't have a lot of depression, too. I didn't know much about that, I just figure you do what you gotta do and you're always up. But as I look back, I suspect he had a lot of depression, and that's a hard thing to live with, too."

Eric offered his perspective. "Oh yeah—sitting at the table with him, he was very particular. He had no problem letting you or friends who happened to be over know exactly what he was thinking or feeling—which my mom probably experienced more than we did. He had a lack of good judgment when it came to that—and I think part of that was disposition, but part was also growing up as an only child. Not too many people could deal with his personality. If your family really struggles with it, how can people who are friends be expected to deal with it?"

Friendly visits were increasingly few and far between, and the strains on Alex and Christina's marriage ultimately reached a point of no return. "My dad left the house when I was six," said Dana, "and I was very glad, because my mother and father—you know, basically, what I remember is arguing."

Christina remembers more of the particulars. "He'd have a deadline, but he just seemed to have to wait right up until the last couple of weeks. I remember several times running it to the airport, or wherever I needed to take it for him. Then sometimes the phone would ring, and it'd be someone from one of the offices, or whoever it was connected to where he worked. He'd want me to tell them he was busy or whatever, that he was sleeping. And it got to where I just thought I couldn't do that anymore. It bugged me—a lot of things did.

"So what I did, I called my mom and I said, 'Mom, I just can't live anymore with Alex.' And he heard me, and he knew that when I told my mom, that I really meant it. So that's when we separated."

Damon heard the story of the day his parents separated directly from his father:

I remember asking him about that, a few years before he died. I remember, Dad was sitting on the stairs—there was kind of a little landing. Two steps, the landing, and then the steps kind of turned back.

I was on the couch, and he said, "Your mom collected the kids and you were walking out the front door, because your mom was gonna leave to go to her mom's house. It was Mom with, like, four little ducks walking behind her. And Dana said, 'Why the hell doesn't *he* leave?'"

And Dad said he thought about it and went, "You know what? You're right." He got up and left—and Mom and the four of us stayed. I don't have any recollection of that.

And he was crying when he told me that. He said, "I remember to this day, I remember her saying, 'Why the hell doesn't *he* leave?'" And me going, "You're right. I'll leave."

I just thought that speaks volumes about my dad, because he kind of did the right thing—you know, he shouldn't displace his family because of what's going on. It would make much more sense for him to leave than for his family to go.

My dad did the right thing and took the high road, when needed. I don't think a lot of people would know that or understand that about him. His close friends obviously do, but the Toth fan that knows him through his artwork wouldn't know that of him, I would think.

Alex Toth did not make it easy for his children while he lived with them, and he often did not make it easy for them after he separated from Christina. Yet he never abandoned his responsibilities to them, or to their mother, as each of them noted, independently of one another.

In the years ahead, Alex would help set new standards for television animation, meet the woman who would become his fourth wife, produce comics stories that were both *Creepy* and *Eerie*, and remind the world to shout an exuberant, "Bravo for Adventure!" He would spend years barricaded away from the world, yet the persons he needed and loved the most invariably found their way to him, or back to him.

Best of all—much to the surprise of, as Damon put it, "the people who think of him as just being angry or pissed off all the time"—he ended his life in a state of grace, finally achieving the peace that must have seemed so far away on the day he left that house in Pasadena.

Carrie Toth Morash perhaps summed up Alex Toth best when she said, "My dad was such an 'opposites' kind of a guy. He could be really impatient, short, angry, whatever—and in his creative side, I know, he set high standards for himself and for others, and everybody was exposed to that.

"But on the other side of that was this caring man who just had a really generous heart. Growing up with him was interesting, but that's because he was those two things, you know—very generous and very loving. Yet expecting a lot."

END BOOK ONE

THE ALEX TOTH: GENIUS TRILOGY CONTINUES…

Excitement! Humor! Tragedy! Compassion! And the best of all possible endings. The last four decades of Alex Toth's life tell a story he would have loved to draw—a story that unfolds in our companion volume, GENIUS, ILLUSTRATED.

VOLUME ONE:
GENIUS, ISOLATED

VOLUME TWO:
GENIUS, ILLUSTRATED

VOLUME THREE:
GENIUS, ANIMATED

THE LIBRARY OF AMERICAN COMICS

1943-44

Heroic #??, (Toth claims his first job was at age 15 for **Heroic**), Eastern Color

1945

Heroic 32, "Yankee King" (text illustration), "One of Our Heroes is Missing" (3), Eastern Color, September 1945

Heroic 33, "Pruitt Gets a Pass" (4), "He Brought Them Ridin' High" (1), Eastern Color, November 1945

Heroic #??, "Vilhjalmer Stefansson" (text illustration), Eastern Color. (See page 41.) Not known if published.

1946

Yellowjacket 7, "Little Laffs" (1, five cartoons), The Frank Publishing, January 1946

The Prince and the Pauper by Mark Twain (text illustrations by the students at the School of Industrial Art), The Board of Education, City of New York, 1946

Heroic 35, "The Switchboard Heroine" (5), "The Heroic Traffic Cop" (4), Eastern Color, March 1946

Famous Funnies 141, "Gasoline Cowboy" (2 text illustrations), Eastern Color, March 1946

Heroic 36, "When They Were Young: Abraham Lincoln" (4), Eastern Color, May 1946

Heroic 37, "That Another Might Live" (3), "When They Were Young: Stonewall Jackson" (4), Eastern Color, July 1946

Future World 2, "It's a Secret!!" (text illustration), The Frank Publishing, Fall 1946

Heroic 39, "Forever Vigilant" (2), Eastern Color, November 1946

1947

Heroic 41, "Ferryboat Rescue" (2), Eastern Color, March 1947

Catholic Pictorial 1, "Johnny Donald" (6), "Father Pat Hannegan Missionary" (5), Edward O'Toole, March 1947

Heroic 42, "Snatched From a Quarry Grave" (3), Eastern Color, May 1947

Heroic 43, "Rescue by Air" (4), Eastern Color, July 1947

All-American Comics 88, "Tarantula Unmasks Dr. Mid-Nite" (7), DC Comics, August 1947

Heroic 44, "Mercy Flight" (5), "Nurse Without Fear" (2), Eastern Color, September 1947

Comic Cavalcade 23, cover (Alex Toth/Sheldon Mayer), DC Comics, October 1947

All-Star Comics 37, "Justice Society of America" (10, chapters 5-6), DC Comics, October 1947

Green Lantern 28, "The Fool Comes to Town" (12), "The Tricks of the Sportsmaster" (12, splash by Irwin Hasen), DC Comics, October 1947

Heroic 45, "Acts of Valor" (2), "Vail Medal Award" (2), "The Heroic Tenderfoot" (3), "Paralyzed by Fear" (2), Eastern Color, November 1947

All-American Comics 92, cover, "The Icicle Goes South" (12), DC Comics, December 1947

All-Star Comics 38, cover, "Justice Society" (16, 1st and last chapters [1-12, 35-38]), DC Comics, December 1947

1948

Heroic 46, "Heroine Saves 11" (2), "Safety First" (2), Eastern Color, January 1948

Green Lantern 30, cover, "The Saga of Streak" (12), "The Fatal Chance" (12, inker unknown), DC Comics, February 1948

Heroic 47, "Nothing to It" (2), Eastern Color, March 1948

Comic Cavalcade 26, "Forecast: Danger" (12), DC Comics, March 1948

Green Lantern 31, "Beauty and the Fool" (12), DC Comics, March 1948

Juke Box Comics 1, cover, "Music Was Never Like This" (4), Eastern Color, March 1948

All-American Comics 96, cover, "Mystery of the Emerald Necklace" (12), DC Comics, March 1948

All-Star Comics 40, "The Plight of a Nation" (12, part III, //John Broome), DC Comics, March 1948

All-American Comics 97, cover, DC Comics, May 1948

Sugar Bowl Comics 1, cover, "Randy" (10), "Success Story" (2 text illustrations), "Clubroom Color" (2 text illustrations), Eastern Color, May 1948

All-American Comics 98, cover, "The End of Sports" (12), DC Comics, June 1948

All-Star Comics 41, cover, DC Comics, June 1948

Comic Cavalcade 27, cover, "April Fool's Day Crimes" (13), DC Comics, June 1948

All-American Comics 99, cover, "Nest of Terror" (12), DC Comics, July 1948

Green Lantern 33, cover, DC Comics, July 1948

All-American Comics 100, cover, "Johnny Thunder" (10, //Robert Kanigher), DC Comics, August 1948

Comic Cavalcade 28, "Treasure of Plateau City" (12), DC Comics, August 1948

All-American Comics 101, cover, "Masquerade at Mesa City!" (8, //Robert Kanigher), DC Comics, September 1948

Green Lantern 34, cover, "Streak Meets the Princess" (12), DC Comics, September 1948

Sugar Bowl Comics 3, "Randy" (11), Eastern Color, September 1948

Dale Evans Comics 1, "The Case of the Terrified Tenderfoot!" (8, //Joe Millard, Frank Giacoia inks), DC Comics, September 1948

All-American Comics 102, cover, "The Bridge of Peril!" (12, //Robert Kanigher), DC Comics, October 1948

Dale Evans Comics 2, "The Case of the Battered Balloonist!" (7, //Joe Millard), DC Comics, November 1948

Green Lantern 35, "Smash Finale" (7), "Wonder Dog of the Month: Cappy" (1), DC Comics, November 1948

All-American Western 103, cover, "City Without Guns!" (10, //Robert Kanigher), DC Comics, November 1948

All-American Western 104, cover, "Unseen Allies!" (10, //Robert Kanigher), DC Comics, December 1948

1949

All-American Western 105, cover, "Hidden Guns!" (10, //Robert Kanigher, Frank Giacoia inks), DC Comics, January 1949

Dale Evans Comics 3, "The Case of the Perfumed Plunder!" (8, //Joe Millard), DC Comics, January 1949

Green Lantern 36, cover, "Mystery of the Missing Messenger" (8), "Wonder Dog of the Month: Natch" (1, //Robert Kanigher), DC Comics, January 1949

All-American Western 106, cover, "Snow Mountain Ambush!" (10, //Robert Kanigher, Frank Giacoia inks), DC Comics, February 1949

Dale Evans Comics 4, "The Case of the Outdated Outlaw!" (8, //Joe Millard), DC Comics, March 1949

All-American Western 107, cover, "Cheyenne Justice!" (12, //Robert Kanigher, Frank Giacoia inks), DC Comics, March 1949

Green Lantern 37, cover, "The Unexpected Guest" (8), "Dog Hero of the Month" (2, //Robert Kanigher), "Too Many Suspects" (12, //Robert Kanigher, Frank Giacoia inks), DC Comics, March 1949

Famous Funnies 177, (2 text illustrations), Eastern Color, April 1949

Famous Funnies 178, "Avenging Brakie" (2 text illustrations, //Jack Greene), Eastern Color, May 1949

Green Lantern 38, cover, "The Double Play" (10), "Wonder Dog of the Month: Snowball" (1, //Robert Kanigher), DC Comics, May 1949

Dale Evans Comics 5, "The Case of the Forgotten Stagecoach!" (8, //Joe Millard), DC Comics, May 1949

All-American Western 108, cover, "Vengeance of the Silver Bullet!" (12, //Robert Kanigher), DC Comics, June 1949

Romance Trail 1, "Escape From Love" (12, Frank Giacoia inks), DC Comics, July 1949

Dale Evans Comics 6, "The Case of the Colossal Fossil!" (8, //Joe Millard), DC Comics, July 1949

Sensation Comics 91, "Streak, Special Prosecutor" (7, //Robert Kanigher), DC Comics, July 1949

True Crime Vol. 2, #1, "The Terror" (7, Wally Wood possible inker), Magazine Village, August 1949

Sensation Comics 92, "Wonder Dog of the Month: Brownie" (2), DC Comics, August 1949

Girls' Love Stories 1, "Unlucky Heart" (8, Bernard Sachs inks), DC Comics, August 1949

Romance Trail 2, "Imprisoned Heart" (11, inker unknown), "Prairie Song" (1), DC Comics, September 1949

by **FRANCISCO SAN MILLAN** and **AXEL KAHLSTORFF**
based on an original index by Jim Vadeboncoeur Jr.

with the help of Philippe Angeli, Jean-Michel Blanc, Manuel Auad, Al Dellinges, and Steve Holland

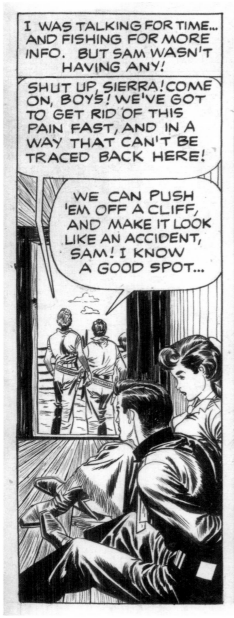

ABOVE: Detail from the original artwork for "The Case of the Haunted Horse!", *Dale Evans Comics* #9 (January 1950).

1950

Dale Evans Comics 7, "The Case of the Teetering Tower!" (8, //Joe Millard), DC Comics, September 1949

All-American Western 109, cover, "Secret of Crazy River!" (10, //Robert Kanigher), DC Comics, August 1949

Jimmy Wakely 1, Contents (1), "The Cowboy Swordsman" (11, Frank Giacoia inks), "Jinx Town Lives Again" (8, Frank Giacoia inks), "The Treasure of Outcast Ridge" (8, Frank Giacoia inks), DC Comics, September 1949

Secret Hearts 1, "Make Believe Sweetheart" (7, inker unknown), DC Comics, September 1949

All-American Western 110, cover, "Ambush at Scarecrow Hills!" (10, //Robert Kanigher, Joe Giella inks), DC Comics, October 1949

Girls' Love Stories 2, "Girl In the Shadows" (9, inker unknown), DC Comics, October 1949

Romance Trail 3, "Yesterday's Sweetheart" (9, Joe Giella possible inker), DC Comics, November 1949

Secret Hearts 2, "I'll Never Forget You!" (12, inker unknown), "It All Came True" (1), DC Comics, November 1949

Dale Evans Comics 8, "The Case of the Five-Cent Fortune!" (8, signed Toth, but he claimed it is not his work), DC Comics, November 1949

Jimmy Wakely 2, "The Trail of the Compass" (9, Joe Giella inks), "The Prize Pony" (10, Bernard Sachs inks), "The Secret of the Wooden Indian" (8, Bernard Sachs inks), DC Comics, November 1949

Girls' Love Stories 3, "The World is Ours" (1), DC Comics, December 1949

All-American Western 111, cover, "The Gun-Shy Sheriff!" (10, //Robert Kanigher, Joe Giella possible inker), DC Comics, December 1949

Secret Hearts 3, "Sing Me a Love Song" (10, inker unknown), DC Comics, January 1950

Dale Evans Comics 9, "The Case of the Haunted Horse!" (8, //Joe Millard, Joe Giella inks), DC Comics, January 1950

Romance Trail 4, "The Fearful Heart" (11, Frank Giacoia inks), DC Comics, January 1950

Jimmy Wakely 3, "The Return of Tulsa Tom" (11, Joe Giella possible inker), "Prairie Town's 30-Day Wonder" (10, Joe Giella possible inker), "The Comeback Trail" (6, Bernard Sachs possible inker), DC Comics, January 1950

Girls' Love Stories 4, "Where There is Love" (8, Joe Giella inks), "The Magic Moment" (1), DC Comics, February 1950

All-American Western 112, "Double Danger!" (10, //Robert Kanigher, Joe Giella inks), DC Comics, February 1950

Girls' Romances 1, "Love in Season" (1), DC Comics, February 1950

Secret Hearts 4, "You Only Love Once" (10, Joe Giella possible inker), DC Comics, March 1950

Jimmy Wakely 4, "Where There's Smoke There's Fire !... Gunfire" (11, Joe Giella inks), "Outlaws of the Night" (8, Joe Giella inks), DC Comics, March 1950

Dale Evans Comics 10, "The Case of the Oily Worm!" (8, //Joe Millard), DC Comics, March 1950

Romance Trail 5, "Western Serenade" (1), DC Comics, April 1950

Girls' Romances 2, "Tragic Choice" (10, Frank Giacoia inks), DC Comics, May 1950

Jimmy Wakely 5, "The Return of the Conquistadors" (11, Joe Giella inks), "Sing, Cowboy, Sing (8, Bernard Sachs inks), "Bullets are Bad Luck" (8, Joe Giella inks), DC Comics, May 1950

Secret Hearts 5, "Wake Up and Love" (11, Joe Giella inks), DC Comics, May 1950

All-American Western 113, cover, "Johnny Thunder Indian Chief!" (12, //Robert Kanigher, Joe Giella inks), DC Comics, May 1950

Dale Evans Comics 11, "The Case of the Furious Fiddler!" (8, //Joe Millard, inker unknown), DC Comics, May 1950

Casey Ruggles, "Aquila" (47 dailies, Warren Tufts story and inks), United Feature Syndicate, May 16-July 8, 1950

All-American Western 114, cover, "The End of Johnny Thunder!" (8, //Robert Kanigher, Joe Giella inks), DC Comics, June 1950

Girls' Romances 3, "Out of Sight...Out of Heart" (8), DC Comics, June 1950

Jimmy Wakely 6, "The Two Lives of Jimmy Wakely" (11, Joe Giella inks), "The Mesa of Murderous Melody" (8, Joe Giella inks), "The Treasure at Rainbow's End" (6, Joe Giella possible inks), DC Comics, July 1950

Casey Ruggles, "The Spanish Mine" (Warren Tufts story and inks), United Feature Syndicate, July 11, 1950

Secret Hearts 6, "Dreamer's Return" (8, Bernard Sachs inks), DC Comics, July 1950

Danger Trail 1, "Appointment in Paris" (8, //Herron), DC Comics, July 1950

All-American Western 115, cover, "Cheyenne Mystery!" (10, //Robert Kanigher, Joe Giella inks), DC Comics, August 1950

Danger Trail 2, "Toreador From Texas!" (10, //Robert Kanigher), DC Comics, September 1950

Jimmy Wakely 7, "The Secret of Hairpin Canyon" (9, Bernard Sachs inks), "Desert Justice" (8, Frank Giacoia inks), DC Comics, September 1950

All-American Western 116, cover, "Buffalo Raiders on the Mesa!" (12, //Robert Kanigher, Joe Giella inks), DC Comics, October 1950

Danger Trail 3, "Battle Flag of the Foreign Legion" (8, //Robert Kanigher), DC Comics, November 1950

Jimmy Wakely 8, "The Lost City of Blue Valley" (11, Bernard Sachs inks), "Big Town Roundup" (8, Bernard Sachs inks), DC Comics, November 1950

All-American Western 117, "Johnny Thunder vs. Black Lightnin'!" (12, //Robert Kanigher, Joe Giella inks), DC Comics, December 1950

The Winslow Boy presented by The Argus Eyes Dramatic Society of St. Peters College, cover, December 1950

The Barrets of Wimpole Street presented by The Argus Eyes Dramatic Society of St. Peters College, cover, probably 1950

1951

Jimmy Wakely 9, "The Return of the Western Firebrands" (9, Bernard Sachs inks), "The Secret of the Old Sourdough" (8, Bernard Sachs inks), DC Comics, January 1951

Danger Trail 4, "The End of the Arctic" (8, Bernard Sachs inks), DC Comics, January 1951

All-American Western 118, "Challenge of the Aztecs!" (12, //Robert Kanigher, Joe Giella inks), DC Comics, February 1951

Danger Trail 5, "The Return of the Pharaoh" (8, Bernard Sachs inks), DC Comics, March 1951

Jimmy Wakely 10, "The Secret of Lantikin's Light" (9, Joe Giella inks), "The Town That Vanished" (8, Frank Giacoia possible inker), "Brand of the Badman" (10, Bernard Sachs inks), DC Comics, March 1951

Unconquered, cover, (14), National Comittee for a Free Europe, Inc., 1951

Mystery in Space 1, "The Men Who Lived Forever" (10, //John Broome, Sy Barry inks), DC Comics, April 1951

All-American Western 119, "The Vanishing Gold Mine!" (12, //Robert Kanigher, Frank Giacoia inks), DC Comics, April 1951

All-Star Western 58, "Gunlords of the Panhandle!" (8, Bernard Sachs inks), DC Comics, April 1951

Jimmy Wakely 11, "The Trail of a Thousand Hoofs" (11, Bernard Sachs inks), "Showdown at Santa Fe" (8, Joe Giella inks), DC Comics, May 1951

Strange Adventures 8, "Time Capsule From Tomorrow" (10, //John Broome, Sy Barry inks), DC Comics, May 1951

All-American Western 120, "Ambush at Painted Mountain!" (12, //Robert Kanigher, Sy Barry inks), DC Comics, June 1951

Strange Adventures 9, "Push-Button Paradise" (8, //Gardner Fox, Bernard Sachs inks), DC Comics, June 1951

All-Star Western 59, "Code of a Ranger" (8, Bernard Sachs), DC Comics, June 1951

Romantic Marriage 5, "Doctor's Wife" (7, inker unknown), Ziff-Davis, July 1951

Jimmy Wakely 12, "The King of Sierra Valley" (12, Sy Barry possible inker), "The Magic Wand of Katawan" (8, Sy Barry inks), "Jimmy Wakely vs. Jimmy Wakely" (8, Frank Giacoia inks), DC Comics, July 1951

Two-Fisted Tales 22, "Dying City" (7, //Harvey Kurtzman story and inks), EC Comics, July 1951

Big Town 8, cover, DC Comics, August 1951

All-American Western 121, cover, "The Unmasking of Johnny Thunder!" (12, //Robert Kanigher, Sy Barry inks), DC Comics, August 1951

All-Star Western 60, "The Nest of the Robber Rangers!" (8, Bernard Sachs), DC Comics, August 1951

Personal Love 11, "I Struck It Rich" (9, signed Hawk), Eastern Color, September 1951

Big Town 9, cover, DC Comics, September 1951

Strange Adventures 12, "The Brain Masters of Polaris" (10, //John Broome, Sy Barry inks), DC Comics, September 1951

Jimmy Wakely 13, cover, "Raiders of Treasure Mountain" (12, Bernard Sachs inks), "Death Valley Ambush" (8, Frank Giacoia inks), "Return of the Golden Herd" (9, Sy Barry inks), DC Comics, September 1951

Big Town 10, cover, DC Comics, October 1951

Strange Adventures 13, "Artist of Other Worlds" (10, //Edmond Hamilton, Sy Barry inks), DC Comics, October 1951

All-American Western 122, cover, "The Real Johnny Thunder!" (10, //Robert Kanigher, Sy Barry inks), DC Comics, October 1951

All-Star Western 61, "The Roving Ranger" (2), DC Comics, October 1951

Big Town 11, cover, DC Comics, November 1951

Jimmy Wakely 14, cover, "The Badmen of Roaring Flame Valley" (10), "The Return of the White Stallion" (6, Joe Giella inks), "Jailbreak for Sale" (8, Sy Barry inks), DC Comics, November 1951

Weird Thrillers 2, "The Fisherman of Space" (7, Sy Barry inks), Ziff-Davis, Winter 1951

Big Town 12, cover, DC Comics, December 1951

All-American Western 123, "Johnny Thunder's Strange Rival!" (8, //Robert Kanigher, Sy Barry inks), DC Comics, December 1951

1952

Sensation Comics 107, "Queen of the Snows!" (8, Sy Barry inks), DC Comics, January 1952

Jimmy Wakely 15, "The Ballad of Boulder Bluff" (6, Frank Giacoia inks), DC Comics, January 1952

Big Town 13, cover, DC Comics, January 1952

Adventures of Rex the Wonder Dog 1, cover, "Rex the Wonder Dog" (8, Sy Barry inks), "Trail of the Flower of Evil" (8, Sy Barry inks), "Rex-Forest Ranger" (8, inker unknown), DC Comics, January 1952

Best Romance 5, "My Stolen Kisses" (7, John Celardo inks), Standard, February 1952

All-American Western 124, cover (inker unknown), "The Iron Horse's Last Run!" (6, //Robert Kanigher, Sy Barry inks), DC Comics, February 1952

Strange Adventures 17, "The Brain of Dr. Royer" (8, //Manny Rubin, Bernard Sachs inks), DC Comics, February 1952

All-Star Western 63, "Find My Killer!" (6, Bernard Sachs inks), DC Comics, February 1952

Adventures of Rex the Wonder Dog 2, cover, "Rex-Hollywood Stunt Dog" (10, Sy Barry inks), "Four-Legged Sheriff" (8, Sy Barry inks), DC Comics, March 1952

Strange Adventures 18, "Girl in the Golden Flower" (6, //Robert Starr, Sy Barry inks), DC Comics, March 1952

New Romances 10, "Be Mine Alone" (7, Mike Peppe inks), Standard, March 1952

Mystery In Space 7, "The World Where Dreams Come True!" (8, //Manny Rubin, Sy Barry possible inker), DC Comics, April 1952

All-American Western 125, cover (Sy Barry inks), Johnny Thunder's Last Roundup!" (8, //Robert Kanigher, Sy Barry inks), DC Comics, April 1952

All-Star Western 64, "The Riddle of the Rival Ranger!" (6, inks by Sy Barry), DC Comics, April 1952

Sensation Comics 108, "I Was King of the Moths!" (8, Sy Barry inks), DC Comics, March 1952

Strange Adventures 19, "The Canals of Earth" (6, //Manny Rubin, Sy Barry inks), DC Comics, April 1952

New Romances 11, "My Empty Promise" (10, Mike Peppe inks), Standard, May 1952

Adventures of Rex the Wonder Dog 3, "Rex-Circus Detective" (8, Frank Giacoia possible inker), DC Comics, May 1952

Today's Romance 6, "Appointment With Love" (3, John Celardo inks), Standard, May 1952

Thrilling Romances 19, "Help Yourself to Love" (2 text illustrations), Standard, May 1952

Sensation Comics 109, "The Demon in the Mirror!" (8, Sy Barry inks), DC Comics, May 1952

My Real Love 5, "Shattered Dream" (3, John Celardo inks), Standard, June 1952

Battlefront 5, "Terror of the Tank Men" (7, John Celardo inks), Standard, June 1952

Unseen 5, "The Blood Money of Galloping Chad Burgess" (8, John Celardo inks), Standard, June 1952

Out of the Shadows 5, "The Shoremouth Horror" (8, Mike Peppe inks), Standard, July 1952

This Is War 5, "Show Them How to Die" (6, John Celardo inks), Standard, July 1952

Adventures Into Darkness 5, "Murder Mansion" (8, Mike Peppe inks), "The Phantom Hounds of Castle Eyne" (1, Mike Peppe inks), Standard, August 1952

Intimate Love 19, "I Married in Haste" (7, Mike Peppe inks), Standard, August 1952

Crime Files 5, "Five State Police Alarm" (1), Standard, September 1952

Frontline Combat 8, "Thunderjet!" (8, //Harvey Kurtzman), EC Comics, September 1952

Unseen 6, "Peg Powler" (1, Mike Peppe inks), Standard, September 1952

Fantastic Worlds 5, "Triumph Over Terror" (8, Mike Peppe inks), "The Invaders" (7, Mike Peppe inks), Standard, September 1952

Lost Worlds 5, "Alice In Terrorland" (5, John Celardo inks), Standard, October 1952

Adventures Into Darkness 6, "Corpse Convention" (½, splash), Standard, October 1952

This Is War 6, "Routine Patrol" (5, John Celardo inks), "Too Many Cooks" (5), Standard, October 1952

Frontline Combat 12, "F-86 Sabre Jet!" (7, //Harvey Kurtzman), EC Comics, October 1952

Fantastic Worlds 6, cover, "The Boy Who Saved the World" (5, Mike Peppe inks), Standard, November 1952

Jet Fighters 5, cover, "The Egg-Beater" (6, Mike Peppe inks), Standard, November 1952

Lost Worlds 6, cover (Mike Peppe inks), "Outlaws of Space" (7, Al Rubano inks), Standard, December 1952

New Romances 14, "Smart Talk" (1, Mike Peppe possible inker), Standard, December 1952

Joe Yank 5, "Black Market Mary" (8, Sy Barry inks, Art Saaf touchups on faces), Standard, March 1952

Joe Yank 6, "Bacon and Bullets" (7, John Celardo inks), Standard, May 1952

Out of the Shadows 6, "The Phantom Ship" (8, Mike Peppe inks), Standard, October 1952

Joe Yank 8, cover, Standard, October 1952

Popular Romance 22, "Blinded By Love" (10, Mike Peppe inks), Standard, January 1953

Who Is Next? 5, "The Crushed Gardenia" (8), Standard, January 1953

Adventures Into Darkness 8, "The House That Jackdaw Built" (7, Mike Peppe inks), "The Twisted Hands" (5, Mike Peppe inks), Standard, February 1953

Joe Yank 10, cover, Standard, February 1953

Intimate Love 21, "Undecided Heart" (7, Mike Peppe possible inker), Standard, February 1953

Jet Fighters 7, "Seeley's Saucer" (6, Mike Peppe inks), Standard, March 1953

Adventures Into Darkness 9, "The Hands of Don José" (8, Mike Peppe inks), Standard, April 1953

Popular Romance 23, "Free My Heart" (10, Mike Peppe inks), Standard, April 1953

Flash Gordon: "The Space Kids on Zoran" (Alex Toth, Al Williamson, Russ Heath ghosting for Dan Barry), King Features Syndicate, April 21-October 24, 1953

This Is War 9, "No Retreat" (7, John Celardo inks), Standard, May 1953

Exciting War 8, "Geronimo Joe" (8, Mike Peppe inks), Standard, May 1953

Intimate Love 22, "I Want Him Back" (10), Standard, May 1953

World's Finest 66, "Australian Code Mystery" (10, //David Vern, Sy Barry inks), DC Comics, September 1953

New Romances 16, "Man of my Heart" (10, Mike Peppe inks), Standard, June 1953

Popular Romance 24, "I Fooled My Heart" (7), Standard, July 1953

New Romances 17, "Stars in my Eyes" (10, Mike Peppe inks), "Uncertain Heart" (6, Mike Peppe, Mike Sekowsky, and Mike Esposito inks), Standard, August 1953

Popular Romance 25, "I Need You" (10, Mike Peppe inks), Standard, September 1953

New Romances 18, "My Dream Is You" (10, Mike Peppe inks), Standard, October 1953

Out of the Shadows 10, "The Corpse That Lived" (3), Standard, October 1953

Unseen 12, "Grip on Life" (4, Mike Peppe inks), Standard, November 1953

Popular Romance 26, "Guilty Heart" (8, Mike Peppe inks), Standard, November 1953

New Romances 19, "Smart Talk" (1, Mike Peppe inks), Standard, December 1953

Thrilling Romances 22, "Heart Divided" (3, Mike Peppe inks), Standard, August 1953

Thrilling Romances 23, "Chance For Happiness" (10, Mike Peppe possible inker), Standard, October 1953

3-D Romance 1, cover, Steriographic, December 1953

Adventures Into Darkness 12, cover (possibly Toth, Mike Peppe inks), Standard, December 1953

Out of the Shadows 11, "The Mask of Graffenwehr" (2, Mike Peppe inks), Standard, January 1954

Thrilling Romances 24, "Ring On Her Finger" (10, Mike Peppe inks), "Frankly Speaking" (2, Mike Peppe or John Celardo possible inker), Standard, January 1954

Popular Romance 27, "Heartbreak Moon" (10, Mike Peppe inks), "Long on Love" (1 Mike Peppe inks), Standard, February 1954

Intimate Love 26, "Lonesome For Kisses" (10, Mike Peppe inks), "If You're New In Town" (1, Mike Peppe inks), "Those Drug-Store Romeos" (1), Standard, February 1954

Boy Loves Girl 43, "I Played With Fire" (7, Mike Peppe inks), Lev Gleason, February 1954

Buster Crabbe 2, cover, "Dark of the Moon" (9, Mike Peppe inks, John Celardo touchups on Crabbe's face), "Killer on the Loose" (8, Mike Peppe inks), Lev Gleason, February 1954

Unseen 13, cover, "The Hole of Hell" (2, Mike Peppe inks), Standard, February 1954

Adventures Into Darkness 13, cover (possibly Toth, Mike Peppe inks), Standard, March 1954

Black Diamond Western 49, cover, Lev Gleason, February/March 1954

Out of the Shadows 12, "The Man Who Was Always on Time!" (5, Mike Peppe inks), "Images of Sand" (6, Mike Peppe inks), Standard, March 1954

Joe Yank 15, "Fire Fighter" (2 text illustrations), Standard, April 1954

Crime and Punishment 66, cover, "War on the Streets" (12), "The Burner" (7), "The Armored Car Murders" (8), Lev Gleason, March 1954

New Romances 20, "Love's Calendar" (½), "Smart Talk" (1), Standard, March 1954

Buster Crabbe 3, "Invisible Monsters of Callisto" (9, Mike Peppe inks), Lev Gleason, April 1954

Boy Loves Girl 46, "No Love for Me" (7), Lev Gleason, May 1954

Tor 3, "Danny Dreams" (5), St. John, May 1954

Boy Loves Girl 47, "Postponed Honeymoon" (7, Mike Peppe inks), Lev Gleason, June 1954

Crime and Punishment 68, cover, Lev Gleason, July 1954

Love Romances 48, "Just My Type!" (5, Mike Peppe possible inker), Atlas, March 1955

Lovers 67, "I Do…" (6, Mike Peppe possible inker), Atlas, May 1955

Love Romances 49, "Something Borrowed, Something Blue…" (6, Mike Peppe inks), Atlas, May 1955

The Tokyo Quartermaster Depot Diary, various cartoons and illustrations, Armed Forces Press, 1955

The Tokyo Quartermaster Depot Diary, "Jon Fury in Japan" (14, //Toth), Armed Forces Press, April 8-July 22, 1955

The Tokyo Quartermaster Depot Diary, "The New Adventures of Jon Fury" (17, //Toth), Armed Forces Press, August 26-December 16, 1955

The Tokyo Quartermaster Depot Diary, bridge strips for "Jon Fury" (3, //Toth), Armed Forces Press, July 22, 1955 and December 23 and 30, 1955

Love Romances 53, "Working Girl's Romance" (6, Mike Peppe inks), Atlas, November 1955

The Tokyo Quartermaster Depot Diary, "Jon Fury" (12-16, //Toth), Armed Forces Press, January 6-April 20, 1956

Air Power, cover, "You Are There: Fools, Daredevils and Geniuses" (25), Prudential Insurance Co. Giveaway

My Own Romance 55, "'Til We Meet Again" (5), Atlas, January 1957

Gene Autry and Champion 113, "Sundown Incident" (4), Dell, January 1957

Western Gunfighters 24, "His Back to the Wall!" (7, //Stan Lee), Atlas, February 1957

Rex Allen 24, "Friend or Foe" (12), Dell, March 1957

Roy Rogers and Trigger 111, "Chuckwagon Charlie's Tales" (4), Dell, March 1957

Jace Pearson's Tales of the Texas Rangers 15, "Famous Texans: Stephen Fuller Austin-Father of Texas" (4), Dell, March 1957

Flying A's Range Rider 17, "Nitro" (6), Dell, March 1957

ABOVE: Splash page from "Toreador from Texas" in *Danger Trail* #2 (September 1950).

My Love Story 7, "More Than a Wife" (4), Atlas, April 1957

Four Color 790, The Wings of Eagles: "The Wings of Eagles" (32, Howard O'Donnell possible inker), "Naval Aviation Firsts" (2), Dell, April 1957

Western Roundup 18, "Hidden Treasure" (8), Dell, April/June 1957

Rockets and Range Riders, cover, "Rockets and Range Riders" (12), Richfield Oil Co. giveaway

Jace Pearson's Tales of the Texas Rangers 16, "Famous Texans: Charles Goodnight" (4), Dell, June 1957

Four Color 822, Paul Revere's Ride: "Paul Revere's Ride" (32), "The Mystery of the Larkin Horse" (1), "A Remarkable Man Was Paul Revere" (1), Dell, August 1957

Four Color 845, The Land Unknown: "The Land Unknown" (32), "Antarctica the Frozen South" (1), "Pioneer of the Pole" (1, uncommon bc), Dell, August 1957

Four Color 846, Gun Glory: "Gun Glory" (32), Dell, October 1957

Roy Rogers and Trigger 119, "Tornado" (11), "The Temptation of Sam McGraw" (9), Dell, November 1957

Roy Rogers and Trigger 120, "Hidden Gold" (10), "Masquerade" (10), Dell, December 1957

Buffalo Bill, Jr And Calamity Coloring Book, line drawings (96), Whitman

Tonto Coloring Book, line drawings (40), Whitman

1958

Roy Rogers and Trigger 121, "Victory Fists" (12), Dell, January 1958

Roy Rogers and Trigger 122, "The Clue of the Cryptic Key" (10), Dell, February 1958

Four Color 882, Zorro: "Presenting Señor Zorro" (18), "Zorro's Secret Passage" (14), Dell, February 1958

Roy Rogers and Trigger 123, "The Sign of the Burning Rock" (12), Dell, March 1958

Four Color 877, Frontier Doctor: "Storm Over King City" (20), "Apache Uprising" (12), "Before the Doctors Came West" (1), "The First Patent Medicines" (1), Dell, February 1958

Four Color 889, Clint and Mac: "Clint and Mac" (32), "Proof Positive" (1), "Scotland Yard's Canine Detectives" (1), Dell, March 1958

Roy Rogers and Trigger 124, "The Rebel Rider" (12), Dell, April 1958

Western Roundup 22, "The Frontiersmen: George Rogers Clark" (4), Dell, April/June 1958

Four Color 907, Sugarfoot: "Brannigan's Boots" (20), "Eye Witness" (12), "The Law Moves West" (1), "The Cowboy Cobbler" (1), Dell, May 1958

Four Color 920, Zorro: "Ghost of the Mission" (26), "A Bad Day For Bernardo" (6), "El Camino Real" (1), Dell, June 1958

Four Color 914, No Time for Sergeants: "No Time for Sergeants" (32), "The Big Change" (1), "The Long Ride Down" (1, bc uncommon), Dell, July 1958

Four Color 933, Zorro: "Garcia's Secret" (14), "The King's Emissary" (12), "The Little Zorro" (6), "Fiesta (1), Dell, September 1958

Four Color 951, The Lennon Sisters: "The Lennon Sisters' Life Story" (29), "The Lennon Sisters' Favorite Games" (1), "The Lennon Sisters' Favorite Recipes" (1), "Let's Polka with the Lennon Sisters" (1), Dell, November 1958

Four Color 960, Zorro: "The Eagle's Brood" (26), "The Visitor" (6), "Yankee Trader's Floating Stores" (1), Dell, December 1958

1959

Four Color 976, Zorro: "The Gypsy Warning" (26), "A Double for Diego" (6), "The Four R's of Learning" (1), Dell, March 1959

Four Color 992, Sugarfoot: "The Stallion Trail" (22), "The Law Trap" (10), "A Handle to Live By" (1), Dell, May 1959

Four Color 1003, Zorro: "The Marauders of Monterey" (26), "The Enchanted Bell" (6), "Monterey Famous Firsts" (1), Dell, June 1959

Four Color 1014, The Lennon Sisters: "The Mystery of Lonesome Farm" (32), Dell, July 1959

Four Color 1018, Rio Bravo: "Rio Bravo" (32), Dell, June 1959

Four Color 1024, Darby O'Gill: "Darby O'Gill and the Little People" (32), Dell, August 1959

Four Color 1041, Sea Hunt: "Valley of the Amazon" (18), "Test Dive" (14), "Did You Know That?" (1), "Caution for Divers" (1), Dell, October 1959

Four Color 1069, The FBI Story: "The FBI Story" (32), "FBI Agent in the Making" (1), "The FBI" (1), Dell, November 1959

Maverick by Charles I. Coombs, (25 illustrations), Whitman

1960

Four Color 1066, 77 Sunset Strip: "Safari in Troublesville" (19), "The Big Catch" (12), "Kookie Talk" (1, text illustration), "Kookie's Clues" (1, uncommon), Dell, January 1960

Four Color 1071, The Real McCoys: "Wild Wheels" (19), "Gettin' Grampa's Goat" (12), "The Think-Alikes" (1, uncommon), "Fair Measure" (1), "The Apology" (1, bc uncommon), Dell, January 1960

Wyatt Earp 10, "The Hidden Menace" (4), Dell, March/May 1960

Four Color 1085, The Time Machine: "The Time Machine" (32), Dell, March 1960

Zorro 9, "The Bandidos" (4), Dell, March 1960

Rifleman 3, "The Wild'un Comes Home" (4), Dell, April 1960

Wagon Train 5, "The Calculating Killer" (4), Dell, April/June 1960

Rin Tin Tin and Rusty 34, "Kangaroo Bluff" (4), Dell, May 1960

Maverick 10, "The Suitor" (4), Dell, May 1960

Lawman 4, "The Horse Stealers" (4), Dell, May 1960

Four Color 1105, Oh! Susanna: "Contents" (1), "The Sea Horse" (22), "Pirate, Beware" (10), "Gale Storm" (1), Dell, June 1960

Four Color 1106, 77 Sunset Strip: "Kookie's Close Call" (16), "Lights, Camera, Danger" (16), "Grapevine Clues" (1), "Kookie's Catch" (1, bc uncommon), Dell, June 1960

Colt .45 6, "The Gunslinger" (4), Dell, August 1960

Four Color 1134, The Real McCoys: "Content" (1), "Run For the Money" (18), "Rembrandt McCoy" (13), "The Woodchopper's Fall" (1), "Grampa's Fortune" (1), "Three Ways Out" (1), Dell, September 1960

Maverick 13, "Stubborn as a Mule" (4), Dell, November 1960

Rin Tin Tin and Rusty 36, "Charley Sing-Song" (4), Dell, November 1960

Wyatt Earp 13, "A Night's Wages" (4), Dell, December/February 1960

Zorro 12, "Contents (1), "The Runaway Witness" (21), "Friend Indeed" (5), "Señor Gomez Hunts a Fox" (1, not in all copies), "Smugglers' Haven" (1), "Clash With Diego" (1), Dell, December/February 1960

School Friend, "Danger Line—'43", 10 (1, ½), 17 (1, ½), 24 (1), Fleetway, UK, December 10-24, 1960

Circus of Horrors (1, movie ad), Sponsored Comics, 1960

Roy Rogers (12 strips, ghosting for Mike Arens), King Features Syndicate, December 19-31, 1960

1961

Roy Rogers (12 strips, ghosting for Mike Arens), King Features Syndicate, January 2-14, 1961

Four Color 1159, 77 Sunset Strip: "Contents" (1), "The Money Wagon" (16), "The Night Visitor" (16), "Clues to the Missing" (1), "Kookie's Quandary" (1, uncommon bc), Dell, January 1961

Rifleman 6, "Reprieve for Ol' Joe" (4), Dell, January 1961

House of Mystery 109, "Track of the Invisible Beast" (9), DC Comics, March 1961

Four Color 1180, The Danny Thomas Show: "Contents" (1), "Weekend Millionaire" (14), "Showdown in Tinsel-town" (10), "Pioneer Picnic" (8), "A Wet Walk" (1), "The Ballgame" (1, uncommon bc), Dell, March 1961

My Greatest Adventure 58, "I Was Trapped in the Land of l'Oz" (8), DC Comics, August 1961

House of Secrets 48, "The Great Dimensional Brain Swap" (8), DC Comics, September 1961

My Greatest Adventure 60 "The Alien Within Me" (8), DC Comics, October 1961

My Greatest Adventure 61, "I Battled for the Doom Stone" (8), DC Comics, November 1961

Master of the World, (1) movie advertising and promotional booklet, Sponsored Comics, 1961

1962

Rip Hunter Time Master 6, "The Secret of the Ancient Seer" (25, //Jack Miller), DC Comics, February 1962

House of Mystery 120, "Secret Hero of Center City" (8), DC Comics, March 1962

Rip Hunter Time Master 7, "Lost Wanderers in Time" (25, //Jack Miller, pp 9-17 Toth and Bill Ely inks, pp 18-25 Mike Esposito inks), DC Comics, April 1962

Pictorial Encyclopedia of American History, vol. 9-16 (some Toth pencils, paintings by unknown), Davco, 1962

Schoolgirls Picture Library 180, "Rally to Catherine!" (19, touchups on faces by other artist), Fleetway, UK, 1962

Bibliography continues in GENIUS, ILLUSTRATED

INTERVIEWS

During two and a half years of research devoted to *Genius, Isolated*, two dozen interviews were conducted with Alex Toth's friends, peers, fans, and family. Each person interviewed provided valuable insights that enrich this biography. What follows is a list of all interviews used in this volume, with notations marking their place of usage in the text. Many thanks to those who graciously agreed to be interviewed, and whose memories form such an important part of both this book and its sequel, *Genius, Illustrated*.

PUBLICATIONS PROVIDING QUOTED MATERIAL

Alex Toth was a dominant figure in his chosen fields: he was the subject of several articles and authored scores of articles for diverse publications. Quotes pulled from this list of publications allowed Alex to speak for himself and helped provide the most fully rounded possible portrayal of the artist and his times.

ADDITIONAL ACKNOWLEDGMENTS, THANKS, COPYRIGHTS, AND PERMISSIONS

Jon Fury, Jon Fury in Japan, and The Fox TM and © 2011 Estate of Alex Toth. Alex Toth artwork on pages 1, 4-5, 7-11, 14, 15, 20, 24, 33, 106, 108-113, 197-199, 328 © 2011 Estate of Alex Toth.

Alex Toth's name and likeness are properties of the Estate of Alex Toth and are used with permission.

Although some of Alex Toth's earlier comics work may legally be in the public domain, there are some rights more important than legal ones. We ask everyone to respect Alex Toth's memory and the moral rights of his children as the beneficiaries of his work. We urge those who wish to reprint any of that earlier work to contact the estate for permission: http://www.tothfans.com

We offer our grateful appreciation to the following for the kind permissions to reprint three important stories:

Dan DiDio, Paul Levitz, Jay Cogan, and Thomas King at DC Comics for "Battle Flag of the Foreign Legion" from *Danger Trail* #3 © 1950 DC Comics. All Rights Reserved. Used with Permission.

John Gertz and Susan Berger at Zorro Productions. "Zorro's Secret Passage," drawn by Alex Toth, is used with the express permission of Zorro Productions, Inc., Berkeley, California. © 2011. All rights reserved. Zorro® is owned by Zorro Production, Inc.

Cathy Gaines Mifsud and Alexandra Ritucci Mifsud at William M. Gaines Agent, Inc. for "Thunderjet!" from *Frontline Combat* #8 © 2011 William M. Gaines Agent, Inc. Used with permission.

Individual pages, drawings, and cover reproductions in this book are copyrighted as follows:
Atlas Comics: 246-249; Cambria Studios: 12-13, 313; Conde Nast: 25; DC Comics: 48-59, 69 (top), 75-85, 310, 319-322; King Features: 30, 104; Martin Pasko/Joe Staton/Scott Shaw!: 96; Tribune Media Services: 29; United Feature Syndicate: 28; Zorro Productions: 6, 257. We have used due diligence to include the proper copyright notices for works reproduced in this book. If any omissions or errors are brought to our attention, they will be rectified in subsequent printings.

The images on the front cover and the first and last pages are from "Taps," originally published in *Bop* #1 (1982).

• • • • •

For invaluable help with interview transcription and data organization, grateful thanks are extended to:
Brenda Burns, Haley Burns, Lyndsay Canwell, and Krista Guglielmetti.

For making available his extensive personal library of comics-related magazines and non-fiction books, a special "Thank you" to old friend Mike Dudley.

The following people have been incredibly gracious with their time, remembrance, and research assistance, by loaning or scanning art from their valuable collections, or by facilitating permissions. This book and *Genius, Illustrated* would be much thinner without their kindnesses. A round of applause to them all:
David Allen, Jim Amash, David Armstrong, Richard Arndt, Manuel Auad, Fershid Bharucha, Steven Bialick, The Milton Caniff Collection at The Ohio State University, Dewey Cassell, Howard Chaykin, Sebastien Chevrot, Jon Cooke, Dorothy Crouch, Raymond Cuthbert, Tom DeRosier, Chuck Dixon, Steve Donnelly/coollinesartwork.com, Dr. Macro's Movie Scans, Mike Esposito, Jackie Estrada, Mark Evanier, Chris Ferguson, Greg Goldstein, Ron Goulart, Luther D. Hanson, Irwin Hasen, HeritageAuctions/ha.com, John Hitchcock, Scott James, Jack Katz, Joe Kubert, Gary Land, Steve Leialoha, Russ Maheras, Joe and Nadia Mannarino/allstarauc.com, Fred Manzano, Jack Mendelsohn, J. Hiroshi Morisaki, John Morrow, Stuart Ng, Bill Pearson, Andrew Pepoy, C. and A. Phang, Paul Rivoche, John Romita Sr., Jeff Rose and tothfans.com, Filip Sablik, Buddy Saunders/Lone Star Comics, Diana Schutz, Greg Scott, Randy Scott/Michigan State University Comic Art Collection (Dean Mullaney/Eclipse Comics collection), Larry Shell, Marc Silvestri, Walter Simonson, Anthony F. Smith, Philip W. Smith II, Tom Stazer, Dave Stewart, Rob Stolzer, Justin Triebwasser, Jim Vadeboncoeur Jr., Grant Vogl, Matt Wagner, Doug Wheatley, and cat yronwode.

PHOTO CREDITS: Pages 2-3: © Chris Merriam. Pages 16, 19, 24 (lower left), 26, 38, 70, 74, 94, 194, 250, 253, 256, 259, 308, 314, 316: © the Estate of Alex Toth. Page 99: © Dewey Cassell. All used with permission.

THE
LIBRARY OF
AMERICAN
COMICS

The Great American Comics

FROM IDW AND THE LIBRARY OF AMERICAN COMICS

THE LIBRARY OF AMERICAN COMICS

IDW

LibraryofAmericanComics.com

*This book is dedicated to
the memory of Alex Toth*